THE ART QUILT

THE ART QUILT

Robert Shaw

HUGH LAUTER LEVIN ASSOCIATES, INC.

Design by Kathleen Herlihy-Paoli, Inkstone Design
Photo Research by Ellin Yassky Silberblatt
Editorial Production by Deborah Teipel Zindell
Printed and bound in China
ISBN 0-88363-007-9

◀ FRONTISPIECE QUILT, QUILT # 118 (DETAIL)

Pamela Studstill. 1995. Pipe Creek, Texas. Hand-painted cottons. Machine pieced, hand quilted by Bettie Studstill. Collection of the artist.

CONTENTS

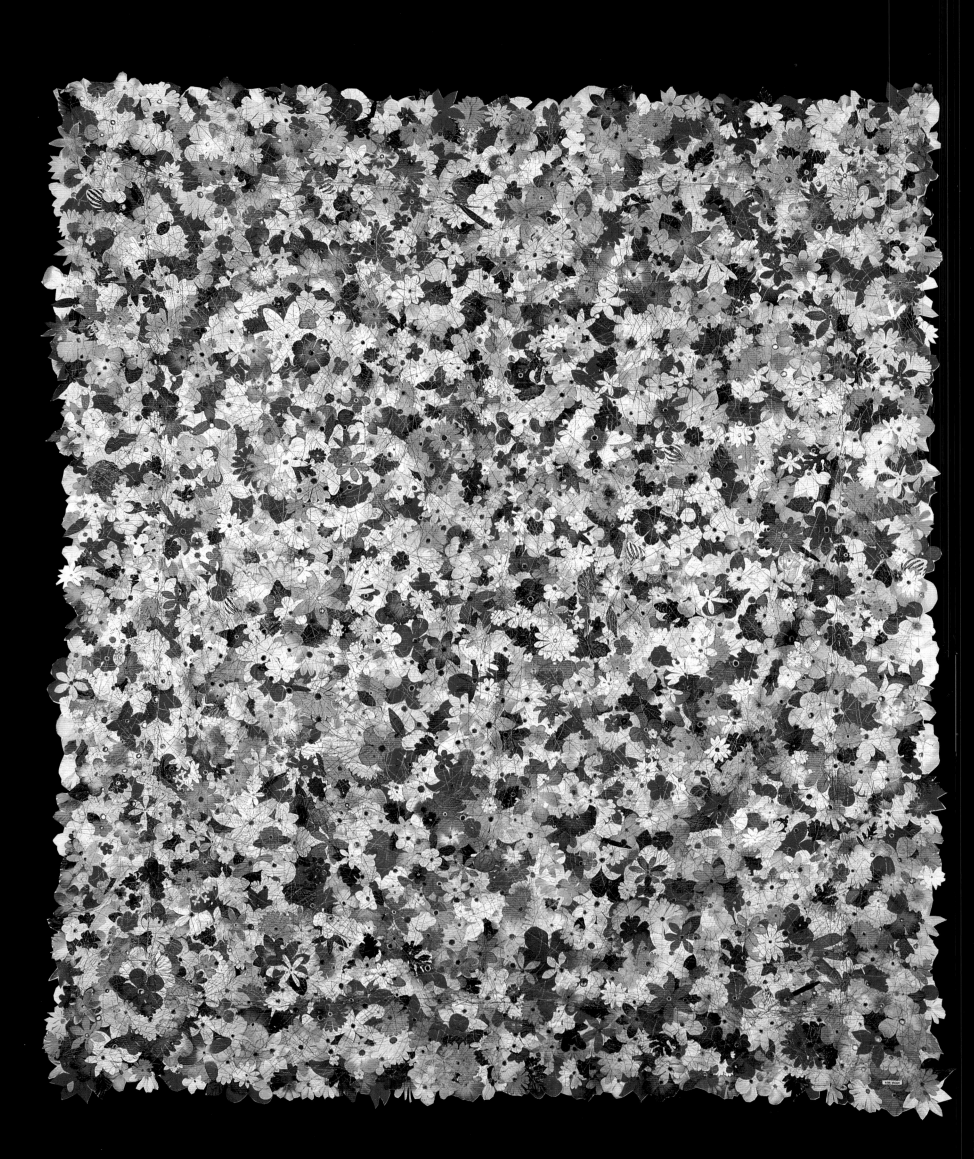

INTRODUCTION

A TRADITION TRANSFORMED: THE QUILT AS ART

The art quilt is a new artistic medium that has developed over the past quarter century and is now the focus of hundreds of artists worldwide. Modern quilt artists have taken the traditional bed quilt and are expanding its expressive possibilities using some of today's most innovative studio techniques. Often made by academically trained artists, art quilts are meant to be seen and judged solely as works of visual art. Most are designed to be hung on a wall and viewed like a painting, rather than seen lying flat, like a traditional bed quilt. Although they usually have the same basic structure as a traditional quilt, most are intentionally non-functional, made to convey their creators' artistic visions instead of decorating a bed or providing warmth.

Many artists have been drawn to the quilt in recent years because they find it offers possibilities not available in other media. Massachusetts quilt artist Rhoda Cohen says, "I started as a painter, having first studied in a variety of art disciplines such as drawing, watercolor, sculpture, color theory, and art history. But once [I was] introduced to quiltmaking with its resonance, its intimacy, [and] its tacticity, I could not continue

◀ FLORA

Susie Brandt. 1993–94. Corinth, New York. Found "silk" flowers, thread. Machine stitched, machine-embroidered eyelet holes. 88 x 75 1/4 in. Collection of Ruth DeYoung Kohler.
Brandt's conceptual "blankets" are obsessively worked from cast-off materials to emphasize the complexity of understanding traditional textiles. She told *Fiber Arts* magazine, "One of the most outstanding things about traditional textiles is their labor intensity. It's a tactile issue. Somebody worked their hands all the time to make it. There's a perversity of labor in my work. It's ridiculously overdone. It can be appealing and repulsive at the same time. It's a fine line."

to paint as before. Fabric has taken the place of all other mediums for me." Susan Wilchins, a professor at North Carolina State University School of Design, explains, "I have chosen to work in textiles because for me they provide a breadth and flexibility which make all other materials seem limited by comparison. They combine the texture and relief qualities of sculpture or pottery, the color range of paint, and the literal expressive potential of photography. Speaking with the products of my own hands is the best way I have found to communicate my thoughts, ideas, and experiences to others."

Unwilling to simply repeat the tried and true formulas of the traditional quiltmaker, quilt artists have fostered an unprecedented outpouring of new and original approaches to design. In addition to lessons learned from careful observation of traditional pieced and appliqué quilts, many quilt artists have integrated the visual effects of modern art into their work, drawing on the work of some of the acknowledged masters of modern painting and textile art. The abstract constructions of Piet Mondrian and Paul Klee, the color experiments of Josef Albers and Mark Rothko, and the illusory Op art geometry of Victor Vasarely and M.C. Escher have all contributed to the extraordinary creative expansion of quilt design in recent years. Even more important and liberating have been the flamboyant and highly visible fabric works of Christo and Claus Oldenburg, the pioneering surface design techniques of such modern textile artists as Mariska Karasz, Katherine Westphal, Ranghild Langlet, and Diane Itter, and the validating impact of the feminist art of Judy Chicago, Miriam Schapiro, and Faith Ringgold, all three of whom have employed or referenced quilting in their work. The rich textile traditions of other cultures, including those of Native America, Africa, South America, and the Far East, have also been explored and exploited, and such formerly exotic design techniques as Seminole Indian strip piecing, shibori, and batik have been adapted and used by art quilters.

Art quilters have also greatly expanded the quilt's permissible subject matter and expressive range, reflecting the diverse and complex concerns of the world in which they live. An arbitrary list of titles—*Pregnant Winter Tree, Bob and Rita Try to Forget, Night Chant, Coffee and Conversation, A Letter from Arthur, Moose River Gothic, The Gift of Tongues, Marsh Light, Lattice Interweave, Orange Construction, Rabbits Dancing Under Jupiter, Expanding Color, No Exit, Threshold, Jitterbug Waltz,* and *Crossfire*—suggests the range of content and imagery that is currently being explored by art quilters. Like other forms of art, art quilts can be high-minded or deadly serious; they can be lighthearted, or even screamingly funny. They can deal with birth, death, human relationships, or political and moral issues; they can express joy, love, fear, anger, sorrow, or wonder. Or, they can simply be works of abstract art—formal studies of light, pattern, line, color, and texture.

Quilts are and always have been a form of art, but they have not been perceived as such from

◄ **LOOK AGAIN**

Marilyn Henrion. 1995. New York, New York. Silk, cotton, reflective synthetic fabrics. Machine pieced, hand quilted. 66 x 66 in. Collection of John Walsh III.
Henrion says she has loved fabric, color, and poetry since she was a child. Her earliest memories are of cutting up fabric scraps to clothe her dolls and spending endless hours with coloring books. This quilt was inspired by her fascination with the wrought iron gates of Spain, "each of which offered tantalizing glimpses into the mysterious world of a courtyard beyond." The title is taken from a line by the poet and painter e.e. cummings: "Worlds? o no; I'm certain they're/ (look again) flowers."

outside their own, traditionally female culture until fairly recently. Unfortunately, the academy and the commercial world of fine art still look down upon the crafts as arts wanna-bes. But quiltmakers, whether in the studio or in the home, have always recognized some of their peers as artists and some of the quilts made by these women as works of art. "I think as long as quilts have been made there have been art quilts—perhaps never hung on a wall, but original and prized for their specialness," says Texas quilt artist Pamela Studstill.

The art quilt extends and expands the traditional parameters of quiltmaking which were established primarily by American women during the nineteenth century. While art quilters do not seek to replicate the past achievements of the American quilt, they do draw sustenance and inspiration from the works of previous generations, seeking to build new dimensions of form, design, and meaning for the quilt medium. The works of traditional quiltmakers also provide a historical context for the quilt as a significant American art form and for the art quilt as an important development in the continuing evolution of that form.

As its seemingly contradictory compound name implies, the art quilt has been forced to negotiate an often uneasy position between the largely non-intersecting worlds of traditional quiltmaking and

contemporary art. It has found champions and detractors in both of these camps, and still struggles to bridge often profound and contentious differences of opinion and perception. Much of the argument about the art quilt derives from the long-fought, festering battle between craft and art. In modern times, craft and art have often been seen as mutually exclusive terms, and the sometimes deeply held prejudices against an integrating viewpoint have created a dividing line for many, both inside and outside the quilt world.

Many curators and art historians still argue that a craft medium, particularly one originally used to create everyday, functional domestic objects, by definition cannot be used to create art.

▲ **SHADOWS**

Kathleen O'Connor. 1991. Westminster, Vermont. Gathered acetate, cotton and nylon threads. Machine appliquéd, embroidered, and quilted, hand dyed. 102 x 92 in. Collection of the artist.
Shadows is part of a series about gardens at night, although O'Connor says other times of day also crept into this piece. She adds that she thinks of the quilt as a "kind of clock."

▲ SLEEPLESS

Linda Levin. 1995. Wayland, Massachusetts. Cottons, Procion dyed by the artist. Machine sewn. 52 x 69 in. Collection of the artist.
This fractured cityscape reflects the troubled sleep of those within the buildings.

Although many modern studio craftspeople have moved away from the functional bases of traditional craft since the 1950s, often by incorporating ideas from the fine arts, the craft-as-art issue is far from settled. The catalogue for *Art That Works*, a 1990 traveling exhibition of functional American decorative arts, notes, "The oft-heard refrain that the crafts are now accepted as art is overstated. Not all collectors or curators will pigeonhole expressive objects according to the materials from which they are made, but there still exists a definite collector-curatorial bias against objects that have evolved from craft materials and techniques." And to fire the debate further, textiles in general and quilts in particular have traditionally been seen as women's work, and therefore not to be taken seriously, certainly not as Art.

Acceptance of the art quilt also lags far behind in that ultimate capitalist proving ground, the marketplace. Despite some significant inroads made in recent years, the demand for art quilts still remains relatively small, far smaller than output might reasonably expect. Only a handful of serious collectors are currently active in the art quilt field, their small numbers giving them enormous influence. The earliest of these discerning collectors, Ardis

and Robert James, first collected antique quilts and became champions of the new form in the early 1980s, confidently exhibiting contemporary work by such major artists as Therese May, Terrie Hancock Mangat, Jan Myers-Newbury, Judith Larzelere, Pamela Studstill, Pauline Burbidge, Michael James, Susan Shie, Nancy Crow, and Gayle Fraas and Duncan Slade alongside acknowledged nineteenth-century masterpieces.

Corporate architects and interior designers have been the art quilt's best commercial clients thus far, and a number of art quilters specialize in site-specific commissions. Many others make quilts primarily to be entered in the many contests and exhibitions generated within the quilt community. The vast majority of professional art quilters do not make a living from the sale of their work. Many support the time they devote to their art by teaching others how to incorporate particular approaches and techniques into their work, or by guiding students to unlock their own creativity. Outstanding teachers such as Nancy Halpern, Michael James, Yvonne Porcella, Nancy Crow, and Jean Ray Laury are in demand around the globe and keep up hectic travel schedules that often limit the amount of time they can spend in their own studios. It is a difficult balance at best, but for many serious and committed artists, it is the only balance currently available.

LANDSCAPE OF MEMORIES ▶

Charlotte Yde. 1993. Copenhagen, Denmark. Hand-dyed and painted cotton sateens, commercial cottons, cotton sateen, and some silk. Machine pieced, hand and machine quilted. 58 x 55 in. Collection of the artist.

Since Denmark has no history or tradition of quilt-making, Yde says she was able to start on her own without preconceptions about quilts and their relationship with beds. This piece was made to commemorate the death of the artist's very best quilting friend.

Categories are necessary, even sometimes useful, evils. But they are all too often tools of ignorance and division rather than instruments of understanding and expansion. This has been particularly true in the case of the art quilt. Canadian artist Barbara Todd articulates the situation this way: "I have reservations about the category 'Art Quilt.' The term 'Art Quilt,' I think, comes out of the craft world as a way to distinguish traditional and hobbyist quilts from those made by professional craftspeople. In that context, it is an innocent and functional term. However, in the larger art world it can appear to be a defensive justification, which in this country at least operates as a way of ghettoizing a practice rather than enhancing the way the work is viewed." Asked by *Quilter's Newsletter Magazine* to share one thought about his experience with quilts, the prominent art quilter Michael James, who has often found himself at the center of the craft vs. art storm, offered a quotation by sculptor Robert Smithson: "Hardening of the categories leads to art disease." In other words, the urge to categorize has an inexorable tendency to become an end in itself, and when it does, it invariably bypasses the essential meanings of the art it attempts to describe.

The great art historian Ernst Gombrich has observed, "There really is no such thing as Art. There are only artists. Art with a capital A has no existence. [It] has become something of a bogey and a fetish." Further, as the architect and Bauhaus founder Walter Gropius pointed out in a 1919 manifesto, any distinctions drawn between art and craft are ultimately arbitrary, and "arrogant . . . There is no essential difference between the artist and the craftsman . . . The artist is an exalted craftsman. In rare moments of inspiration, moments beyond the control of his will, the grace of heaven may cause his work to blossom into art. But proficiency in his craft is essential to every artist. Therein lies a source of creative imagination."

Quiltmaking, just like painting or sculpture, embodies both art and craft, both creativity and technique. Quilts, whether made for the bed or the wall, are not wholly either craft or art but both. In the act of quiltmaking, the two are joined, bonded and inseparable. The only real question is the one implied by Gropius: How much inspiration does the work reveal, or, in other words, how good is it?

As in any other form of art, the overarching criteria used in making this judgement should be originality of concept, power of expression, interest and balance of color, line, pattern, texture, scale, and other formal elements, and, most important, the cohesion and integrity of the overall work. An art quilt should embody a solid understanding of both parts of its name; the most successful art quilts strike a balance between the worlds of fine art and quiltmaking by taking a fresh, innovative approach to the medium while at the same time mining the rich history, symbolism, and meaning of the traditional quilt. The mainstream art world still tends to value quilts that look like paintings, and which thereby validate the primacy of fine art. But this narrow, aesthetics-only approach denies the art quilt a significant part of its meaning, which lies in the democratic accessibility of the craft of quiltmaking, the quilt's historical resonance as a familiar and beloved household object, and the quilt medium's own language of technique, pattern, texture, and form. As Edward Lucie-Smith put it in *The Story of Craft: The Craftsman's Role in Society*, "The ambiguously labeled artist-craftman . . . takes his place in industrial society as a necessary antonym, a visible reminder of where industry has come from . . . His products speak of individual fantasy, of the primacy of instinct, of direct relationships to materials. The fine artist has a comparatively short history—far shorter than the immense history of craft."

▲ LET HER

Rachel Brumer. 1993. Seattle, Washington. Cotton, fabric paints, polyester batting. Machine pieced, hand appliquéd, stenciled, hand quilted. 72 x 61 in. Collection of John Walsh III.

This quilt celebrates Brumer's five-year-old daughter's sometimes questionable fashion sense and a loving mother's forbearance when asked, "Does this go together?" Brumer says she has usually been able to hold her criticism in check by answering, calmly, "What do you think?"

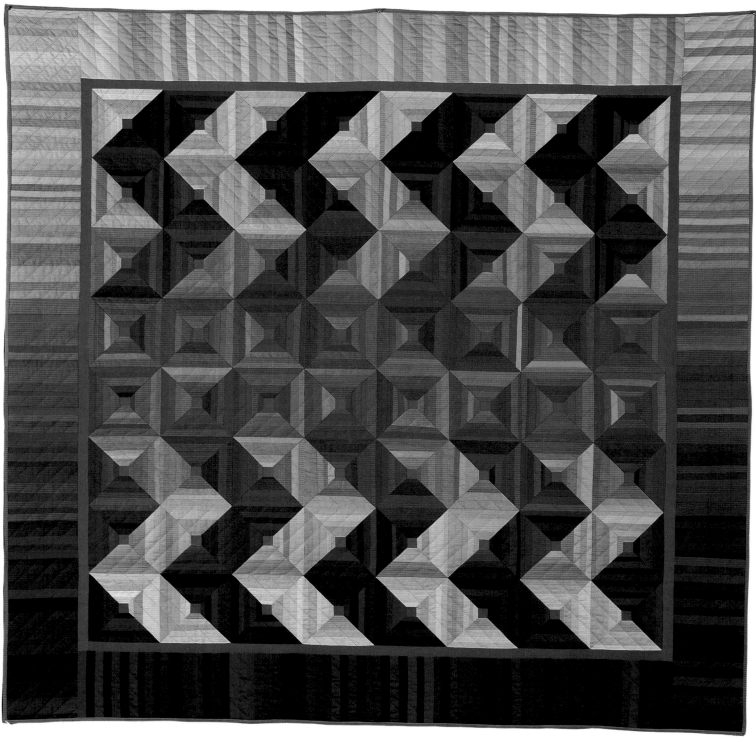

▲ ZIG-ZAG LOG CABIN

Carol Hemphill Gersen. 1995. Boonsboro, Maryland. Cottons, hand dyed by the artist. Machine pieced, hand quilted, signed and dated in quilting on the quilt top. 72 x 72 in. Collection of John Walsh III.
In 1987 Gersen made a Log Cabin quilt similar to this one called *Rivers in the Sky* using only blue and red fabrics. This full-color sister piece made use of many of the fabrics Gersen dyed between 1988 and 1995.

As its name implies, the successful art quilt does not ask its audience (or its maker) to choose art or quilt, but both. Craftsmanship usually helps make it possible for the artist to realize his original conception. It is possible, if unusual, for a poorly crafted quilt to have considerable visual interest, or, more commonly, for a beautifully crafted piece to have little or none. In any form of artistic ex-

pression, there are practitioners whose technical abilities far outrun their creative capabilities. Technique can sometimes mask a lack of originality or depth of meaning; it should always be a means to an end, never an end in itself. Some of today's quiltmakers have become victims of their own facility, repeating a single trick of technique over and over again like a musical virtuoso playing

a demanding but emotionally uninvolving exercise. But the work of today's best quilt artists demonstrates a willingness to take risks and grow, to move beyond the safe and familiar in search of something new and self-revealing. Like outstanding artists or craftspeople working in any other medium, these quilters have created consistent, articulate bodies of work reflecting their own original and distinctive visual styles. Over years of experimentation and dozens, or even hundreds, of quilts, they have each discovered a unique, personal vocabulary of visual ideas, symbols, and techniques that expresses their individuality at the same time it reaches toward the core of our shared experience as human beings.

The moniker "art quilt," first applied in the mid-1980s, is now permanently attached to the work of studio artists using the quilt as their medium. Despite the fact that the term has an over ten-year history, *art* is not the first—or probably even the second—word that comes to most people's minds in connection with the word *quilt*. Asked to free associate with the word *quilt*, most people would offer words like *comfort, warm, soft, cozy, safe,* or *bed*—or perhaps, *patchwork, home, crazy, bee,* or *Log Cabin*—but probably not *art*. Therefore, in an effort to distance themselves from the nexus of female domestic associations that the word *quilt* conjures, some artists have suggested alternatives such as "fabric collage" or "fabric constructions," while others seek to avoid the negative and pretentious connotations of the word *art* by calling their creations "studio quilts" or "non-traditional quilts." These constructions, however, suffer from the opposite problem, in that they so lack resonance that they seem bland, academic, artificial, or even essentially meaningless. For better or for worse, then, *art quilt* will have to do.

But semantics can cause misunderstandings. An encounter between art quilter Nancy Halpern and some new foreign acquaintances neatly sums up the multiple problems language and nomenclature can pose for art quilters, and also perhaps suggests a simple path out of the maze. While traveling in Czechoslovakia, Halpern asked two friendly and somewhat inebriated strangers to help her read a hotel menu. When asked what she did for a living, she drew a picture of a bed and then, seeing the surprised look on her new friends' faces, quickly realized that the wrong message had been sent. She then showed them a photograph of one of her quilts, without attempting to explain her medium. "Oh, you are an artist," they exclaimed. "Yes," thought Halpern, "I am an artist." Nothing more, nothing less. Further explanation was unnecessary.

Quilts are complex and can be inherently contradictory objects, suffused with a host of personal and historical meanings and associations. Traditional quilts can be at once functional and decorative, mundane and extraordinary, communal and personal, inclusive and individual, imitative and creative. They have been the dominant form of artistic expression of American women for two hundred years, and, as such, have been recognized since the 1970s as one of the major repositories of classic American design. They are also significant cultural documents that tell the otherwise unrecorded story of American women, and are therefore among the richest, most important, and most telling manifestations of American history and culture available to us today. Millions of American women of all kinds, upper and lower class, black and white, urban and rural, educated and illiterate, have made quilts to warm their loved ones and express their personal and social concerns. They are America's common object, uniting women in a continuing community of familial love, beauty, and self-expression.

Quiltmaking today is a bigger and more diverse tent than ever before in history. The hundreds of thousands of men and women in the United

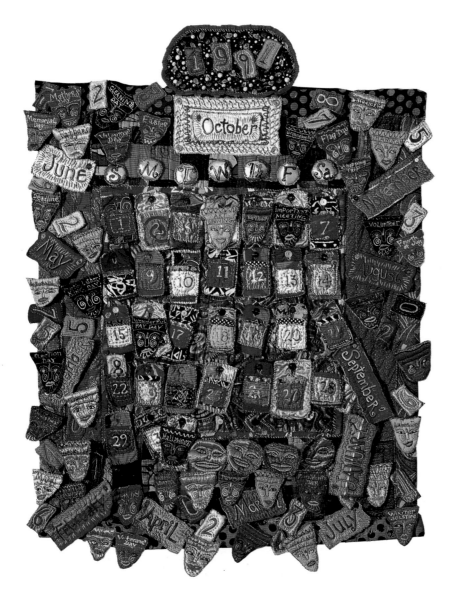

◄ THE CALENDAR FETISH: AN ALTAR TO TIME
Susan Shie. 1989. Wooster, Ohio. Cottons, satins, metallics, textile paint, quartz crystals, buttons, pins. Hand sewn, hand quilted and embroidered. 72 x 60 x 3 in. Collection of Ardis and Robert James.
This functioning interactive quilted calendar includes over 125 moveable pieces. Shie says, "When I think about the *Calendar Quilt*, I get kinda happy inside. . . . I had to do it. I, as most Americans, adore my six or seven calendars (one in every room?). So this is my ultimate in designer calendars! Eat your heart out, Hallmark! And don't even try to copy! Don't even try!"

amateurs and professionals, teachers and students. At best, the diversity of the quilt world can be a powerfully enriching force that allows different traditions and approaches to cross-fertilize and revitalize each other; at worst, it has, unfortunately, also been the source of argument, misunderstanding, and distrust.

Despite their many (and sometimes public) differences, however, quiltmakers of all kinds share a passion for fabric. For most quilters, the medium is the message, and it forms a major component of the meaning of their work. Fabric is and always has been a basic necessity of human life, used for clothing, shelter, bed and floor coverings, draperies, and hundreds of other purposes. It has carried important functional and ceremonial uses in cultures around the world and throughout history. We respond to cloth through touch, the most intimate and primal of the senses. We are wrapped in cloth at birth, covered in it in life, and shrouded in it in death. Cloth can cover, warm, comfort, disguise, or create an image. All of these simple but extraordinarily rich meanings are part of the symbolic vocabulary of the quilt artist, inherent in the medium in which she works.

The pioneer art quilter and therapist Radka Donnell has pointed out that quilts are perceived as "good objects. They are, and also stand symbolically for, the epitome of warmth and its comforts and for the pleasures of closeness with a

States, Japan, Europe, Canada, Australia, and other countries now making quilts represent an ever-increasing number of sometimes divisive camps, intentions, and approaches. Just as Ernst Gombrich advises us to be aware that *art* is a word that "may mean very different things in different times and places," so too we should be mindful of the complexities of the word *quilt*. Every quilt is different because its maker brings her or his own sensibilities and talents to its creation, and every viewer brings a different set of understandings and experiences to the appreciation of a quilt. To follow Gombrich's assertion about Art, there is, properly speaking, no such thing as Quilt, there are only quilters. And, they are a wildly diverse lot. There are art quilters, traditional quilters, and feminist quilters; African-American quilters, Native American quilters, and Hawaiian quilters; hand piecers and machine quilters, painters and dyers, printers and embellishers, computer planners and improvisers,

desired object. They provide a full and lasting though silent embrace." Our familiarity and sense of ease with cloth and quilts can be at once the quiltmaker's greatest asset, and her greatest liability as a visual artist. It offers a disarming directness of sensory approach, but it can also undermine the serious intent of the work. It is a razor's edge that must be carefully navigated and that is, unfortunately, not always within the artist's control.

Cloth also provides a soft, tactile third dimension unavailable to the painter. Quilts may now hang on gallery walls like paintings, but they project different meanings and sensations. While paintings are often cool, remote, even forbidding, the stitched textile surfaces of quilts are inherently and symbolically warm and inviting, drawing the viewer in and often invoking and playing to the sense of touch as well as sight. Maine quilt

▲ REEF I/CORAL

Ardyth Davis. 1996. Reston, Virginia. Silk. Hand painted, pleated, hand stitched and tied. Collection of the artist.
Many of Davis's abstract quilts are influenced by landscape, in this case the textures and formations of coral reefs. She notes, "I am intrigued by the irony of using a soft, flexible medium to depict the hardness and rigidity of these forms."

artists Gayle Fraas and Duncan Slade note, "We feel the quilt surface enhances the emotional response the viewer may have to a work. It is our intent to play off the rich heritage of the quilt and its relationship to time: time spent sleeping, looking, or stitching." Deidre Scherer, who creates appliquéd portraits of nursing home residents that are often disturbingly vivid, has found that her use of cloth makes her sometimes difficult subject matter more acceptable to viewers. "You can say something with fabric that you can't say with paint," she explains. Quilt Art, a group of European quilt artists, sum up their attraction to fabric as a medium: "Why do we use cloth when paint is normally so much quicker and better respected? It is not because we cannot paint or draw, but because there is something about the quality of fabric and stitch which best suits what we want to say and how we want to work. There are many reasons for our choice: flexibility,

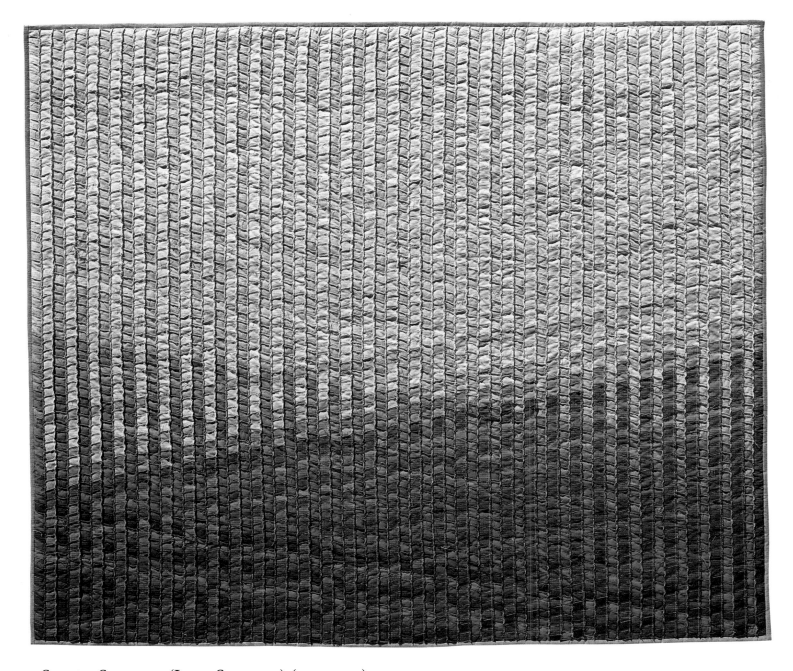

▲ Spater Sommer (Late Summer) (◄ detail)

Inge Hueber. 1991. Koln, Germany. Hand-dyed cotton. Machine sewn, hand quilted. 59 x 68 7/8 in. Private collection.
Inge Hueber uses strip piecing methods first devised by Florida's Seminole Indians to create complex, abstract three-dimensional surfaces full of light, movement, and color. This example of her work evokes the richly textured light and colors of late summer.

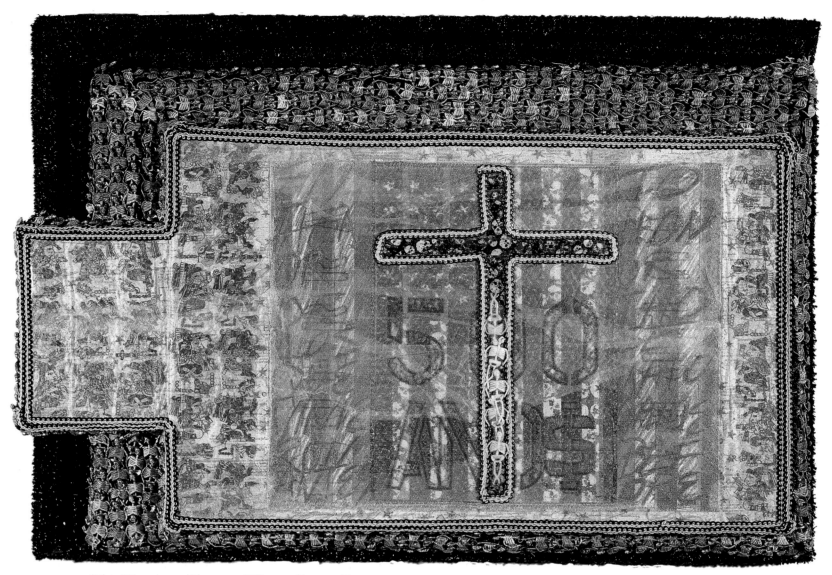

▲ TO HONOR THOSE WHO CAME BEFORE

Arturo Alonzo Sandoval. 1995. Lexington, Kentucky. Acetate transparencies, Astro turf, plastic skeletons, paint, colored threads, Mylar, polymer medium, Styrofoam, masonite. Machine stitched and pieced. 28 x 36 x 5 in. Collection of the artist.
This small but powerful quilt was created in celebration of the 500th anniversary of Columbus' discovery of the Americas. As in all of Sandoval's work, unusual materials form part of the piece's message.

softness, variety of texture, being at ease with the techniques, the slow meditative quality of work with cloth, the feeling that it is a female or feminine medium, and even that it seems fragile and impermanent. What is important is that the medium and the message hang together."

Some quilt artists continue to work within the grid system of the traditional pieced quilt, while others work with appliqué or more painterly techniques, often taking pictorial or narrative approaches to the medium. Whether they choose to work within traditional formats or not, art quil-

ters share a respect for the traditional quilt, and most see themselves as part of a community of quiltmakers that stretches backward and forward in time. As author and artist Jean Ray Laury has observed, "We don't have the continuity in our lives that our mothers and grandmothers had as women. Quiltmaking gives us that—a connection with other women, both horizontally and vertically." Radka Donnell adds, "Laying out and piecing quilts gave me a sense of wholeness and certainty that I had lacked as a painter." Many art quilters find particular meaning in the meditative, time-consuming handwork of piecing and needlework, which they find binds them directly to a vast

continuum of women (and men) who have found solace and satisfaction in this humble, repetitive, self-effacing part of the work of quiltmaking.

A sense of order is at the heart of traditional quiltmaking, both in terms of process and symbolism. The metaphor of quiltmaking, of making something of nothing, of ordering random scraps of fabric into a coherent whole, was clear to nineteenth-century quiltmakers and continues to resonate powerfully today. Eliza Calvert Hall's fictional *Aunt Jane of Kentucky* articulated the feelings of many quilters when she said, "Did you ever think how much piecin' a quilt's like livin' a life? . . . The Lord sends us the pieces, but we can cut 'em out and put 'em together pretty much to suit ourselves, and there's a heap more in the cuttin' out and the sewin' than there is in the caliker. Patchwork? Ah, no! It was memory, imagination, history, biography, joy, sorrow, philosophy, religion, romance, realism, life, love and death; and over all . . . the love of the artist for her work and the soul's longing for immortality." The metaphor of quiltmaking has become such a part of American thought that modern American writers from Whitney Otto in *How to Make an American Quilt* to Alice Walker in *The Color Purple* have embraced it. A typical and lovely example is Douglas Malloch's poem "A Crazy Quilt," which

runs: "And so the hand of time will take / The fragments of our lives and make / Out of life's remnants, as they fall, / A thing of beauty, after all."

The world of today's quiltmaker is, of course, infinitely wider than that of her nineteenth-century predecessors, and contemporary quilt artists take full advantage of its richness. Studio quiltmakers draw on a variety of sources in their search for personal expression. And while they certainly know and appreciate the quilt's rich history, many of their sources have little or nothing to do with the traditions of American quiltmaking. The quilt is their starting point, the basic structure upon which they build. Like other modern artists and craftspeople, the range of influences and sources that

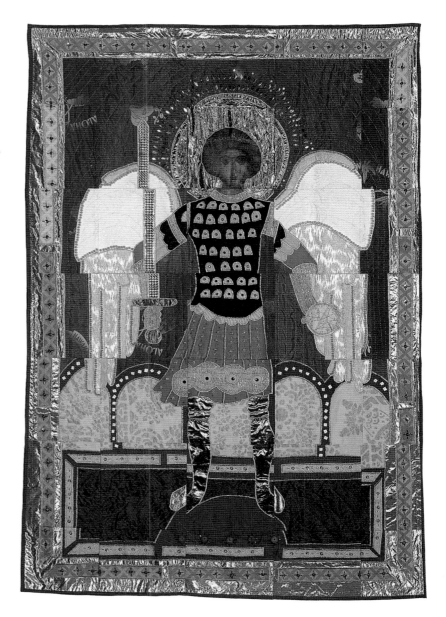

THE ARCHANGEL MICHAEL BIDS YOU ALOHA ▶

Mary Catherine Lamb. 1991. Portland, Oregon. Secondhand household fabrics (table linens, clothing, and curtain panels), metallics, embellishments. Photo-transferred face, machine appliquéd and hand quilted with metallic thread, machine pieced. 56 x 38 in. Collection of the artist.

Many of Lamb's quilts are constructed almost entirely from vintage 1950's and 1960's textiles found at garage sales and thrift stores. This piece's iconography was drawn from memories of the "holy cards" she received in parochial school as a child. She says, "I remember the sense of promise, of security that the pictures of saints and angels imparted. As a skeptical adult I conjure up those images with a mixture of yearning and irony, using domestic textiles from the time when I believed and found comfort in the myths and symbols of the Catholic pantheon. I also find humor in the transformations (tablecloth into mantle, skirt into halo) and hope the viewer does [too.]"

quilt artists draw upon is wide ranging and eclectic. As trained artists, they can bring their knowledge of the studio processes of printmaking, photography, and painting, as well as those of such related textile arts of weaving, dyeing, and embroidery, to bear on the problems encountered in their search for artistic expression. And, as late twentieth-century denizens of the information age, they can access images, ideas, and techniques from the artistic traditions of cultures past and present from every part of the world and incorporate or assimilate them into their own work.

The range of available materials has also expanded dramatically in recent years, as manufacturers have responded to the burgeoning demand for new options. In addition to an ever-widening array of commercial fabrics from around the world, which now includes such extraordinary exotics as African Kente cloth and historic and contemporary Japanese kimono silks, a host of new fabrics are being custom made especially for quilters. Many quiltmakers are also dyeing, printing, or painting cloth to serve specific personal and professional needs. Prominent and enterprising figures like Nancy Crow, Terrie Mangat, and Ruth McDowell have even designed their own lines of commercial fabrics. In addition to traditional cloth and thread, metallic threads, metal foils and leafs, plastics, netting, and space-age synthetics such as Mylar and acetate have also become part of the repertoire of quilt artists. Susan Shie, who works with her husband James Acord on quilts of obsessively embellished detail, notes, "I think we and all craft artists are very seduced by our materials and processes. Our imaginations and curiosity are driven by the raw materials and jump ahead to images of possibilities. I guess we are in love with materials because they, and we, are sensual. The urge to create is not satisfied by pencil and paper alone. Ideas in themselves are not enough. The sexy salad of mixed media, handled and rehandled, is what satisfies our hunger."

This study offers an overview of the origins and development of the art quilt, and examines the techniques and artistic achievements of contemporary art quiltmakers. While the text and illustrations necessarily focus on the small number of outstanding artists who, through their work, teaching, and by example have helped shape the art quilt over the past twenty-five years, the book also presents remarkable quilts by unjustly neglected artists as well as a host of younger, rising stars. Many of the quilts shown in these pages have been made in the past two or three years; they are representative of the high overall technical quality and enormous stylistic diversity of current art quiltmaking.

The art quilt is still a very young art form, born in the 1970s and, after a generation of development, just now reaching its first blushes of maturity. Only a handful of the artists represented in this book have been working within the quilt format for more than thirty years, and even such acknowledged trailblazers as Nancy Crow and Michael James made their first quilts in the early to mid-1970s, just a little over twenty years ago. Many of today's quilt artists have come to the discipline quite recently, and it remains to be seen how their involvement with the medium will develop and what impact, if any, they will have in long run. Immersed in the present as we are, we can only guess which of today's quilts will be judged of lasting importance by future generations.

Whatever the future of the art quilt, it has already helped to revitalize and extend the tradition in which it is grounded, and many extraordinary quilts have been created. The overwhelming outpouring of quilts of all kinds in the last quarter of this century rivals that of a hundred years earlier, the so-called Great Age of Quiltmaking. The richness and diversity of today's approaches to art quiltmaking and the infusion of ideas and techniques from outside the quilt tradition assure that

▲ THE MOUNTAIN AND THE MAGIC: TONIGHT, IN THE SKY

Judi Warren. 1995. Maumee, Ohio. Cotton, Skydyes cotton, beads. Machine pieced, hand quilted. 31 x 25 1/2 in. Collection of the artist.
This small quilted triptych was inspired by a haiku by Kobayashi Issa which runs: "Tonight in the sky/ even the stars/ seem to whisper/ to one another."

the art quilt will not be a passing fad. Some of the avenues opened up by contemporary art quilters will continue to bear fruit; others, undoubtedly, will not. But whatever path art quilters choose to take, we may be sure that the ongoing evolution of this remarkable new art form and the explorations of its creative possibilities will be worth following. Many people believe that the quilt is America's art form; it surely is a great democratic institution, an art form that has been available to women (and men) of every race, social class, and level of education. The art quilt represents the future of quilting, its best chance to remain active and vibrant into the next century.

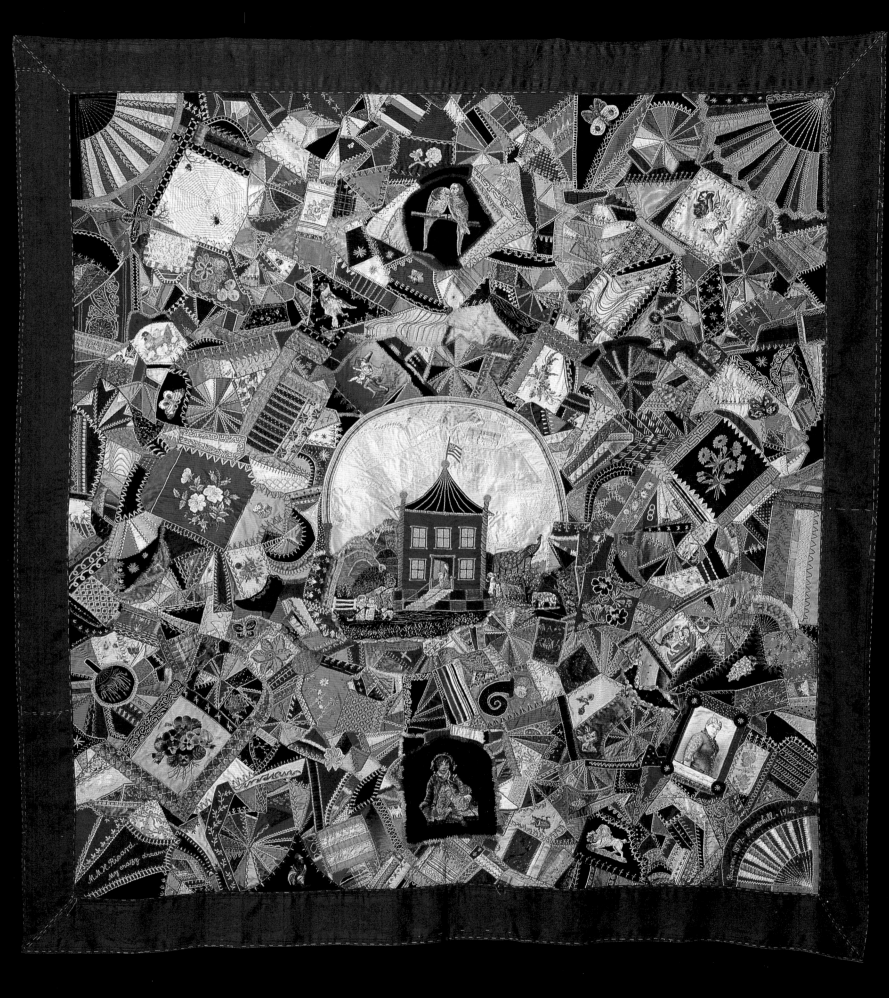

PRECEDENTS AND INFLUENCES

The works of today's quiltmakers reflect the enormously expanded and diverse information base of the modern world as well as a broad and often academically disciplined knowledge of the visual arts that was largely unavailable to traditional quiltmakers. Like their predecessors, today's art quilters draw on their knowledge, education, and experience. Unlike earlier quiltmakers, however, art quiltmakers are aware of and influenced by many forms of art and visual experience, both historic and contemporary. They know the history of quiltmaking, they are proud of its accomplishments, and they are masters of its techniques. As trained artists, they are also conversant with the history and techniques of painting, sculpture, printmaking, and other visual arts, and can draw freely on ideas from many disciplines, times, and cultures. They are as likely to find inspiration in an Impressionist painting, an African textile, or a contemporary craft object as in a traditional quilt pattern. In a recent interview, Michael James told fellow quilt artist Patricia Malarcher that his work has been influenced by hundreds of painters and studio craft artists, by artist's writings and critical commentaries, and by his study of Amish quilts and other textiles. He concluded, "The question of influences is very complex."

As a modern "craft" medium, the origins of the art quilt can be traced in part to the The Arts and Crafts Movement, which sought to recapture the once high social status

◄ My Crazy Dream

M.M. Hernandred Ricard. 1877–1912. Boston and Haverhill, Massachusetts. Embroidered silks. 65 x 60 in. Collection of Ardis and Robert James.
This extraordinary work of art pokes fun at itself both in its title and through the artist's inclusion of her own photograph at bottom right. Like most crazy quilts, it was clearly made for show, not for use.

and quality standards of the hand craftsman. Both had been terribly debased by the unimaginative machine-made products of the Industrial Revolution. Led by the theories of Englishmen John Ruskin and William Morris, The Arts and Crafts Movement encouraged an integration of art and craft, bridging a rift that had grown in the West since the Italian Renaissance first separated the work of fine artists from that of mere craftsmen. Morris and his compatriots attempted to bring original artistic design out of the academy and into the realm of daily life by designing everything from furniture to wallpaper. As artist/craftspeople, they sought to reestablish the value of handwork, denouncing the uniformity of machine-made products. As Ruskin put it, "Men were not intended to work with the accuracy of tools. It would be well if all of us were good handicraftsmen of some kind and the dishonour of manual labor done with altogether. No master should be too proud to do the hardest work."

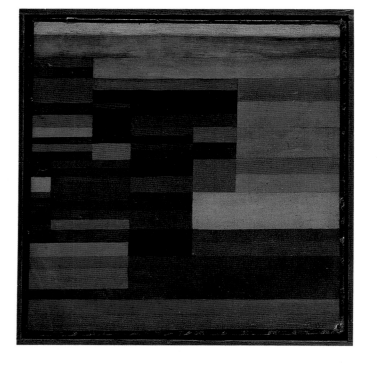

The Arts and Crafts Movement, which traveled to the United States in the late 1800s and early 1900s, inspired Americans to investigate their own forgotten handcraft traditions just in time to save many from extinction, and also fostered the work of such artist/craftsmen and designers as the aristocratic Louis Comfort Tiffany on the one hand, and the populist Roycrofters and Gustav Stickney on the other. The modern crafts movement, which brought the Arts and Crafts ideal up to date by integrating ideas from the then radical world of contemporary art with the techniques and values

of fine traditional hand craftsmanship, was born after World War II. Just as art quilters would in the 1970s and 1980s, the pioneering studio furniture makers, ceramists, and fiber artists of the 1950s created works that often consciously separated form and content from traditional function. In doing so, they experimented with new techniques and materials, drawing from their knowledge of Western fine arts as well as the crafts of other cultures around the world. The lines between craft and art have continued to blur ever since.

The art quilt should also be placed in the context of the larger world of fiber or textile art, which came into being as a serious academic discipline under the influence of the feminist movement of the 1970s. Weaving, which unlike quiltmaking has serious commercial applications, was the only textile discipline taught in most art schools in the 1950s and 1960s. Through the work of such advocates as Anni Albers (wife of the highly influential painter and teacher Josef Albers), and Dorothy Liebes, weaving was also accorded a measure of artistic validity not yet given to most other textile mediums, and because of its intimate connections to the processes of making cloth and clothing, weaving was also a staple of the back-to-the-land movement of the 1960s. For these reasons, many artists who were interested in working with cloth, including Joan Lintault, Nancy Crow, and Yvonne Porcella, began their involvement with textiles as weavers and only came to the quilt later, as it began to gain some measure of respect and visibility.

During the 1950s and 1960s, the works and teachings of such influential textile artists as embroiderer Mariska Karasz, basketmaker and weaver Ed Rossbach, and his wife, fabric designer Katherine Westphal, increased respect and awareness of the rich artistic possibilities of textile media, and helped pave the way for the art quilt. Westphal, who taught for many years at the University of Washington and then at the University of California at Davis, was a pioneer in many dye and photo-transfer techniques now used by art quilters; she also occasionally made quilts herself in addition to her work with clothing, fabric design, and other textile disciplines. Perhaps the most celebrated fiber artist of the following generation was Diane Itter, who died of cancer in 1989. Itter developed a unique process of knotting extremely fine linen threads into complex and colorful miniature fan or kimono-shaped structures with more than four hundred knots per square inch. Itter's work and example have influenced art quilters as disparate as Michael James and Jane Burch Cochran, whose recent quilt *Homage to Diane Itter* includes a representation of one of Itter's knotted textiles.

Like almost everything else, attitudes toward cloth and fiber changed profoundly during the 1960s. On the popular level the '60s ushered in new ways of dressing, including embroidered blue jeans and other forms of wearable art, and the tie-dyed T-shirt, which Duncan Slade somewhat archly credits with the upgrade of dye technologies that have made his and Gayle Fraas's quilt art possible. The '60s also shook the Eurocentric worldview that had prevailed for so long. President John Fitzgerald Kennedy's Peace Corps exposed young Americans to the cultures, arts, and values of societies around the globe. Textile traditions and techniques from Native American and non-Western cultures began to be investigated seriously by scholars and craftspeople.

◄ **FIRE AT EVENING**

Paul Klee. 1929. Oil on board. 13 3/8 x 13 1/4 in. Museum of Modern Art, New York.
Some of Klee's quirky paintings and drawings have suggested new avenues of approach to several quilt artists.

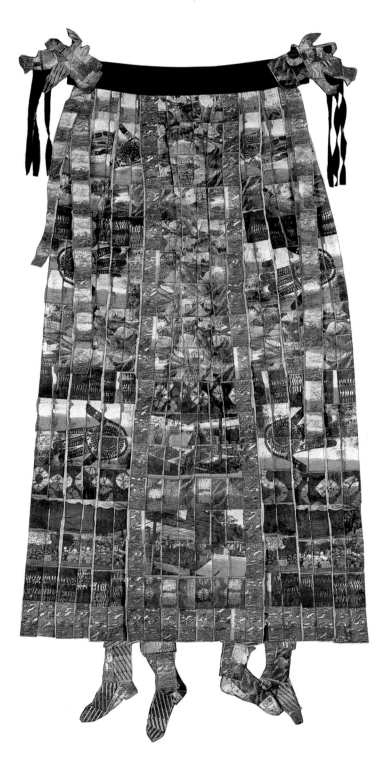

◄ **DRAGON DANCING SKIRT**

Katherine Westphal. 1987. Berkeley, California. Paper. Dyed, stamped, transfer printed with color Xerox, machine stitched. 82 x 45 in. Collection of the artist.
Both as a teacher and an artist, Westphal has championed innovative contemporary approaches to textile design. All of the surface design techniques employed on this paper skirt are now part of the repertoire of quilt artists.

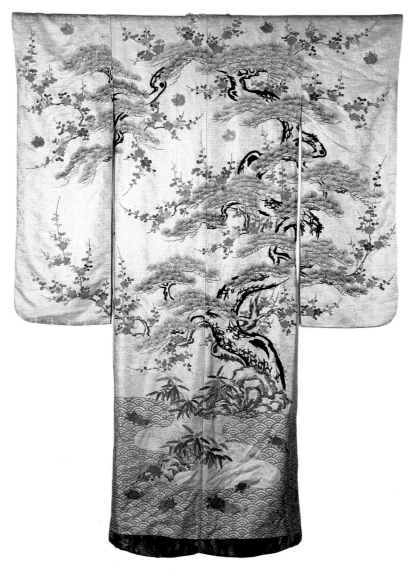

▲ WEDDING KIMONO

Artist unknown. Late 19th century. Japan. Monrinzu silk, silk brocade. Stencil painted and embroidered. Length: 70 in. Robert Hull Fleming Museum, University of Vermont, Burlington, Vermont.

Japan's venerable textile traditions have influenced many art quilters. Some use Japanese surface design techniques such as shibori in their work, while others have employed the kimono form. This elegant embroidered silk wedding kimono was used in a Shogun family or by a Samurai woman. The designs signify a wish for long life.

African textiles, Peruvian weavings, Far Eastern dye technologies such as batik and shibori, Plains Indian beadwork, Seminole patchwork clothing, Japanese kimonos, and Navajo rugs and serapes began to be explored in depth and eventually became grist for the mills of many artists and craftspeople.

The contemporary textile surface design movement, which concerns itself with fabric printing, painting, and dyeing, grew in part out of the expansion of textile sources and technologies that began in the 1960s. It has combined old and rediscovered processes with modern techniques such as heat-transfer printing and dye painting to create a new range of artistic possibilities for cloth. All of these methodologies have also been incorporated by quilt artists, many of whom are conversant with the work of contemporaries in other textile media. Indeed, the worlds of textile art, surface design, and the art quilt increasingly overlap and intersect, and it is sometimes futile or pointless to try to separate one from another. Several art quilters, including Joan Lintault, Susan Wilchins, and Arturo Alonzo Sandoval, hold academic positions in university textile arts programs, while many others teach classes at major craft schools such as Penland, Haystack, and Arrowmont. And an increasing number of artists, including Wilchins, Sandoval, Patricia Malarcher, Erma Martin Yost, Dorothy Caldwell, Deborah Felix, Deidre Scherer, and the late Lenore Davis, also work in other mixed textile media in addition to producing works that meet at least some of the evolving definitions of what a quilt is. Joan Lintault explains her position this way: "I place myself solidly in a textile tradition, and because of that I feel free to use any textile technique that would contribute to my work. I look back in history to see where I came from, but the new comes through my experience of working."

The world of high art also began paying more attention to fabric in the 1960s. The immense fabric-wrapped objects and constructions of Christo and the playful Pop art "soft sculptures" of Claus Oldenburg brought new validation to the use of cloth by artists, opening doors for many other artists. Oldenberg's work influenced many early quilt experiments, such as Ros Cross's early 1970s *Pancakes, Butter and Syrup Quilt* and *Fried Egg*

Baby Quilt with Bacon Rug. Andy Warhol's silk-screened canvases of repeated, grid-like soup cans and Marilyn Monroe's lips inspired one of Duncan Slade and Gayle Fraas's first quilts, a repeating silk screen called *42 Boys with the Mona Lisa Smile.*

Since the 1970s, many art historians have pointed out the similarity of certain quilts to modern abstract and optical paintings. It was the high critical

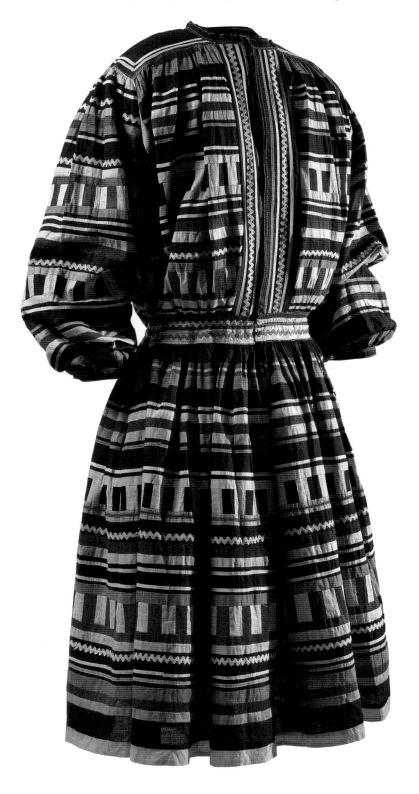

regard of work by the likes of Rothko, Albers, and Newman that first allowed the lowly quilt to be officially elevated to fine art status, via Jonathan Holstein's *Abstract Design in American Quilts* exhibition at the prestigious Whitney Museum of American Art in 1971. Quilts and modern paintings do indeed share a number of visual attributes which invite comparisons: flatness, monumentality of scale, a strong tendency to abstraction, a constructivist approach to design, the use of repeating patterns or geometric forms as an organizing principle, and an interest in intense, saturated color. Although unaware of the historical importance of their achievement, American quiltmakers certainly predate modern painting and rightly deserve a certain pride of place.

The geometric quilts of the Amish, particularly those from Lancaster County, Pennsylvania, have been the focus of most of the debate comparing abstract paintings and quilts. But it is only possible to compare them visually, as they could scarcely be farther apart in intention and contextual, societal meaning. The Amish women who made the great glowing quilts that are so highly valued today were members of a conservative Christian fundamentalist sect that continues to define itself in diametric opposition to the values of the modern world. The Amish value community above all else, and totally reject individualism. Their lives and their religion are one and the same; they strive to live in a constant

◄ **MICOSUKEE-SEMINOLE MAN'S FOKSICO.BI (BIG SHIRT)**

Artist unknown. c. 1925–35. Everglades region, Florida. Cottons. Length: 59 3/4 in. Museum of the American Indian, Smithsonian Institution, New York, New York.
In the early 20th century, both the Seminole and less well-known Micosukee Indians of the Florida Everglades decorated their clothing with machine-sewn patchwork. The use of the sewing machine allowed them to sew small bits of fabric together into strips of new cloth, which could then be cut and rearranged into intricate patterns and resewn. The concept of "strip piecing" has been taken up and further developed by a number of art quilters since the mid-1970s.

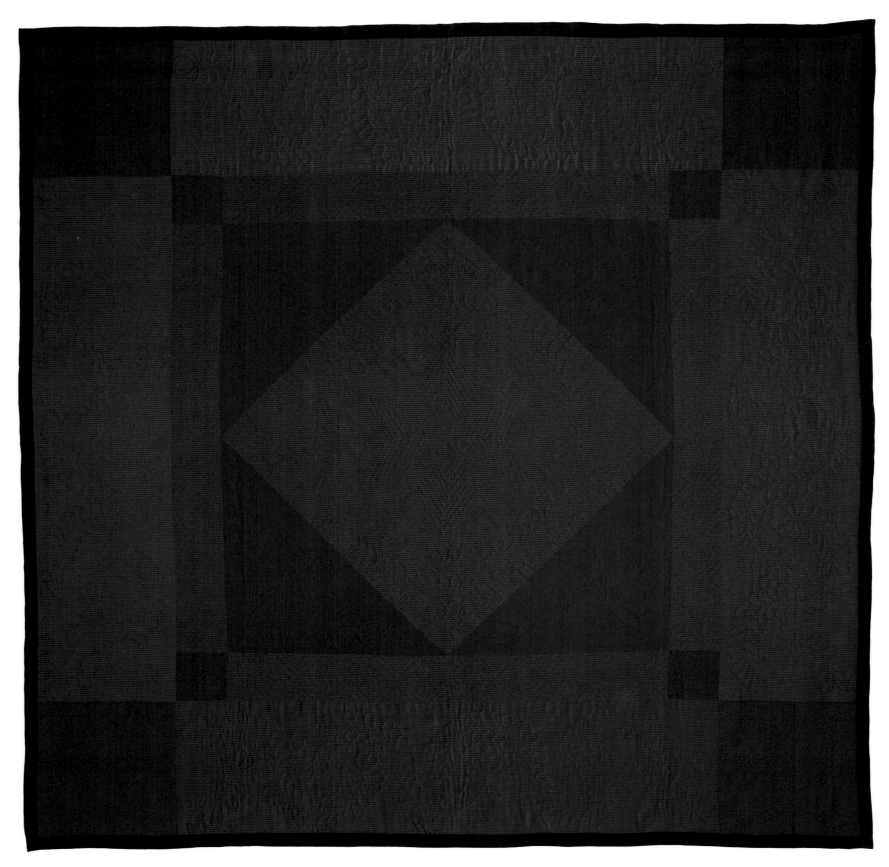

▲ DIAMOND IN THE SQUARE

Unknown Amish artist. c. 1920. Lancaster County, Pennsylvania.
Pieced wools. Hand quilted. 77 x 77 in. Private collection.
This quintessential Lancaster Amish Diamond employs only
twenty-one pieces of glowing red, purple, and blue wool set
within the frame of its thin black outer border. The interplay
of the large geometric fields of color is balanced by intricate
floral quilting.

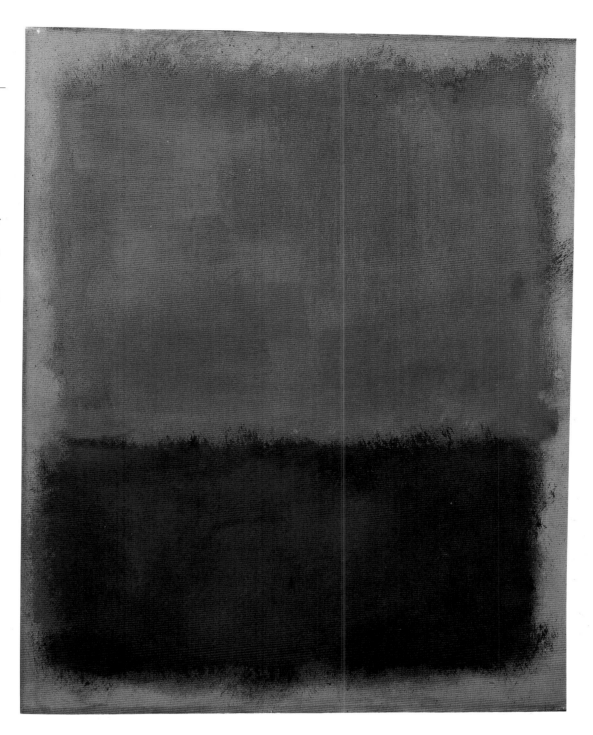

UNTITLED ▶

Mark Rothko. 1960–61. Private collection.
Rothko's enveloping abstractions sought to convey what he described as "tragic and timeless meaning" through the direct emotional experience of large color forms. Lancaster County Amish quilts have been compared to paintings like this example, and Rothko's Color Field paintings have in turn influenced such major art quilters as Judith Larzelere.

state of devotion and worship. They live lives of voluntary simplicity, stripped to the essentials to avoid temptation by what they view as the meaningless and superfluous materialism and complexity of modern society.

The Amish also have no use for art, because it serves no function. Use and beauty are indivisible for them, and form follows function in everything they create. Amish quilts were created out of this purposefully simple and intuitive approach to life, and their elemental power proceeds from and reflects the clarity and purity of their creators'

worldview. Amish quilts are, at once, statements of love and faith, documents of community, and expressions of simple, integrated beauty. They are also well-crafted and functional bedcovers, made of warm, soft, pliable fabrics, not of tightly stretched canvas, and their richly colored surfaces are covered with intricate textured patterns of hand quilting, not brushstrokes. Indeed, quilting represents half the art and meaning of Lancaster Amish quilts, albeit the less obvious half.

American abstract painting, by contrast, was a highly intellectual and self-conscious pursuit, an

expression of high art that was aware of and reacting to all previous high art, as well as to the influence of popular culture. It attempted to strip away narrative and associative concerns in order to reveal buried emotional truths through the language of color, form, and gesture. It departed from the traditions of all previous Western painting, especially the illusion of spatial depth that had been a key element of Western art since Giotto, and instead deliberately drew attention to the flat field of the stretched canvas. Without a recognizable subject matter, the interplay of colors and forms and the strokes (or drips) of the painter's brush became the expressive content of the work, rather than a technical means to a larger aesthetic end. Both in method and intention, these works of pure

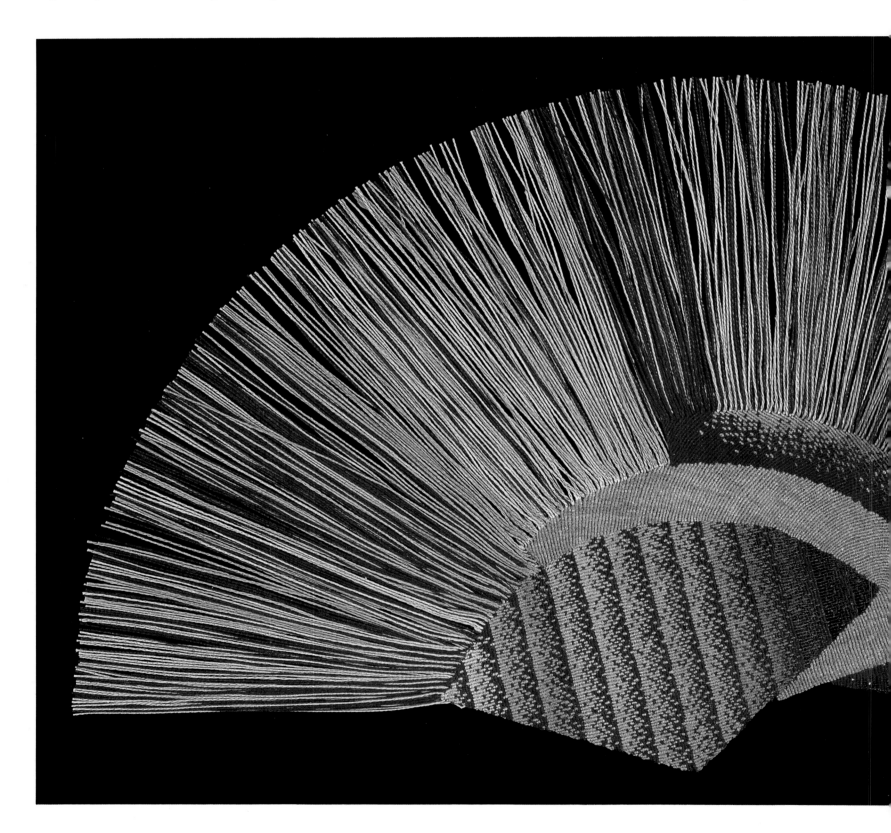

visual art could not have been farther removed from the concerns that guided the Amish to sometimes strikingly similar color effects and solutions.

The connection between quilts and abstract art probably lies deeper in the human psyche than sociological examination can reveal, however. In his recent study *The Stone and the Thread*, Cesar Paternosto has demonstrated a direct link between the buildings, basketry, and textile arts of Native Americans from both North and South America and the abstract art of Barnett Newman and Mark Rothko. He argues that constructive Native arts provided Newman and his followers with the structures and basic intellectual principles of American abstraction, allowing the "ancient 'crafts' to re-emerge in Western artistic consciousness as art sources." While their influence may never be as directly established as source material, traditional pieced quilts manifest these same constructivist principles and have been such familiar objects that modern artists could scarcely be unaware of them or of their sometimes remarkable visual sophistication. Modernists from Hamilton Easter Field (the founder of the Ogunquit art school and one of the first collectors of American folk art) to Robert Rauschenberg have clearly been aware of quilts as visual statements on some level. But it may be that the quilt's very familiarity mitigated against its recognition as an art source, just as it has weighed against its recognition as an art object. While the non-Western "otherness" of African and other countries' native arts appealed enormously to modernists from Picasso on, the homey, close-at-hand domestic and female context of quilts helped mask the seriousness of their aesthetic achievement from artists as well as academics. Caught in societal stereotypes, male artists and art theorists did not begin to examine or find strength in the quilt until the 1970s. It is largely women artists who have had to reclaim the quilt and its history as their own, and have begun to free it from its former constraints.

◄ **LAYERED FANS**

Diane Itter. 1980. Bloomington, Indiana. Knotted linen. 18 3/8 x 24 3/8 in. The American Craft Museum, New York.
Itter's small and intricate works carry a power far greater than their size. Her finely tuned color sense has influenced many art quilters.

▲ BED

Robert Rauschenberg. 1955. Oil and pencil on pillow, quilt and sheet on wood supports. 75 1/4 x 31 1/2 x 8 in. Museum of Modern Art, New York. Gift of Leo Castelli in honor of Alfred H. Barr, Jr. With no canvas available, Rauschenberg appropriated his own sheets and pillow and a friend's quilt as raw material for this combine-painting. Although it is considered an icon of modern art, the work has also been attacked by feminists and appalled quilters.

The issues involved in this reclaimation are deep and complex. For example, controversy has surrounded one of Robert Rauschenberg's mid-1950s combine-paintings, *Bed*, which incorporates a friend's Log Cabin quilt as part of its canvas. Rauschenberg's work has been attacked by feminist historians (and more than a few quilters) as an appropriation of female handwork, involving the destruction of a quilt for the sake of his own (male-dominant) artistic needs. While most such discussions ignore the far less well-known fact that the female artist Ann Wilson also painted on a Log Cabin quilt the same year, both these works certainly are indicative of the low status of the quilt at that time. Today, Rauschenberg's *Bed* is one of the best-known works of quilt-related art; it resides in the collection of the Museum of Modern Art.

In recent years, many modern artists have incorporated concepts derived from their observation of quilts (and other textile "crafts") into their work. Since the 1970s, a number of feminist artists have looked to the quilt as a historic foreground to their work and helped to legitimize it as an artistic medium. Some of these painters have included representations of quilts and other women's needlework in their paintings, while others actually made quilts or otherwise incorporated fabric into their work. A number of art quilters have been inspired by the work of Miriam Schapiro, who has been one of the mainstream art world's most visible champions and validators of the quilt. Schapiro has declared her belief that "quilts are the great American art form," and since the early 1970s produced canvases that combine acrylic paint and found pieces of historic needlework. She paints patterns and symbols derived from quilts and other needlework on her huge canvases as a means of paying homage to female predecessors, whose work she feels has been unjustly ignored by the fine art establishment. In a 1981 interview with quilt expert Penny McMorris, Schapiro noted, "Feminists have picked up on the content of quiltmaking because the

▲ WONDERLAND

Miriam Schapiro. 1983. Acrylic and fabric on canvas. 90 x 144 in. Collection of the National Museum of American Art, Smithsonian Institution, Washington D.C. Courtesy Steinbaum Krauss Gallery, New York.

This massive painting honors the decorative surface patterns of quilts and other women's domestic needlework by repeating them in the "fine art" medium of paint, and also incorporates pieces of historic handmade textiles as equal parts of the composition.

feminists in the '70s who made art frequently made art about their own lives. There is a saying 'the personal is the political,' and nothing in history is more personal than quiltmaking."

Schapiro's work has done a great deal to help reclaim the history of the quilt as women's art, and her notion of combining paint and fabric has directly influenced many younger artists who now make quilts. One of these artists is Susan Shie, who says, "As for influences, the feminist movement and the artist Miriam Schapiro had big ones on me. I was doing a B.A. in painting in the late '70s, early '80s, when Schapiro came as a visiting artist. I started combining the sewing I did all the time, outside the studio, with the painting I did inside. We were bringing 'women's work' into our artistic wholeness and I loved it! I finished [my B.A.], having worked on painted, stitched, and unstretched fabric for two years. Then I did a M.F.A. in painting,

again on unstretched, sewn, painted fabric and then in mixed media and writing and sculpture. My thesis was 'Quilt Diary Paintings,' and I didn't know anyone else was making 'art quilts.'"

Conversely, just as contemporary painters have been inspired by quilts, so too quilters have incorporated ideas drawn from modern painting, from the Impressionists to the present day. A few quilts, such as Nancy Halpern's punning *Hopper*, Meiny Vermass-van der Heide's *Op-Art* and *Homage to Mondrian*, and Holley Junker's tongue-in-cheek *Que Seurat? Seurat!* freely pronounce their sources of inspiration. In most instances however, the influence is more general and less easily traced. As Judith Larzelere explains, "I have been particularly influenced by the Abstract Expressionist painters, who used color, texture, and gesture to represent emotional states. In my quilts I feel I am exploring the same problems and

▲ PICTORIAL QUILT

James Williams. 1842–52. Wrexham, Denbighshire, Wales. Cottons. Hand pieced and appliquéd. 90 x 82 in. Welsh Folk Museum, St. Fagans, Cardiff, Wales.
Williams was a tailor, and one of the few documented male quiltmakers of the nineteenth century. His masterwork combines vibrant piecework patterns with a central collage of pictorial appliqués, including biblical scenes and representations of a Chinese pagoda, the recently completed Cefn Viaduct, and several British crowns.

Whether they began as quilters or came to the quilt from painting or other disciplines, all art quilters can still turn to the traditional quilt for sustenance and validation of their work. Pauline Burbidge speaks for many quilt artists when she says, "My work springs from a love for traditional quilts." Yvonne Porcella adds, in the catalogue for the traveling exhibition *The Art Quilt*, "Although I have never made a traditional style quilt, I enjoy and appreciate the beauty of traditional patterns and antique quilts. I feel a strong link to earlier quiltmakers. And I feel a strong link to today's traditional quiltmakers as well. We [all] came to quiltmaking for basically the same reasons."

Quilts which qualify as masterpieces of visual art can be found throughout the history of quiltmaking and in every stylistic category and regional tradition. Any careful consideration of the universe of historic quilts will reveal extraordinary examples of whole cloth quilts, central medallions, chintz appliqués, white work, Baltimore albums, block-style pieced quilts, crazies, and Amish, African-American, and Hawaiian works, to name but a few of the most obvious categories. All are part of the rich history of American quiltmaking, and all have, by example, helped to pave the way for the art quilt. They form a historic continuum of artistic excellence which challenges today's quilt artists to rise to the level of their predecessors' ingenuity and expressive capability. Quilters of all kinds can look with pride and awe to the works of such masters as Sarah Furman Warner Williams, Susan McCord, Ann Robinson, Elizabeth Roseberry Mitchell, and Harriet Powers, as well as the host of other extraordinary talents whose names have unfortunately not been preserved, for validation of their chosen art form. These women belong on any short list of great nineteenth-century American artists, along with the likes of the folk painters Ammi Phillips and Edward Hicks, decoy makers William Bowman and Nathan Cobb, Jr., and sculptors Wilhelm Schimmel and Samuel Robb, not to mention the more familiar,

expressing the same inspirations as if I were a painter using oils or acrylics. Instead, I choose colored cloth as a medium because I like the collage aspect of designing with fabric, I like selecting from available color rather than mixing paints, and I love the tactile pleasure of handling cloth."

Despite all these complex and divergent recent influences, however, the roots of the art quilt are, first and foremost, to be found in the traditional, functional quilted bedcover. Traditional quilts remain the bedrock for the art quilt, representing the touchstone where many art quilters began.

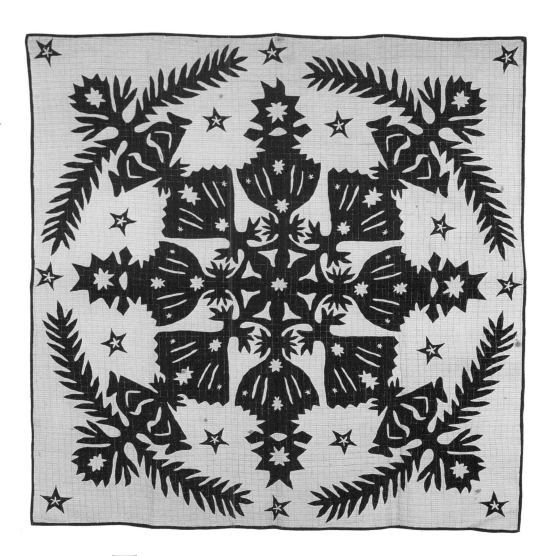

KE KAHI O KAʻIULANI (THE CROWN OF KAʻIULANI) ▶

Artist unknown. Early 20th century. Island of Hawaii. Cotton. Hand appliquéd, machine quilted. 88 1/2 x 84 in. Honolulu Academy of Arts, Honolulu, Hawaii. Gift of Mrs. Richard A. Cooke, 1927.

Many Hawaiian quilts were made to honor the country's revered royal family. This choice example pays homage to Princess Victoria Kaʻiulani, the niece of the last Hawaiian monarch, Queen Liliʻuokalani. The young princess had been appointed by Liliʻuokalani to succeed her to the throne. However, she died from rheumatic fever in 1899, only a year after the islands were annexed by the United States, and with her died any hope of restoring Hawaii's sovereignty. The pattern represents the princess's hair combs, and the eight five-pointed stars stand for the eight major islands of Hawaii.

officially sanctioned names of Copley, Cole, Church, Eakins, Cassatt, Homer, and so on. Only the pervasive anonymity of their accomplishment can now be cited as an excuse to assign them to lower status.

Not all quilts are works of art, of course, nor do all quilts strive to be. Many quiltmakers through the years have been content to produce copies of existing designs without adding their own ideas, while others have aimed simply to create warm and appealing bedcovers for their families. And some have attempted to create works of beauty and fallen short of their ambitions. Just as most paintings are not great original works of art, so too the majority of quilts do not rise above the functional, the competent, the imitative, or the merely decorative. But more than a few historic quilts combine an original vision with an aesthetic ability that transcends the norm and is able to speak directly and convincingly across the years. Whatever their makers' original intentions, they thereby become objects of lasting aesthetic interest and expressive power.

The two surviving Bible quilts by the aforementioned Harriet Powers illustrate the democratic possibilities of the quilt medium as well as any works extant. Their creator was an illiterate former slave from Athens, Georgia, who worked in the final decades of the nineteenth century. In the opinion of most experts, these quilts rank among the greatest treasures of American folk art. Powers's quilts, which articulate an intensely private, personal Christian vision, have set a powerful standard for all American quiltmakers. Although Powers's intentions are unclear, the quilts' unusual sizes and horizontal formats strongly suggest they were not made to function as bedcovers. Each of the two quilts is made up of a number of appliquéd scenes derived from the Old and New Testaments, while the later of the two quilts (now in the Museum of Fine Arts Boston) mixes in several scenes based on unusual natural or meteorological phenomena. The appliqués are set off in framed blocks. They are composed with great thought and care, both individually and in relation to each other. Powers was totally committed

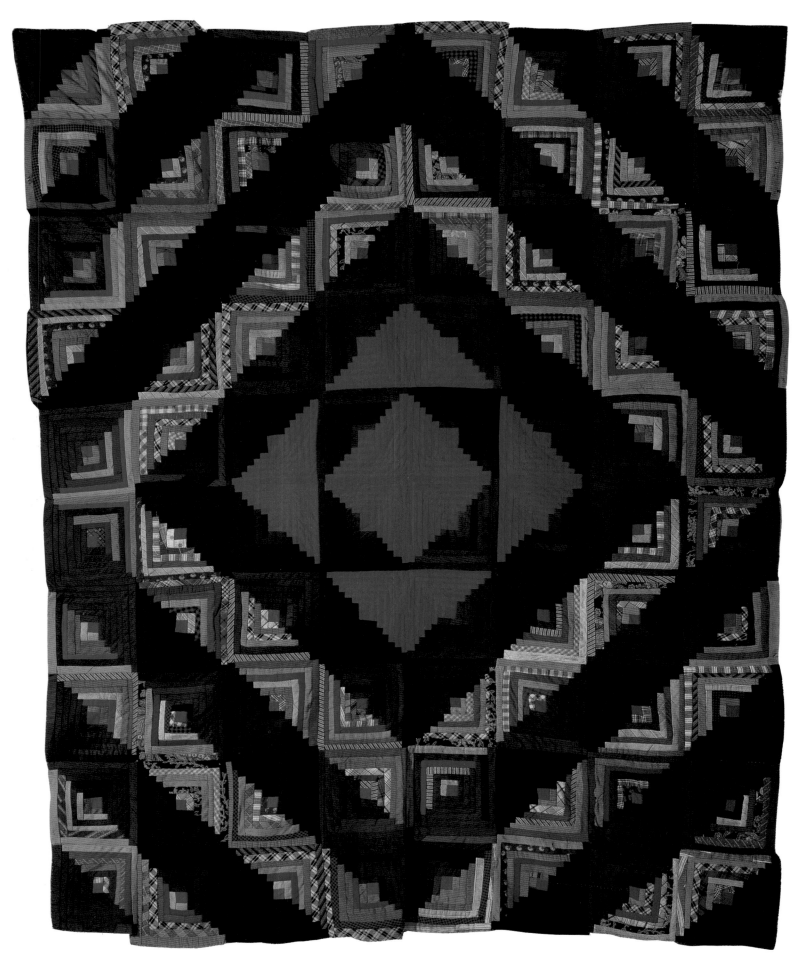

▲ LOG CABIN BARN RAISING VARIATION

Artist unknown. c. 1890. Kentucky. Cottons. Hand pieced. 80 1/2 x 64 1/4 in. Kentucky Historical Society, Frankfort, Kentucky.
The powerful overall design of this Log Cabin was created by dividing each block into a light and dark half. The unusual and highly effective red and black center creates a strong focus from which the black "barn beams" seem to radiate like ripples on a pond.

SUNSHINE AND
SHADOW ▶

*Unknown Amish artist. c. 1910.
Lancaster County, Pennsylvania.
Pieced wools. Hand quilted. 80
x 80 in. Private collection.*
The Sunshine and Shadow
pattern alternates light and
dark fabrics to create pulsating
bands of color. The palette
chosen for this superb Lancaster
Amish example is remarkably
cool and sophisticated.

to what she called the "darling offspring of my brain," and after reluctantly selling the quilts to white collectors for much needed cash, she dictated extensive notes on their iconography. Few American quilts are as well documented, and fewer still retain such an aura of impenetrable mystery and wonder. Both quilts are expressive masterpieces, able to stand on their own with the finest paintings and sculptures this country has produced. They are "sermons in cloth" (Powers's own term) that speak eloquently of their creator's indomitable faith.

Like all artists, quiltmakers of earlier eras looked to the things they knew for subject material for their quilts, drawing inspiration and meaning from their families, their religion, their community, their political beliefs, the events of the day, and the objects and animals they encountered in the

course of daily life. Pattern names attached to nineteenth-century quilts are instructive because they reflect the visual vocabulary of early American quiltmakers, just as individual titles like *PCB Bop, Head Gasket Maze, Last Picture Show, Acid Rain, Checker Cab, Subway Graffiti,* or *Parallelogram Diptych* define the world of today's quilt artists. Whether the abstract pattern was inspired by an object or concept, or whether the name was given to an already conceptualized design, is fairly unimportant; the names paint a picture of the quiltmaker's world for us, and help place the quilts in the visual context of their time. Many traditional names came from the natural world: Wild Goose Chase, Duck's Foot in the Mud, Bear Paw, Pine Tree, Rainbow, Honey Comb, Ocean Waves, Peony and Prairie Flower, while others were derived from man-made objects: Mariner's Compass, Sawtooth, Monkey Wrench, Baby's Blocks, Dresden Plate, Bow Tie, Double

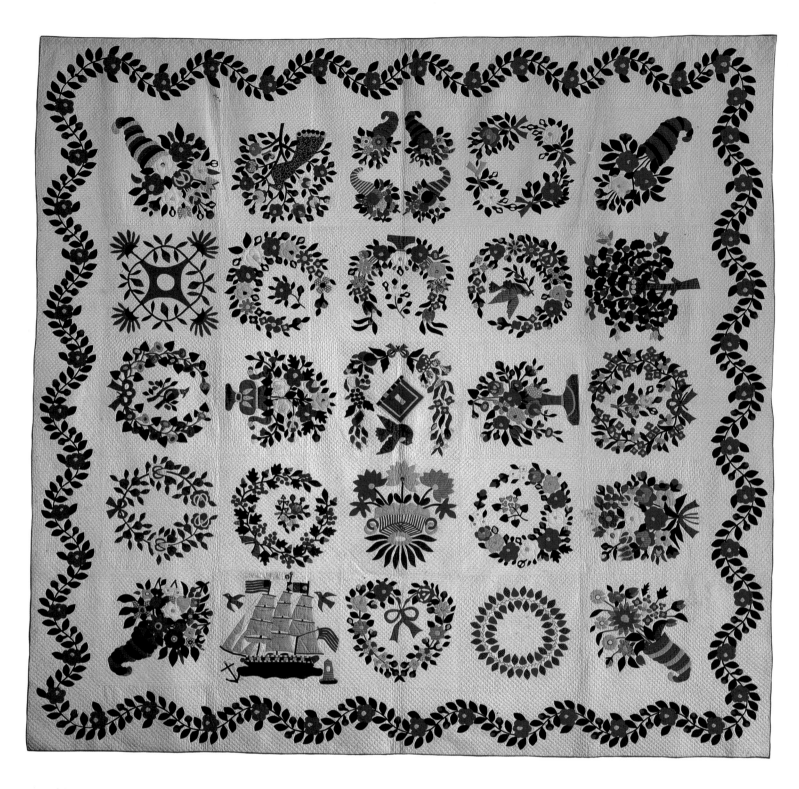

Wedding Ring. Because quiltmaking is a constructive art, many quiltmakers found inspiration in the building arts and created patterns with parallels in brick or masonry work, house framing and construction, window panes or stained glass designs. The descriptive names of many block patterns confirm this suggestive influence. The most enduring family of block patterns so inspired is the ubiquitous Log Cabin and its various subsets, which include Windmill Blades, Courthouse Steps, Barn Raising, and Fence Rails. Other construction-related pattern names include Schoolhouse, Brick Wall, Carpenter's Square and Carpenter's Wheel, Roman Wall, and Stepping Stones. On a more abstract and philosophical level, such patterns as Joseph's Coat, Robbing Peter to Pay Paul, World Without End, Jacob's Ladder, Tree of Paradise, and Crown of Thorns reference the Bible, while patriotic and geographical themes informed such designs as Rocky Road to Kansas, Underground Railroad, Tippecanoe and Tyler Too, Whig Rose, Burgoyne Surrounded, and Lone Star.

◄ **BALTIMORE ALBUM QUILT**

Artist unknown. c. 1845. Baltimore, Maryland. Cottons. Hand appliquéd and quilted. Collection of Ardis and Robert James. Baltimore's legendary pictorial album quilts were created by master professional seamstresses who took full advantage of that port city's access to a wide range of printed American and British cotton fabrics.

Art quilters not only share with earlier American quiltmakers their interest in creating objects of beauty out of their own experiences, but an interest in expressing their concerns about contemporary social and political issues as well. Terese Agnew's *Proposed Deep Pit Mine Site* and Merrill Mason's *Scrap Thatch* comment on environmental issues, and Arturo Alonzo Sandoval's *Lady Liberty/Babylon II* and Barbara Todd's *Security Blanket: B2 Stealth Bomber* decry the products and mentality of the military industrial complex. On a more specific note, Elizabeth Busch's *Alert!* is part of a series about a woman accidentally killed by a Maine hunter in her own backyard. Quilts have been used to express community sentiments and make political statements since the early decades of the nineteenth century. Friends and family members often contributed personalized squares to a wedding quilt for a bride, and female parishioners often worked collaboratively on a quilt honoring the service of a departing minister. Quilts were associated with many women's social reform issues of the nineteenth and early twentieth centuries. Beginning in the 1830s, women sold quilts to help support abolition, and actually did the majority of the fund-raising for the antislavery movement. Church-going women also gathered to make fund-raising quilts to support missionary

▲ **PICTORIAL BIBLE QUILT**

Harriet Powers. c. 1891–98. Athens, Georgia. Pieced, appliquéd, and printed cotton, embroidered with cotton and metallic yarns. 60 x 105 in. Museum of Fine Arts Boston. Bequest of Maxim Karolik Collection.
Powers explained that her quilt's fifteen pictorial squares depict Adam and Eve in the garden, the creation of the animals, John baptizing Jesus, the Crucifixion, and other biblical scenes as well as such natural events as "The dark day of May 19, 1780," "The falling of the stars on November 13, 1833," and "Cold Thursday 10 of Feb. 1895. A woman frozen while at prayer."

work among the "heathen," on the continent and beyond. During the Civil War, sewing societies in both the North and the South made tens of thousands of quilts for soldiers and hospitals, and quilts were also essential to the fund-raising efforts of the Women's Christian Temperance Movement, which was founded in 1874. These traditions have continued to the present day; an exhibition of art quilts made to memorialize the Oklahoma City bombing is currently touring the country, and the massive and heartbreaking AIDS quilt organized by the NAMES Project is the most effective grassroots consciousness raiser in the long and noble history of the American quilt as an instrument of social change.

Art quilters are not alone in their exploitation of new technologies. Quiltmakers have always incorporated changes in technology into the process of their work. As the American textile industry burgeoned during the nineteenth century, quiltmakers took advantage of every advance. Beginning in the 1850s, for example, the bright, clear colors of commercial aniline chemical dyes expanded the range of fabric color available to quilters tremendously. Within twenty years of the introduction of aniline dyes, over twelve hundred different roller-printed fabric colors were available in stores around the country. The sewing machine, which was also introduced in the 1850s, was adopted quickly as well, and by the 1870s well over half a million were being purchased each year. The sewing machine made the commercial clothes-making industry possible, and had largely eliminated homemade clothing by the turn of the twentieth century. By freeing women from the time-consuming necessity of home clothes-making, the sewing machine ironically encouraged them to do more sewing, and helped facilitate the enormous creative energy of late nineteenth-century quiltmakers. Even the Amish were quick to adopt it. Technological and commercial advances have not always had a positive effect on quiltmaking, however. For example, the proliferation of commercially distributed patterns and quilt kits in the 1930s discouraged creativity and had a homogenizing effect on the appearance of American quilts resulting in thousands of bland and virtually identical quilts. Similarly, the explosion of how-to books and quilting classes in the past two decades has resulted in myriad copy-cat quilts that simply imitate the style and methods of authors and teachers. Too many of today's quilts focus on technique rather than individual expression.

Although art quilters represent the first generation of quiltmakers to proclaim themselves artists, the decorative and expressive aspects of the quilt medium have stood side by side with practical and functional concerns from the earliest times. A few talented early quiltmakers who had access to high quality fabrics (and were fortunate enough to have the time to lavish working with them) made one-of-a-kind appliqué quilts that were reserved for the eyes of company or other special occasions. The extraordinary *Phebe Warner Coverlet* epitomizes this rare type of quilt. On a similar note, the magnificent mid-nineteenth-century appliqués now known as "Baltimore album quilts" were also made primarily for show. These complex creations were showcases for highly skilled middle Atlantic needleworkers, many of them professional seamstresses, and for the products of the rapidly expanding American and English textile industries. America's greatest contribution to quilt design, the block-style pieced quilt, also arose out of the mid-century proliferation of printed cottons, and its possibilities unlocked the creative imagination of American women as nothing had done before. The breathtaking geometric abstractions of the best of these intuitive artists foreshadowed many of the formal developments of twentieth-century fine art and set lofty standards for modern quiltmakers.

In both intention and unrestricted creative exuberance, however, the Victorian-era crazy quilt is arguably the most direct ancestor of the art quilt. The influence of crazies is wide but can be seen most directly in the work of embellishers such as Terrie Hancock Mangat, Jane Burch Cochran, and Susan Shie, who are creating some of today's most original quilts. Like the art quilt, crazies mark a real break in the evolution of quiltmaking. They were never intended to function as bedcovers; they were unlined, and because they were typically made of fragile silks and satins, they could neither be washed nor quilted. They were, in effect, fabric collages that could include scraps of fancy dress fabrics, bits of hand-painted fabric, pieces of a husband's tie or a mother's apron, printed commemorative handkerchiefs, cigar bands, lace, ribbons, buttons, beads, and a host of embroidered stitches and pictures.

▲ THE PHEBE WARNER COVERLET

Probably by Sarah Furman Warner Williams. c. 1803. New York, New York. Linen and cotton. Hand appliquéd, hand pieced, hand embroidered. 103 1/4 x 90 1/2 in. The Metropolitan Museum of Art, New York. Gift of Catherine E. Cotheal.
One of the towering masterworks of American quiltmaking, this appliquéd top is believed to have been made as a wedding present for Phebe Barrien Warner, who married Henry Cotheal on October 17, 1803. Sarah Furman Warner Williams was Phebe's first cousin; she would have been approaching forty at the time of the quilt's completion. Most of the quilt's fabrics were cut from English-manufactured chintzes, linens, calicos, and plaids, and its design was influenced by Indian palampores and eighteenth-century needlework pictures.

Many crazies are no more than whimsical jumbles, but the best, like M.M. Hernandred Ricard's *My Crazy Dream*, qualify as coherent artistic statements of a very high order. They are "art quilts" indeed.

A HISTORY OF THE ART QUILT

The art quilt grew out of the great quilt revival that began in the 1960s and continues undiminished to the present day. Interest in handcrafts of all kinds was a strong element of the youth rebellion of the 1960s, as young people across the country sought alternatives to a society they perceived as spiritually bankrupt and morally corrupt. Back-to-the-landers sought meaning in the simpler lifestyles of early America, and taught themselves the traditional nineteenth-century arts that had been rejected by their parents and grandparents as hopelessly old-fashioned. They rediscovered and elevated neglected older craftspeople who still remembered how to make things by hand, and where the craftspeople were unavailable, taught themselves by direct study of surviving objects or long out-of-print how-to books.

Interest in quilts and quiltmaking exploded in the years leading up to the Bicentennial, as women reclaimed a heritage that had been largely lost in the profound societal changes that followed World War II. Feminist historians began to reexamine the role of women in American society and art and pointed with great pride to the forgotten work of their foremothers. For the first time, quilts were read as social documents, embodying the history and values of their otherwise silent makers. Old quilts became

◄ BETWEEN ASLEEP AND AWAKE

Susan Hoffman. 1976. New York, New York. Cottons with some cotton blends, silks, and wools. Machine pieced, hand quilted. 68 1/2 x 52 in. Collection of the artist.

Set within a series of cool-hued fabric frames, this painterly abstraction employs carefully graded strips of fabric to create a constant push/pull of contrasts that keep the eye moving over the entire surface of the quilt. Lines of diagonal quilting set up strong visual cross-rhythms against the horizontal strips.

collector's items, valued for their craftsmanship, design, and history, and thousands of women (and a few men) began to learn how to make quilts again. Many recalled a grandmother or other relative who had quilted, and also found in quiltmaking a way of discovering their personal and family roots as well as a collective past.

At least initially, most of these new quilters were content to recreate the patterns invented by their nineteenth-century predecessors, both as a means of learning the craft of quiltmaking and as a way of reconnecting with its history and traditions. In his book *The Quiltmaker's Handbook*, Michael James recalled his "apprenticeship" this way: "My initial exploration of the medium revolved around the making of countless copies of traditional blocks as well as several small quilts in traditional patterns and finally two large, traditional quilts." James's experience was typical of most would-be quilt designers; although he had trained at art school as a painter, he still had to master the craft of his new medium before he could create his own original designs, and that learning took time and diligent study.

Although non-traditional approaches to quiltmaking did not receive much attention until the mid-1970s, a handful of pioneering artists and craftspeople began experimenting with modern designs for quilts in the 1950s and 1960s. The most prominent and influential of these early

modern quiltmakers was Jean Ray Laury, an academically trained artist and designer who encouraged women to create their own new designs based on their own experiences, surroundings, and ideas rather than traditional patterns.

Now in her late sixties, Laury is still very active today and is seen as the mother of the art quilt by many contemporary artists. She made her first full-sized quilt in 1956 as part of a masters degree project in art at Stanford University. After receiving favorable responses to her work from her professor as well as at regional craft and quilt exhibitions, Laury entered the quilt in the 1958 Eastern States Exposition, where it attracted the attention of Roxa Wright, then needlework editor for *House Beautiful* magazine. Wright later wrote of the experience: "In over twenty years as a needlework editor, I have seen countless quilts and helped to judge many quilt exhibitions. It was at such an exhibition, about a decade ago, that I saw Jean Laury's first quilt—a delightful, completely unorthodox quilt depicting all the things that interested and excited her children, at that time very young. It was like a fresh breeze, the first contemporary quilt I had ever seen that really came off successfully, yet it was far simpler and more direct in stitchery than the many fine traditional quilts in the exhibition." She soon contacted Laury and asked her to contribute to her new publication, *Woman's Day*, an invitation at which Laury jumped. She recalls, "Roxa's encouragement was so important to me, as nobody I knew was doing anything like this. The letter of encouragement

◄ SEED PODS

Jean Ray Laury. 1960. Clovis, California. Wool felt. Hand appliquéd, stretched, and mounted on wood. 28 x 20 in. Private collection.
This charming little appliqué is typical of Laury's innovative, modern approach to quilt design. Through her many books and extensive teaching, Laury has inspired scores of other women to take up quiltmaking, and her direct and utterly unpretentious style has been a major force in the development of the art quilt.

from her about my first quilt was a tremendous boost. It was like official sanction."

Woman's Day provided Laury and the new, non-traditional quilt with a forum throughout the 1960s; her inventive and charming designs were also published by *Better Homes and Gardens, Family Circle*, and other popular women's periodicals. Laury was also commissioned to create quilts for a number of regional banks and office buildings, and those public installations helped establish fiber arts as a legitimate pursuit in California. Her work was exhibited and received warmly at Stanford, the M.H. deYoung Museum in San Francisco, the Fresno Art Museum, and the Museum of Contemporary Crafts in New York in the 1960s. Laury also published a series of influential books, beginning with *Appliqué Stitchery* in 1966. Her *Quilts and Coverlets: A Contemporary Approach* was published in 1970, and in addition to her own innovative designs, included photos of remarkable quilts by such pioneer modern quilters as Charles and Rubynelle Counts, Therese May, and Joan Lintault.

"The things I have to say are not profound," Laury said with typically straightforward modesty in 1959. "They concern the simple and familiar objects that I find about me." In *Quilts and Coverlets*, she put her case this way: "In early America, the sources for quilt design came from nature and from all the articles of everyday life—the patterns on dishes, the designs from cast-iron stoves, political symbols such as the eagle and the star, wild flowers and other plant forms. In the twentieth century, however, none of the new influences of the time seem to have permeated quilt design. Even the strong influence of Art Nouveau, which was apparent in other crafts, had almost no effect on quilt making. Perhaps women lost confidence in their ability to design. We saw watered-down versions of old designs, used over and over, with few of the revitalizing changes essential in any 'lively' art. Modern designers of quilts are not concerned with reiterating statements made years ago. They have their own comments to make, comments which are relevant to our own times. At last we can look forward to exciting designs. Traditional designs no longer meet our needs. Creativity and inventiveness make it possible to modify and rejuvenate the old approaches and techniques. Systems of construction in quilt making are strong, durable, and beautiful. If we can retain the structural integrity of the traditional quilt and add to it a contemporary approach to color and design, we will achieve a quilt which merges past and present." From today's vantage point, Laury's statement can be read as a manifesto for the art quilt.

Another extremely important and influential early quilt artist is Radka Donnell, a Bulgarian-born painter who gave up her brushes in 1965 to work full time with the pieced quilt and was one of the first quilt artists to attempt to support herself solely on her own work. (Finding this impossible she has taken a variety of other jobs to support her obsession with the quilt over the years.) After emigrating to the United States in 1951, Donnell studied at Stanford and the University of Colorado at Boulder, where she earned her M.F.A. In the early 1970s she lived in Boston, and her decidedly non-traditional quilts strongly affected many younger artists in the region, including Sylvia Einstein, Michael James, Rhoda Cohen, and Nancy Halpern. She was also instrumental in securing and organizing shows of her own and

◄ **DIALOGUE**

Radka Donnell. 1973. Cambridge, Massachusetts. Cottons. Hand pieced, hand quilted by Claire Mielke. 108 x 89 in. Private collection.
As a former painter, Donnell was among the first quilt-makers to apply the techniques and theories of fine art to her work in fabric. Also, she found in the quilt a powerful but hidden history of female artistic expression that paralleled the more accepted world of male-dominated High Art. A companion to this quilt was included in *The New American Quilt* exhibition when it appeared at The American Craft Museum in 1976.

other contemporary quilts, and in seeking respect, recognition, and reward for quilt artists on equal footing with those working in recognized media. She recalls, "[When] I first saw quilts in a museum, [they] were in back of the exhibition rooms in the hall leading to the Ladies Room. What I had dimly perceived until then I realized clearly and resolved to change: namely, the arts or crafts made by women were [always] given the rear entrance, and it was time to get them to enter through the grand, front entrance." To that end, her 1975 exhibition (with Susan Hoffman and Molly Upton) at Harvard University's Carpenter Center for the Arts marked the first time quilts had been featured in such a prestigious East Coast art gallery setting.

Where Jean Ray Laury's approach was breezy and purposefully simple, Donnell's stated intentions were deeply intellectual and spiritual. Trained as an art therapist as well as a painter, Donnell became a champion of quiltmaking as a women's healing art. She was also the first quilt artist to take a feminist stand and speak of quilts as a "Liberation" issue. "Quiltmaking politicized me," she says. In her lectures and writings, she articulated the expressive possibilities of the quilt better than anyone else had previously done and made a powerful case for the quilt as "the associative field of the body," a direct link to the most primal of human needs and acts. "By its original closeness to a person's body, the quilt can become an icon of personal feeling and hope," she wrote in her introduction to *The Contemporary Quilt* in 1977. "This is its nature, invoking no absolutes, but open as to a human embrace."

Donnell found enormous meaning in the functional and familial aspects of quilts and quilt-making, and her quilts were always made to be used as well as appreciated as wall hangings. They typically placed carefully composed collages of strips and blocks of plain-colored and printed fabric within a relatively wide outer fabric frame. All were machine quilted by her associates Claire Mielke or Ruth Alex to assure they would stand up to hard use and repeated encounters with a washing machine if such was the desire of the new owner. The use of the machine also saved time, a critical argument in its favor for a working artist like Donnell, who was thereby freed to focus solely on designing and piecing new quilts. Donnell was one of the first quilters to make extensive use of the sewing machine for quilting, and the hard-edged look of her quilts' surfaces was as new to many viewers as were her abstract, painterly designs.

UNTITLED ▶

Designed by Charles Counts, made by Rubynelle Counts and members of the New Salem Community. c. 1965. Rising Fawn, Lookout Mountain, Georgia. Cotton. Hand appliquéd and quilted. 101 x 73 in. Collection of Glendal P. and John E. LaRowe. Charles Counts's quilt designs were revolutionary because they were not based on traditional quilt design. Instead, Counts approached the new medium as he had ceramic decoration, marking design forms and quilting patterns directly on fabric with a ballpoint pen. The quilts were then constructed and quilted by his wife, Rubynelle, and traditional quilters in their community. Counts's pen marks can still be seen on this quilt.

Donnell has remained active both as an artist and a teacher. She has produced nearly five hundred quilts over the past thirty years, written the eloquent book *Quilts as Women's Art: A Quilt Poetics*, and, most recently, taught a course on the history, theory, and techniques of quilting at both Simmons College and Westfield State College in Massachusetts. She rejects the term "art quilt" to describe her work, disliking any association with the elitist, male-dominated world of High Art. She writes, "I stepped out of the 'art scene' when I began doing my quilts. I have stayed with quilt-making because it helped me to find wholeness and be open to enjoy, advise, and validate the creativity of other women. I believe we are all equally creative, and my happiest moment regarding art was when one of my students said about my course, 'It helped me realize that I am more creative than I thought before.' This is my [current] objective, and if it does not make me an 'artist,' that's OK with me."

Like Radka Donnell, Charles and Rubynelle Counts also began their involvement with quiltmaking in the 1960s. They were artists who had studied various crafts at Berea College in Kentucky during the 1950s, including weaving and pottery; Charles also studied pottery at Southern Illinois University and the University of Southern California. Berea had been an important center for crafts since the 1890s, when its presi-dent, Dr. William Goodell Frost, became the first to champion the traditional crafts of rural Appalachia. Frost saw the value of the region's "fireside industries," as he dubbed them, and encouraged local weavers through annual home-spun fairs. Berea established classes in the traditional arts in 1902 and also marketed the work of students and local craftspeople.

After further study with the noted potter Marguerite Wildhain in California, the Countses settled at Rising Fawn on Lookout Mountain in northwestern Georgia, where they founded a crafts center to market Charles's pottery and Rubynelle's weavings. Charles Counts was raised in the ravaged coal fields of Harlan County, Kentucky, and like earlier crafts exponents such as Dr. Frost, he was deeply concerned about the devastated economy of rural Appalachia. In 1965 the Countses received federal funding for a

◄ SHROUD IV: OBSCENITIES

M. Joan Lintault. 1975. Carbondale, Illinois. Kwick print on satin, dye crayon. Hand pieced and quilted. 79 x 69 in. Collection of the artist.
This unsettling pieced Baby Blocks quilt, made partially in response to the horrors of the Vietnam War, presents printed images and lines from the classic children's ballad, "Cock Robin." Two other quilts from the *Shrouds* series were included in the traveling exhibition *The New American Quilt*, organized by the Museum of Contemporary Crafts in New York. The series was inspired by visual similarities Lintault observed between early American gravestone carvings and seventeenth- and eighteenth-century needlework samplers made by English schoolgirls.

training program in pottery for three local people; of that venture Counts said, "Should we not take up this admittedly thin thread of hope, then the possibility exists these people would have been cast out into the human junkyard—unemployment, uneducation—more poverty and more ignorance." After being introduced to local quiltmakers, the Countses decided to add quilts to the center's repertoire, and Charles began to design original tops which were executed and quilted by the local artisans. The resulting quilts were a unique composite of Counts's innovative, modern craft designs with the meticulous hand sewing and workmanship of the local traditional Georgia quilters. The linear designs of the quilt tops were based on the surface decoration that Charles applied to his pottery. Rising Fawn continued to

produce quilts into the mid-1970s; they were not seen by many other artists and, unlike Jean Ray Laury's quilts, had little or no influence on the direction of other's work. Although they are still little known today, Charles Counts's designs were far ahead of their time, and they remain utterly distinctive.

Another relatively unheralded early quilt artist is Joan Lintault. Lintault received a M.F.A. from Southern Illinois University in 1962, where she concentrated in ceramics, and then spent three years working as a crafts developer for the Peace Corps in Peru, where she assisted weavers, knitters, and dyers in improving the quality of their work and set up a craft cooperative. She began

making quilts in 1965 while working as a lecturer in ceramics and art fundamentals at the University of Hawaii. From the first, she drew on a wide range of historic and contemporary sources and techniques. She writes, "I never wanted to be a traditional quiltmaker. I wanted to use all the elements of art that I was taught by using thread as line, fabric as shape, and color as a painter. I could never understand why there was this deep prejudice against artists who used fabric and fiber. I still don't understand it."

After moving from Hawaii to California in the late 1960s, Lintault also began to collect quilts, which were then still virtually worthless. Many of her early prizes were discovered in the local Salvation Army store. Lintault's work was completely original from the start. Her *La Chola en La Colcha (The Woman on the Bed)*, which was made in 1966 and was included in Laury's book *Quilts and Coverlets*, places a larger than life-sized stuffed and padded figure against the backdrop of a traditional patchwork quilt top. The quilt is huge, measuring 9 feet, 14 inches tall by 7 feet 1/2 inch wide. As Laury noted, the figure, which also wears a dress made of patchwork, "appears to be both under the quilt and growing out from the surface." *Clouds*, from 1971, is a 36-inch by 13-foot-long series of stuffed silver lamé cloud forms that play across the pillow-like grids of four pieced and quilted poly/cotton surfaces, while *Dubious Information*, from 1972, presents a pair of eight-sided stuffed frames surrounding groups of almost (but not quite) identical pieced and quilted baby blocks. Her astonishing *Heavenly Bodies*, from 1979, presents twenty-five openwork blocks of Xerox-transferred photographs of naked women and babies in a variety of poses; the batted and quilted blocks are cut out around the body forms, leaving their centers completely open, and the whole is surrounded by a wide border punctuated by the image of a child with her arms wrapped around her own hunched knees.

Lintault has been a professor of art specializing in fibers and textile design at her alma mater since 1973 and has continued to make innovative and totally distinctive quilts through the years. She is a perfectionist who works deliberately. "As it was with my predecessors—the embroiderers, quilters, and lacemakers who worked with fabric and thread—time is not a factor when I work. I do not choose to reject a technique simply because it is laborious. I base my work on geological rather than TV time. I am obsessed with every colored spot of dye and how it looks next to another colored spot." Although her work is too idiosyncratic and diverse in approach to have influenced other artists directly, Lintault deserves to be recognized as one of the most consistent and original of all contemporary quiltmakers.

Therese May, whose work, like Joan Lintault's, was first championed by Jean Ray Laury, began making quilts just before finishing her undergraduate work in painting at the University of Wisconsin in the late 1960s. She says, "I simply began to sew, and I was also making some collages with torn paper of bright colors. When my children were small I finished my degree in painting and began making quilts for the beds. Soon I began using photographic images, and my quilts became art objects." May would project a slide onto a piece of paper and make a drawing based on the image. The drawing was used as a pattern for fabric, which was then cut into pieces and arranged in muffin tins. The pieces were rearranged on identically sized squares of muslin, resulting in eighty to one hundred pinned blocks of appliquéd patchwork. May finished the quilts with "a machine straight stitch around each piece and a satin stitch over that." One of these photographic quilts was a self-portrait called *Therese* that appeared in Laury's *Quilts and Coverlets* and began May's career as an art quilter. She developed an even more personal way of working in the 1980s that incorporated her painting background, and she has been one of the most visible and

highly regarded of quilt artists for many years. Her embellished and painted quilts, which draw on a whimsical private array of dreamlike figures and symbols, are at once instantly recognizable and inimitably her own.

At the same time that these and other pioneering quilters were moving away from traditional design, collectors and art historians began to recognize the importance of historic quilts as an American design tradition. In 1971 the Whitney Museum of American Art in New York presented *Abstract Design in American Quilts*, an exhibition that marked a turning point in the appreciation of the quilt. The show, organized by collectors Jonathan Holstein and Gail van der Hoof, drew on their unusual collection of quilts, which had been chosen strictly for their aesthetic interest. The quilts were hung on the museum's stark white walls like paintings, and the accompanying labels were modeled after art museum labels, offering only the piece's materials, place of origin, and approximate date. The emphasis of the show, then, was placed squarely on the visual impact of the quilts, and little effort was made to place them in any kind of historical context. The exhibition's approach was not entirely new—quilts had been hung at country fairs (and on wash lines) since at least the mid-nineteenth century and by collector Electra Webb at her Shelburne Museum since the late 1950s, and the Newark Museum had presented an exhibition of *Optical Quilts* in 1965. But museum display was new to most viewers and critics, and this was, after all, the Whitney Museum and New York City, not Newark, New Jersey, or Shelburne, Vermont. The Whitney was a fully sanctified showcase for American art, and the show carried enormous weight.

In his introduction to the catalogue for the exhibition, Robert Doty, the curator of the Whitney, made the show's parameters and intentions crystal clear: "This exhibition is not a comprehensive review of quilt making in America but rather a demonstration of inherent regard for a tangible form of visual satisfaction. Considerations of technique, geographical distinction and historic significance have been excluded in favor of visual content. Color, pattern and line take precedent over fabric, stitching and regional traits. The exhibition is devoted to pieced quilts because that technique produced a body of work notable for its strong visual qualities."

In his essay for the exhibition catalogue, Jonathan Holstein summarized his understanding of the achievement of American quiltmakers this way: "Quilt makers did in effect paint with fabrics, laying on colors and textures. In all periods there are to be found in pieced quilts both unique and conventional designs; within the framework of the latter each maker had full liberty in terms of colors, arrangements, sizes of the blocks and her own variations. So no two are ever alike; each reflects the sensibilities and visual skills of its maker. Moreover, it must be emphasized that the planning of these tops was in no sense haphazard. Even the simplest show the highest degree of control for visual effect. There was at work a traditional American approach to design—vigorous, simple, reductive, 'flat'—and a bold use of color which can be traced throughout American art. The best were valued aesthetically when they were made and have lost none of their power with passing time and fashions, exhibiting those extraordinary visual qualities which are ageless."

The Whitney show caused a sensation, turning heads wherever it was shown. It elicited glowing reviews from a host of major art critics who had never deigned to write about quilts before, and it was enthusiastically received by the public. For some viewers, the exhibition was a gratifying recognition of the quilt that was long overdue, but for most, it was an eye-opening revelation of the expressive power of a previously unexamined

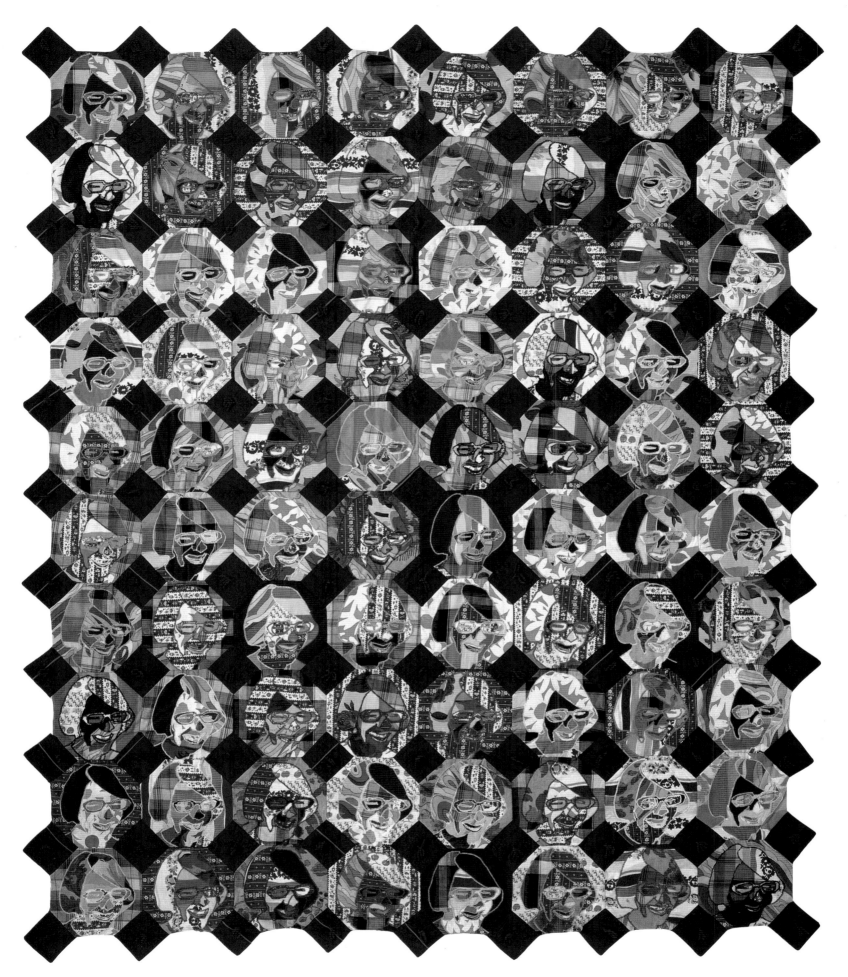

▲ **THERESE**

Therese May. 1969. San José, California. Cottons on muslin backing. Machine appliquéd, hand sewn, tied. 90 x 72 in. Collection of the artist.

Each block is based on a photographic image of the artist, which was traced onto eighty different fabrics. Each tracing was cut following the same lines, the resulting pieces then mixed and reassembled like miniature jigsaw puzzles before being appliquéd to the backing. No two blocks are the same.

medium. The response of Hilton Kramer in *The New York Times* typifies the critical take on the show: "The suspicion persists that the most authentic visual articulation of the American imagination in the last century is to be found in the so-called 'minor' arts—especially in the visual crafts that had their origins in the workaday functions of regional life. . . . For a century or more preceding the self-conscious invention of pictorial abstraction in European painting, the anonymous quilt-makers of the American provinces created a remarkable succession of visual masterpieces that anticipated many of the forms that were later prized for their originality and courage."

The show *Abstract Design in American Quilts* is cited by many of today's quilt artists as the beginning of their involvement with the quilt as an art form. It also set off an explosion of interest in collecting historic quilts, and started quilt values on a steady climb. The show proved seminal for four reasons: it asked that the quilts on exhibit be judged solely as works of visual art; it was presented by a major metropolitan museum of American art; the timing was right; and perhaps most important, it traveled extensively and was seen by thousands and thousands of viewers across the country. Holstein has been censured by feminists for divorcing the quilts from their historical context, for applying a traditional male-dominated sense of aesthetic value to a woman's art, for dismissing appliqué quilts as artistically inferior to pieced examples, and especially for his apparent lack of concern as a collector for the stories of the women who made the quilts, thereby marginalizing the makers by denying them their personal identities. There is some merit in each of these charges, although it must be said that Holstein freely admitted his biases in organizing the show. But even these negative responses to the show have helped to broaden public awareness and understanding of the importance of the quilt to American history and art. If nothing else,

Holstein's thesis has served as a flash point for other, perhaps more comprehensive approaches to the American quilt that have developed since.

Many who saw the Whitney show were inspired to try their hand at quiltmaking. However, in New England and many other parts of the country, quiltmaking had been moribund for at least a generation, and no one knew how to practice the craft. The new practitioners had to rely on the handful of older books still available on the craft of quiltmaking, most of them written during the previous revival, thirty or more years earlier. Dover Publications reprinted Ruby McKim's *One Hundred and One Patchwork Patterns* and Kretsinger and Hall's *The Romance of the Patchwork Quilt* in inexpensive paperback editions, and they became bibles of the budding movement.

Many of the new quiltmakers quickly found themselves teaching others what they had learned. Demand far outstripped supply in those early days; far more people wanted to learn than there were teachers to teach. Beth Gutcheon, who began teaching quilting in New York in 1971, quickly became the most prominent teacher on the East Coast. When Gutcheon advertised for students, she was astonished that no one asked about her credentials, only where to find her and when they could start. Quilt guilds sprang up like mushrooms all over the country as women banded together to share their knowledge and enthusiasm for the quilt and quiltmaking. This burgeoning network of local guilds sponsored teachers such as Gutcheon, Nancy Halpern, Michael James, and Nancy Crow, and enabled them to make a living, if not from their work, then from a pursuit intimately related to it. It also served as a connecting network for early non-traditional quiltmakers, who met each other through the guilds and recommended and supported each other as teachers and artists. Artists who had worked in isolation suddenly

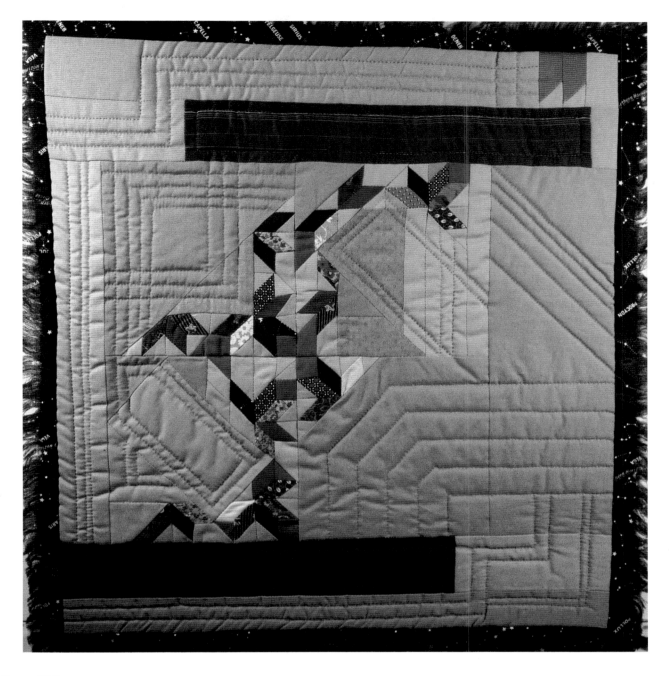

DAY LILY IV ▲

Beth Gutcheon. 1979. San Francisco, California. Cotton and cotton blends, polyester batting. Machine pieced, hand quilted. 25 x 23 in. Collection of Michael James.

This quilt is part of a suite of five identically sized variations on the traditional Carolina Lily pattern. The five small fringed quilts, which were originally intended to be hung together, move away from the pattern step by step until only a few "leaves" of the abstract lily are left, making Gutcheon's hand quilting the dominant design element.

discovered that they were not alone, and a creative synergy grew as the supporting network of innovative quiltmakers expanded.

In addition to their teaching, both Beth Gutcheon and Michael James also wrote influential books that promoted contemporary design. Gutcheon's *The Perfect Patchwork Primer*, published in 1973, was the most widely distributed and used of the new generation's how-to books. It reflected Gutcheon's populist, anybody-can-do-it approach and was aimed directly at the hobbyist quiltmaker, with plans for "more than 70 projects to make with patchworks—tote bags, wall hangings, coasters, mats, hot pads, skirts, vests, pillows, playpen liners, coffee-pot cozies, bibs, floor furniture, a traveling board game, cookbook covers, and other gifts, wearables and usables." While Gutcheon's book, like Jean Ray Laury's writings, was embraced by quilters of all stripes, Michael James's more technically

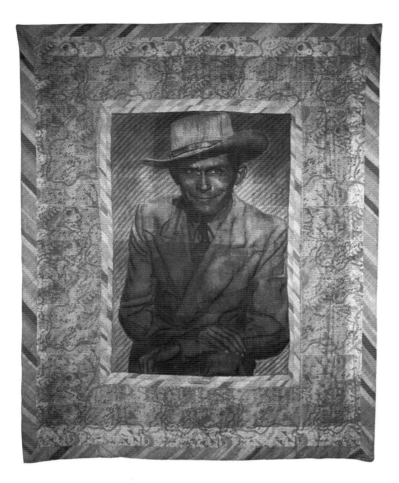

▲ **HANK WILLIAMS: BIGGER THAN LIFE**

Sandra Humberson. 1974. Baltimore, Maryland. Cotton, textile printing ink, polyester filling. Photo silk screened, hand dyed, hand and machine stitched. 100 x 80 x 3 in. Included in the exhibition The New American Quilt *at The Museum of Contemporary Crafts, New York.*

This Pop-art–influenced work places an enormous silk-screened photo of country music legend Hank Williams—the composer of such classic songs as "Your Cheatin' Heart" and "I'm So Lonesome I Could Cry"—at its center. The giant picture is framed with a series of pastel fabric borders, putting a modern twist on the traditional central medallion quilt format.

THE DENIM QUILT ▶

Teresa Barkley. 1972. Maplewood, New Jersey. Denim. Hand appliquéd, crocheted, and embroidered, hand pieced. 94 x 77 in. Collection of the artist.

Barkley was fourteen when she started this quilt, which was included in the seminal exhibition *The New American Quilt* at The Museum of Contemporary Crafts in New York in 1976. The idea for the quilt came from her great-aunt, who had made a denim quilt following instructions in a mid-1960s *Woman's Day* magazine. By the time Barkley began her own version, people from coast to coast were decorating their blue jeans with patches, and she decided to make her quilt with as many interesting patches as she could find. Included on the 396 four-inch squares that make up the quilt are flags, the signs of the zodiac, emblems from her school uniform, vacation souvenirs, military patches from her father's childhood collection, and a close friend's Girl Scout badges.

rigorous *The Quiltmaker's Handbook: A Guide to Design and Construction*, which was first published in 1978, served as the how-to text for the growing art quilt movement. Reflecting James's art school training, his book set out to provide a thorough textbook for contemporary artisans. Many of today's quilt artists cut their eye teeth on the book. It was followed by a second volume in 1981, subtitled *Creative Approaches to Contemporary Quilt Design*. In addition to James's own work, the second volume included photos and careful analyses of quilts by Nancy Halpern, Beth Gutcheon, Radka Donnell, Nancy Crow, Francoise Barnes, Katie Pasquini, and other contemporary artists.

Public exhibitions, of course, also played a major role in the development of the art quilt, by offering both artists and audiences an opportunity to view and judge new works and validating innovative approaches to the quilt. The earliest shows highlighting the works of non-traditional quilters took place in the 1970s. On the West Coast, quilt historian Joyce Gross organized the first of a series of annual exhibitions that included non-traditional work in 1972, and in the East, a number of important early exhibitions took place in the Boston area, which was a hot bed of non-traditional quilting activity. In addition to their aforementioned Harvard University show, Radka Donnell, Molly Upton, and Susan Hoffman also were part of *Bed and Board*, an exhibition of work by contemporary woodworkers and quilt artists. Organized by The DeCordova Museum, a museum of twentieth-century American art in Lincoln, the show ran from June to September 1975 and also included work by Charles Counts, Lenore Davis, Beth Gutcheon, Jeffrey Gutcheon, Sas Colby, Elsa Brown, and Elizabeth Gurrier. In the catalogue, museum director Frederick P. Walkey noted, "The [quilt] field was far more fertile than we had imagined, [ranging] from variations on traditional designs to humorous and provocative images drawn from [such] unlikely inspirational sources

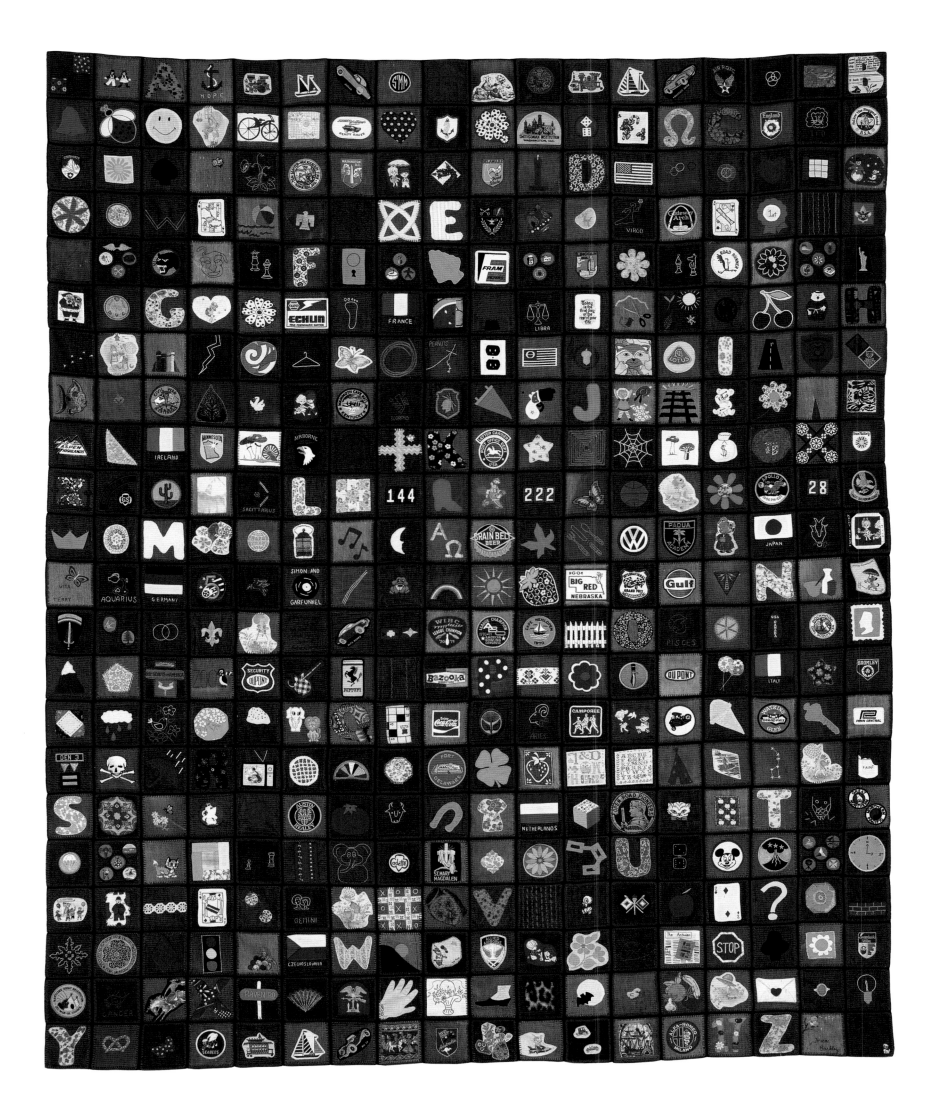

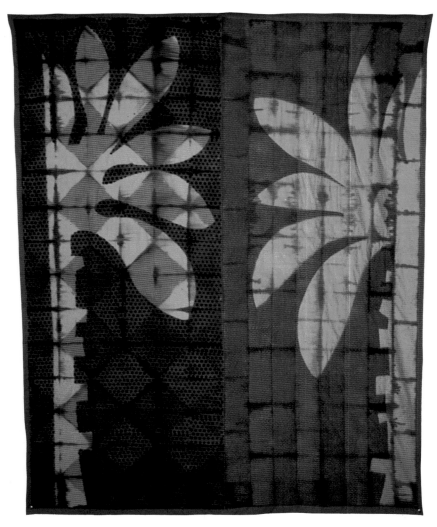

▲ **PANCAKES, BUTTER, AND SYRUP QUILT**

Ros Cross. 1973. Polyester/cotton, bonded polyester filling. Machine appliquéd. 106 x 96 in. Included in the exhibition The New American Quilt *at The Museum of Contemporary Crafts, New York.*
This tongue-in-cheek quilt, reminiscent of the soft sculptures of Pop artist Claus Oldenburg, is mounted over a wooden platform; syrup slides off the unseen proper right side of the quilt onto a huge slice of fabric bacon.

▲ **DOUBLE PALM**

Katherine Westphal. 1972. Berkeley, California. Cotton. Stenciled, blocked, quilted. 99 x 78 in. Included in the exhibition The New American Quilt *at The Museum of Contemporary Crafts, New York.*
Westphal was a pioneer in modern textile surface design techniques. This early stenciled and blocked quilt places two large palm trees against repeating geometric patterns of different color and form.

as gravestone rubbings, television commercials, and even the butterfly." Michael James, who was teaching quiltmaking at the museum at the time, also participated; he says the show made him aware of the work of other artists for the first time and recalls that his own quilts seemed rather traditional in comparison to those of other exhibitors.

In November 1975 the Boston Center for the Arts unveiled *Quilts '76*, an exhibition organized for the Bicentennial. The unjuried show, held in the cavernous Cyclorama building downtown, included 173 quilts by 163 artists representing a wide range of traditional and contemporary styles, techniques, approaches, and abilities. The show

provided a showcase for the Boston area's many non-traditional quiltmakers, including James, Donnell, Halpern, and Sylvia Einstein; their work was a revelation to some of the Boston art critics who saw and reviewed the show as well as to many attendees, especially other quilters. "The sense of excitement and discovery was palpable in those days," Nancy Halpern says with some sentiment. A particularly informed review by Jane Holtz Kay in the alternative *Real Paper* noted, "[The show is] a real mixed bag—there are single creators and communal ones, designs that are syrupy coy and some as stunning as any of the abstractions of the hour. Quiltmaking is not simply design in fabric, but a new art form: the needle is no quick substitute for the brush and the quilt for all its charms no facile switch from the canvas. With all the

drama and decorative strength here, then, there are perhaps only a dozen quilts that connect in quite the right way or linger in the mind long enough to define themselves as a fusion of fine art and fine craftsmanship. But that is probably enough for now. There is a takeoff if not a soaring here."

Also in 1975, the innovative "quilted tapestries" of Molly Upton and Susan Hoffman were first presented by the Kornblee Gallery on 57th Street in Manhattan. Upton and Hoffman were among the first to dare to invite comparison of their work with other forms of contemporary art, and to ask art world prices for it. Their extremely ambitious work set high standards of aesthetic quality alongside an uncompromising vision of its own value and importance.

Both women were self-taught as quiltmakers. Hoffman began making quilts she was still in high school. She initially followed traditional patterns, but as her hobby grew into a full-time obsession in the early 1970s she began designing her own. In 1974 she made a breakthrough, creating overall abstractions by tearing fabric into strips and laying

▼ **WATCHTOWER**

Molly Upton. 1975. Bedford, New Hampshire. Cotton, wool, crepe, rayon, velveteen. Machine pieced, hand quilted. 90 x 110 in. Included in the exhibition The New American Quilt *at The Museum of Contemporary Crafts, New York.*
This pictorial quilt presents a complex geometric abstraction of natural forms built almost entirely from right-angled shapes in a wide range of sizes. Upton also thoughtfully juxtaposed five different types of material, drawing on each fabric's unique visual qualities to suggest depth and help differentiate foreground from background.

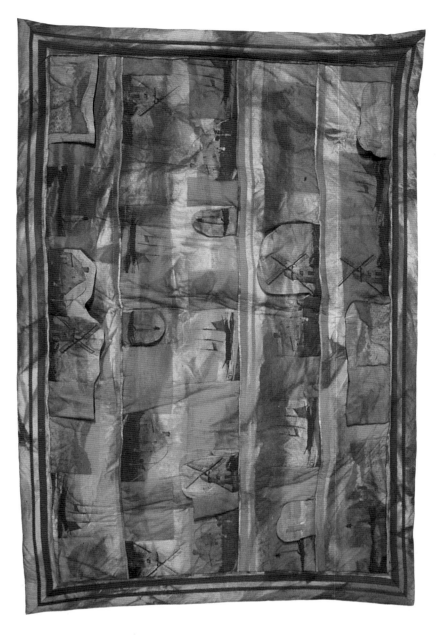

◄ DREAM QUILT: NANTUCKET'S POP-UP LANDSCAPE

Wenda F. von Weise. 1975. Gates Mills, Ohio. Cotton, dacron filler. Photo silk-screened with dyes, hand quilted. 92 x 60 in. Included in the exhibition The New American Quilt *at The Museum of Contemporary Crafts, New York.*
The late Wenda F. von Weise specialized in the use of ethereal, dreamlike photographic images. This example of her work combines screened images of Nantucket, including a sailing ship, a saltbox house, a dirt road, a lighthouse, and a windmill.

Upton and Hoffman initiated their artistic partnership with "The Pair Collection," in which each made a quilt on a particular theme (plants or the use of black and white fabric were among the choices), and the resulting pair of quilts was exhibited together. After this experimental collaboration, they worked separately and in a wide range of styles, from stunning pictorial realism to complete abstraction. Whatever the style, both women approached the quilt surface "whole"-istically, creating painterly "canvases" rather then employing the grid and unit structure that is the basis of traditional quiltmaking.

them out on the floor in a way that she describes as "gestural." Hoffman's longtime friend Molly Upton made her first quilts that same year; she immediately applied her art school training to the medium, approaching quilting as an expressive art form fully as valid as painting, dance, or music, rather than as a traditional craft. A unique synergy developed between the two young women; they pushed each other constantly by drawing on an eclectic range of artistic interests and concerns, most of them far removed from traditional quilting. Hoffman recalls studying Josef Albers's book on color theory intensely, and cites the music of Bach, Abstract Expressionist painting, Navajo weavings, Japanese Noh robes, Bauhaus theory and architecture, Pierre Bonnard, Paul Klee, Joseph Cornell, and Kurt Schwitters as among her influences.

Like the quilts of their friend Radka Donnell, the extremely wide-ranging mid-'70s work of Upton and Hoffman marks a distinct break with the methods and imagery of the traditional quilt. Where other quilters were moving away from the traditional quilt one step at a time, seeing how far they could push the quilt format while still remaining connected to historical precedent, Hoffman and Upton largely ignored the rules and the assumed limitations of traditional quilting and simply leapt forward. For many of the other early non-traditional quilters, their work was a stunning revelation of the quilt's promise and possibilities. Nancy Halpern, who is an ardent admirer of Upton's work in particular, says, "For me, her quilts are like those Olympic gymnasts, defying all laws of both human anatomy and physical gravity."

FALLS ISLAND/REVERSING FALLS ▶

Nancy Halpern. 1977–79. Natick, Massachusetts. Cottons and cotton blends. Hand pieced and quilted. 84 x 84 in. Collection of the artist.

After piecing this quilt's top, Halpern found she could not figure out how to quilt curves against straight lines to suggest the movement of wind, water, and fog. In 1979, Halpern happened on a solution when her friend and quilting colleague Rhoda Cohen took her to visit New Hampshire glassblower Dudley Giberson. The fluid striations in Giberson's glass and the eddies along the Reversing Falls between Cobscook and Whiting bays in Maine influenced Halpern to flip the quilt over, draw lines freehand on its back, and then quilt back to front. She notes, "The look of this [style of] quilting has [since] become so popular it's now almost a cliché."

MAINE QUILT ▶

Rhoda Cohen. 1977. Weston, Massachusetts. Cottons and blends. Hand pieced and quilted. 102 x 72 in. Collection of the artist.

This large, strip-pieced landscape quilt was included in the first *Quilt National* exhibition in 1979. Rhoda Cohen has been an influential force among Massachusetts non-traditional quilters since the early 1970s. Here she uses carefully chosen, irregular shapes of fabric to suggest the modulations of land forms.

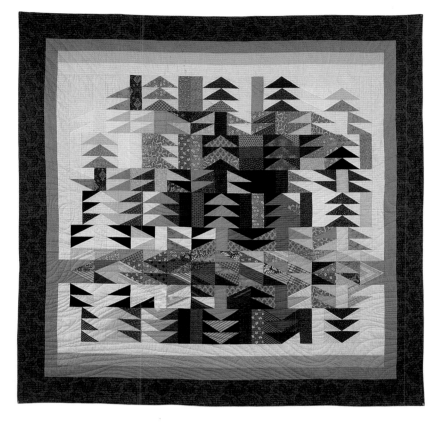

Tragically, Molly Upton took her own life in 1977. She was not yet twenty-five. Twenty years after her untimely death, her quilts are still remarkably powerful and fresh. Although devastated by Upton's death and almost inevitably shadowed by it, Susan Hoffman remained active through the mid-1980s. She currently works creatively as a freelance floral designer and hopes to become involved in quiltmaking once again. Like Upton's, Hoffman's strong, original work deserves far more recognition than it has received.

In 1976 the Museum of Contemporary Crafts in New York, now The American Craft Museum, presented *The New American Quilt*, the first major museum exhibition of non-traditional quilts. The museum advertised widely for entries and reviewed works by over three hundred artists, "all of whom," stated the museum's director, Paul Smith, "are doing highly accomplished work. It was obviously impossible to include all the

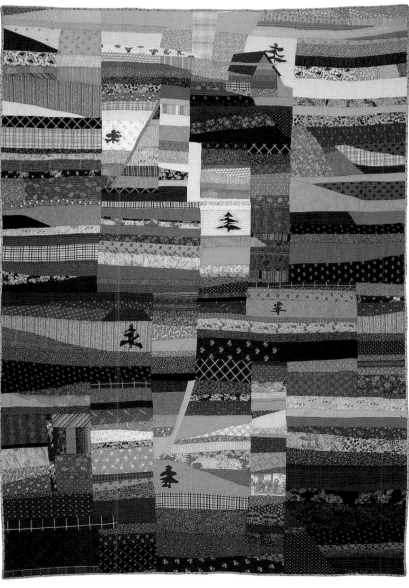

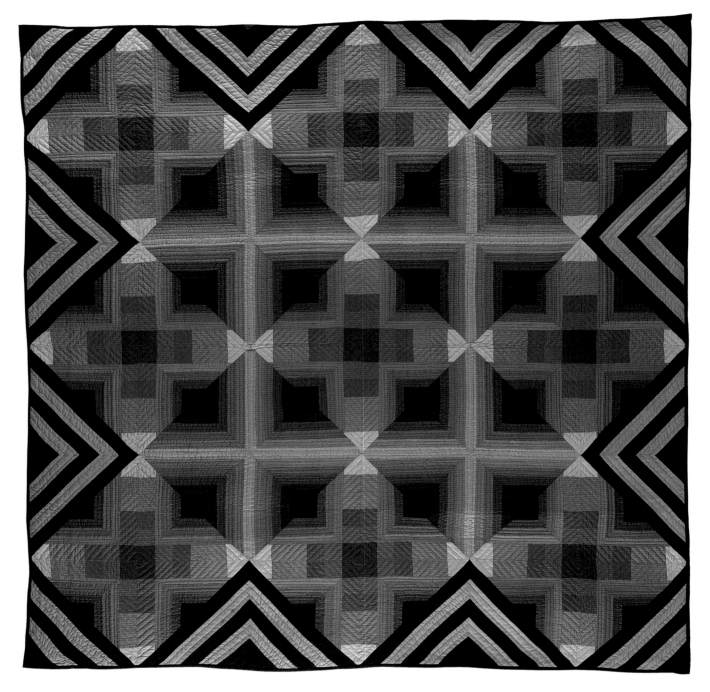

◄ **CROSSES**

Nancy Crow. 1976. Baltimore, Ohio. Cottons. Machine pieced, hand quilted by a group of Holmes County, Ohio, Amish women. 96 x 96 in. Collection of Ardis and Robert James. This large (eight-foot-square) and powerfully graphic piece is one of the first quilts made by Nancy Crow. The pattern is an original Log Cabin variation bordered with Crow's adaptation of a Roman Stripe design.

outstanding examples of quiltmaking; therefore our emphasis in making selections was focused on innovation and new directions." Among the artists whose work was selected were Radka Donnell, Elizabeth Gurrier, Susan Hoffman, Molly Upton, Duncan Slade and Gayle Fraas, Helen Bitar, Wenda von Weise, Sandra Humberson, Teresa Barkley, Lenore Davis, Katherine Westphal, and Joan Lintault. Exhibition curator Ruth Amdur Tanenbaum noted in the catalogue, "No longer relegated to a purely utilitarian role, these contemporary examples of a traditional American craft place form over function. Many of these pieces are characteristic of soft sculpture in their three-dimensionality. Unique themes and the application of new materials and techniques distinguish the present from the past. The use of photosensitized cloth, tie-dye, silk screen, and batik permit the quilter to achieve strong personal statements through bold graphic treatment."

These early exhibitions of non-traditional quilts, however, proved the exception rather than the rule. The new works were just too strange, too radical and innovative for the highly conservative world of the traditional quilt to accept. Although the number of quilt exhibitions increased every

year, very few highlighted art quilts, and by the late 1970s many art quilters were feeling frustrated by the lack of showcases for their work. Their innovations made their work unwelcome at many traditional quilt shows, where they were all too often relegated to a corner and marginalized, and their only other available option—showing at mixed-media fiber art shows, alongside baskets, weavings, rugs, and other textiles—did not provide the clarity of focus they sought. The non-traditional quilt had outgrown its origins. It needed its own place to stand.

Quilt National, the first ongoing juried exhibition of non-traditional quilts, was initiated in 1979 and has been held every other year since. The exhibition was conceived and organized by quilters Francoise Barnes, Nancy Crow, and the late Virginia Randles and was shown at the Dairy Barn in Athens, Ohio, a former farm barn that had been renovated into a cultural arts center. The first Quilt National presented 56 quilts by 44 artists, chosen from a field of 390 quilts by 196 individuals. Only one of the entrants was not American. In addition to works by Randles, Crow, and Barnes, the first show included quilts by Radka Donnell, Beth Gutcheon, Nancy Halpern, Rhoda Cohen, Cynthia Nixon-Hudson, Tafi Brown, Terrie Hancock Mangat, Chris Wolf Edmonds, and Joyce Marquess Carey, as well as an invitational work by Michael James, who was one of the show's jurors. In a flyer accompanying the show, Gary J. Schwindler, Associate Professor of Art at Ohio University, stated: *"Quilt National '79* demonstrates eloquently two important phenomena characteristic of the contemporary American art scene. First, there is increasing prominence of the so-called 'crafts' within the broad spectrum of the plastic arts; and second, quilting in particular is emerging as a vital category of the fiber arts and possesses enormous expressive potential. American quilt making is now at a stage of experimentation and development as it prepares to take its place as a major form of artistic endeavor."

Quilt National has been the most important ongoing forum for the art quilt since its inception, and has premiered the work of such major artists as Terrie Mangat, Pamela Studstill, and Susan Shie. It is judged by a three-person panel, usually made up largely, if not entirely, of recognized quilt artists. A full-color catalogue is produced of each year's winners, and a smaller, traveling exhibition is organized after the Dairy Barn showing closes. The event has grown steadily; the most recent competition, Quilt National '95, drew 1230 entries from 613 artists in forty-four states and thirteen foreign countries. Eighty quilts by 80 different artists were chosen by the jurors, including works by artists from Mali, New Zealand, the Netherlands, England, Australia, and Switzerland.

CRAZY QUILT ▶

Jean Ray Laury. 1981. Clovis, California. Machine-sewn cotton fabrics. 60 x 60 in. Collection of the artist.
This is an excellent example of Laury's uncanny ability to breathe new life into an old idea. Here she modernizes the crazy quilt by working it in contemporary fabrics and colors.

Selections from the 1995 Dairy Barn exhibition traveled to over twenty museums, galleries, and art centers around the country after leaving Athens in September 1995.

In the 1980s the art quilt was also given a tremendous boost by the late San Francisco quilt dealer Michael Kile, the co-founder of the highly influential journal *The Quilt Digest*. This seminal publication set a new standard for quilt scholarship; it was also beautifully produced, presenting quilts in better, sharper color than ever before. Reflecting Kile's interests, *The Quilt Digest* drew no distinctions between old and new quilts; it showcased and championed work by emerging artists alongside great historic discoveries, and did much to validate and publicize the accomplishments of leading contemporary artists.

Soon after launching *The Quilt Digest* in 1983, Kile teamed with curator and writer Penny McMorris to organize *The Art Quilt*, a catalogued traveling exhibition of brand new works by sixteen artists they considered trailblazers in the field. McMorris brought substantial credits to the enterprise; she had organized shows including non-traditional quilts as early as 1976 and also served as host and producer of two PBS series on quilting that were televised nationally in 1981 and introduced viewers to the work of many new and innovative artists. Kile and McMorris were the first to use the term *art quilt* to describe the work of these modern quiltmakers. McMorris recalls, "Michael and I were talking on the phone one night about what to call the book and exhibition we were working on, going through all kinds of possible variations such as 'Quilted Art,' 'The Art of the Quilt,' 'The Quilter's Art,' etc. When we said the words 'Art Quilt' it felt right, as the briefest titles usually do. Up until then we had never heard the term used; since then I've come across it used back at the turn of the century." The name felt right to quilt artists as well, and it soon became the generic term for the genre.

The Art Quilt, which opened at The Los Angeles Municipal Art Gallery in September 1986 and traveled to seven other sites over its three-year run, was even more influential than *The Quilt Digest* in bringing attention to the works of non-traditional

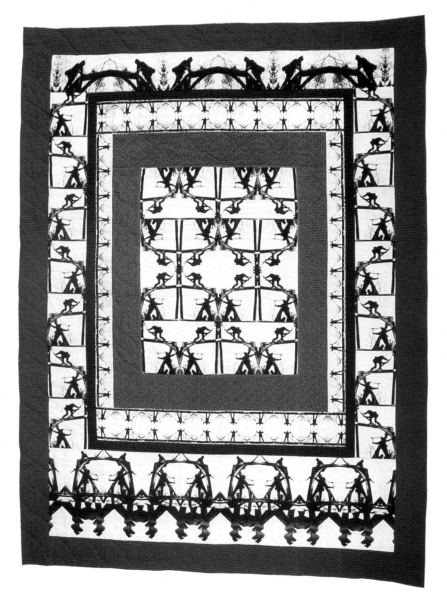

◀ **ROCKINGHAM RAISING: SLING**

Tafi Brown. 1979. Alstead, New Hampshire. Cyanotype prints on cotton, commercial cottons, cotton batting. Machine pieced, hand quilted. 95 x 66 in. Photographic collection of Georgia Power Corporation.

Brown designed timber frame buildings for over twenty years, and her cyanotype "blueprint" images of timber frames form the basis of many of her quilts. This piece is one of a series of ten made from photographs taken during the raising of a saltbox in Rockingham, Vermont. She explains, "Four of the five images have to do with releasing rigging (the sling and come-a-long) after a bent has been raised. The fifth is a detail of the teardrop on the frame."

FLOWER POWER ▶

Helen Bitar. 1976. Portland, Oregon. Cottons, satins. 56 x 56 in. Collection of the artist.

Bitar's innovative mid-'70s work is cited as an early source of inspiration by several quilt artists. This typically vibrant and cheerful block-style quilt offers sixteen completely original floral designs set within a colorful patchwork border. Bitar, who no longer makes quilts and has turned her creative attention to gardening, says she loved making up her own flowers in this piece.

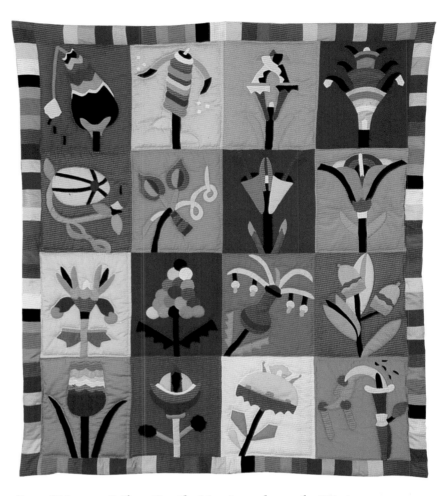

quilters. As the first major curated exhibit of its kind, *The Art Quilt* defined the cutting edge of the new movement and identified its leading practitioners. By limiting the exhibit to twenty-five works by a select group of artists (including Yvonne Porcella, Michael James, Nancy Crow, Jan Myers-Newbury, Jean Hewes, Joan Schulze, Pauline Burbidge, Therese May, Pamela Studstill, Terrie Mangat, and Fraas and Slade), Kile and McMorris gave a cohesion and clarity of focus to the non-traditional quilt that *Quilt National* could not provide. The catalogue, the first extensive scholarly exposé on the new art form, declared, "The art quilt has emerged, and it heralds a dramatic and fundamental change in the history of quilts. It is art for walls, not beds, created by artists abandoning media like painting, printmaking and ceramics to express themselves in original designs of cloth and thread."

Over the past ten years, the art quilt movement has continued to gain momentum and now, in the waning years of the twentieth century, seems to be reaching some sort of critical mass. After nearly thirty years of growth, the art quilt has proved its staying power and is finally making inroads into the world of fine art. A significant number of artists have developed original styles and created consistent bodies of work. Solo and group exhibitions of art quilts have proliferated. Dozens are now held each year throughout the United States and around the world. Beginning in 1987, *Quilt National* was joined by a second major juried exhibition called *Visions*, organized by Quilt

San Diego. Like *Quilt National*, each *Visions* offers an accompanying catalogue and ancillary traveling exhibition and provides an important focus for art quilters. Since 1990, its opening exhibition has alternated years with *Quilt National*. Studio Art Quilt Associates, a non-profit advocacy group, was founded by Yvonne Porcella in 1989, and has done much to advance awareness of the medium among collectors, curators, and critics. Learning opportunities for quiltmakers have also vastly expanded and improved, led by Nancy Crow's and Linda Fowler's annual two-week Quilt Surface Design Symposium, which was inaugurated in 1989. The 1996 session, for example, offered forty-five courses by over thirty teachers in topics ranging from compositional planning and alternative construction techniques to the use of dyes, paste resists, and paper and fabric collage.

Art quilts have entered the permanent collections of such major public art institutions as the High Museum in Atlanta, the Newark Museum, The Philadelphia Museum of Art, the Los Angeles

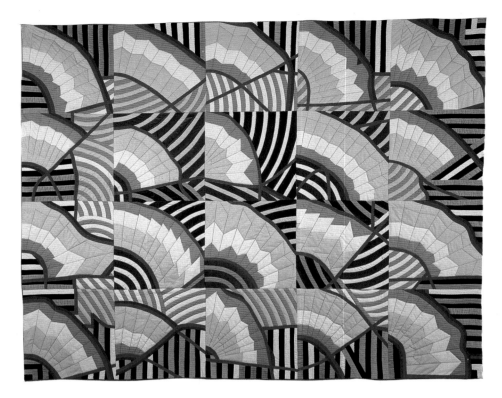

▲ CEDAR BOX FAN CLUB (FRONT AND BACK SIDES)

Nancy Gipple. 1981. Afton, Minnesota. Cotton and cotton blend fabrics, broadcloth, velveteen, corduroy, Mountain Mist batting. Machine pieced, constructed, and quilted, with some hand finishing. 74 x 92 in. Collection of the artist.
This double-sided quilt was created shortly after the death of Gipple's grandmother, who had kept a cedar box full of personal mementos in her attic. Gipple explains, "When she showed [the box's] contents to her four grandchildren, we got a tour of some of the special times in her life. As we listened to her stories, we all wondered what things would be like in our own lives. How would our cedar boxes be similar to and different from [hers]?"

County Museum, and the M.H. deYoung Museum in San Francisco in recent years, in addition to those of the country's two most prestigious "craft" museums, The American Craft Museum and the Smithsonian's Renwick Gallery. In 1995 the Renwick premiered *Full Deck Art Quilts*, a catalogued exhibition of fifty-four quilted playing cards by a like number of artists. The *Full Deck* project was conceived by art quilter Sue Pierce and organized by SITES, the Smithsonian Institution's Traveling Exhibition Service. The show gives the art quilt its most accessible and easily digestible public outlet ever; it has proven tremendously popular and remains on national tour at this writing. Later in 1995, the Renwick offered *Improvisational Quilts* by Nancy Crow, its first solo exhibition of art quilts, and an ambitious new periodical, *Art/Quilt Magazine*, was launched by quilter Lynn Lewis Young, offering quilt artists a regular printed forum all their own.

As the millennium approaches, the art quilt is, perhaps, poised to move decisively beyond its own, often too self-referential, world. In the years to come, it may at last find the public and critical attention and acceptance it has sought since its earliest days. It still has many obstacles to overcome, some external, others at least partly of the movement's own creation, and many personal and artistic growing pains to endure as it strives to become an acknowledged part of the larger art world. Whatever their future recognition and achievements may be, however, the art quilt's brightest and best proponents are unlikely to rest on their laurels, but will instead keep pushing forward, driven by their insatiable creative desires. As Jean Ray Laury puts it, "I don't know whether an artist ever feels really successful. Nothing is ever really complete. There's always something else you need to try, some idea of where you'd like to go next."

▲ **RUTH FRESNO'S DREAM**

Linda MacDonald. 1982. Willits, California. Cottons, polyester batting. Hand and machine sewn, hand quilted. 82 x 82 in.
The American Craft Museum, New York.
This outstanding example of MacDonald's early geometric work was included in The American Craft Museum's traveling exhibition *Craft Today*. The elaborate hand quilting emphasizes three-dimensional forms and curvilinear shapes and was intended to stand alone as a design element.

▲ **CONSTRUCTION WITH POLISHED ORANGE (ORANGE CONSTRUCTION)**

David Hornung. 1982. Saratoga Springs, New York. Cottons and polished cottons. Hand appliquéd, machine pieced and quilted. 68 x 55 in. Collection of Michael James.

Hornung is an abstract painter who made a number of truly remarkable quilts in the 1970s and 1980s, but has unfortunately given up quiltmaking. He currently teaches at the Rhode Island School of Design and at Pratt Institute in New York, where he now lives.

▲ RABBITS DANCING UNDER JUPITER

Nancy Erickson, 1980. Missoula, Montana. Cotton, velvet, satin, acrylics. Hand sewn, appliquéd, quilted, and painted. 45 x 88 in. Museum of Missoula, Missoula, Montana.
Like most of Erickson's work, this piece is based on drawings of animals, in this case a pet rabbit. She says that since exhibiting this and other rabbit pieces several people have confirmed her observations of their dances.

CRYSTAL MOUNTAIN ▶

Jeffrey Gutcheon. 1977–78. Puyallup, Washington. Cottons, poly-cottons, rayons, poly-rayons, brushed corduroy, nylon grillcloth. Machine and hand pieced, appliquéd and reverse appliquéd, hand quilted. 571/2 x 431/2 in. Private collection.
Through his teaching and writing, Jeffrey Gutcheon was instrumental in popularizing modern approaches to quilt design during the 1970s and 1980s. This quilt is the first Gutcheon made employing "Diamond Patchwork," an influential isometric pattern technique that he invented, taught widely, and eventually wrote a book about. The Crystal Mountain was the site of a Tibetan monastery in Peter Matthieson's book *The Snow Leopard*, and the pattern here represents the book's elusive monk perched on a Himalayan ledge. Gutcheon, who is also a professional musician, explains that Diamond Patchwork "imposes flat patterns on a matrix that is three-dimensional in appearance. I like that ambiguity. It's sort of like playing triplets over 4/4 time, which is the essence of rock 'n roll."

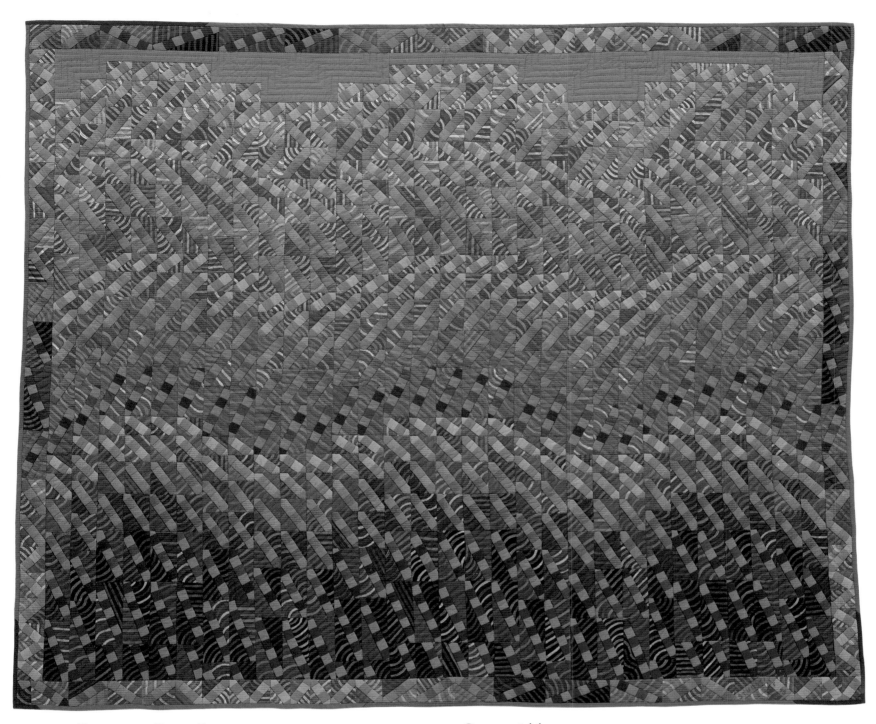

◀ RED AND BLUE JAR

Judith Larzelere. 1984. Belmont, Massachusetts. Commercial cotton cloth. Machine strip-pieced, machine strip-quilted. 72 x 48 in. Collection of Ardis and Robert James.

Red and Blue Jar is based on a greatly enlarged Log Cabin block. Its two differently colored sections were constructed separately; the quilt's dramatic jar-like form did not appear until the sections were joined, and came as a complete surprise to the artist.

▲ QUILT #44

Pamela Studstill. 1985. Pipe Creek, Texas. Hand-painted cottons. Machine pieced, hand quilted by Bettie Studstill. 54 x 64 in. Collection of Martha and Pat Connell.

This early quilt by Studstill, in which rippling, pulsating ribbons of color are set within a thin outer border, demonstrates an already fully formed mastery of original pieced design. The composition was inspired by waving roadside grasses.

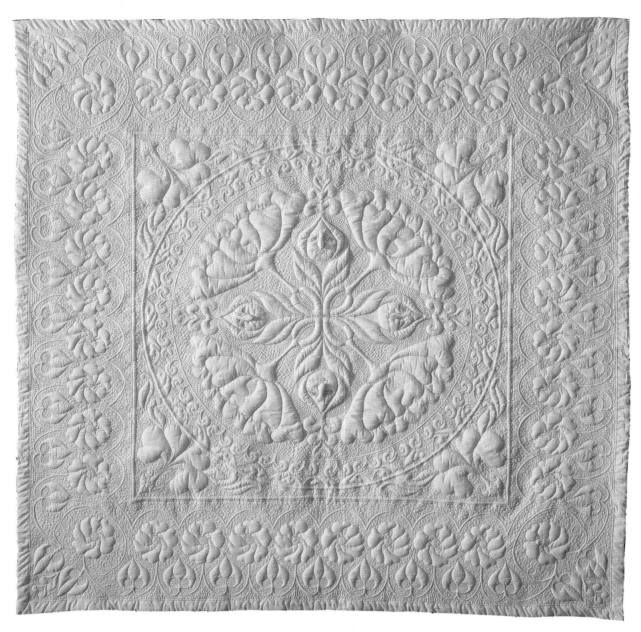

◄ THE LADIES ARE IN THE GARDEN

Elizabeth Gurrier. 1983. Hollis, New Hampshire. Unbleached muslin, polyester batting and fill. Machine quilted, hand embroidered. 58 x 58 in. Collection of Michael James.

Gurrier participated in many of the seminal exhibitions of non-traditional quilts in the 1970s. Her unusual sculptural quilts, which typically feature charming stylized human faces and large-scale floral motifs, recall the white-on-white stuffed-work trapunto quilts that were popular in the early decades of the nineteenth century as well as early New England gravestone carvings. This quilt's surface is covered with very tightly spaced and complex machine "meander" quilting, a technique that has only recently been taken up by other artists.

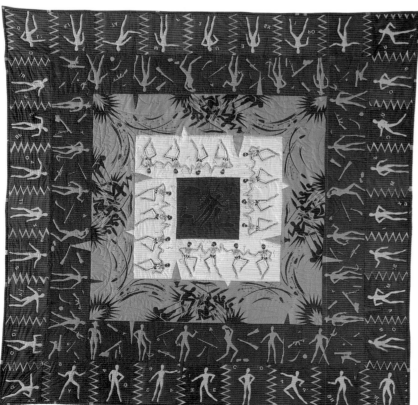

◄ BORDER WARS

Katherine Knauer. 1985. New York, New York. Cottons, paint, beads. Stenciled, airbrushed, hand and machine quilted, embroidered, beaded. 84 x 84 in. Collection of the artist.

Knauer explains, "Read from the outer band into the center, the story is as follows: First, one can see an argument taking place across a boundary; in the second band, the parties have taken up arms; in the third, they are engaged in combat which leads to their deaths, depicted in the fourth band. The angel in the center observes the perpetual folly of mortals."

SNOWING IN THE WHITES ▶

Nancy Crasco. 1986. Brighton, Massachusetts. Commercial cottons and cotton blends, fiberfill batting. Strip-pieced by machine, hand quilted. 45 x 70 in. Collection of the artist.
This quilt is an impressionistic study of snow among birch trees in the White Mountains of New Hampshire. Crasco comments: "I had a sense of the light snow falling in planar sheets as I moved through it. The sensation of passing tree trunk after tree trunk, branches bare to the clouds, added to the sensation of falling sheets of weather." Crasco was a founding member of the Quilter's Connection in Arlington, Massachusetts, a progressive guild that has fostered the work of area art quilters for over twenty years.

▼ BLOODROOT

Ruth McDowell. 1986. Winchester, Massachusetts. Cotton, cotton/polyester blends, velvets, upholstery and drapery fabrics, cotton thread, polyester batting, polyester interfacing. Machine pieced, hand appliquéd, hand quilted. 70 x 114 x 7 in. New England Quilt Museum, Lowell, Massachusetts.
McDowell is one of a handful of quilt artists who have steadfastly concentrated on nature themes over the years. This three-dimensional study of a common New England spring wildflower was commissioned by the New England Quilt Museum, which has mounted many shows of art quilts since it opened to the public in 1987.

▲ SHRINE TO THE BEGINNING

Terrie Hancock Mangat. 1973–88. Cincinnati, Ohio. Cottons, oil on canvas, embellishments. Hand painted and embroidered, hand pieced and appliquéd, hand quilted by Sue Rule. 101 x 96 in. Collection of the artist.

Hancock describes this quilt as a record of her early years and also of her development as a quiltmaker. She began work on the quilt when she was first married at age twenty-two and carried "the little cloth parts" in a box through five moves and the birth of two children before it was finished fifteen years later. She comments: "[*Shrine to the Beginning*] started out to be a map of Airdrie Farm (the home of the past governor of Kentucky), where we had a gardener's cottage while my husband went to medical school. When I finished the quilt I put my husband (painted oil on canvas) and myself (pieced and embroidered) as the occupants of this shrine. There are the sheep and sheep barn which later became the Foal Barn. There is a stone arch and huge morning glories painted oil on canvas and stitched on with embroidery thread. I finished this just about the time the marriage ended."

DISCUSSING PLANTS FOR THE FUTURE ▶

Deborah Felix. 1985. Oakland, California. Canvas and cotton blends, textile paints. Hand painted and rubber stamped, hand appliquéd, hand and machine quilted, signed in reverse appliqué. 69 x 90 in. Collection of the artist.
Felix is best known for her colorful figural work, which usually combines appliqué and hand painting. This quilt was included in the traveling exhibition *The Art Quilt.*

▲ SUBWAY GRAFFITI #3

Faith Ringgold. 1987. Englewood, New Jersey. Acrylic on canvas framed with pieced tie-dyed fabrics. 60 x 84 in. Collection of the artist.
Ringgold is a renowned African-American artist, storyteller, feminist, and activist who has worked in a wide range of media since the 1960s, creating sculpture, dolls, masks, performance pieces, and books for children in addition to quilt-framed paintings on unstretched canvas like this example. This diversely peopled story quilt was inspired by a trip to Japan.

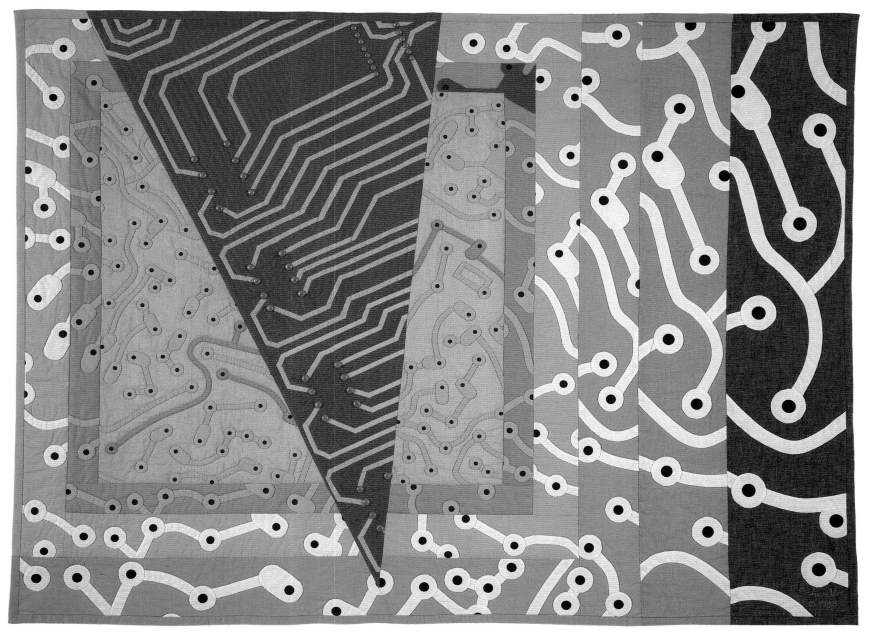

▲ **PCB BOP**

Robin Schwalb. 1988. Brooklyn, New York. Cotton fabrics, some stenciled, metal studs. Machine pieced, hand appliquéd, hand quilted. 41 x 55 in. Collection of the artist.

Schwalb explains that her inspiration for this quilt was "both sublime and ridiculous: a combination of an Edward Weston photograph and the sweat stains on Joe Cocker's brocade shirt during a rousing 1987 performance." The design evolved into patterns that recall those of PCBs (the printed circuit boards of computers). *PCB Bop* won the *Quilt National '89* Award of Excellence.

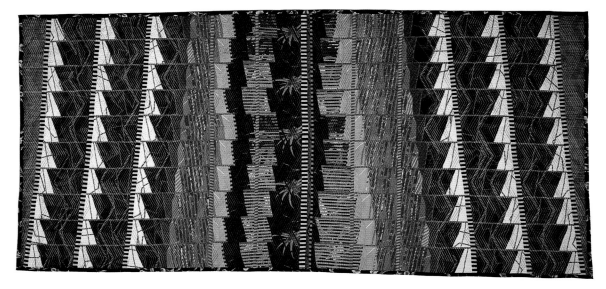

◀ **YUCATAN**

Veronica Fitzgerald. 1986. Andersonville, Tennessee. Silk and cotton. Machine pieced, hand quilted. 85 x 168 in. Collection of the artist.

Fitzgerald is a biochemist who created a handful of the most distinctive and original pieced quilts of the 1980s. An untitled companion to this typically enormous but minutely detailed piece was included in the traveling exhibition *The Art Quilt.*

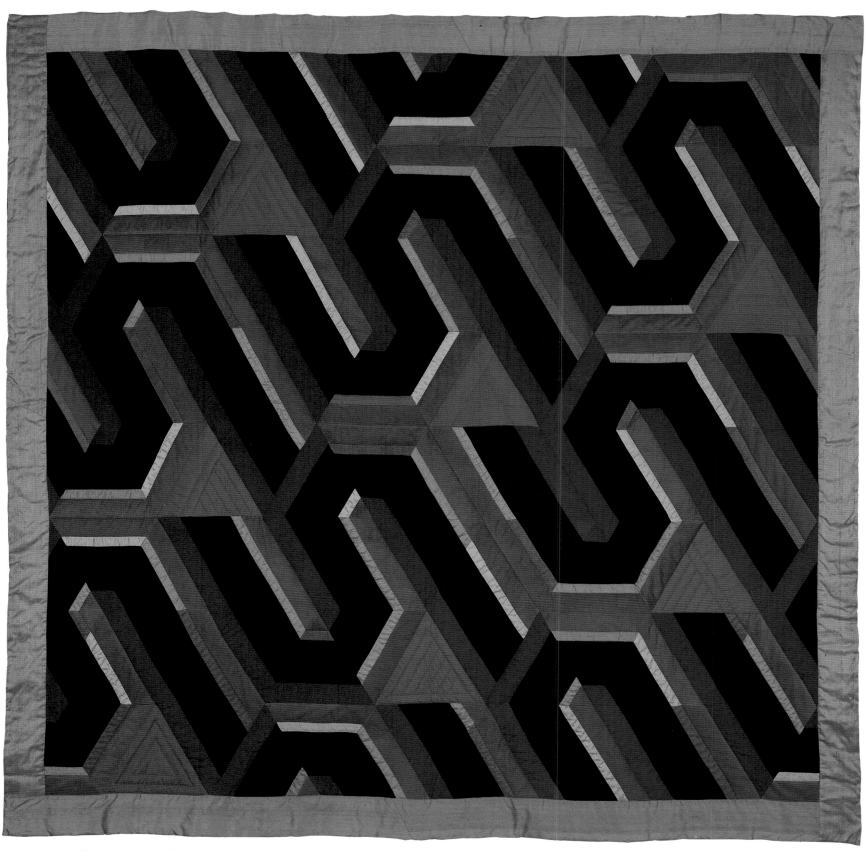

▲ COMING TO MEET

Nancy Whittington. 1987. Carrboro, North Carolina. Silk, wool, and ultrasuede. Machine pieced, hand quilted. 96 x 96 in.
The American Craft Museum, New York.
Coming to Meet was one of only six quilts selected for The American Craft Museum's monumental *Craft Today* exhibition, which traveled to Paris, Barcelona, Ankara, Athens, Warsaw, Berlin, Moscow, and five other European cities between 1989 and 1993.

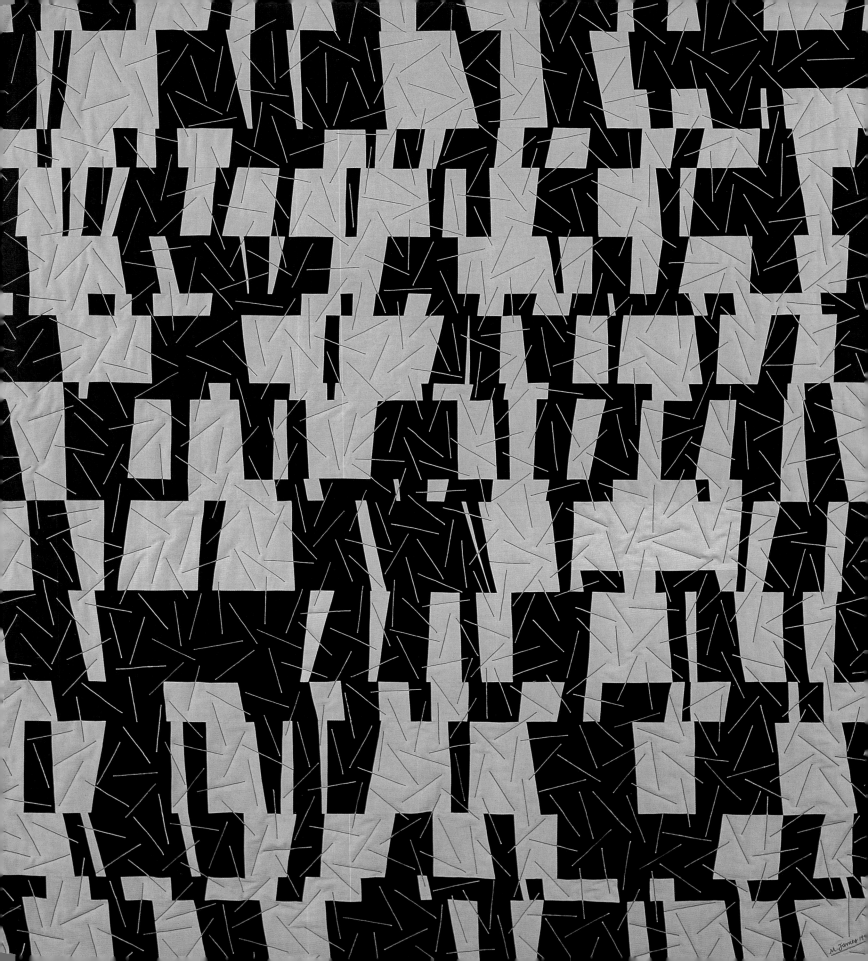

While the traditional quiltmaker's list of materials rarely included much more than cotton, wool, or silk fabric for the top, a muslin backing, wool or cotton batting, and cotton thread for piecework and appliqué sewing and quilting, art quiltmakers use an extremely wide range of natural and synthetic materials to achieve special effects. Commercial and hand-dyed or printed cottons continue to be the quilter's dominant material, and many also work with silk. But blends and synthetics are also common, and some regularly work with such exotic "fabrics" as Mylar, paper, cellophane, acetate, and netting. A listing of materials from one recent exhibition catalogue includes buttons, beads, oil and acrylic paint, leather, glass, bone carvings, felt, ribbons, yarn, embroidery floss, gemstones, fiber-reactive dyes, painted canvas, photo-transfers, metallic threads, and string. Quilts have also been made from recycled copper, used tea bags, and dyed dryer lint,

▲ ARCHES

Leah Kaspar. 1994. Burlington, New Jersey. Cotton, polyester batting. Machine pieced, hand appliquéd, machine quilted. 102 x 132 in. Collection of the artist.

This massive quilt is based on an actual building, and uses large-scale floral patterned prints to translate the design elements of the architecture into the piecing techniques of traditional quiltmaking. The quilt's monumental scale draws parallels between the sheltering qualities of quilts and buildings, which Kaspar is now exploring further in a three-dimensional, tent-like work.

SLEEP PRODUCT ▶
(◀ DETAIL)

Susie Brandt. 1986–89. Corinth, New York. Found clothing labels, ribbon, fabric, thread, batting. Hand stitched and stuffed. 83 1/2 x 731/4 in. Neutrogena Collection, Museum of International Folk Art, A Unit of the Museum of New Mexico, Sante Fe, New Mexico.

Sleep Product is a double-bed-sized quilt made of thousands of labels cut from shirts and dresses; Brandt refers ironically to the resonant myth of the scrap quilt while at the same time creating an original work of art from the humblest but most identifiable of contemporary commercial clothing scraps. Jean Ray Laury presented a similar, although decidedly non-conceptual quilt in her 1970 book *Quilts and Coverlets*, noting, "Labels provide a colorful source of 'prefinished blocks' for an appliquéd coverlet."

and have incorporated such seemingly bizarre materials as egg shells, dried banana peels and orange rinds, coffee grounds, human hair, bras, zippers, old gloves and dresses, violin strings, a Slinky, toy airplanes, and X-Acto knife blades.

Materials can also become the quilt's intellectual content. Susie Brandt, for example, makes quilts that are "about" quilts; she questions assumptions about quilts and quiltmaking by making her "blankets" from found materials, from other people's castoffs, scraps, and selvage. She scours flea markets and secondhand clothing stores for lowly used fabric the way many quilters peruse the latest and most sumptuous commercial yardage offerings. She has recently made a series of very traditional patchwork quilt patterns such as Flying Geese, Sunshine and Shadow, and Drunkard's Path entirely from machine-stitched pieces of cheap lace. Brandt's self-referentially titled *Sleep Product* is made entirely of labels cut from shirts and dresses, thus inviting viewers to draw parallels with historic quilts that incorporated recycled materials, while her *Flora* is made up of hundreds of silk flower petals joined and covered by networks of thread, and is intended to raise questions about the traditional nexus of flowers, femininity, and needlework.

▲ COLOURWASH WINDMILL GRID

Deirdre Amsden. 1995. London, England. Cottons and cotton blends. Machine pieced, hand quilted. 34 x 34 in. Collection of the artist.

Amsden began making quilts in 1974 and has been a leader among British quilt artists for many years. This little quilt is an excellent example of her "Colourwash" piecing, which uses a carefully graded host of small fragments of printed fabric to create the illusion of a single piece of cloth. Amsden notes, "Fabric prints lose some of their identity when cut into small patches, and in arrangement with many other prints become transformed into a random, irregular visual texture." Here the "colourwash" is accented by black and white pinwheels that appear to change value as the fabrics wash from dark to light.

TRADITIONAL PIECING

Many art quilters still use traditional hand piecing methods to assemble the tops of their quilts, cutting small pieces of fabric with the aid of paper templates and sewing the carefully arranged pieces together to form a single textile. Most, however, now use a sewing machine to speed the assembly process.

Although their methods may be traditional, many art quilters have found novel, modern approaches to designing pieced quilts. Michael James, Nancy Crow, and others have expanded the technically complex technique of curved seamed piecing, which was used in such traditional patterns as Drunkard's Path, Robbing Peter to Pay Paul, and Double Wedding Ring. While these traditional patterns were organized symmetrically, modern arrangements often employ asymmetrical curvilinear shapes drawn with the aid of a compass to create swirling overall compositions. James's *Aurora*, for example, is composed of two basic forms, an S curve and a quarter circle. Each of the quilt's blocks is subdivided into eight equal triangles, and the flowing curved forms are further divided into equal bands of warm-colored fabric.

Piecing is no longer solely geometric either, nor does it necessarily rely on an underlying grid structure. For example, Evelyn Montague's *Homage to Bill Hayter* is a pieced collage of many different fabric shapes, while Patty Hawkins's landscape quilt *Indian Gap Near Lyons II* aligns pieces by cutting their forms into other fabric and inlaying them like puzzle pieces.

The English quilt artist Deirdre Amsden works with what she calls "colourwash," a methodology derived from her art school experiences with watercolor painting. In watercolor class, Amsden recalls being asked by her teacher to create a smooth, seamless wash of color that moved from light to dark without sharp, obvious transitions, and decided to apply the concept to her fabric work. Drawing from an immense variety of commercial printed fabrics, Amsden creates painterly washes of color in her abstract quilts by carefully assessing the relative tonal value of different materials and piecing together compositions full of close color values and subtle distinctions of pattern and tone. To keep the viewer's eyes moving, she uses as wide a variety of printed patterns as possible in each quilt and rarely cuts more than one or two pieces from the same bolt of fabric.

STRIP PIECING

The Seminole Indians of the Florida Everglades developed a unique machine-piecing method that has been used by a number of art quiltmakers, including Michael James, Nancy Crow, Judith Larzelere, and Joy Saville. The Indians did not make quilts, but rather used their piecework to decorate their clothing. The advent of the sewing machine made it possible for the Seminoles to sew cloth together in strips that were too narrow to be worked by hand. The resulting lengths of fabric, made up of thin bands of different colors, became a new raw material, which could be cut into short segments and then reassembled in a variety of ways. They could be cut into narrow pieces at a 90-degree angle, and the pieces reassembled side by side but with every other piece turned upside down to reverse its banded pattern. They could be offset so the bands did not line up exactly, or they could be cut at a slant and reassembled in either of the ways described above. By combining bands of three or more colors, checkerboard-like patterns could be developed.

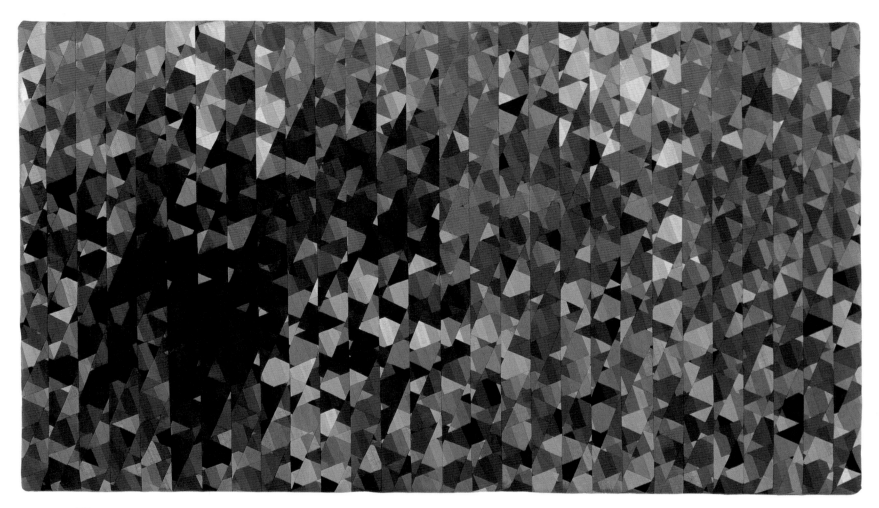

Judith Larzelere has used the concept of strip piecing for many years to enliven her abstract quilts, which not unlike Amish quilts or Color Field paintings, often juxtapose large areas of similar hue or value. Larzelere makes up strips using colors chosen from the same family, but breaks up the closely related color rhythms of her strips by occasionally inserting narrow bands of an entirely different color or colors. The Seminoles arranged their strips in repeating motifs, but Larzelere purposefully avoids repeating her patterns. But like the Seminoles, she seams the assembled strips together by machine, quilting through a batting and backing layer at the same time. The result is a flat but variegated surface that glows with close color rhythms broken up by glittering flecks of contrasting colors.

Joy Saville has also developed a unique style based on Seminole strip piecing, which, like Larzelere's approach, allows her to manipulate color and avoid repeating geometric patterns. Instead of cutting the cloth for her strips into narrow bands, however, she employs a variety of more complicated geometric shapes, including triangles, trapezoids, and parallelograms. She cuts pieces of cotton, wool, silk, or linen in a wide variety of different sizes and colors, some no larger than bits of confetti, and then painstakingly assembles them into carefully composed strips full of shimmering color and fragmented form. The resulting strips are then assembled in rows to form the overall composition, which can contain as many as five or six thousand pieces. Saville, who cites the paintings of Monet, Seurat, Van Gogh, and Georgia O'Keeffe as her inspirations, often uses more than one hundred shades of color in a single quilt.

Jane Burch Cochran, who employs patchwork as a background element in her complex pictorial quilts, takes a completely different and far less carefully planned approach. She says, "I use strip

◄ NOVEMBER EVE

Joy Saville. 1993. Princeton, New Jersey. Cotton, linen, silk. Machine sewn. 39 x 67 1/2 in. The American Craft Museum, New York.
Saville's evocative impressionistic strip-pieced quilts present frozen moments in time, records of color and light at play in a landscape at a particular time and place.

STRINGS AND TRIANGLES ►

Anna Williams. 1995. Baton Rouge, Louisiana. Cottons. Machine sewn, hand quilted by Mary Walker. Approx. 80 x 68 in. Collection of John Walsh III.
The complex geometric and color rhythms of this strip-pieced quilt epitomize Williams's highly influential improvisational approach to quilt construction and design.

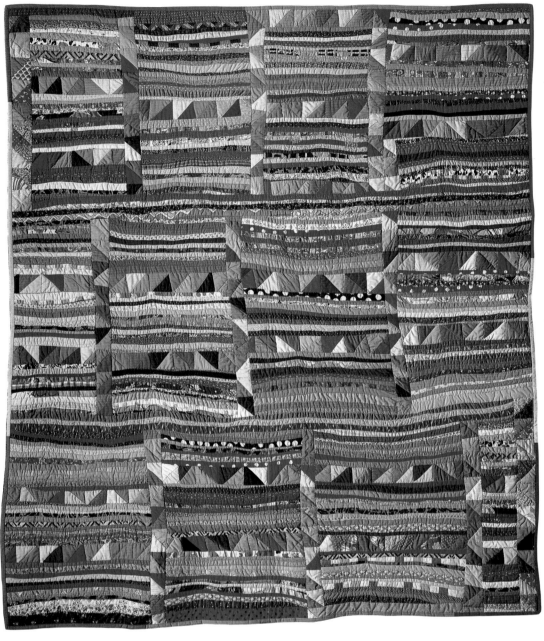

piecing to make my patchwork. I don't measure but just start cutting and sewing strips usually in combinations of three strips. I then cut these apart into smaller pieces and just keep sewing and adding until it grows into large enough patches to use. I love to make the patchwork. It's like making lots of small paintings."

IMPROVISATIONAL PIECING

Following the lead of African-American quiltmakers, a number of art quiltmakers have given up using templates to plan their piecework in recent years and moved to riskier but more direct and spontaneous methods of construction and composition. These new, freer directions have drawn considerable inspiration from the work of Anna Williams, an untrained seventy-year-old African-American quiltmaker from Baton Rouge, Louisiana, whose methodology has profoundly influenced such prominent art quilters as Nancy Crow, Jan Myers-Newbury, Pamela Studstill, and Liz Axford. The unassuming, grandmotherly Williams is a surprising artistic source to be sure, but her work has been featured and studied at numerous workshops and surface design conferences as well as in a 1995 exhibition sponsored by the American Quilters Society in Paducah, Kentucky. Williams works "without a net," eschewing the use of patterns or templates of any

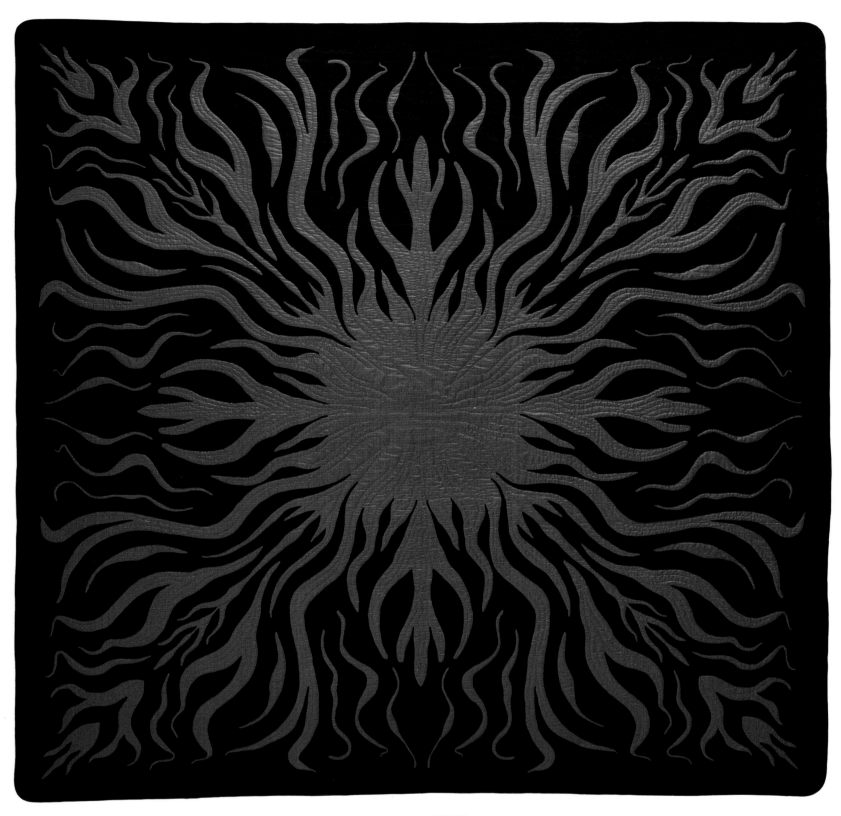

kind. She cuts her fabric directly and assembles the resulting pieces into freely improvised tops of often dizzying complexity, trusting her eye and her powerful innate sense of color and compositional balance to make each quilt work. After completing a top, Williams passes it along to others to be quilted, moving quickly on to the creative challenges of her next design.

Her example has been liberating for many art quilters, some of whom, like Nancy Crow, have drastically changed their approach to quiltmaking since encountering her work. In a 1994 interview with Elizabeth Walker, Crow said, "I don't want my work to look like it was derivative in any way of Anna Williams, but I will say that the fact that this woman works the way she works gave me the courage to throw away all the templates and get on with it."

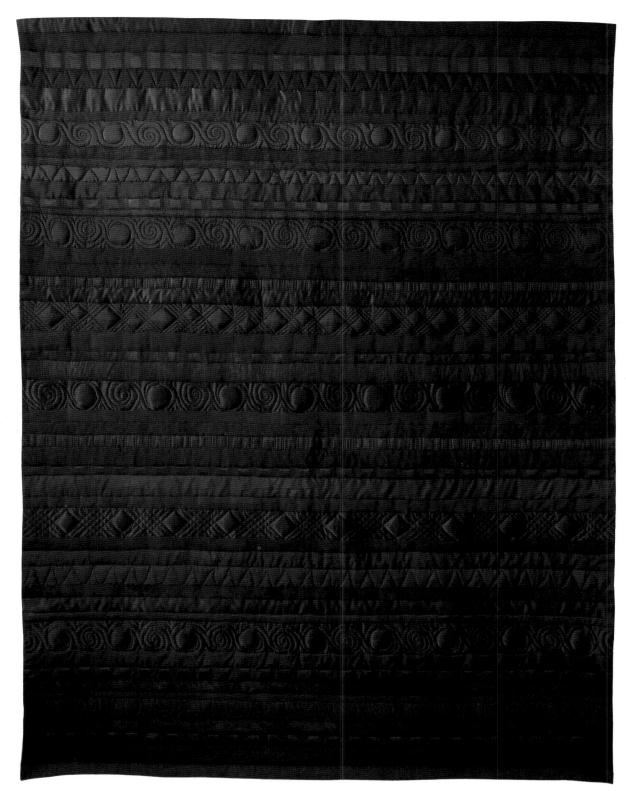

◄ **I KA HOʻOKUMU ANA (VOLCANO QUILT)**

Helen Friend. 1992. Honolulu, Hawaii. Cotton with cotton batting. Hand sewn. 96 x 96 in. The Persis Corporation Collection, Honolulu, Hawaii.

This quilt was inspired by "The Kumulipo," an ancient Hawaiian creation chant that describes the land rising out of the oceans and the births of all the island's various life forms. Unlike most Hawaiian quilts, the central image is reverse appliquéd.

EXPERIMENTS WITH BLUE SILK ►

Mary Fogg. 1995. Surrey, England. Various lightweight silks, cotton backing. Hand dyed, machine sewn. 77 x 57 1/2 in. Collection of the artist.

This modern variation on a whole cloth quilt plays with subtle modulations of color and surface texture. The transparent silks are dyed similarly but backed with different colored cottons.

Crow goes on to explain the approach she has taken since the early 1990s: "I learned to make quilts using traditional templates and made quilts in a tight, controlled way for fifteen years. Template-making was a process I enjoyed until my quilts developed to the point where I was making between sixty and eighty templates for each quilt. Then the whole process became tedious and ultimately boring to me. I wanted a more direct way to create shapes to make my compositions dance with freshness. So I plunged in until I taught myself how to cut shapes directly out of the fabric without templates, without even knowing ahead of time what the overall compositions might be. I equate this 'direct cutting' with drawing. I am drawing with the fabric in terms of the lines I cut whether they be straight lines or curvilinear. It is challenging and exciting to realize that I can cut a line of beauty on the first try."

machine-applied appliqué and embroidery stitches to add highlights and shadows as well as to secure the pieces of fabric.

While appliqué places one layer of cloth on top of another, in reverse appliqué, the top layer (or layers) of fabric is cut out to reveal an underlying layer. The cut seams of the top layer are then turned under and sewn to the bottom layer of cloth. Reverse appliqué is a difficult and time-consuming process and is far less commonly employed than standard appliqué, but it does provide an unusual textural effect, allowing the quiltmaker to recess one color or pattern within another. Reverse appliqué has been used particularly effectively by Deborah Felix, who creates complex pictorial narratives that juxtapose a variety of bold, vibrant colors. And the method is used to dramatic results by Hawaiian quilter Helen Friend, who in her spectacular *Volcano Quilt* cuts through the outer black form of the volcano to reveal its fiery, seething red core.

APPLIQUÉ

Appliqué is employed by many art quilters, especially those who take a more pictorial or narrative approach in their work. Some, like Therese May and Terrie Mangat, follow more or less traditional methods, cutting figures and other pictorial elements from cloth and stitching them to a background. Others, like Risë Nagin and Deidre Scherer, stretch the process in new directions to achieve special results.

Nagin often works with lightweight, diaphanous fabrics such as sheer silks or rayon organzas and uses appliqué as a means of layering the cloth to create combined color or textural effects. Deidre Scherer creates highly detailed portraits of elderly people by layering appliqué pieces in a collage-like technique. After sketching her subject, she draws with her scissors to cut the outlines of the composition, which form the first, background layer of fabric. Several layers of tiny pieces of fabric are then carefully added to flesh out the portrait. As the layers are built up, she uses

WHOLE CLOTH

A few quiltmakers create whole cloth quilts, with tops made from a single piece of cloth (or several pieces of the same material). Some of these artists, like Ardyth Davis and Mary Fogg, are interested in the enhanced ability to explore texture and the effects of light that the whole cloth format permits. Others, including Lenore Davis and Gayle Fraas and Duncan Slade, delight in fooling the viewer's eye by creating the illusion of pieced surfaces where none exist.

◄ RELIEF STRUCTURE (ANGER III)

Helen Parrott. 1994–96. Sheffield, England. Hand-dyed fabrics, damask tablecloth, metal rod, dress-making pins. Hand slashed, pinned, and interlaced. 65 x 82 in. Collection of the artist.

Parrott has a degree in geography and finds her inspiration in landscape, particularly as seen from the air. She explains, "I found an easy link between landscape, maps, geography, and creating large [three-dimensional] textiles which are often viewed from different angles, including from above."

THE LITTLE CITY ►

Lenore Davis. 1990. Newport, Kentucky. Cotton, textile paint, fiber-reactive dyes. Hand painted, monoprinted, and hand tied. 70 x 70 in. Collection of Ardis and Robert James.

This tongue-in-cheek whole cloth quilt's "squares" are actually printed, and its "feathered plume" border was painted by hand. The printed architectural forms within the squares are reminiscent of the geometric pen and ink landscapes of Paul Klee.

Whole cloth quilts were common in England and America in the late eighteenth and early nineteenth centuries. These early examples were usually made of solid-colored glazed wool and covered with intricate quilting motifs that provided the only surface decoration. The tightly spaced lines of quilting stitches created a raised, puckered surface that shimmered in the candlelight of Colonial bedrooms. Mary Fogg's *Experiments with Blue Silk* is a modern variation on this theme that combines silks of different weaves and degrees of transparency into a seemingly unified whole. Fogg dyed all the silks with "the same highly saturated acid blue color and then quilted in low relief by spontaneous free machine quilting and padding. The color changes subtly as the viewer moves or the light changes."

Lenore Davis, who died in 1996, often block-printed the surfaces of her whole cloth quilts; the block-shaped patterns suggest the repeating format of the traditional pieced quilt, and their intricate curvilinear designs often suggest quilt stitching. Her *The Little City* surrounds a tile-like center with a boldly painted lacy border motif that plays on traditional feathered-wreath and feathered-star patterns. Similarly, Fraas and Slade often screen print or paint patterns of checkerboard patchwork on the surfaces of their whole cloth quilts, using them to frame or otherwise complement their realistic landscape paintings.

MICHAEL JAMES

Michael James is an impeccable craftsman who insists that complete mastery of the craft of quiltmaking is essential to any artist. James is first and foremost a colorist, whose abstract, non-programmatic work explores formal elements within tightly organized, pieced compositions. The bulk of his work employs colored stripes set on the diagonal so that they run against the boundaries of the quilt's overall form and underlying geometry. The 3/4-to-one-inch-wide stripes are often aligned between the quilt's pieces, but they change color and length unpredictably, suggesting shafts of light broken into prisms of pure, soothing color.

James uses up to 150 different colors in a single quilt. He first chooses his palette and fabricates panels of strip-pieced cotton stripes. Each panel is made up of thirty-six solid colors, which are arranged in carefully graded runs of intensity or hue. He then cuts the shapes that will make up the quilt, juxtaposing forms and different groups of stripes to achieve a constantly shifting play of light and color. Quilting is run in the seams to leave the surface smooth and unbroken.

Although traditional grid structures grounded his work for many years, James moved decisively beyond the grid system in the early 1990s by creating quilts built from graffiti-like forms. In 1996 he took an entirely new direction, working in wool and within a severely restricted palette and vocabulary of forms.

◄ AURORA

Michael James. 1978. Somerset Village, Massachusetts. Cotton, cotton velveteen, satin, polyester batting. Hand pieced and quilted. 108 x 96 in. Collection of Ardis and Robert James.
This early quilt by James is an outstanding example of his work with curved seams, combining block patterns based on a soft S curve and a quarter circle.

▲ A FINE ROMANCE

Michael James. 1996. Somerset Village, Massachusetts. Cotton, silk, cotton batting. Machine pieced, machine quilted. Signed, bottom right. 59 x 57 1/2 in. Private collection.
This diptych evokes a dance between two very different personalities, the essence of a fine romance. James says that after making it, he realized that in some sense it represents portraits of himself and his wife, although he notes that some friends wonder which is which.

◄ QUILT FOR THE DEATH OF ONE I LOVE(D) (COMPOST QUILT) (REVERSE ►)

Mimi Holmes. 1993. Minneapolis, Minnesota. Obi stiffener fabric, netting, leather, wood, paint, zippers, thread, egg shells, dryer lint, vermiculite, dried coffee grounds, orange rinds, banana skins, grapefruit rind, fake horsehair (upholstery material), spray paint, copper. Machine embroidered, machine stitched, hand stitched, hand appliquéd. 60 x 34 in. Collection of the artist.

Holmes made this biodegradable quilt for her grandmother, Sophia Antoinette Trastour. It was intended to serve as her burial shroud. According to Holmes, "The hand motif refers to my grandmother's always busy hands: making candy, crocheting, knitting, china painting, embroidering, typing, caressing, playing bridge, working puzzles, etc. The triangles symbolize a feminine trinity, here indicating the closeness of my grandmother, mother, and me. The crescents reflect our ties to the moon. The squares are symbols of our life on

earth (people needing to order and grid the natural world), and there are pockets to hold notes to my grandmother of memories of her and our shared experiences. The quilt is composed of nine strips to represent her ninety years of life. The strips are joined by zippers to reinforce a sense of the accumulation of experience and symbolize the irregularities of one's progress, as well as punning on the need of the living to separate from the dead. I was thinking about how historically quilts were made by older women for births and weddings and keeping children and families warm. I wanted to turn that around and have a younger life make a quilt for an older death. I also wanted to make a quilt that wouldn't last, but was meant to decompose."

She adds as a postscript, "My Gram passed away on the afternoon of my fortieth birthday, November 10, 1996. She was cremated, and the quilt did not go with her. I have it and it comforts me, but I'm not sure what to do with it. I think I'll keep filling the pockets with stories about her and keep her memory and spirit near me."

▲ ECLIPSE (DETAIL ▶)

Judith Dingle. 1994. Screen, wood, rubber, silk and metallic fabrics. Machine pieced, stuffed, painted, and constructed. 62 x 84 in. Collection of Rolex Watch of Canada.

Dingle creates three-dimensional textile constructions which, through their highly unusual materials and construction methods, extend the traditional definition of the quilt. Her constructivist methodology has been influenced by both natural geometric structures and modern architecture, while her approach to surface design and use of repeating units draw upon the rich history of quiltmaking. This quilt's fabrics are shaded by a layer of screening to simulate the effects of a total eclipse of the sun seen in Toronto in 1994.

INDIAN GAP NEAR LYONS II ▶

Patty Hawkins. 1992. Lyons, Colorado. Cottons, blended and lamé fabrics, threads, glass beads. Machine pieced using inlaid construction, machine quilted. 55 x 77 in. Collection of the artist. This landscape was inspired by drives through the Colorado mountains. The quilt employs inlay piecing to achieve a flat, contiguous surface made up of irregularly shaped pieces, not unlike a jigsaw puzzle.

▲ SOMETHING LIKE A JITTERBUG

Carole Harris. 1994. Detroit, Michigan. Cottons. Machine pieced and hand quilted. 65 1/2 x 44 1/2 in. Collection of the artist. Harris is a professional interior designer and fabric artist who has created improvisational pieced quilts since the late 1960s. Both her mother and grandmother made traditional quilts, so it was natural for Harris to combine her art school training with her family interest in quilted fabric. "I've worked with fabric all my life," she says. "I never felt comfortable with paint." As in this example, her works often layer strips of geometric piecework to create three-dimensional textures.

HOMAGE TO BILL HAYTER ▶

Evelyn Montague. 1995. Cork, Ireland. Mixed fabrics. Machine pieced, hand quilted. 33 x 44 1/2 in. Collection of the artist. Montague is interested in the symbolic use of color. This pieced fabric collage explores the individual and collective associations of different fabrics.

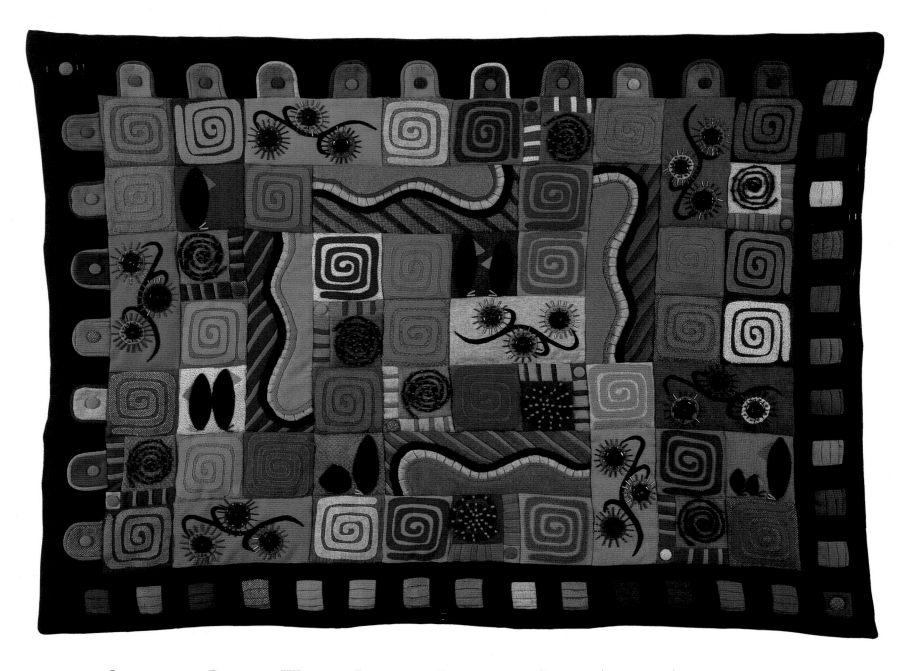

▲ OUT OF THE DARK OF WINTER, INTO THE BOISTEROUS SPRING (DETAIL ▶)

Karen Larsen. 1996. Cambridge, Massachusetts. Wool, beads, hand-covered buttons. Hand and machine pieced, machine quilted with some hand quilting, appliquéd, pleated, piped, with some piecing that rises from the surface. 38 x 48 x 1/2 in. Collection of the artist.

Larsen works in wool because she finds its depth of color and multifaceted textures unmatched by any other fabric. She says, "I love the way wool absorbs light instead of reflecting it, giving my pieces a soft, opulent tone." This quilt celebrates "that day every year has when it's clear that winter is over and spring has arrived."

▲ TIPI

Margaret Wood. 1986–94. Phoenix, Arizona.
Hand-painted cotton. Machine pieced, hand
quilted. 85 x 148 in. Collection of the artist.
Wood is a Native American artist who draws
on a wide range of traditional Indian forms
and symbols in her quilts. This quilted tipi
can be hung flat in a half circle and can also
be set up with tipi poles.

◄ ABSTRACTION V: FIELD OF
YELLOW

Jean Neblett. 1993. San Francisco, California.
Hand-dyed cottons by Nancy Crow, Eric Morti,
and Debra Lunn, commercial cottons, netting,
and ribbon. Torn, folded, machine appliquéd,
machine quilted, scrimmed. 49 x 49 in.
Collection of the artist.
In this trompe l'oeil quilt Neblett creates the
illusion of planes advancing and receding in
space through the clever manipulation of
color and form.

▲ ANCIENT ACTIVITIES

Charlotte Patera. 1996. Grass Valley, California. Cottons, cotton batting. Figures reverse appliquéd by hand, machine pieced, machine quilted, stipple quilting around figures. 45 x 55 in. Collection of the artist.

Patera is an expert on molas, the traditional reverse appliqué work of the Kuna Indians of Panama. Since 1980, she has made five trips to the San Blas islands to visit with Kuna women and study their techniques. She currently tries to find ways to simplify their complex methods and incorporates these evolved variations into most of her quilts. In this example, the reverse appliquéd figures are based on prehistoric American petroglyphs. Each panel represents a different activity: blue is ceremonial dancing, brown is hunting, orange is combat, and magenta is celebration.

◄ **LITTLE WATERFALL**

Susan Sawyer. 1994. Calais, Vermont.
Cottons. Machine pieced, hand quilted.
50 x 35 in. Collection of the artist.
Sawyer's impressionistic quilts are
pieced from thousands of tiny bits of
cloth, which she cuts with a paper cut-
ter. This quilt's notched form is remi-
niscent of early four-poster bed quilts
as well as the kimono, although
Sawyer says her intention in choosing
it was "to show the shining white
water falling."

HOLIDAY ▶

Nancy Herman. 1996. Merion, Pennsylvania. Cottons, synthetics, silk, and velvet. Machine sewn (only around the edge). 103 x 55 in. Collection of PECO, Philadelphia, Pennsylvania.

Herman has been making distinctive abstract quilts which explore the movement of color within a composition since the 1970s. This recent example of her work is made up of eight woven fabric strips, which were joined to form a new whole.

EMMESHES V ▶

Sally-Ann Boyd. 1996. Cheltenham, England. Assorted silks with some lurex, rayon backing, cotton interlining. Machine pieced, hand embroidered with heavy silk thread, fringe hand made in fine silk and rayon thread. 40 x 40 in. (including fringe). Collection of the artist.
The small squares of this quilt were made randomly using scraps left over from other strip-pieced patchwork quilts. Boyd's quilts are intended to hang loosely or flow over a form. She notes, "It is important to me that the finished piece still retains the draping quality of fabric."

◀ BANNER DANCE

Patricia Malarcher. 1995. Englewood, New Jersey. Thai silk, linen, gold leaf, metallic thread. Machine appliquéd, hand-sewn construction. 96 x 60 in. (mounted on board). In the collection East Meets West, curated by Jackie Bailey Labovitz for the American Embassy in Bangkok, Thailand.
Banner Dance was created on commission for the Cultural Fiber Collection of the American Embassy in Bangkok, which celebrates the "common threads" of American and Thai heritage and experience. Charged to find inspiration in Thai textile art, Malarcher chose a piece that had only a simple fold. She says she added the "flips" because she felt her piece needed more energy.

IN PARADISUM V ▶

Linda Fowler. 1993. Columbus, Ohio. Cotton and cotton blends. Machine appliquéd and quilted. 45 x 45 in. Collection of the artist.
Fowler comments: "This series was initiated when a friend died of cancer. The title was taken from the Latin Funeral Mass and refers to the line 'May the angels lead you into paradise.' The forms in the series evolved into an abstract landscape."

▲ Freehand 3: Blue

Liz Axford. 1991. Houston, Texas. Hand-dyed and commercial cottons, cotton and silk threads, cotton batting. Machine pieced, machine quilted, hand embellished. 42 x 52 in. Collection of Ann Glazier.

Axford says she first doodled the complex design for this pieced block quilt while talking on the phone. She set it so the small squares could continue from block to block. She continues, "The connection between quiltmaking and architecture was revealed to me in a new and unexpected way one day when I drove into the parking lot of a local nursery that I'd probably visited a hundred times in the past ten years. There ahead of me was 'my block' in the form of concrete masonry, used as a screen wall for a service building. I'd never noticed it though I know I'd seen it all these years."

▲ **KALEIDOSCOPE XVI: MORE IS MORE**

Paula Nadelstern. 1996. Bronx, New York. Cottons, silk. Machine pieced, hand quilted. 64 x 64 in. Collection of the artist.
The impression of circles and curves in Nadelstern's kaleidoscope quilts is an illusion actually created by piecing straight lines.
She says making kaleidoscope quilts allows her to "synthesize meticulous planning and happy coincidence, to merge control
and spontaneity [and] spark something unexpected. There is an air of abracadabra as the last seam is stitched because the
whole is truly greater than the sum of its parts."

RETREAD 2 ▶

Michele Walker. 1996. Brighton, England. Plastic materials, dustbin liners, potato bags, etc. Machine appliquéd and quilted. 78 x 78 in. Collection of the artist.

Walker uses traditional techniques, but works with recycled plastic materials and household packaging from our "fast food culture" to make statements about environmental and land use issues. The quilting design for this quilt originated from patterns in a used tire dump. Walker says the patchwork landscape symbolizes the British countryside, "which is under greater threat from development and pollution than ever before."

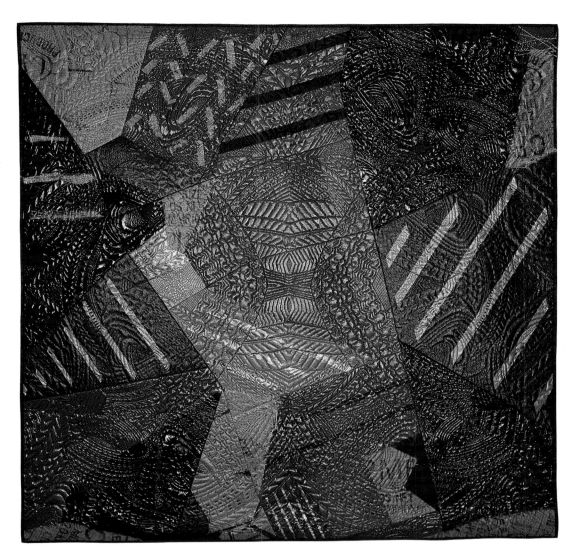

FALLING ANGEL #6 (HASTE) ▶

Kathleen O'Connor. 1996. Westminster, Vermont. Hand-dyed fabrics, metallic fabrics, acrylic paint, mounted on plywood frame. Hand painted, hand and machine appliquéd, machine quilted. 84 x 70 in. Collection of Paula and Ted Bier.

O'Connor uses Velcro to attach her irregularly shaped quilts to plywood mounts that are cut to fit their shapes exactly. She uses multiple layers of sheer fabric to build color, and shapes her pieces carefully to create an internal sense of movement. This quilt is one of a series based on human forms that explores the positive aspects of negative personality traits. The initial piece in the series was inspired by a quote from Chekhov about the possibility that angels can only find the solitude they desire when they fall from grace. This piece was informed in part by the motto on the coat of arms that Tom Sawyer makes for Jim in Mark Twain's *Huckleberry Finn:* "Motto, Maggiore fretta, minore atto," Tom explains to Huck. "Got it out of a book—means the more haste the less speed."

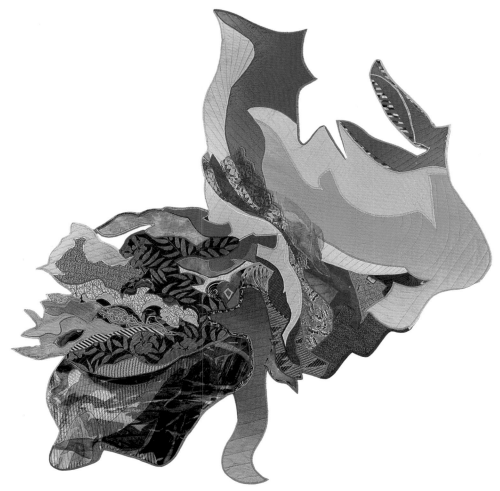

JUDITH LARZELERE

Judith Larzelere relates viscerally to color, and her quilts, with titles like *Seeing Red*, *Rippling Color*, *Magnolia*, *Chains of Blood*, *Dayglow,* and *Bittersweet*, are about "color, color, color." While her palette is most often hot and intense, Larzelere occasionally works in cool, reflective colors as well, especially when her inspiration comes from observation of the sky, flowers, water, or other natural phenomena. She works abstractly, but, unlike most abstract quilters, her work is non-geometric and does not rely on an underlying block or grid structure. Instead, she allows color to dominate and organize her compositions. "My work gives me a way to communicate feelings without using words," she says. "I use colors to gain a mood response from a viewer."

Since Larzelere's art is constructive but not ruled by rigid geometric structures, each quilt evolves as she works. She chooses her palette from solid-colored commercial cottons, which she reassembles into long, narrow strips broken at odd intervals by slim horizontal bands of contrasting color.

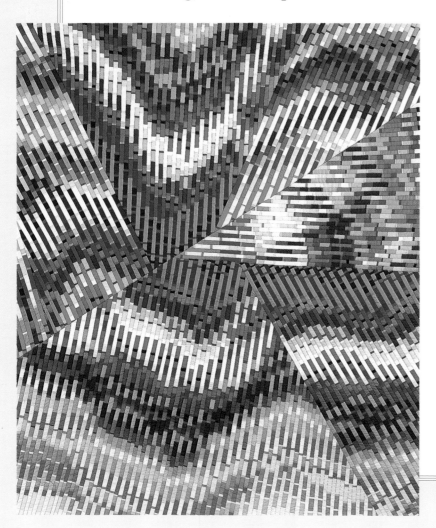

This strip-pieced raw material is then cut into varying lengths and organized by placing strips adjacent to or at angles to one another. By setting bands in the material off center, Larzelere can create swirling cross-rhythms of color and form while at the same time uniting the composition through the repeating hues and patterns of the strip-pieced material.

◄ **ESSEX COUNTY: APRIL**

Judith Larzelere. 1989. Belmont, Massachusetts. Commercial cotton cloth. Machine strip-pieced, machine strip-quilted. 74 x 74 in. The American Craft Museum, New York.
While driving the back roads of Essex County in northeastern Massachusetts one foggy, rainy morning in early April, Larzelere was entranced by the combination of colors around her: a delicate haze of reddish maroon from the budding maple trees, the dark wet bark of the trees, a cloudy grey sky, and straw-colored grass, not yet greening up with the advent of spring. She put together the palette of colors for this quilt as soon as she got home, although she did not begin work on the non-representational piece until several months later.

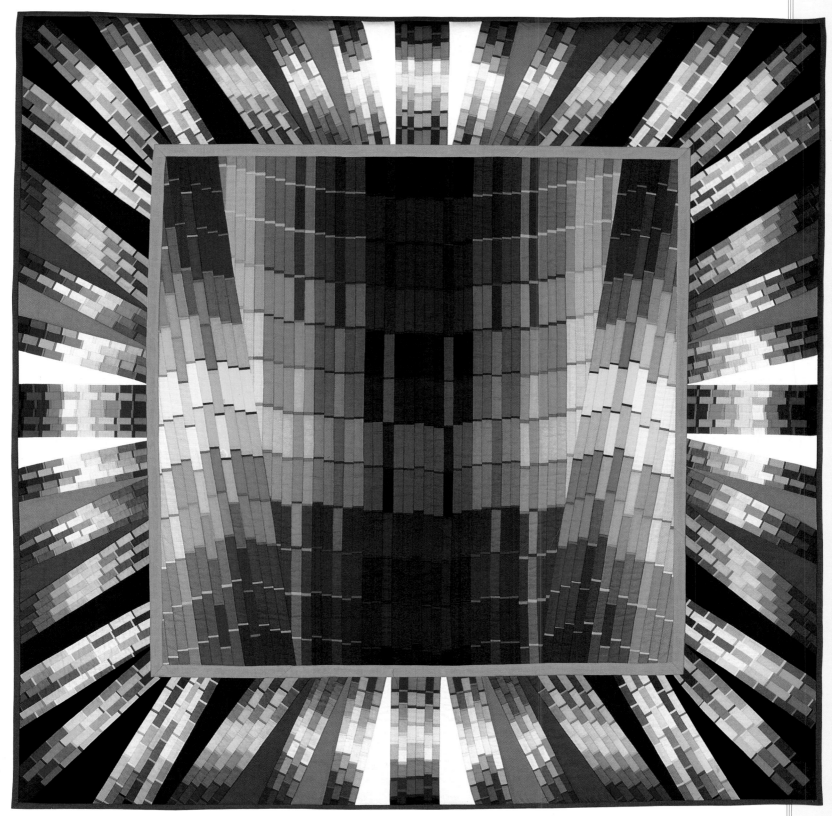

▲ EXPANDING COLOR

Judith Larzelere. 1996. Belmont, Massachusetts. Commercial cotton fabrics produced by P & B Textiles. Machine strip-pieced, machine quilted. 59 x 59 in. Collection of P & B Textiles, Burlingame, California.

This piece was commissioned by P & B Textiles to demonstrate the range and beauty of their solid-colored cotton fabrics. The glowing blue inner border contains the intense hues of the central section, from which the colors of the spectrum radiate and diffuse.

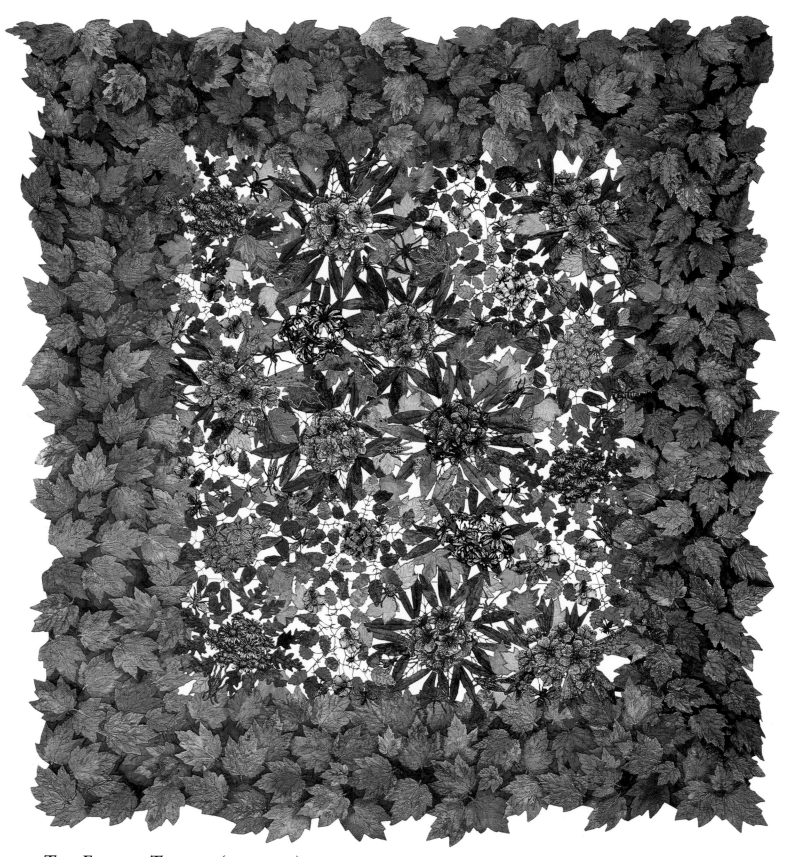

▲ **THE FLOWER THIEVES (DETAIL ▶)**

M. Joan Lintault. 1992. Carbondale, Illinois. Hand-dyed cotton, sewing machine lace. Screen printed, painted, hand pieced and quilted. 99 x 88 in. Collection of Anne L. Stone.

Lintault has created a number of openwork quilts over the years. Contrary to standard quilt construction, the images that make up these unique quilts are not sewn to a background. Instead, they are joined in a sort of web so that everything is foreground; the viewer also can look through the quilt. Lintault notes, "Fabric can be made to have weight, mass, and texture. I am intrigued by the mystery of negative space. I like to eliminate the ground so the images are suspended in space." She begins a quilt like this with a sheet of plain white muslin, saying, "I see its possibilities." The images of insects and fauna are printed and painted on the muslin, which is then sewn to a backing. Lintault then cuts out and stuffs each image before joining them together, in this case by hand.

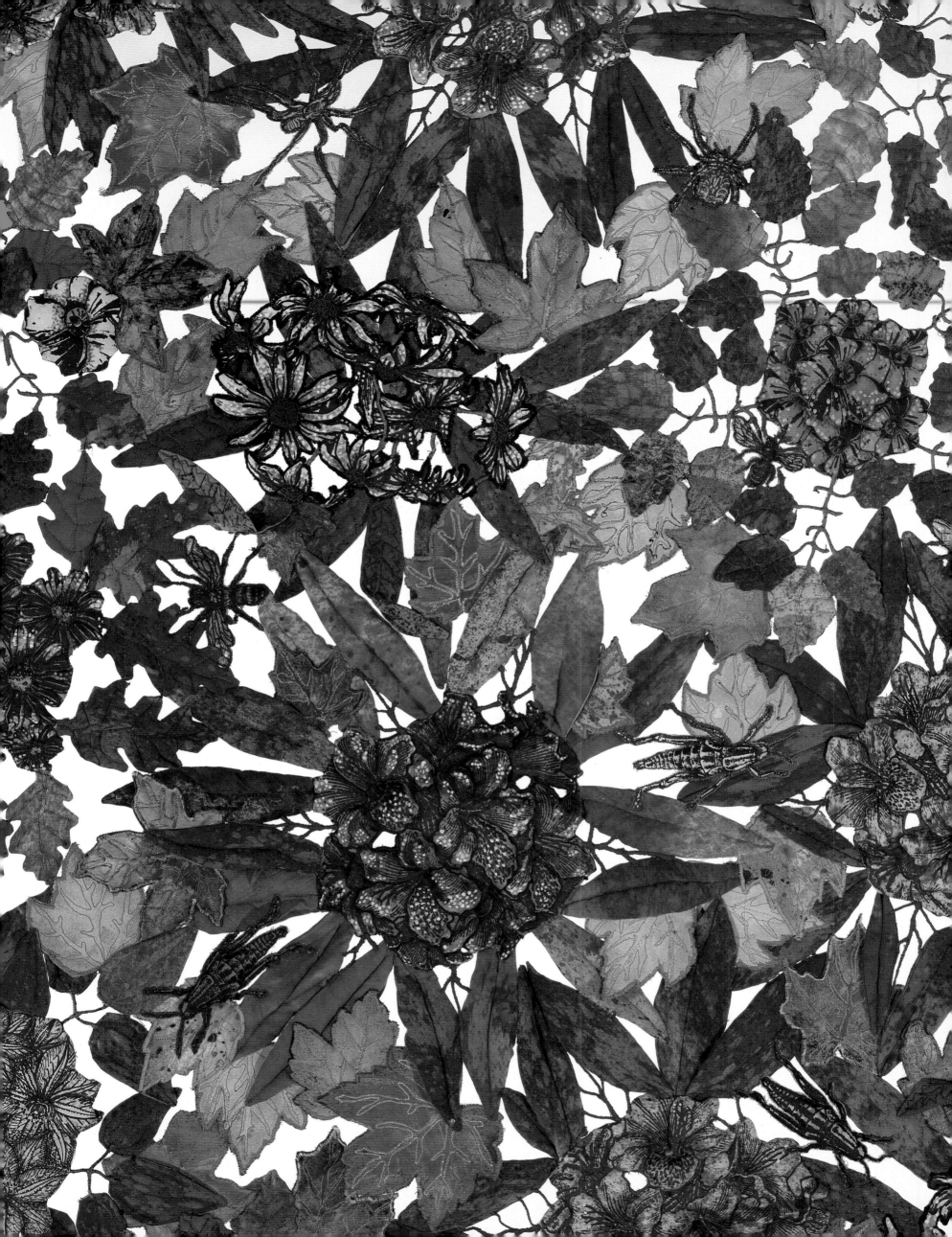

SURFACE DESIGN: PATTERN, COLOR, AND ORNAMENT

IMMERSION DYEING

The wide range of color and patterning possible in hand-dyed fabric appeals to many art quilters. Some purchase fabric dyed by such masters as Eric Morti or Debra Lunn, but many now do their own dyeing to get just the color or pattern they want for a specific use. Although it can involve many steps, immersion dyeing is technically simple: fabric is simply submerged in a water-based bath of dye mixed with fixers such as acids, mineral salts, soaps, or sodas and left for a period of time to allow the dye to soak into the cloth. After the desired hue is achieved, the cloth is washed to remove excess, unfixed dye.

Versatile fiber-reactive Procion dyes are the most commonly used dye stuffs, although natural dyes such as indigo are still sometimes employed. The development of synthetic

◄ BIG RED SUN (THANKS TO LUCINDA WILLIAMS)

Elizabeth Cherry Owen. 1994. Baton Rouge, Louisiana. Commercial and hand-dyed cottons, various embellishments including glass beads, shisha mirrors, and yo-yos made by the artist. Machine pieced, hand appliquéd, reverse appliquéd, hand quilted, hand embroidered. 46 x 48 1/2 in. Collection of the artist.

Owen cites the assemblages of Joseph Cornell as a major influence, saying "he has always been in my studio whispering in my ear. I think he has inspired me in my fusion of the personal with the historical and in a preservationist's desire to make visual references to art and craft forms of the past and of other cultures." This quilt was inspired by "Big Red Sun Blues" by Lucinda Williams, an Arkansas singer/songwriter best known for her song "Passionate Kisses."

fiber-reactive dyes, which were introduced in 1956, has opened up a new world of possibilities to home dyers. These dyes link chemically with the molecules of the textile to create a totally integrated colored fabric. They are also color fast, although several washings are usually needed to completely remove unfixed dye. They are very easy to use, since they are mixed in cold water and need only the addition of plain table salt and washing soda to work, and the results can be an extremely wide range of tones and colors of great intensity. Depending on the amount of dye used and the length of time the cloth is immersed, the intensity of the color produced can range from the softest pastels to the richest and most saturated hues imaginable. They are also relatively inexpensive and readily available.

LIQUID RESIST DYEING

Liquid resist dyeing involves the application of a liquid or paste, such as melted wax or rice paste, to fabric. The resist material is allowed to dry and then, when dye is applied to the cloth, leaves contrasting patterns of undyed material. After dyeing is completed, the dried resist material is removed from the fabric. Depending on the desired effects, the resist material can be painted on with any type of brushstroke, or stenciled or stamped in repeating patterns. Similarly, dye can be painted on or the cloth can be immersed in a bath.

Batik, which is believed to have had its origins on the Indonesian island of Java, is the most common and best-known liquid resist dye method. Batik is traditionally used to create bold, graphic designs but can also be manipulated to result in subtle dappled patterns of light and dark, an approach taken by Dorothy Caldwell in a recent series of quilts. In batik, designs are painted or stamped on fabric with melted wax or can be scratched through a dried layer of wax. After all the wax has dried, the fabric is bunched and immersed in a liquid dye bath. The wax protects the portions of fabric it covers from the dye and when it is removed leaves a negative pattern in the dyed fabric. Dye also seeps into spots where the dried wax has cracked, often leaving a somewhat mottled, uneven quality to the edges of the patterns and also creating completely unpredictable patterns of fine undyed lines.

BOUND RESIST DYEING

As its name describes, bound resist dyeing involves tying, clamping, or sewing fabric before it is dyed, thereby blocking the dye from reaching portions of the cloth. An opposite process called *discharge* employs bleaching agents to subtract color from exposed portions of cloth. Depending on how the cloth is bound, the resulting patterns can range from large, simple spots of color to intricate linear designs. Cloth can be twisted, folded, pleated, wrinkled, or knotted in various ways and then

◄ FOUR FIELDS MEET

Dorothy Caldwell. 1995. Hastings, Ontario. Batiked and stitched cotton. Hand sewn. 60 x 60 in. Collection of the artist.
Caldwell's abstract resist-dyed compositions often find their inspiration in landscape. This piece suggests an aerial view of cultivated fields.

TRANCE ►

Judith Content. 1995. Palo Alto, California. 100% Black Thai silk, dyed and discharged using an adaptation of the Japanese thread resist process called Arashi Shibori. *Pieced, machine quilted and appliquéd. 40 x 70 in. Collection of Linda Brownrigg.*
Content began making art quilts in the early 1980s after several years of producing dyed and quilted "wearable art." Freed from the size limitations of clothing, she created commissioned architectural works that reached two and three stories in size. In 1991 she began looking back and realized that the essential form of clothing, especially the kimono, still held a fascination. This kimono-shaped work refers to the inherent mysticism of Native American ceremonial dress.

bound with yarn, thread, wire, rubber bands, or clamps. Unlike other dyeing methods, bound resists produce soft edges and gentle transitions of color between dyed and undyed areas of the cloth. Bound resist dyeing is most commonly associated with Far Eastern textiles, but was also practiced in East Africa and Peru. Tie-dye, as resist dye has become generically known, became cliché in the hippie culture of the 1960s. The ubiquitous repeating positive/negative circular patterns of hippie T-shirts are but some of the many pattern possibilities of tie-dye methods, which can also produce a variety of linear and other geometric forms.

Shibori is a sophisticated tie-dye process named for the Japanese city where it originated. The Japanese used shibori techniques to dye kimono silks using indigo. In traditional shibori, silk is pleated, wrapped around long poles, and tied in place with thread, then dipped into a dye vat repeatedly until the desired intensity of color is achieved. Both the pleats and thread resist the dye, leaving unpredictably complex patterns of undyed cloth that stand out against the darker hues.

Judith Content has developed a unique adaptation of the traditional Japanese technique which involves wrapping small pieces of carefully pleated silks around clear glass wine bottles, securing them with fine thread, and dyeing them with subtle gradations of color. The resulting fabric becomes the raw material for her work. She tears the dyed silk into strips and then assembles the pieces into quilted panels. Many of her works take the form of a kimono, although they are often gigantic in size.

Jan Myers-Newbury has also used shibori and other tie-dye methods in many of her recent quilts. She dyes cotton rather than the more traditional silk and calls her rather unstructured approach "scrunch" dying. Myers-Newbury's quilts are usually based on geometric structures, and she uses tie-die to create a more interesting and varied surface, full of unpredictable changes of color and texture. The uneven color patterns of the tie-dyed fabric soften and blur the hard edges of the quilts' underlying geometry, paradoxically lending a sense of overall unity and integrity to the compositions.

DYE PAINTING

In addition to traditional immersion dyeing methods, many quilt artists are painting with dye, applying it directly to fabric with brushes. This approach has been made possible by new fiber-reactive dyes such as Procion and Cibacron, which bond with fabric rather than lying on top of it like acrylic or other paints. Because fiber-reactive dyes link with the molecular structure of the fabric to which they are applied, they, unlike paint, do not change the texture of the textile's surface. The use of brushes gives the dye painter precise control of his results and allows an extremely wide range of painterly effects, from the thinnest of lines to broad areas of color, and from realistic depiction to the freest sort of abstraction.

Two of the pioneers of dye painting have been Gayle Fraas and Duncan Slade. They began experimenting with dyes in 1975, not long after graduating from art school, and soon discovered the new fiber-reactive dyes, which at that time were being marketed to industrial users rather than studio artists. At first the pair used the dyes only in silk screen printing, but in 1979 turned to the use of brushes to explore a range of painterly techniques, from soft impressionistic washes to solid colors with hard, linear edges. A Fraas and Slade quilt typically depicts a highly realistic landscape scene surrounded by a frame of geometric quilting or other patterned fabric. The frame is illusory, however, as the entire composition is painted with dye onto a whole cloth surface and then finished with machine or hand stitching to give it real dimension. According to Fraas and Slade, "[Painting] directly on fabric [made it] possible to employ painterly techniques without a look associated with traditional textile techniques. The materials no longer dictated imagery or idea. Directly applying dye to the fabric with a brush allowed us to use an array of complex patterning and color that would have been drudgery in the silk screen process. With painting we could create a rich surface of overlapping patterns, florals, geometrics, [and] stripes [as well as] patterns of varying sizes, juxtaposing large open patterned areas to tight repetitive geometrics."

ACRYLIC PAINT

Many art quilters trained as painters in art school and have found ways to incorporate brushwork with acrylic paint into their quilts. Nancy Erickson, who received a M.F.A. in painting from the University of Montana, is a figural painter who often works in oil on canvas as well as in fabric. She makes what are in effect quilted paintings, combining fabric appliqués and acrylic paint in large and carefully planned narrative pictures. She works from drawings which she projects onto paper and traces to create patterns for her appliqués. She traces the outlines of the patterns onto fabric with paint to blur the crisp lines of her drawings and adds paint to the cut fabric appliqués before combining them into the final composition. Quilting adds a subtle third dimension to the surfaces of her quilts. Although her images can be achieved solely with paint, Erickson chooses to work with fabric both because she finds textiles far more versatile than oil on stretched canvas and also because she likes to deliberately blur the perceived

LODGEPOLE DILEMMA ▶

Gayle Fraas and Duncan Slade. 1995. Edgecomb, Maine. Fiber-reactive dye, pima cotton, batting, metal foil. Hand painted, hand and machine quilted. 56 x 36 in. Collection Pointe Hilton Tapatio Cliffs Resort, Phoenix, Arizona. Fraas and Slade have been collaborating on their unique quilted textiles for over twenty years. This piece, created while the couple was in residence at an arts center in Banff, British Columbia, deals with the vexing problems of controlled burns in public forest management. While many wild places have been managed to maximize their scenic beauty, the recent devastating fire at Yellowstone National Park has forced foresters to face the central and inevitable role of fire in the cycle of forest life. The particular dilemma posed by the Lodgepole pine is that its cones must be exposed to heat before they will release their seeds.

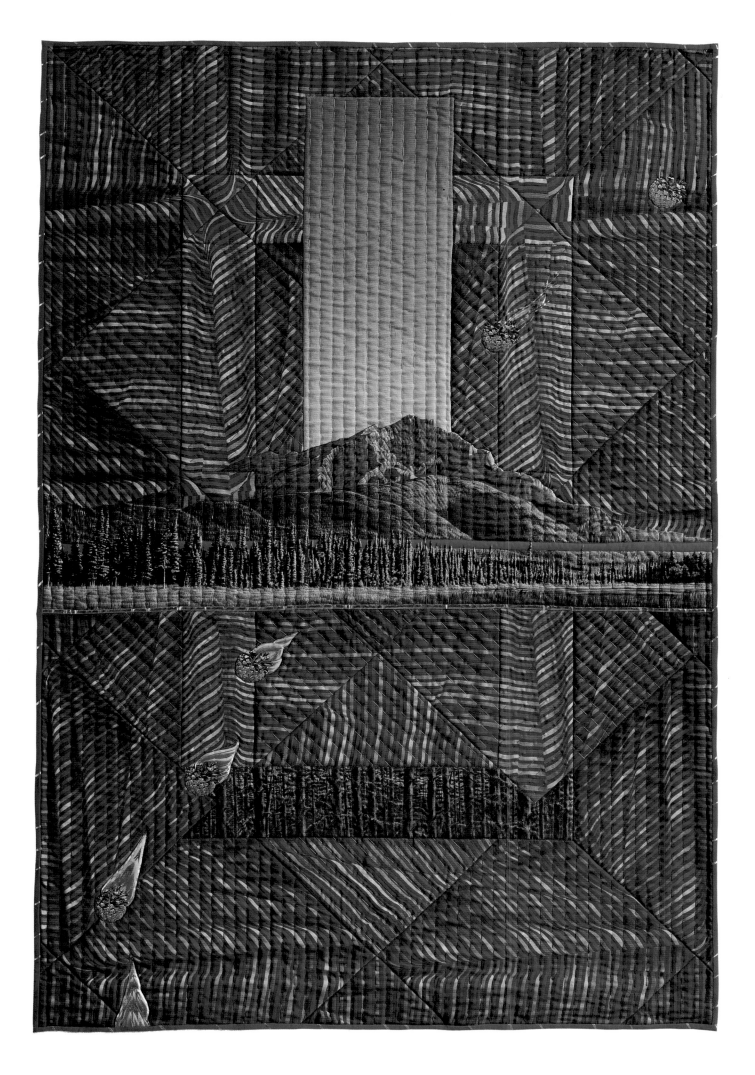

lines between craft and art. The combination of textures and the equality of fabric and paint in her quilts beg all the questions of the distinction between the two genres.

Elizabeth Busch studied painting at the Rhode Island School of Design and came to fabric after an eighteen-year career as an architectural designer. During those years, she made a variety of hand-sewn toys and mobiles for her children and also often painted abstract landscapes in oil or acrylic on canvas. In 1983, something happened serendipitously that changed her life dramatically: "I painted a painting I disliked and decided to cut it up. The painting looked great cut up. I thought I might combine it with other fabric I had collected." Unlike many other quilt artists, Busch had no history of quilts or quiltmaking in her family and therefore had no rules to break. She found encouragement and inspiration in Michael James's *Quiltmaker's Handbook* and "in one fell swoop, I was able to satisfy my great passions for painting and hand sewing. While my imagery and methods evolve as I do, I am basically still working with the same processes and materials today that I did in 1983: acrylic paint on seven oz. duck, purchased fabric, machine piecing, and hand quilting." Busch begins by completing a painting on the duck, which becomes either the top of the quilt, or, more often, is cut up into pieces for reassembly. Before cutting the painting, she takes Polaroid snapshots of the painting and cuts them into different shapes until she finds a pattern that works. The cut-up painting is combined with pieces of fabric to compose the quilt top; the pieces are then sewn together by machine and embellished with hand stitches in thread or yarn.

Unlike Erickson and Busch, Therese May adds paint to her quilts only after the fabric surface has been completed. "I paint on my quilts because I like to embellish and decorate," she explains. "Once a design is finished in cloth I like to keep going and enhance as much as possible. In a way, painting on an already finished quilt is to make it less precious—to take the risk of losing it or messing it up. But in another way, painting on a quilt and embellishing it is to make it more precious and jewel-like. Making mistakes is interesting because that changes the course of things—it makes unexpected things happen. Painting is a way of emphasizing and exploring those little quirks that make the art very personal."

DIRECT PRINTING

Direct printing has been used since ancient times to create repeated images or patterns on cloth and is familiar to most Americans through grade school memories of potato printing. Rubber stamps and linoleum blocks are the most commonly used tools for direct printing by quilt artists. An image or pattern is relief-carved into the stamp or block, which is then inked with dye pastes or paste paints and pressed against the cloth to create a mirror image impression. Typically, the same stamps or blocks are printed a number of times side by side to create repeating overall patterns. Complex patterns can be created by using several different blocks repeated in various orders and combinations.

Gayle Fraas and Duncan Slade often use rubber stamps to create illusory repeating geometric quilt patterns. Jeanne Wiliamson is a former computer type designer, many of whose whole cloth quilts are covered with hundreds of repeated rubber stamp imprints. Her work is so obsessively detailed that she recently began to suffer a form of repetitive motion syndrome from the endless stamping and has had to alter her working methods and designs accordingly.

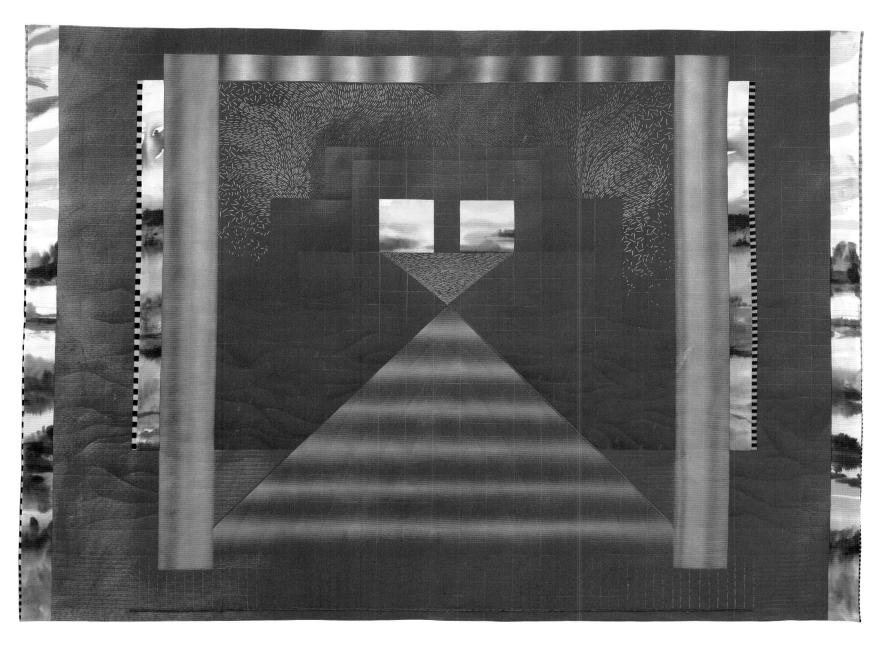

▲ **LAST PICTURE SHOW**

Elizabeth A. Busch. 1990. Glenburn, Maine. Acrylic paint on 7 oz. duck, dye on muslin, purchased fabric, polyester batting. Hand painted, airbrushed, machine pieced, hand quilted, hand embroidered, hand appliquéd. 67 x 86 in. Collection of the artist.
After working for many years as an architectural designer, Busch has made her living as an artist since 1987, primarily by creating large-scale sculptures for public spaces. She notes, "My art quilts are my deepest work, but certainly [don't provide] a monetary living for me." Like many modern artists, she likes the visual impact of working on a large scale, and enjoys contemplating truly massive projects. She told *Maine Preview* interviewer Maureen Farr, "I've thought that, for the rest of my life, I'd like to have something that would eject paint from my car so that everywhere I went there would be this trail! Or, all the telephone poles in this country—paint them all! Bridges are another thing."

STENCILS AND SILK SCREEN PRINTING

Stencils are patterns cut into cardboard or other stiff paper or metal. The resulting cut patterns can be placed against cloth and painted through with dye paint using a brush or airbrush. A number of Linda MacDonald's recent quilts, including *My Grisaille Portraits*, employ stencils painted with an airbrush. Silk screen is a far more complex and technically advanced variation of the same basic process, which uses a very fine stretched mesh of steel wire, silk, or nylon through which paint is forced. The image is formed using stencils or an applied liquid resist paste called "tusche." While silk screen is most often a commercial process used to create multiple copies of the same image, it has been employed by some ambitious quilt artists to create complicated repeated images, like

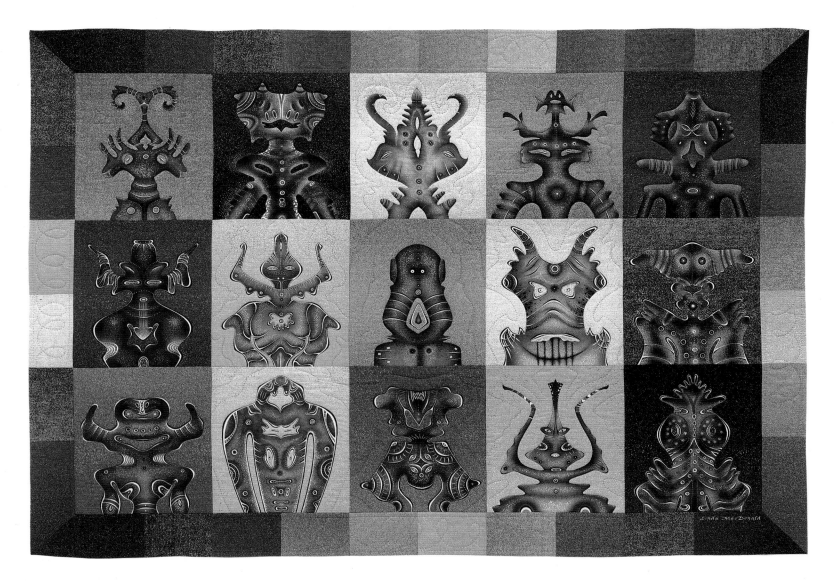

▲ MY GRISAILLE PORTRAITS (DETAIL ▶)

Linda MacDonald. 1996. Willits, California. Commercial cottons. Airbrushed and hand painted, hand quilted. 47 x 67 in. Collection of the artist.

MacDonald often chooses to work within narrowly limited color palettes. The word *grisaille* refers to a monochromatic work of art executed solely in black, white, and shades of grey. MacDonald explains that these fanciful abstract portraits belong to "a group of innerworld characters. They are combinations of objects that interest me: insects, plants, people, the unusual."

Joan Lintault, who used silk screen to create images of the various insects in her *The Flower Thieves*.

PHOTO TRANSFER

Photographic images of many types and sizes can be easily and successfully transferred to cloth. Many quilters use color or black-and-white photocopying machines to print single or repeated images on fabric. The desired images are photocopied on special heat-transfer paper and then adhered to cloth with a very hot, dry iron. The resulting printed fabrics can then be cut out and either pieced or appliquéd into the surface of the quilt. Catherine McConnell, for example, uses photographs documenting her own life and activities to create transfers that provide the central images for her quilts. She sees this use of personal photography as a modern continuation of the traditional quilter's use of fabric salvaged from family clothing to create "a kaleidoscope of memories, a diary of biological associations."

Merrill Mason juxtaposes the unflinching realism of photography with the comforting appeal of fine traditional quiltmaking to create works whose power emerges from the clash of their opposing contexts. She often covers the surfaces of her

▲ SCRAP THATCH (◄ DETAIL)

Merrill Mason. 1991. Jersey City, New Jersey. Photo-transfer on poly/cotton cloth, sewing thread, embroidery floss. Machine pieced and appliquéd, machine and hand embroidered, hand quilted. 65 x 91 in. Collection of the artist.
Scrap Thatch combines a visually seductive and beautifully crafted surface with an unpleasant subject. The quilt won the *Quilt National '93* Award of Excellence.

beautifully crafted quilts with transfer photographs of subjects that would normally be considered ugly or disturbing. Her *Scrap Thatch*, for example, uses photographs of jumbled piles of scrap aluminum, taken at a commercial recycling site in the heart of industrial New Jersey, to create a seductive and ultimately unsettling image. "Comforter or discomforter?" she writes. "My quilts contrast the conventional associations of stitched cloth—beauty, security and domesticity—with unlikely, provocative content. . . . [They] treat ugliness as though it were beautiful."

Tafi Brown has used the obscure archival technique of cyanotype or blueprint photographic printing in her quilts for nearly twenty years. Cyanotype images are toned like black-and-white prints but print in ghostly shades of blue rather than black. Brown creates her images from slides, which she transfers to high-contrast Kodalith blueprint film negatives in the darkroom. The negatives are used to transfer her images directly to cloth. After applying special chemicals to the fabric, she sandwiches the negative against the fabric under a plate of glass. When this is exposed

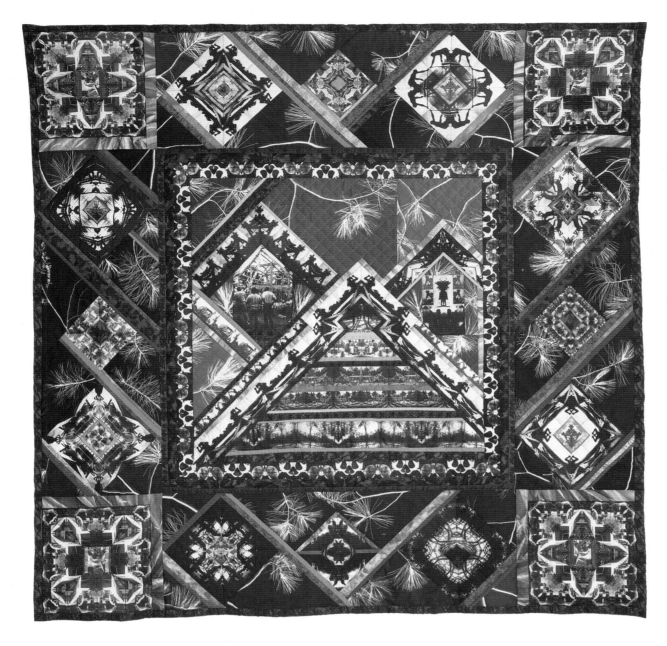

◄ JOINT EFFORT

Tafi Brown. 1993. Alstead, New Hampshire. Commercial cottons, hand-dyed and airbrushed cottons, cotton batting. Machine pieced and appliquéd, machine quilted. 62 x 62 in. Collection of the artist. Beginning in the late 1980s, Brown designed and contracted the construction of her own home, a process that took five years to complete. *Joint Effort* is the last of a series of quilts based on photos of her own house-building. She says, "I wanted to document community because I could not have built my house without the efforts of friends, neighbors, and colleagues. I used cyanotype photograms of pines because most of the structural and finish materials in my house are pine, because I like the sound of the wind through the pines around my house, [and] because I like the form and structure of [the trees.]"

to light, the blueprint image is transferred to the material. Her quilts often combine images of the New Hampshire forest that surrounds her home with repeating photos of graphically compelling timber-framed structures she has built and designed over the years.

QUILTING

Quilting is, in effect, drawing or sculpting with thread. It can add another element of overall design to the surface of the quilt, and by isolating bits of batting can also create a three-dimensional texture of subtly varied depth that some quilters compare to architecture. Like the quilt itself, quilting can be at once decorative and functional, adding pattern and texture to the quilt's surface at the same time it serves to unite the layers of the quilt and hold the central batting layer in place.

Many quiltmakers enjoy the slow, repetitive nature of quilt stitchery; California quilter Jonathan Shannon, for one, goes so far as to liken the process to Zen meditation. Hand stitching for some quilters provides a tactile intimacy with their creation that is savored as a nourishing, regenerative process. But others, either frustrated by hand quilting's slow pace or simply uninterested in investing their time in the

process, hire other skilled craftspeople to complete their work, often following designs they have drawn.

Another time-saving option employed by many art quilters is to quilt with a sewing machine, rather than by hand. Sewing machines are more versatile than ever before, and technically innovative machine quilters such as Harriet Hargrave have used the machine to open up broad new avenues of possibility in the past decade. Machines are now used to create patterns of extraordinary complexity that formerly could be executed only by the most highly skilled hand sewers. However, machine stitching is by definition harder edged and far more regular in appearance than any created by hand. When a softer, less mechanical touch is desired, hand sewing is still the method of choice.

Quilt stitches pierce the surface at right angles, and the running lines of the stitches create a puckered surface texture. Many quilters use the most traditional approach, sewing with thread that closely matches the colors of the fabric so that the pattern of the stitching is subtle and can only be seen clearly on close examination. If no clear pattern is desired, however, the artist can stitch with virtually invisible nylon monofilament thread or run the stitches in the seams of the fabric. On the other hand, the quiltmaker may choose to sew with thread of conspicuous color or size to emphasize or accentuate patterns or outlines. Some quilt artists sew with sparkling metallic threads, multicolored threads, or thick, colorful yarns which stand out boldly as elements of the overall composition. And a few, including Therese May and Susan Shie, will purposefully leave some or all of their threads dangling and untrimmed to add another layer of texture, color, and tactile interest to the surface of their quilts. Fran Skiles, who calls herself a dysfunctional quilter, says that unity in stitch length and construction has always been difficult for her, "like staying within the lines of a coloring book." In her quilts, she creates heavily

painted surfaces and thus feels free to machine stitch the pieces together without worrying about seams and unraveling edges.

EMBELLISHMENT

Several art quilters have created distinctive personal styles through the use of embellishment, that is, the addition of many small, usually non-fabric objects to the assembled surfaces of their quilts. The pioneer in this type of work is Terrie Hancock Mangat, who has created a number of extraordinary and highly personal narrative quilts since the late 1970s. To her complex assembled pictorial surfaces, which usually combine piecework and appliqué and often include found materials, Mangat adds pictorial embroidery, pieces of jewelry, and small personal mementos. Her *Hancock Memorial Quilt*, for example, was made as a memorial to her parents, who died in a car crash. Hancock explains the elements of the quilt's surface this way: "The crosses are on a mound made of an old Grandmother's Flower Garden quilt with grandchildren's names embroidered on the flowers. By my dad's cross are embroidered dog trophies because he raised beagles, and grocery items and coins because he sold groceries and collected coins. On my mom's cross is a wreath made of an old embroidered tablecloth embellished with her jewelry because she loved a festive house. Around her cross are cooking utensils because she cooked well for many." In addition to the embroideries and quilt stitching, the quilt is also embellished with many small beads.

Other important embellishers include Jane Burch Cochran and Susan Shie, who has worked with her husband James Acord since 1989. Cochran studied painting at the Cincinnati Art Academy before turning to the quilt as her medium in the mid-1980s. She often includes old clothing, gloves, buttons, and beads in her compositions. Her metaphorical *Life Line*, depicting a pair of

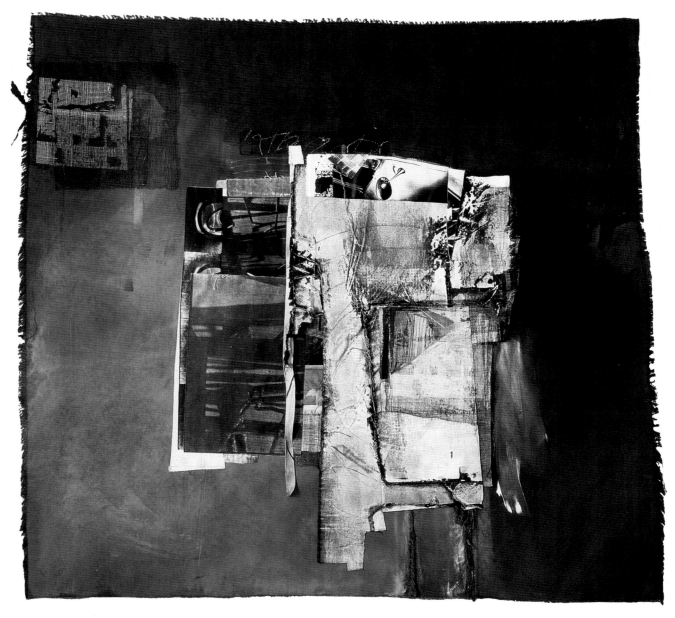

◄ **PIER CONSTRUCTION**

Fran Skiles. 1995. Plantation, Florida. Blue, black, and white cotton duck, woven painted hemp, acrylic paint, fabric paint, metallic paint, and thread. Photo silk screen, color copy transfer, machine stitching. 54 x 55 in. Collection of Francie Bishop Good and David Horvitz. Skiles uses photographs as a major design element in her work and creates textured depth by adding painted and printed woven hemp or nylon toile to a base of cotton duck.

personalized country clotheslines, is made of "various fabrics and old clothing [four gloves, a shirt, a pair of pants, and a skirt] that have been treated with paint and colored pencils, beads, and buttons." Draped over the rear clothesline is a patchwork quilt that serves as both a background to the lower half of the composition and a clever and resonant internal reference. The quilt was strip pieced by Cochran and then appliquéd to the background with thread strung with tiny beads.

Like Mangat and Cochran, Shie also trained as a painter, receiving her M.F.A. from Kent State University. She has been legally blind since birth, and the quilts she and James Acord assemble are as much tactile works as they are visual ones, em-

bellished with a host of small objects that invite the viewer to come in closer and closer and even touch the quilt. It is not possible to see them well or understand them from a polite distance, so the viewer is asked to share and participate in the artist's myopia. *Night Chant—A Green Quilt* is typical of Shie and Acord's recent work. Its strongly tactile, three-dimensional surface is heavily embellished with leather and clay faces, figures, and animals as well as beads, gemstones, and bone carvings and is further encrusted with Shie's spontaneous, diary-like writings, which offer running commentaries on the quilt's meaning and process. The artists explain, "Susan writes on the quilts after meditation and simply lets it come out. The first draft is on the piece."

KING OF SPADES ▶

Deidre Scherer. 1994. Williamsville, Vermont. Silk and cotton fabric and threads. Machine appliqué, embroidery, and quilting. 28 x 18 in. Collection of the artist.

This is one of the fifty-four similarly sized quilt "cards" included in the *Full Deck Art Quilts* exhibition organized by Sue Pierce and the Smithsonian Institution. Scherer based her image on a photograph of her father. She notes, "Initially the *King of Spades* had the myth of heavy power; now I'm feeling more benevolence behind this figure."

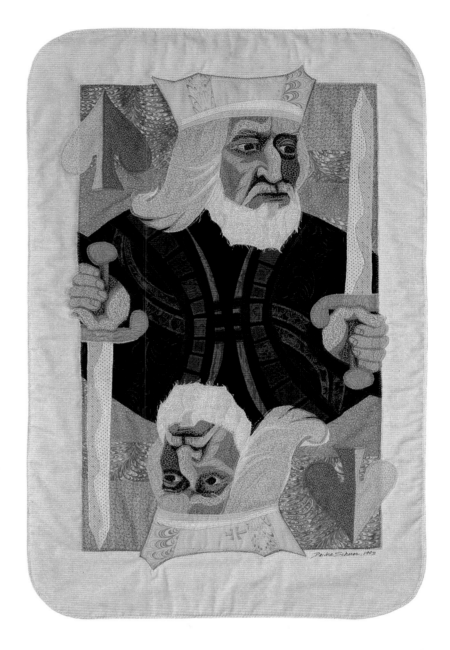

EMBROIDERY

Decorative stitching that pierces only the top layer of the quilt is also used by some quilt artists. Embroidery stitches were a mainstay of Victorian-era crazy quilters, many of whom outlined the edges of their piecework with a variety of conspicuous decorative stitches or added stitched pictures of birds, butterflies, or flowers.

Today's quilters can still stitch their embroidery by hand, as the Victorians did, or they can use a sewing machine to "draw" linear patterns or add pictorial designs to the surface of their quilts. Machine embroidery has the great advantages of speed and spontaneity, allowing the quilter to realize her design ideas quickly; it usually cannot be ripped out and changed, however, so the facility it provides is a double-edged sword.

Joan Schulze often combines hand and machine embroidery in her quilts, using the stitches to add texture to the subtle but complex surfaces. Terrie Mangat and Therese May both use embroidery as integral parts of their pictorial quilts. Mangat is a particularly versatile and highly skilled embroiderer who often combines fine stitches with paint in her figures and objects; a person's clothing might be painted and his features and outline delineated in thread, for example.

Art quilters continue to experiment with surface design methods, constantly bringing new techniques to their work and adapting and combining approaches to solve new artistic problems. As the range of techniques expands, so must definitions of the quilt's substance and meaning. Contests and exhibition guidelines follow the artists' lead, trying to make sense of the sometimes dizzying pace of change in the medium. But artists have thankfully always broken the rules that judges, curators, and historians attempt to impose, and, at least from a technical point of view, the explainers will undoubtedly be chasing the art quilt for years to come.

SUSAN SHIE AND JAMES ACORD

Susan Shie's and James Acord's wildly original quilts are a mixture of poetry, diary, humor, and prayer which they say are intended "to inform and heal." Although the pair has recently made a few unembellished, painted pieces, most of their quilts are mixed-media extravaganzas that stretch the definition of quilt so far that the artists themselves call them their "whatever-they-ares." A single work, which can take three or four months to complete, might combine machine-quilted fabric, painted images, Susan's automatic writing, stuffed and sewn "dolls," beads, hand-tooled leather hands, heads or animals (Acord is a leather worker), gemstones, ceramic creations (Shie was a potter in the 1970s), glow-in-the-dark paint, and large, funky hand stitches.

Shie has been legally blind since birth, and her myopia defines her highly tactile approach to art. She made many strongly three-dimensional quilts on her own before beginning to collaborate with Acord in 1989, and the couple's work together simply adds his talents to the mix she was already stirring. The two work intuitively, allowing their inclinations and the materials at hand to guide them. Their quilts serve as a spontaneous, ongoing diary of their life together, recording their thoughts, concerns, and everyday domestic experiences. Everything is grist for their mill, and recipes, friends, trips, a parent's bout with Alzheimer's, lava lamps, moon phases, teapots, gardens, a daughter's move to college, and concerns for the earth and environment have all found their way into their work.

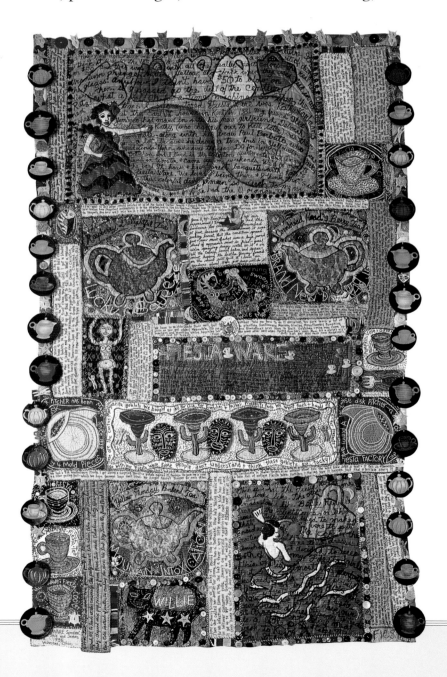

NIGHT CHANT: A GREEN QUILT ▶

Susan Shie and James Acord. 1993. Wooster, Ohio. Various fabrics, Deka Permanent fabric paint, glow-in-the dark acrylic paint, leather, glass beads, gemstones, buttons, carved bone, painted wood drummer pin, 3-D polyclay figures. Hand sewn, hand quilted, hand and machine embroidered, leather tooled, hand painted and airbrushed. 76 x 63 in. Collection of the artists.
According to the artists, "*Night Chant* celebrates the Higher Self. Glow-in-the-dark paint makes this quilt a lively experience at night—makes you feel like chanting and telling ghost stories! We need encouragement to un-program our sophisticated, logical thinking to open up to joyful spirits! This quilt is best experienced to the accompaniment of uplifting rhythmic music (drums and rattles) in the dark!"

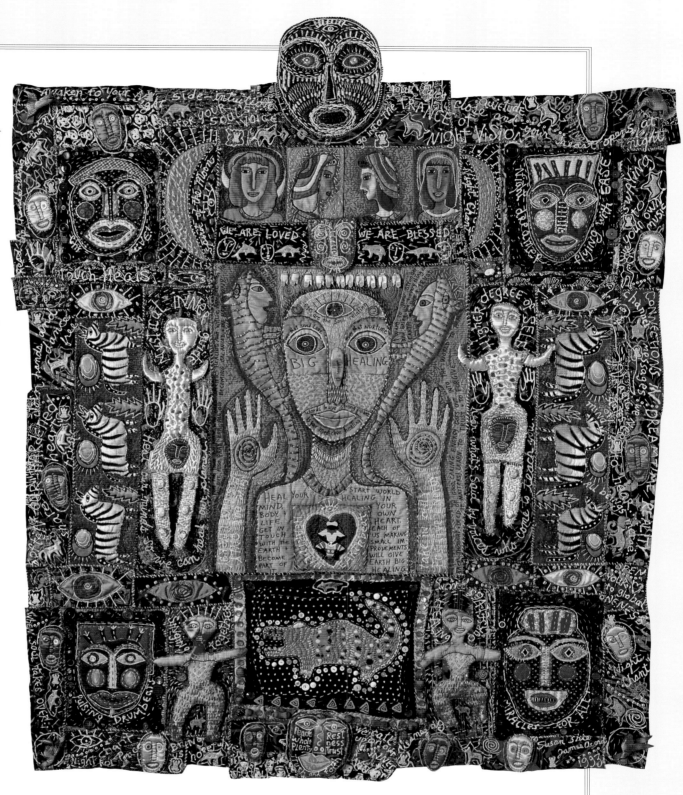

◀ THE FIESTA WARE QUILT

Susan Shie and James Acord. 1995. Wooster, Ohio. Mixed fabrics, paint, clay, beads, tooled leather, plastic cactus goblets, polished gemstones, buttons, pennies, embroidery floss, laundry marker. Hand appliquéd, hand painted, hand embroidered, hand and machine quilted. 87 x 54 in. Collection of the artists.

Shie comments, "Our work grows, like a garden, over several months. This is a diary/story quilt entwining our adventures between March and September 1995 and the theme Fiesta Ware—the playful, color mixable, cult-collectible dinnerware made by the Homer Laughlin China Co. since 1936. Fiesta's senorita logo lady makes two appearances along with various painted, stitched, beaded, clay, and tooled leather images of the famous Deco dishes. What happened to us that season is chronicled, [written] first draft right on the quilt. [Beginning] our Fiesta collection, finding the Laughlin factory only two hours from home, emptying my parents' house, creating a prosperity margarita party ritual package for our daughter and her beau, the mix-up when our Trooper got rear-ended, thought he smelled pot in our car, and we finally realized he was smelling my perfume. Entries about the garden, reminiscences about the first friends we had with Fiesta dishes."

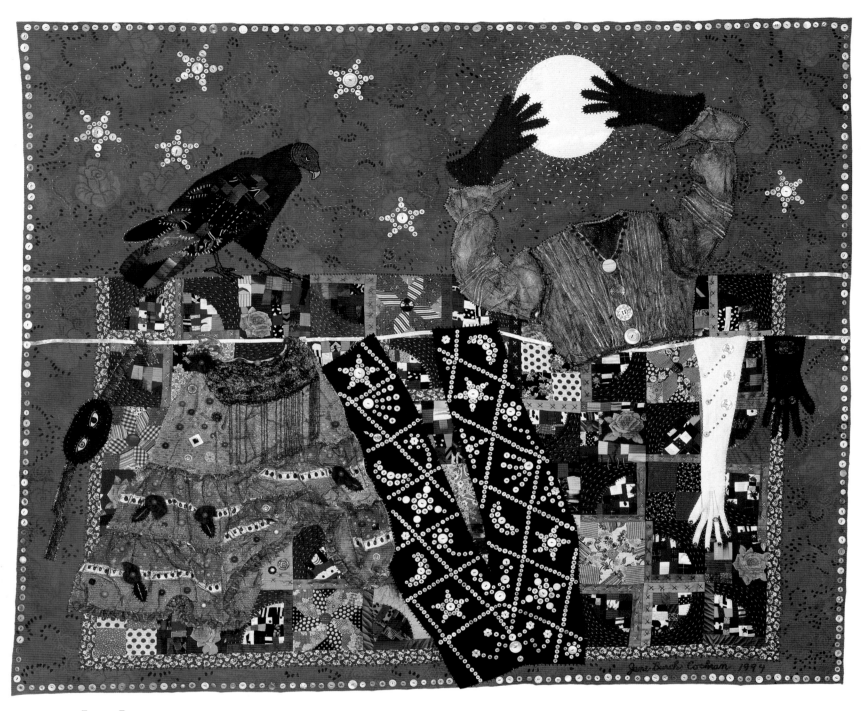

▲ LIFE LINE

Jane Burch Cochran. 1994. Rabbit Hash, Kentucky. Fabric, beads, buttons, paint, colored pencil, ribbon, found objects including gloves, blouse, petticoat, and mask. Machine pieced, hand appliquéd with beads, hand embellished. 68 x 82 in. Collection of the artist.

According to the artist, "In rural Kentucky, you still see a few clotheslines. I love to see the clothes waving in the breeze. They tell a story about a family. *Life Line* is a self portrait: part gypsy butterfly, part pearly queen, part moon chaser. The pearly kings and queens are a group of cockney English who cover their clothes with buttons and collect alms for the poor. The turkey buzzard is a bird I see every day. They look so beautiful when they are flying and soaring, but up close they are ugly by our standards. Perhaps made of beads and silks, it seems more beautiful."

▲ OUT OF THE SHADOWS

Susan Wilchins. 1991. Raleigh, North Carolina. Dyed, screen printed, overdyed, pieced, appliquéd and machine-stitched cotton fabrics. 40 x 48 in. Collection of the artist.

Wilchins notes, "My work [uses] fabric to describe my intense visual experiences of the Earth and its natural phenomena. I am particularly interested in using color, the layering and juxtaposition of patterns, and the exaggeration of detail as means of imbuing the images with emotional meaning."

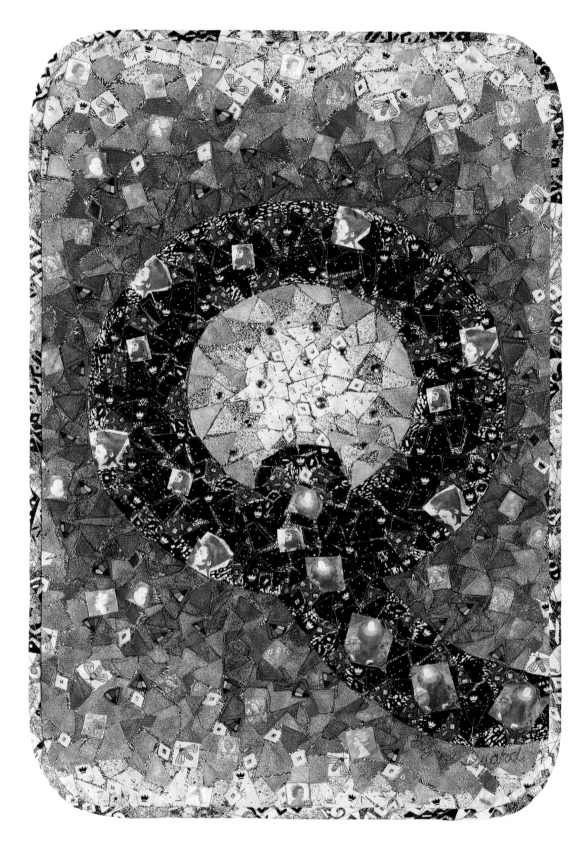

◄ QUEEN OF DIAMONDS

Lynne Sward. 1993. Virginia Beach, Virginia. Cotton, cotton blends, crystal and plastic cabochons, flannel batting. Photo-transfers, machine appliqué and free-motion embroidery, hand stitching. 28 x 18 in. Collection of the artist.

This is one of the fifty-four quilt "cards" included in the *Full Deck Art Quilts* exhibition organized by Sue Pierce and the Smithsonian Institution. The card includes photo-transfer images of diamonds, Elizabeth Taylor playing Cleopatra, queen bees, and Britain's Elizabeths I and II. In addition to her meticulously detailed quilts, Sward also makes quilted clothing and jewelry.

AMERICAN IN ASIA ►

Niki Bonnett. 1995–96. Greenwich, Connecticut. Flag made with colored pencils and spray paints on canvas dropcloth; commercial, hand-dyed, and surface-designed fabrics including silk, cotton, cotton blends, artist's linen, and Ikat-dyed cloth; paint, colored pencil, found objects, photocopies on paper and acetate, glue. Pieced, appliquéd, collaged, hand and machine sewn. 53 x 83 in. Collection of the artist.

When Bonnett had the opportunity to travel to Asia for a month early in 1995, she decided to make a wordless fabric diary of her trip, "illustrating the way my American outlook would be daily influenced and overlaid with things Asian." Before the trip, she made the flag, which was then torn into twenty-eight diary "pages." She took these with her, intending to work on the piece daily as she traveled, but she was not able to finish it until a year later. She worked on the pages individually, employing sketches, notes, photographs, and souvenirs (including Asian fabrics, origami paper, postage stamps, postcards, luggage tags, and coins) from the trip, and then reassembled the flag by hand sewing the completed pieces to a fabric background.

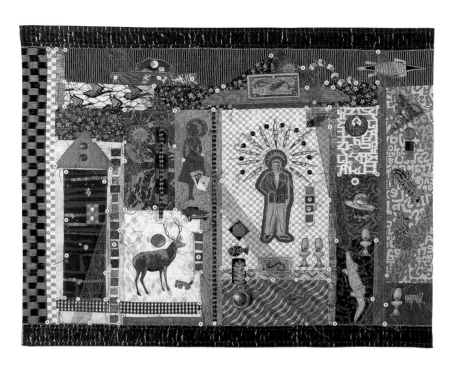
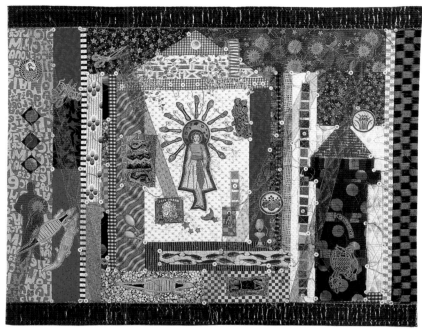

▲ BOB AND RITA TRY TO FORGET

Gretchen Echols. 1993. Seattle, Washington. Cotton, heat transfers of color images, ribbon, buttons, DMC perle cotton, Cotton Classic batting. Machine pieced, appliquéd, and quilted, hand quilted. 48 x 96 in. Collection of the artist.

Echols presents mysterious, dreamlike images focused around color copy images of her large childhood paper doll collection. According to the artist, this diptych comments on learning and forgetting, problems in human communication, and the hope of rebirth in the face of loss. She calls it a "story of an inner journey," and she notes that "we need reflection to bring light into the dark corners."

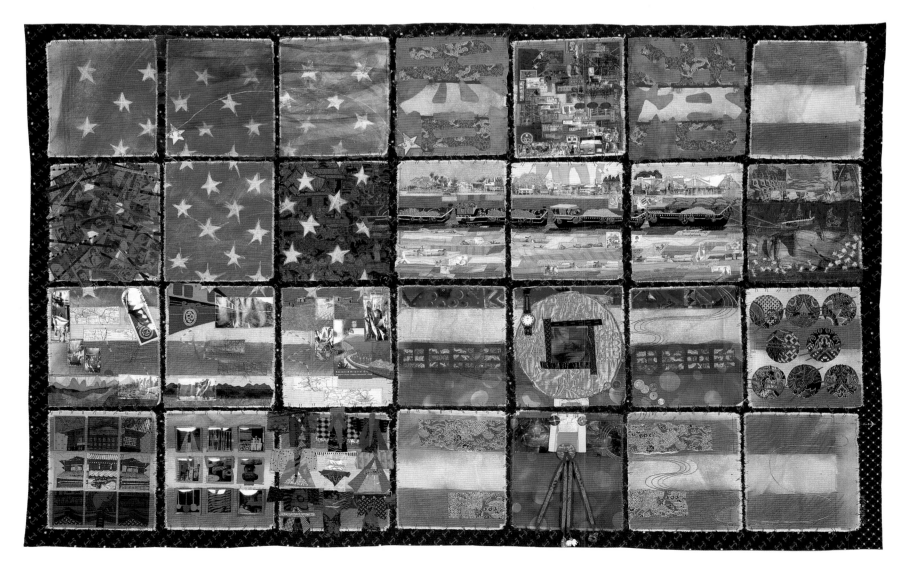

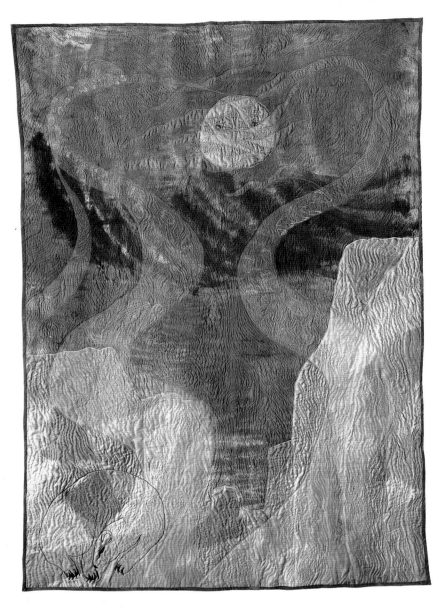

◄ ARCTIC DREAMS

Ellen Anne Eddy. 1992. Chicago, Illinois. Hand-dyed blue and purple cottons, nylon organzas, metallic, rayon, iridescent and monofilament nylon thread, perle cotton thread. Direct and reverse appliquéd, machine quilted. 67 x 47 in. Collection of John Walsh III.

Eddy usually works from her dreams. She made this quilt after a traumatic experience stopped her dreams entirely, hoping that this dream quilt would reverse the process and stimulate new dreams. Happily, it did. A large polar bear lies curled asleep on the iceberg at lower left, while smaller spirit bears walk up paths to the moon, leaving trails of footprints. The contoured free-form quilting is arranged in watery swirls and eddies, and the entire icy surface glints and sparkles with dots of metallic and iridescent threads. The icebergs are built of as many as a dozen layers of sheer fabric.

HOME SERIES: HOME IS WHERE YOU FIND IT ►

Barbara Otto. 1992. Stillwater, Minnesota. Unbleached cotton muslin, Procion H dye, wax resist. Hand painted with dyes, machine quilted along the off-white resist lines. 91 x 73 in. Collection of the artist.

The simple geometric shapes in this hand-painted whole cloth quilt were influenced by the paintings of Paul Klee as well as by traditional American pieced quilts. Otto describes the quilt as "a sort of imaginary landscape" and notes that drawing directly on cloth allows more varied and complicated shapes than she would be willing to use with traditional piecing techniques. Besides, she adds, "The distinction between painting and quilting gets blurred, and the painted quilts encourage people to wonder about how we define art."

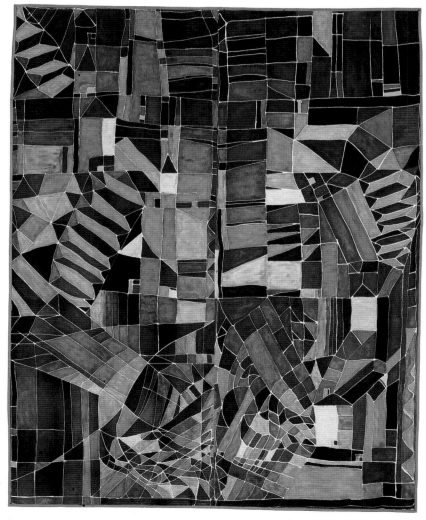

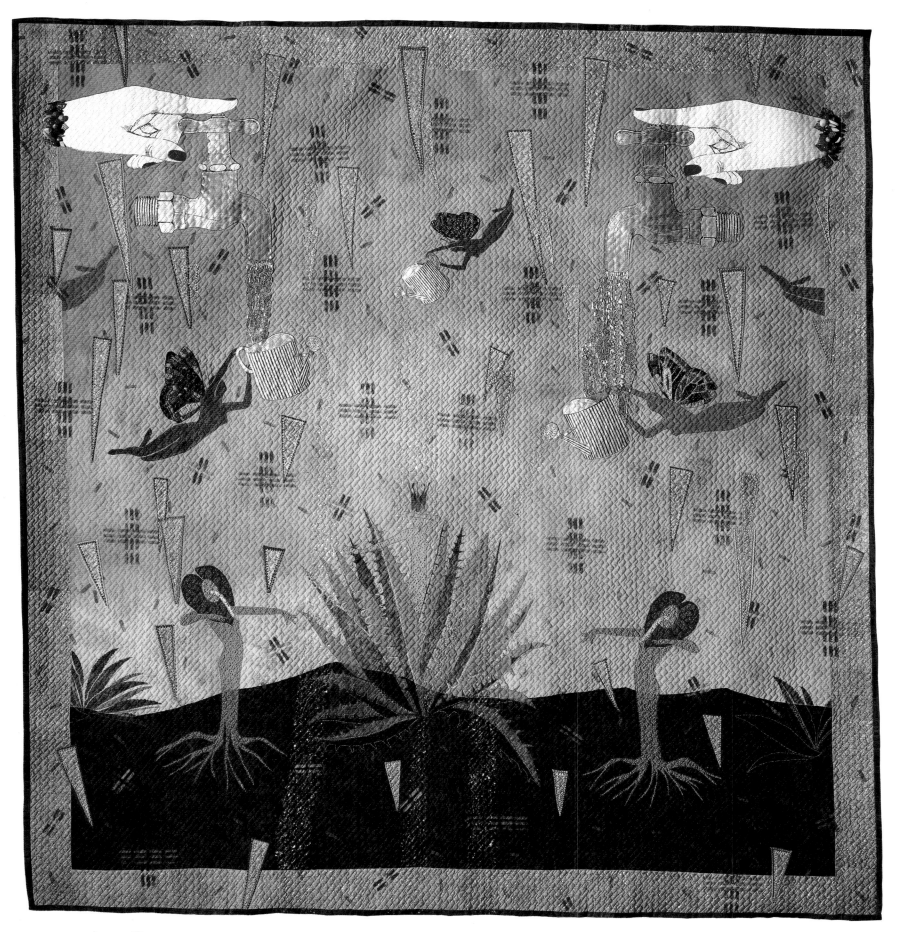

▲ **ACID RAIN**

Wendy Huhn. 1994. Dexter, Oregon. Cottons and blends, photo-copy fabric, phosphorescent medium, beads, paint, stencils, colored transfers. Machine pieced and quilted, appliquéd. 60 x 56 x 1/2 in. Collection of John Walsh III.

When she was invited to create a quilt on the theme of water for a 1994 museum exhibition, Huhn came up with this psyche-delic vision of a world drenched in a special kind of precipitation. She explains, "I am a child of the sixties, and the term 'acid rain' held a different context then than it does now. I did inhale, etc. But then I'll never run for public office." The surface of the quilt is covered with thousands of beads, another icon of the 1960s.

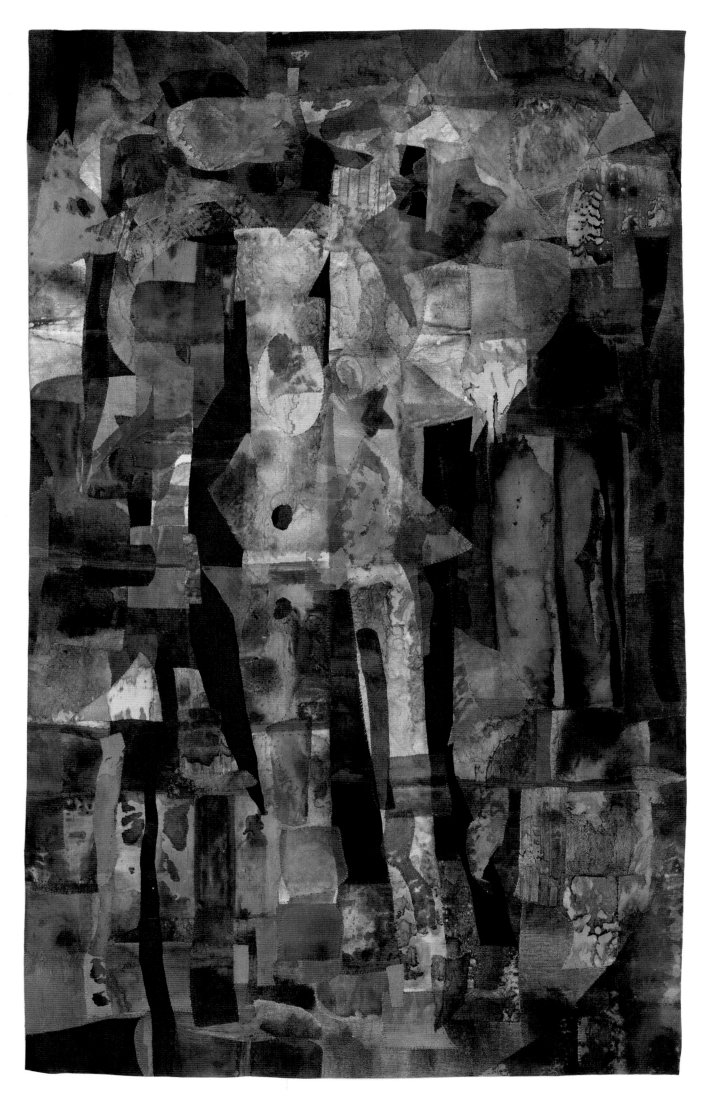

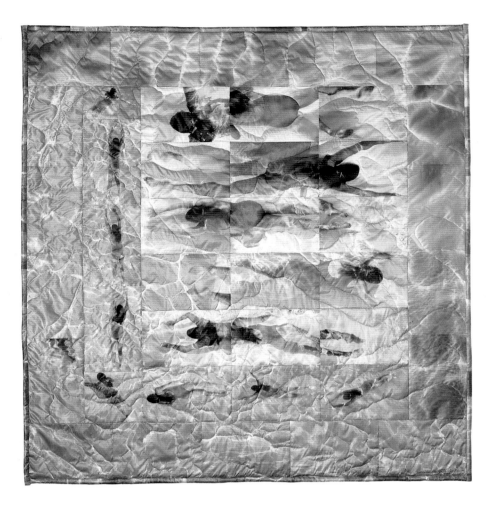

◄ VERMONT SWIMMERS

*Catherine McConnell. 1991. Pittsburgh, Pennsylvania.
Heat transfers on acetate, cotton backing. Machine
quilted. 85 x 85 in. Collection of John Walsh III.*
McConnell here juxtaposes the three-dimensional
texture of a puckered, quilted surface with flat
photo-transfer images that give the illusion of depth.

▼ WALLS 4

*Cherilyn Martin. 1994. The Netherlands. Batiked silk
by Els van Baarle, mixed fabrics, newspaper, fiberfill.
Hand painted, machine construction, machine quilted
and embroidered. 53 x 48 in. Collection of the artist.*
Martin studied embroidery at Manchester Metro-
politan University in England and uses it as a major
element in her quilts. She employs hand and
machine embroidery to create rich textures on the
quilted surfaces and often works with unusual
shapes which she says are "reflections of construc-
tions, details, or elements of buildings. The influ-
ence of architectural forms both ancient and modern
has been great."

◄ MISSING I: THE LANDSCAPE

*Emily Richardson. 1994. Philadelphia,
Pennsylvania. Textile paint on silk and
cotton. Hand appliquéd, embroidered,
and quilted. 43 x 26 1/2 in. Collection
of Peggy and Al Richardson.*
Richardson is a freelance theatrical
costumer who draws on her dramatic
experience to create her layered,
painterly abstractions. She often uses
transparent hand-painted silks to
build veiled, spatially ambiguous com-
positions such as this piece.

▲ CHECKING OVER THE RAINBOW #17

Caryl Bryer Fallert. 1994. Oswego, Illinois. Hand-dyed and painted cottons, wool batting. Machine pieced, pleated, and quilted.
46 1/2 x 77 in. Collection of Fidelity Investments, Covington, Kentucky.
This is one of a series of quilts Fallert designed on a computer in which three-dimensional fabric "tucks" are incorporated into a pieced background. The alternating rows of background strips create the illusion of black checks floating in space, with unexpected areas of light and color. In addition, the tucks have color and value gradations on each side to create the illusion of movement and light across the quilt's surface. Because different gradations are used on either side of the tucks, the appearance of the quilt can change significantly as the viewer alters his point of view.

▲ CROSSFIRE

Libby Lehman. 1996. Houston, Texas. Hand-dyed and commercial cottons, rayons, metallic and decorative threads, Soft Touch cotton batting. Machine sewn. 46 x 46 in. Collection of the artist.

Lehman describes her creative process this way: "I work on one quilt at a time and very seldom have a preconceived idea of what it will look like. I begin with one idea, do that, stare at it until I come up with another idea or it tells me what to do next, do that, and keep on until it seems complete. This sounds simple,and sometimes it is. Other times, it is pure agony. I called one quilt *Silent Partners* because it never answered back!" This piece uses thread as one of its essential design elements.

◄ SPIRIT HOUSE

Jan Myers-Newbury. 1991.
Pittsburgh, Pennsylvania. Procion-
dyed 100% cotton muslin.
Machine pieced and quilted.
70 1/2 x 75 1/2 in. Collection of
the artist.

Myers-Newbury made this atypical personal narrative quilt as a response to several years of unsuccessful attempts to conceive a child with her husband. She notes, " *Spirit House* was a sort of fertility object, an outlet for my feelings of loss and a focus for the future. There are three abstract figures in the quilt, two adults and one child—an attempt to invite the spirit of a child into our home. For the first time, I worked with color purely on a gut level, and did not use any 'trademark' sequences of gradated solid [fabrics]." The quilt's fabrics were tie-dyed by Newbury.

◄ OPENING PALM

Nancy Whittington. 1993. Carrboro, North Carolina. Hand-painted silk. Hand pieced and quilted. 31 x 52 in. Collection of the artist.

Worked entirely in hand-painted silk, this piece has a shimmering surface quality that closely approximates the look and texture of its subject. Whittington explains: "I make quilts because of the beauty of the textile surface. This richly decorative patterned surface creates an aesthetic different from painting. Quilts have a monumental presence [but also] share the intimate quality of all objects made by hand."

▼ GERANIUM

Velda E. Newman. 1993. Nevada City, California. Hand-dyed cottons. Hand stitched. 80 x 98 in. Collection of John Walsh III.

Newman dyes all her own fabrics, working slowly and deliberately to render nuances of color and light in her enormous still-lifes of plants and flowers. Although she has produced only a handful of quilts, her unique hyper-realistic approach and extraordinary workmanship set her apart.

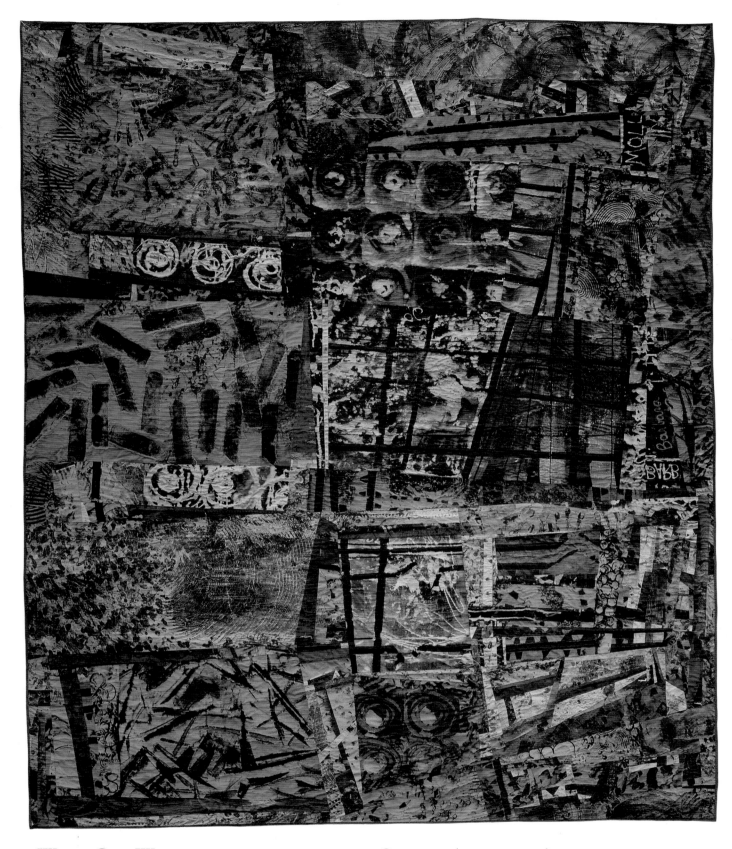

▲ WHEN GOD WEEPS

Barbara Moll. 1996. Muncie, Indiana. Cotton, Procion dyes, polyester batting. Hand painted, machine pieced, hand quilted. 86 x 72 in. Collection of the artist.
This abstract quilted painting employs a somber palette and enveloping size to project both sorrow and comfort.

OVERLAY (DEEP BLUES) ▶

Barbara Todd. 1995. Montreal, Quebec. Woolen fabric with wool batting and cotton back. Hand sewn and quilted. 86 x 68 in. Collection of the artist.
Like a traditional wool whole cloth quilt, this piece emphasizes the textures and patterns of its hand quilting. Two coffin-like shapes cast ominous shadows on the swirling quilting. In a recent exhibition of her work, Todd presented the following lines by the poet Muriel Rukeyser as a counterpoint to her quilts: "The days grow and the stars cross over/ And my wild bed turns slowly among the stars."

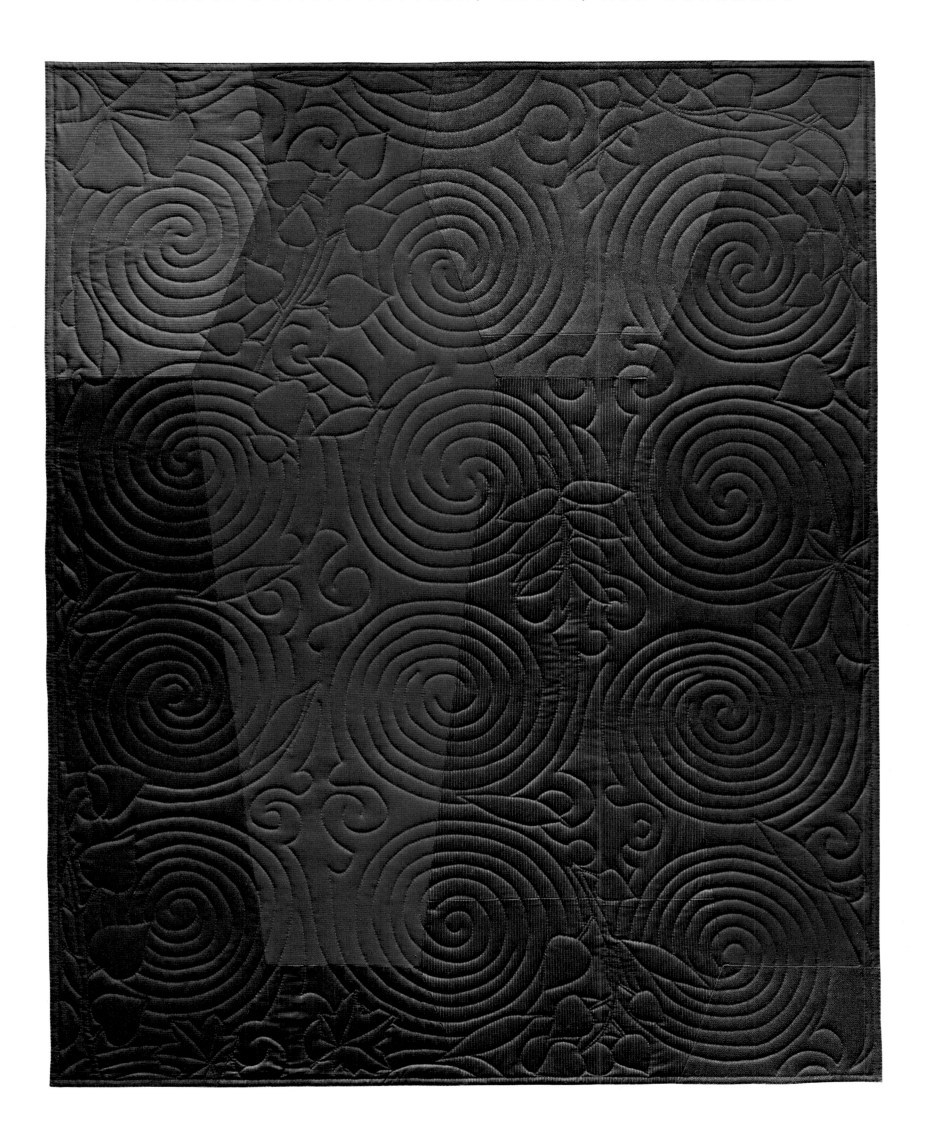

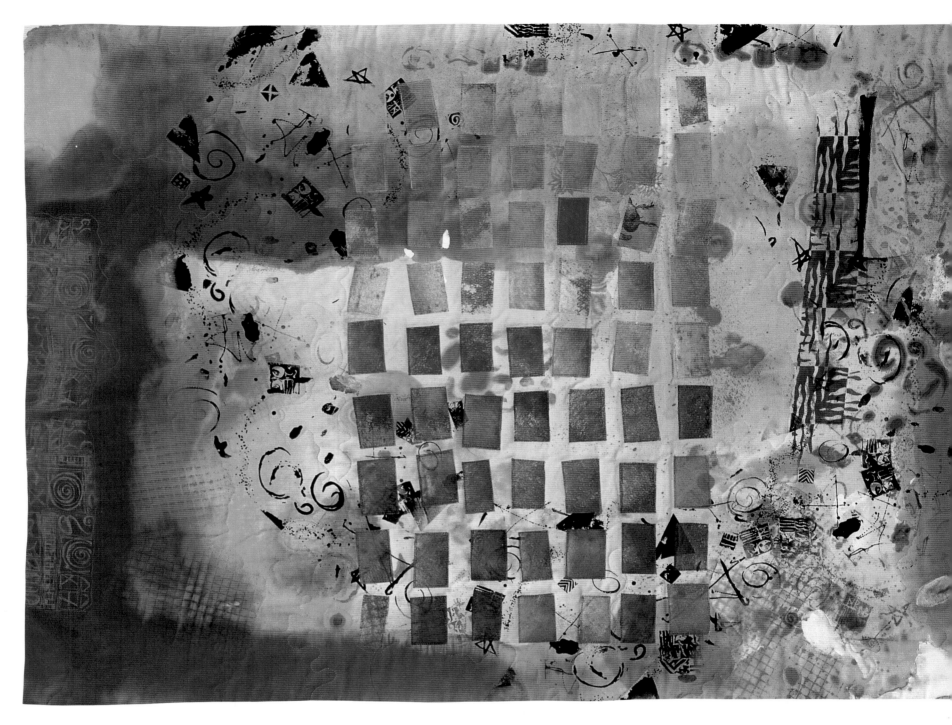

▲ ORDERING CHAOS

Jane Dunnewold. 1996. San Antonio, Texas. Hand-painted vintage cotton, silk-screened and stenciled, appliquéd with hand-painted industrial interfacing. Machine assembled and quilted. 54 x 84 in. Collection of the artist.

Dunnewold came to the art quilt through fabric painting and surface design, taking up quiltmaking when the cloth she was making became "too nice" to cut. By using the cloth for quilts, she found she could keep it whole and also add stitching and a host of other surface design elements.

NIGHT LIFE ▶

Melissa Holzinger. 1995. Arlington, Washington. Canvas painted with acrylics and pastels. Machine-enhanced stitching, airbrushed, stenciled, collaged. 45 x 36 in. Collection of Bonnie Boydosarian.

Holzinger combines the materials of a painter with the techniques of traditional quiltmaking, sewing pieces of painted canvas together into complex stitched collages. She began making quilts in 1983, at first using hand-dyed cottons and silks and sewing by hand. Acrylic paints, pastels, and graphite have now replaced dyed fabric, and all her sewing is done on an industrial sewing machine. To the question, "Why sew at all?" she responds, "I think of sewing as my 'native language.' It speaks to and of a cultural context and a historical legacy in a way that I cannot find elsewhere."

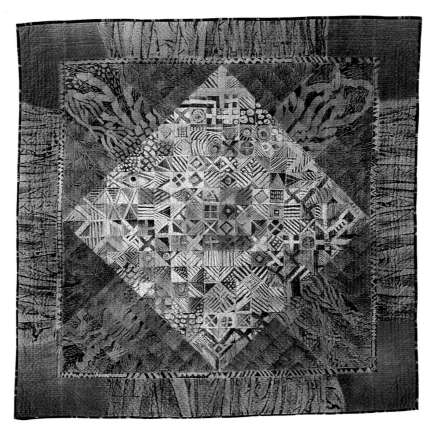

◄ **DIAMOND AND CROSS**

Lenore Davis. 1992. Newport, Kentucky. Cotton velveteen, metallic thread, textile paint and dye. Monotyped, painted, and hand quilted with tailor's collar stitch. 56 x 56 in. Collection of John Walsh III.

The printed and painted patterns of this whole cloth quilt suggest traditional piecework, as does the center diamond format of the design.

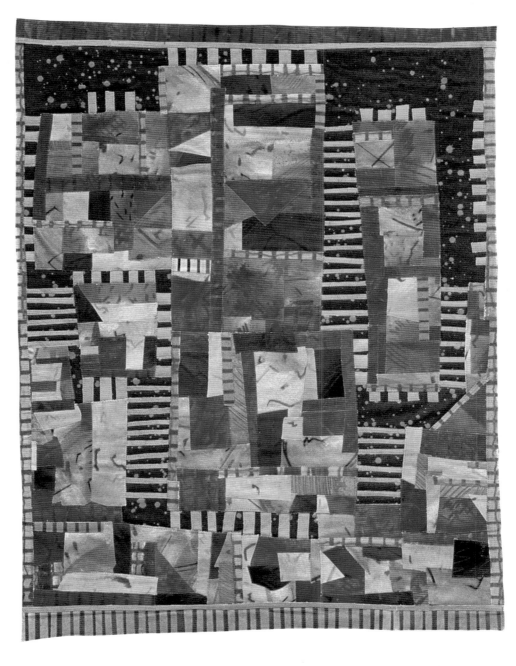

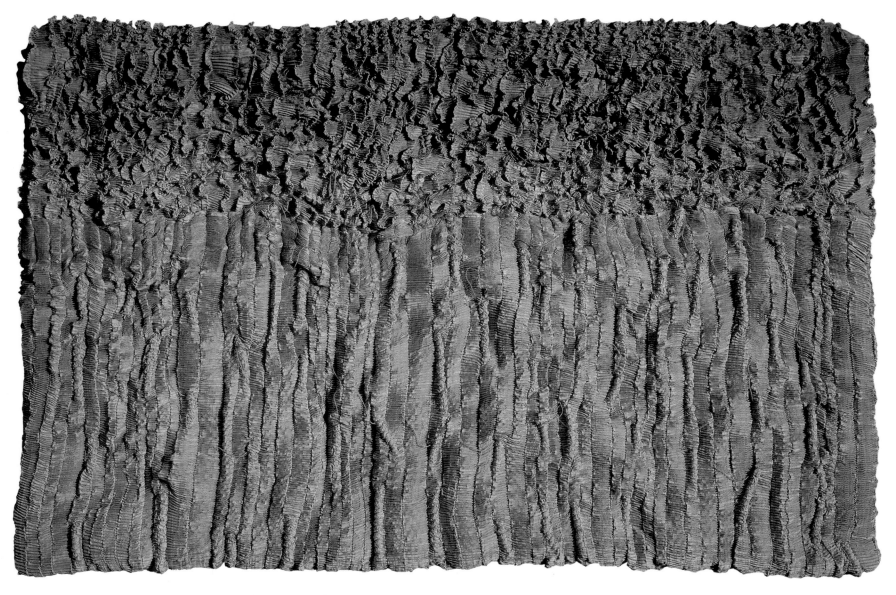

▲ HORIZON X/AMBER (DETAIL ▶)

Ardyth Davis. 1993. Reston, Virginia. Hand-painted and pleated silk, piping cord, and filling. Hand and machine stitched, hand tied. 32 x 48 in. Collection of John Walsh III. Davis's abstract quilts explore the color and texture of fabric; the medium is her message. Here, subtle gradations of painted color are combined with a heavily textured, pleated surface.

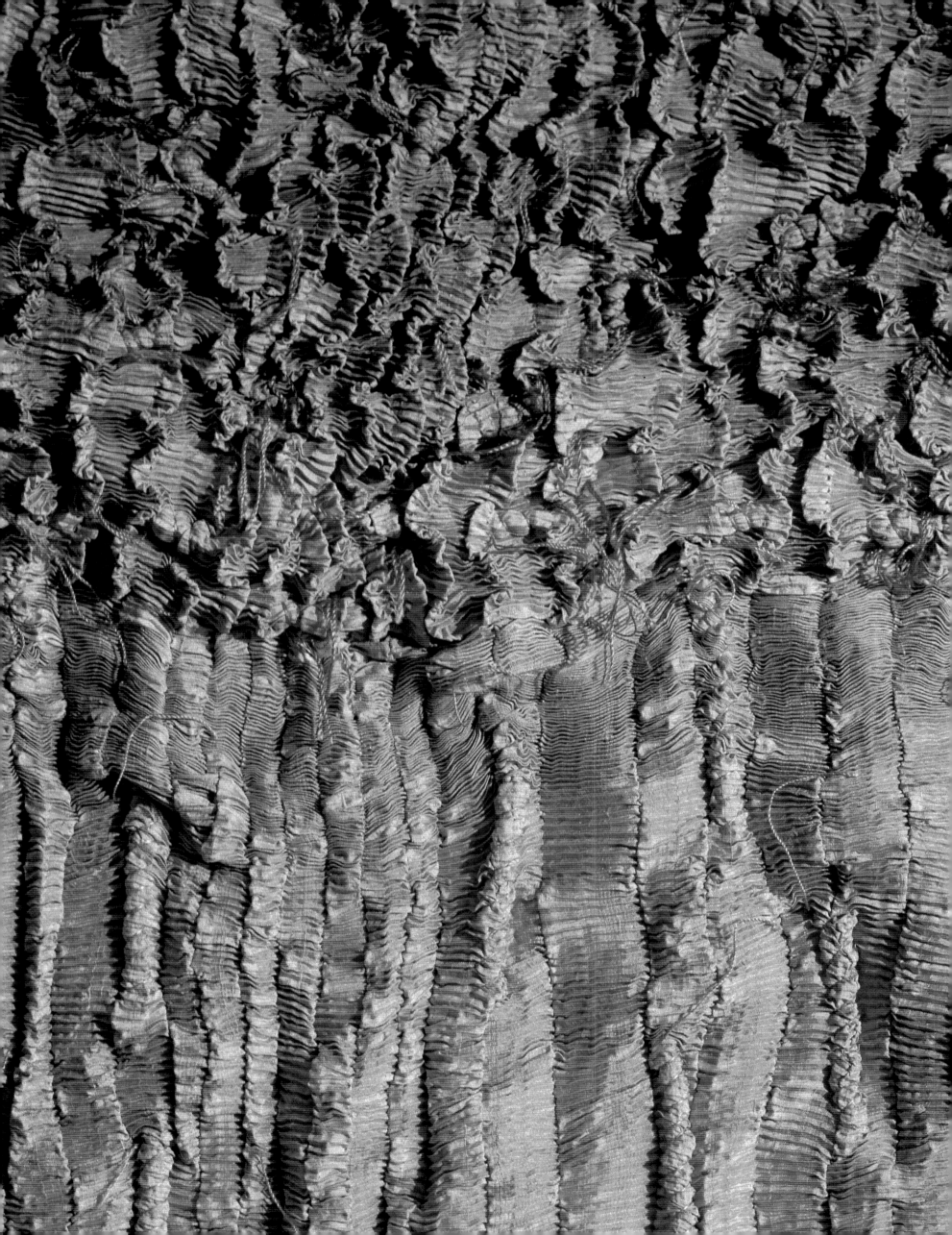

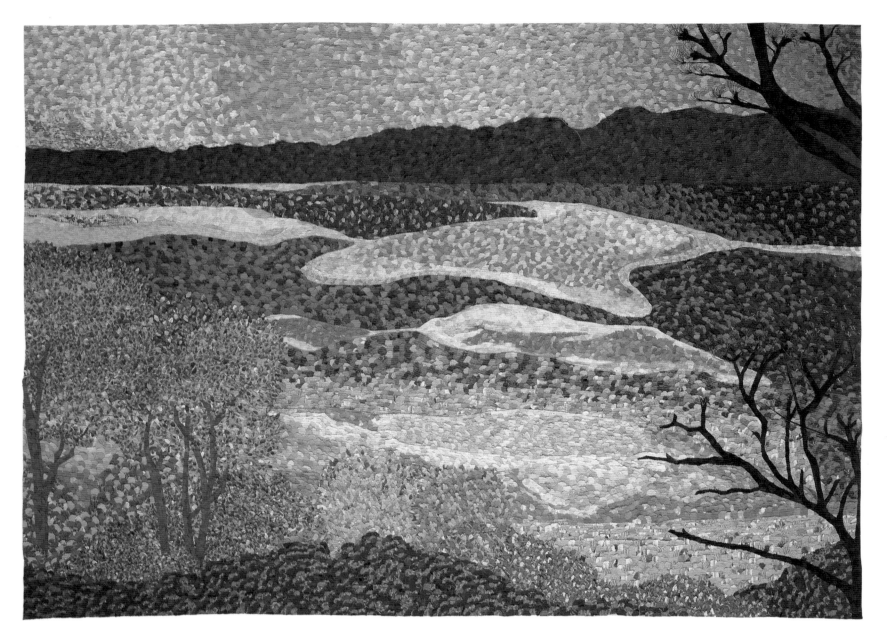

▲ SALT MEADOW

Holley Junker. 1991. Sacramento, California. Cotton fabrics. Machine sewn, hand tied. 84 x 91 in. Collection of Elizabeth Carlisle Byerly.
Junker layers hundreds of tiny pieces of fabric cut with pinking shears to produce the soft, shimmering, pointillistic surfaces of her landscape quilts. The textural quality of the many overlapping pieces of fabric gives tactile and visual depth to her investigations of light and texture in the landscape. This piece was made as a commission for a North Carolina beach home and depicts the view from the building's second story.

NEW MOON OVER MEXICO ▶

Sandra Sider. 1990. Bronx, New York. Cyanotype photo transfers, cotton fabrics, fabric paint, mounted on canvas backing. Machine pieced, mounted with hand-embroidered French knots. 41 x 38 in. Collection of the artist.

Sider photographed the images used here on New Year's Eve 1989 in Mexico City. The center shows riot police outside the British Embassy; other images include a photo shop, a cathedral, and an antique wall of skulls. To create the quilt, Sider first transferred her 8 x 10 black-and-white high-contrast photographs onto transparency film. They were next masked and etched and then sunprinted in negative onto different colored cotton fabrics sensitized with cyanotype chemicals. A few of the prints were toned after printing; other images were stamp printed in silver fabric paint using carved erasers.

THE RIVER QUILT ▶

Jean Ray Laury. 1995. Clovis, California. Cottons. Silk screened, dye painted, machine quilted. 113 x 89 in. Collection of The Yosemite Bank, Yosemite, California.

Laury was a pioneer in the use of silk-screened images on quilts. This large recent piece was commissioned by the Yosemite Bank and features photo silk screens of area flora and fauna. All the screens were printed in one color, and then other colors were added by hand.

YVONNE PORCELLA

Yvonne Porcella is entirely self-taught in both art and textile work, unlike most art quilters, who come from an art school background. Porcella worked for nineteen years as an operating room nurse, and became deeply involved in the creation of ethnically influenced pieced clothing in the 1960s. From there, she moved to designing wearable art, what she calls "collaged clothing with flowing color and patterns across the front, back, and sides of a garment." She made the transition to art quilts in 1981, when two of her pieced and quilted kimonos were accepted into *Quilt National*.

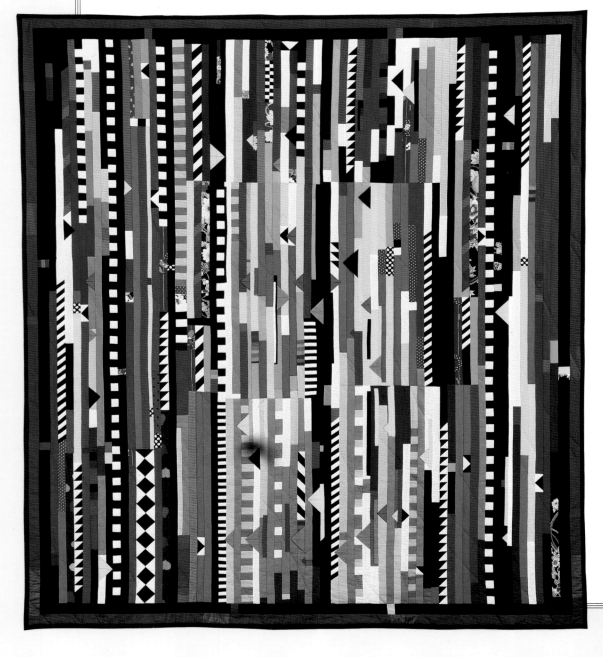

Porcella's creative output is as varied as anyone's in the field, ranging from ethereal hand-painted silk florals to exuberantly playful pieced and appliquéd compositions full of amusing Pop art graphics and bright, bold color combinations. Her repertoire of piecework forms is limited to stripes, squares, and half-square triangles ("I couldn't make a traditional pattern like a Drunkard's Path," she laughs), with which she builds striped panels, checkerboards, or Log Cabin variations. By juxtaposing colorful appliquéd and painted objects and figures—cartoon-like stars and hearts, pet dogs, cats and birds, flowers, people, flags and other Americana—against or next to simple geometric background elements,

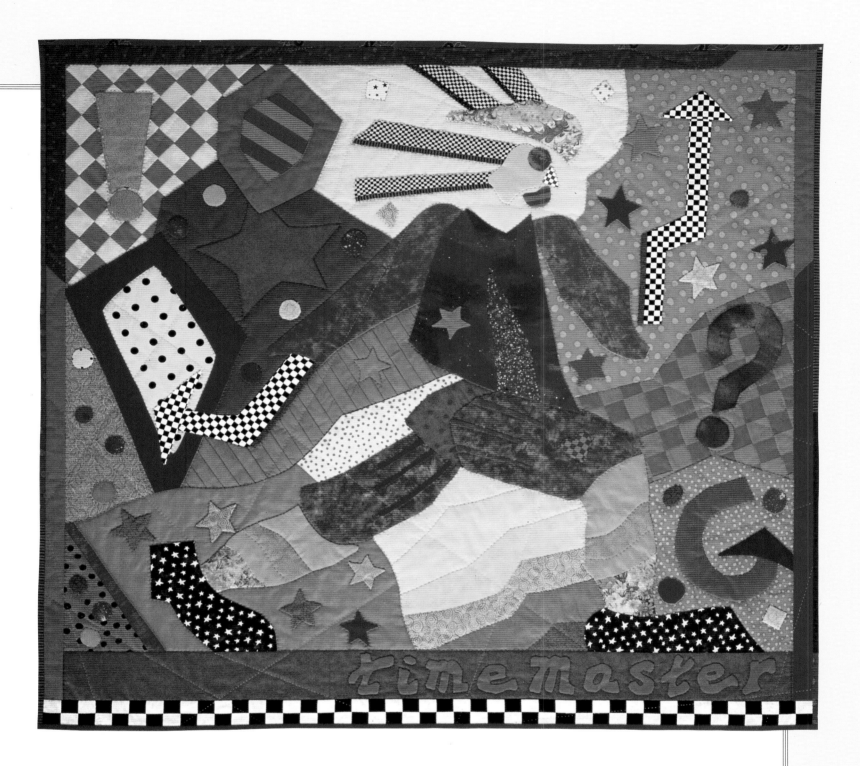

◄ TAKOAGE

Yvonne Porcella., 1980. Modesto, California. Cottons. Machine pieced, hand quilted. 82 x 72 in. The Renwick Gallery, National Museum of American Art, Smithsonian Institution, Washington, D.C.

This is Porcella's first traditionally shaped quilt, made from vibrantly colored strip-pieced cloth originally intended for her kimonos.

▲ TIME MASTER

Yvonne Porcella. 1996. Modesto, California. Cottons. Hand appliquéd, machine pieced, hand quilted. 49 x 53 in. Collection of the artist.

Porcella describes this recent work as her "angst" quilt. It explores the artist's eternal conflict over direction as she wonders, "Do I go back to what's worked before or forward to something new?"

she creates inviting, cheerful narratives. Full titles such as *If I could make a glass dog bark, I could make a bright colored flag mountain, and fish to swim in a checkerboard sea* vividly describe both Porcella's fanciful, upbeat intent and her artistic process.

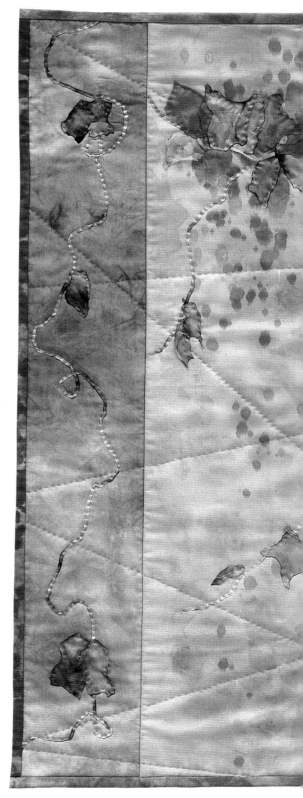

◄ **SPRING BLIZZARD**

Jeanne Williamson. 1996. Natick, Massachusetts. Cotton, painted fabric, purchased fabric, fabric paint, cotton thread, cotton batting. Hand stamped with rubber erasers, hand painted, machine appliquéd, machine quilted. 51 x 35 in. Collection of the artist.

Spring Blizzard was started by stamping the geometric shapes of hand-cut erasers onto a piece of fabric with fabric paint. Williamson then added images of flowers to a purchased piece of fabric which had "a swishing paint design," and after cutting out the flowers, she machine appliquéd them in place "by scribbling lines back and forth" with her sewing machine to add texture to the quilt.

◄ **HEXAGON**

Susan Hagley. 1995. Ipswich, Suffolk, England. Cottons. Hand dyed, machine pieced and quilted. 54 x 54 in. Collection of the artist.
Hagley often sets her pale hand-dyed colors against white or cream backgrounds, exploring extremely subtle shifts of hue within a repeating geometric design. She considers dyeing the fabric a critical part of her creative process. This quilt is one of a series that includes small irregular frayed strips of fabric sewn into the seams. One edge of the flaps defines a hexagon, the other a diamond. The flaps, which contrast with the body of the quilt, cast shadows and create color changes.

▼ **ON DWIGHT WAY**

Yvonne Porcella. 1995. Modesto, California. Hand-painted silk and ribbons, burned silk appliqué, metallic paints and ink. Hand quilted. 34 x 53 in. Collection of the artist.
Porcella's painted silk florals have an ineffable delicacy that would be impossible to achieve in any other material.

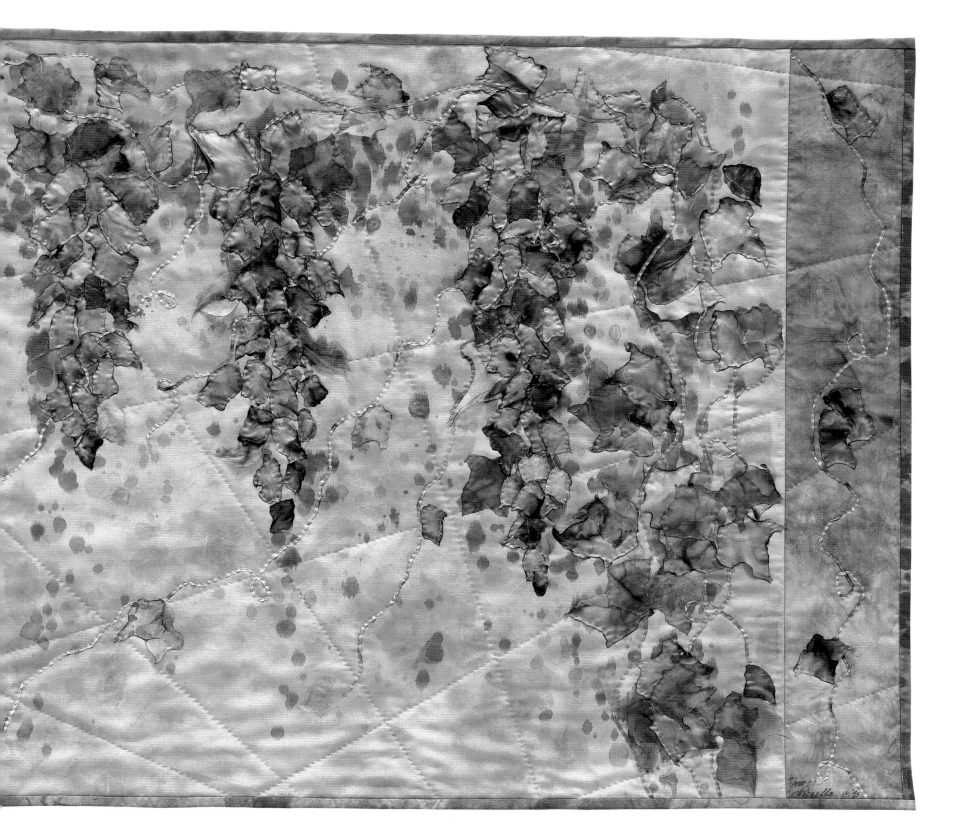

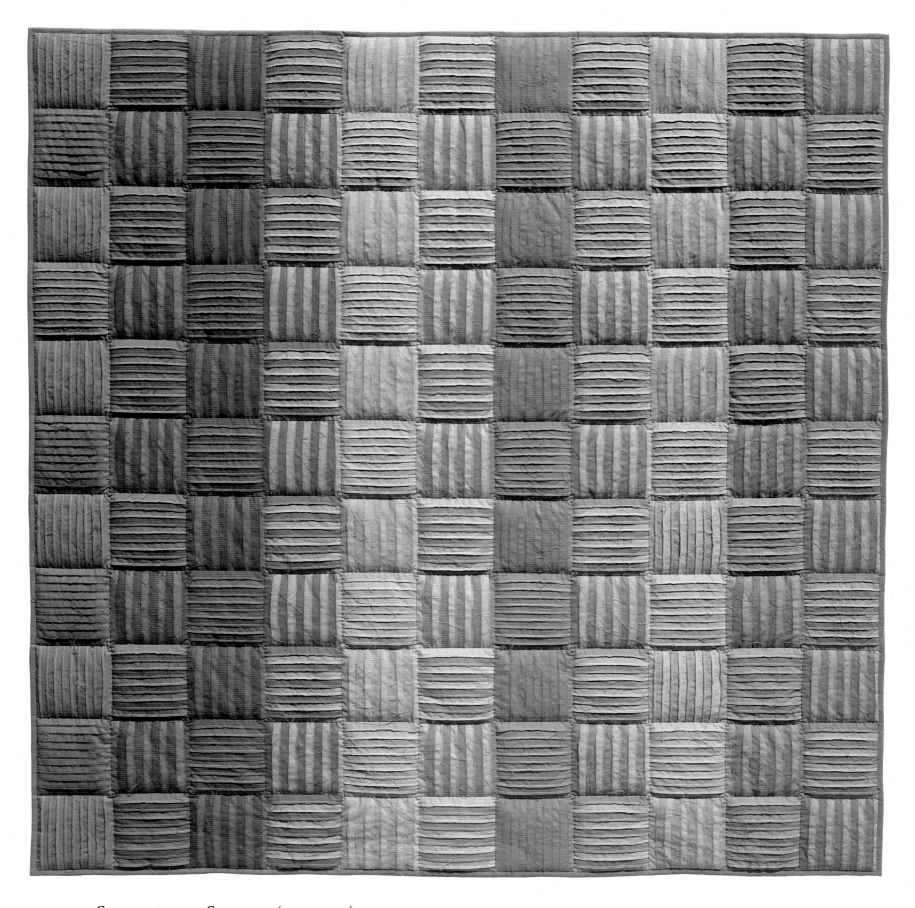

▲ SQUARES AND STRIPES (◄ DETAIL)

Inge Hueber. 1995. Köln, Germany. Cottons, hand dyed by the artist. Machine sewn, hand quilted. 70 x 65 3/4 in. Collection of Marc Grainer.
Hueber often creates a three-dimensional surface by quilting from the back and leaving her seams visible. This strongly textured color study also takes advantage of the subtle manipulation of hue possible in hand-dyed fabric.

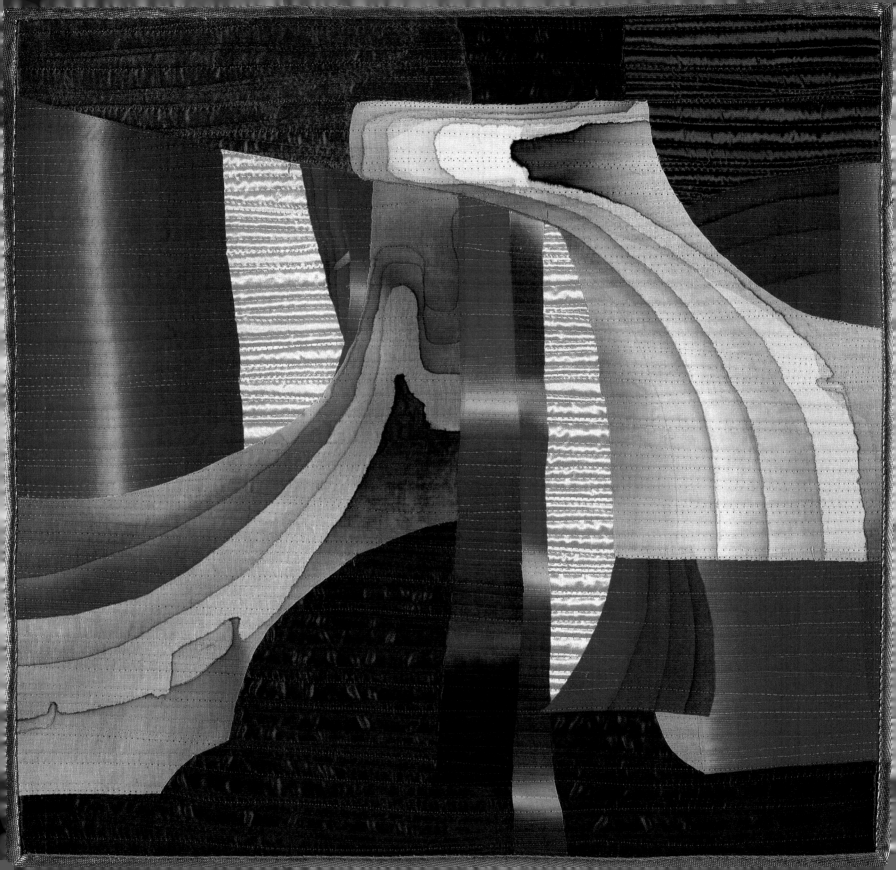

THE QUILTMAKER AS ARTIST

ABSTRACT QUILTS

Asked to imagine a quilt in the mind's eye or to draw one on paper, most people will almost inevitably think of an abstract design, typically some variation on a Log Cabin pattern. Abstract design has been a hallmark of American quilts since the early nineteenth century, and the seemingly endless creative variety of geometric patterns developed by American women defines much of the achievement of the quilt as an American art form. From the interlocking overall visual illusions of such block patterns as Tumbling Blocks, Barn Raising, Wheel of Mystery, and Robbing Peter to Pay Paul to the simple glowing geometric color fields of such favored Amish patterns as Diamond in the Square, Bars, and Sunshine and Shadow, American quiltmakers have created abstract designs of often astonishing power and ingenuity. The best of these works have been the focus of most of the art world's interest in the quilt since the early 1970s, and they have lured many artists to the quilt from other media.

◄ (FROM) THE LITTLE PICTURES SERIES

Ludmila Uspenskaya. 1996. Brooklyn, New York. Silk and cotton. Fabric collage, hand painted, batiked, machine quilted. 21 x 21 in. Collection of the artist.

Although the Russian artist Ludmila Uspenskaya has been working in textiles since graduating from art school in 1967, she did not make her first quilt until 1989. By December 1994, when she first came to the United States, she had one hundred quilts to bring with her. Uspenskaya was born in St. Petersburg, where she worked closely with architects and interior designers to create many important commissions, including the theater curtain for St. Petersburg Music Hall. Her surreal landscape quilts are inspired by nature and employ a variety of techniques, including piecing, hand-painting, batik, and her own unique method of fabric collage.

Art quiltmakers have continued the geometric experiments of traditional quiltmakers, building on the conceptual base set by earlier pieces while reaching new levels of compositional complexity and intellectual rigor. Such contemporary masters of abstract design as Pamela Studstill, Jan Myers-Newbury, Judith Larzelere, Michael James, and Nancy Crow have employed and adapted the techniques of traditional piecework to create quilts of significant originality and imagination. Other outstanding abstract artists, such as Ellen Oppenheimer, Lenore Davis, Linda MacDonald, and Patricia Malarcher, have brought entirely new and non-traditional techniques and materials to the service of their abstractions.

Many, if not most, abstract quilts are pieced, constructed of many small, geometrically shaped bits of fabric that are sewn together to form an overall composition. Nineteenth-century American quiltmakers developed the block-style organization of the pieced top, a construction process in which a number of identical small square units were joined to complete the top of the quilt.

Traditional patterns and block-style organization are still employed as points of departure or reference by some art quilters. The familiar yet endlessly variable Log Cabin pattern has been a particular favorite of artists such as Nancy Crow, Susan Webb Lee, and Liz Axford, who have used it as a framework for work done in a largely unplanned, improvisational style. Judith Larzelere has also created several fascinating variations on the Log Cabin pattern by enlarging the size of her blocks three to six times the normal size and creating quilts made up of only two or four enormous strip-pieced blocks. Several of Ellen Oppenheimer's labyrinthine quilts, including *Log Cabin Maze* and *Head Gasket Maze*, play on the block concept of the Log Cabin to create overall compositions of astonishing linear complexity. *Log Cabin Maze* creates a light and dark design reminiscent of a single Log Cabin block, but actually has a continuous line of yellow running through its deceptively arranged overall color pattern. By careful manipulation of color using her own hand-dyed fabric, Carol Gersen has made remarkable Log Cabin variations that manage to be at once traditional and modern-looking, while Glenda King's *Structural* series, on the other hand, updates the architectural reference of the Log Cabin by adapting modern skyscraper construction principles.

The majority of contemporary quilters, however, create designs that do not directly reference traditional themes. Pauline Burbidge, for one, has based many of her quilt compositions on mirrored images. She uses cut paper to devise complex block forms that are then set perpendicular to each other. The repeating block forms can be varied dramatically by using completely different fabric colors in different blocks and often modulate from realism to complete abstraction. Her *The Pink Teapot*, for example, deconstructs its title image across the course of nine squares which, like a traditional block-format quilt, can be read in a number of different sequences and combinations, i.e., left to right, back and forth, up and down, diagonally, or as a whole.

Although geometric grid structures still underlie the organization of most pieced quilts, some artists have attempted to move beyond the grid while still maintaining a cohesive structure. Michael James has been particularly successful in this endeavor in recent years, creating a number of works with surfaces built from large, interlocking abstract forms rather than repeating motifs. The forms, which are made up of complex combinations of linear and curvilinear shapes, are defined spatially by the solid colors of the stripes of cloth from which they are crafted. The resulting quilt surfaces seem to dance as the eye shifts between large and small patterns of light and dark colors and the surging, swirling motion of the abstract forms, which continually appear to shape and reshape themselves in relation to one another. The strip-pieced works of Judith Larzelere and Joy Saville are also non-geometric, focusing on the shimmering movement of color for their visual organization.

◄ **LIVE WIRE**

Judy Becker. 1995. Newton, Massachusetts. Cottons, cotton batting. Machine pieced and quilted. 52 x 42 in. Private collection.
Becker is a former jazz pianist who listens to jazz as she works in her studio. She sees strong parallels between quilting and jazz, noting that they are both improvisational art forms that piece new identities out of improbable parts, and that they are both American inventions.

LOG CABIN MAZE ►

Ellen Oppenheimer. 1993. Oakland, California. Hand-dyed and silk-screened commercial fabrics. Machine sewn, hand quilted. 72 x 72 in. The Renwick Gallery, National Museum of American Art, Smithsonian Institution, Washington, D.C.
Oppenheimer says she has always been fascinated with the Log Cabin pattern and was delighted to realize she could adapt a Log Cabin block to make one of her maze quilts. She continues, "This quilt has a continuous line going through it—in mathematical terms the yellow line is a 'continuous curve.' In symbolic terms, this quilt represents the convoluted journeys that we take to get to exactly where we started."

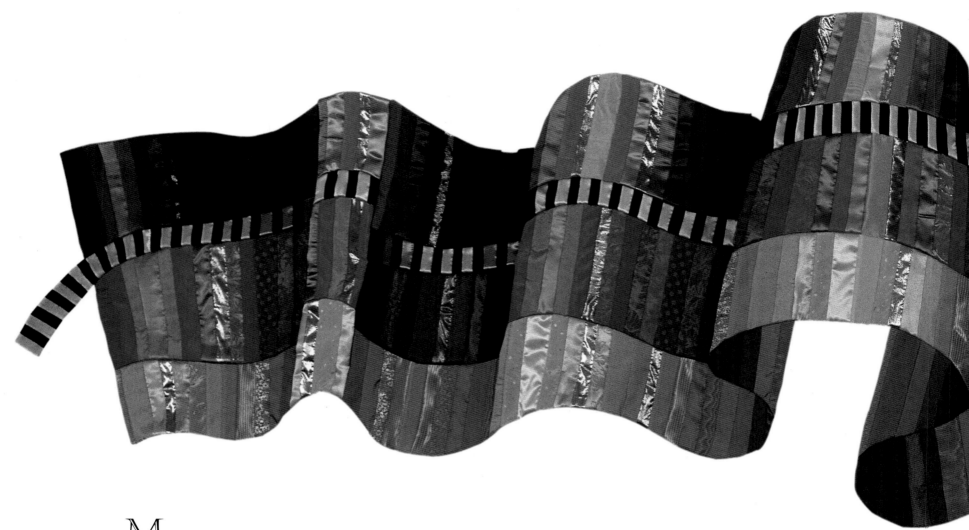

Most art quiltmakers title their works, often suggesting inspirations, personal experiences, or conceptual themes. Like the names of traditional quilt patterns, titles often work best when they are broadly suggestive rather than narrowly specific. Along with titles, it has also become customary for quilt artists to attach "artists' statements" to their works, a sort of program note explaining the genesis and meaning of the piece. These have become de rigeur for art quilt exhibitions and publications, forcing the artists to be the primary interpreters of their own work. This can be a dangerous practice, however. Titles and statements are particularly problematic for abstract works, which rather like music, can often elicit a variety of different responses from an audience. While both titles and statements can be useful to the viewer when they suggest avenues for exploration and consideration, they can run the risk of exposing an artist's pretensions and, like all labels, can also limit or constrict the viewer's possible responses to the work. They are most often best regarded as one person's approach to the content of a piece rather than its only meaning. Good art will usually survive any attempt to pin it down, even by the artist, because its meaning does not, indeed cannot, belong solely to its creator. If art is a means of communication, it must be a two-way street. As Meiny Vermaas-van der Heide sees it, "Art should make visible the invisible from within. This is true for the maker as well as for the viewer. It is irrelevant whether the visible is something different for everyone: the artwork is the mediator, the focal point enabling the viewer to let the mind wander in prayer." Judith Larzelere concurs: "[Some] pieces hold a power I cannot predict. They are numinous, that is, they hold a spirit beyond their physical reality. In me they evoke the same meditation that I give to natural things like the ocean, the northern lights, a waterfall, a flower. I feel this content is beyond my power to control. I don't understand what it is that I do that sometimes makes a work take on additional importance. I feel that I become a medium that can execute the work, that can control the crafting of, but cannot dictate the content of, the final image."

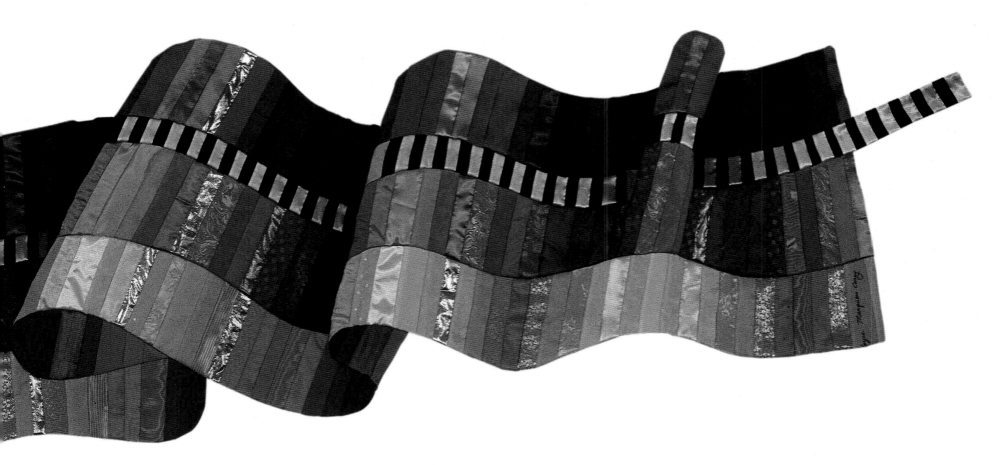

▲ **RIBBON**

Joyce Marquess Carey. 1995. Madison, Wisconsin. Assorted fabrics, including silk, satin, cotton, and metallics. Machine pieced. 33 x 126 in. Collection of Mr. and Mrs. Andy Newman. Although its true character defies both the eye and the camera, this remarkable work of trompe l'oeil is absolutely flat.

For these and other reasons, some quilt artists, particularly those who create abstractions, feel uncomfortable with titles and artists' statements. Pamela Studstill, for example, simply assigns numbers to her works, preferring to leave any interpretation entirely up to the viewer. Nancy Crow says of her admittedly non-programmatic quilts, "My work is based on strong feeling. [But] when you look at those quilts, you wouldn't know [the whole story behind them.] It's more important to me that the quilt speak without a detailed report on what it's supposed to be about." Tired of being asked to explain her work, Miriam Kaye summed up her feelings about verbal interpretations by submitting the following poem, "My Message to a Windy City . . . ," as her statement to accompany a quilt included in a *Quilt National* show:

Don't talk about quilts
Don't think about them
Sink into them through your eyes
Let them take you where they will
To places beyond words
Beyond goals.
Beyond us
Fast and Far and Forever

Many abstract quiltmakers work in series, creating a number of works that explore a particular nexus of forms, colors, or techniques. Deirdre Amsden's *Colourwash* series, for example, uses carefully graded variations of commercially printed fabrics to create subtly shaded washes of color. Ellen Oppenheimer has created a series of quilts exploring the concept of mazes, and Caryl Bryer Fallert has made several quilt series that make use of multicolored tucks or pleats of fabric sewn at right angles to the quilt's surface. As the viewer moves past the quilt, the vertically oriented strips of cloth present different aspects of their color, shifting the entire pattern of the surface.

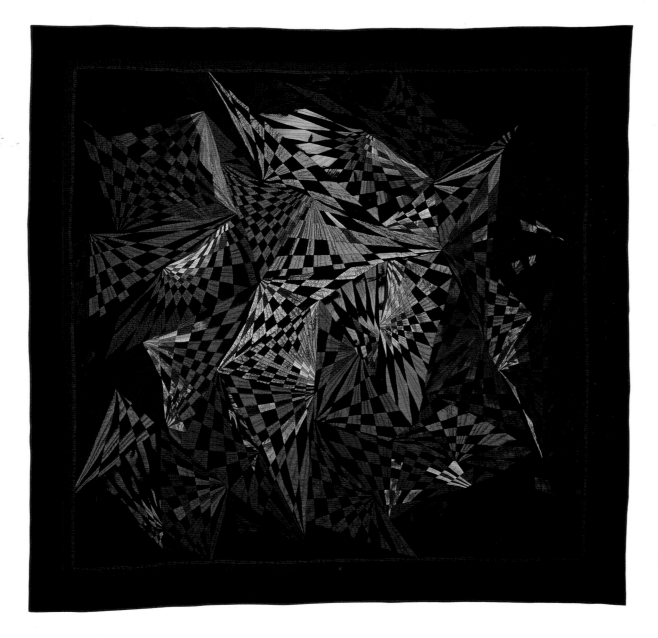

◄ COSMOS III
(GLORIES OF STARS)

Shoko Hatano. 1992. Tokyo, Japan. Silk, cotton, satin, and synthetic fiber. Machine pieced, hand quilted. 86 1/2 x 86 1/2 in. Collection of the artist.
Hatano comments, "The stars twinkling in the remote universe look as if they were alive, splitting or merging, changing colors and expanding or shrinking."

One of the longest running series, Nancy Crow's *Color Blocks*, was begun in 1988 and now numbers over seventy pieced quilts. It has evolved from complex and rigidly geometric compositions to freely cut improvisations; the quilts in the series range in size from twenty-two inches square to pieces of traditional bed-size. Many are variations on a Log Cabin format, while others resemble cut-paper collage; some are made of commercial fabrics, while others are created entirely from hand-dyed materials. Crow has worked in several other, smaller series over the past seven years, including pieces titled *Double Wedding Rings, Linear Studies, Chinese Souls,* and *Bow Ties,* but she keeps returning to the wide-open possibilities of the *Color Blocks* concept and finding new ways to expand it.

Like painters, some quilt artists enjoy playing with the illusion of three-dimensional forms and spaces created in a basically two-dimensional medium. Joyce Marquess Carey creates flat, pieced works that powerfully imitate rolled, folded, and twisted ribbons, flags, and other three-dimensional fabric forms. Her trompe l'oeil works do not flatten out until the viewer is practically on top of them. She says of her work, "The viewer is invited to solve visual riddles in which edges, corners, and whole planes seem to shift forward and back in imaginary spaces." Miriam Nathan-Roberts has made a number of quilts in which pieced bands seemingly interlace, moving over and under each other in space. Japanese quilters like Shoko Hatano often create quilts full of illusory spatial relationships.

Advances in dye technology and influences from non-Western textile traditions have allowed quilt artists to create painterly abstractions that often have little or no relation to the geometry of traditional pieced quilts. Jan Myers-Newbury, for example, has increasingly moved from geometric abstractions to pieces based on manipulation of color using shibori and other tie-dye techniques. Much of her recent work combines the two approaches, using homecolored tie-dyed fabrics to add shifting fields of color to the complex planes of the composition. Linda MacDonald, an art school trained painter, has exploited new technology, as her quilts have evolved from colorful pieced work exploring decidedly modern geometric constructions to largely mono-chromatic abstractions painted with an airbrush.

A number of her recent works present abstract "portraits" organized in block format. Dorothy Caldwell is a renowned Canadian textile artist who has recently created a number of bed-sized quilts that combine North American quilting traditions with Far Eastern batik dye techniques. Interestingly, it was on a trip to Japan to explore that country's venerable textile traditions that Caldwell discovered she had overlooked the quilt. Japan's great reverence for the American quilt moved her, on her return home, toward the study of historic quilts in the collection of the Royal Ontario Museum in Toronto. She now uses resist and discharge dyeing techniques to create subtly modulated surfaces that often find their starting point in landscape.

LETTING GO ▶

Miriam Nathan-Roberts. 1985. Berkeley, California. Hand-dyed and hand-painted cottons. Machine pieced, hand quilted by Sue Herschberger. 70 x 70 in. Collection of the artist. Nathan-Roberts had no depth perception until she was thirty years old. This is one of a number of her quilts that play with the illusion of three dimensions. The ribbons, which seem to weave in front of and behind each other, are in reality flat intersecting bands of fabric that create their illusion through the careful manipulation of form and color. The scattered triangles are subtly complemented by quilted triangles of the same size.

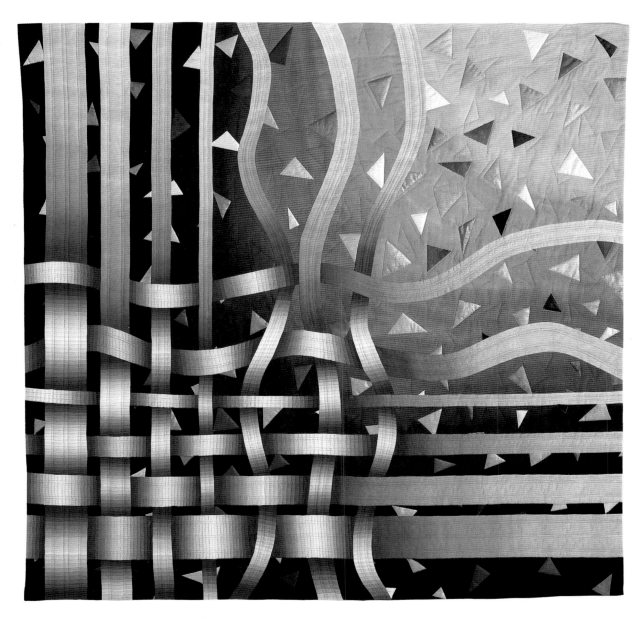

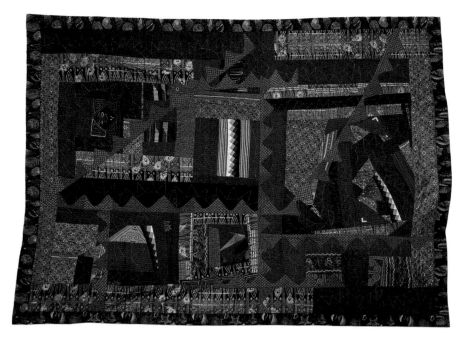

◄ THE THREADS THAT BIND US TOGETHER, II

Ed Johnetta Miller. 1996. Hartford, Connecticut.
Silks and cottons. Machine pieced and quilted.
54 x 73 1/2 in. Collection of the artist.
Miller's quilts have been described as prayers that suggest the hope of unity between cultures where none currently exists. This recent example of her work mixes South American molas, Seminole Indian patchwork, hand-dyed silk noil, and fabrics from India, Vietnam, and the West African republic of Senegal in a harmonious collage.

In addition to traditional and non-traditional fabrics, some abstract quilt artists are also working with modern synthetic materials, thereby bringing the products of the modern world into their art. Patricia Malarcher, for example, makes many of her pieced geometric works from the shiny metallic plastic "fabric" Mylar, which is both tremendously strong and extremely pliable. She says, "I like the fact that Mylar, which was used for the skin of the lunar module, contributed to one of humankind's wildest dreams. Its significance has changed for me over the [more than] twenty years I've been using it. First of all, I was interested in its ability to reinforce dimensional structures in fabric. Then I realized that its reflective character connects it to many traditional art forms—religious icons, Indian mirror cloth, and Chinese embroideries—as well as to other contemporary work."

TYGER, TYGER ►

Patricia Malarcher. 1990. Englewood, New Jersey. Mylar, cotton, linen, painted canvas, Xerox transfer print. Machine appliqué, hand-sewn construction. 78 x 60 in. Collection of the artist.
Malarcher says her work is often built bit by bit, as she asks herself, "What could this be part of?" This piece began with two seemingly unrelated bits: the oil-on-canvas image of the eye at top center, which was cut from an old church painting of a saint, and a square painted with gold leaf, on which the eye is set. She added the tiger print cloth "because the color was right." As the work developed, Malarcher realized that it had "a sense of connection with the ambiance of [William Blake's well-known] poem," hence the title. Blake's first verse runs: "Tyger, tyger burning bright/ In the forest of the night/ What immortal hand or eye/ Could frame thy fearful symmetry?"

Other quiltmakers are taking advantage of the extraordinary palette of fabrics now available to artists by creating abstract collage-like constructions that allow their choices of cloth to speak directly. Colorful, asymmetrically patterned African textiles are a favored element of many artists who work in this type of fabric collage. Ed Johnetta Miller's *The Threads That Bind Us Together, II* is an example of this type of quiltmaking, which, like improvised strip piecing, often exhibits the influence of the

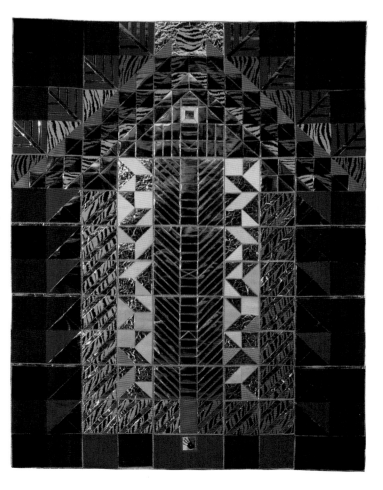

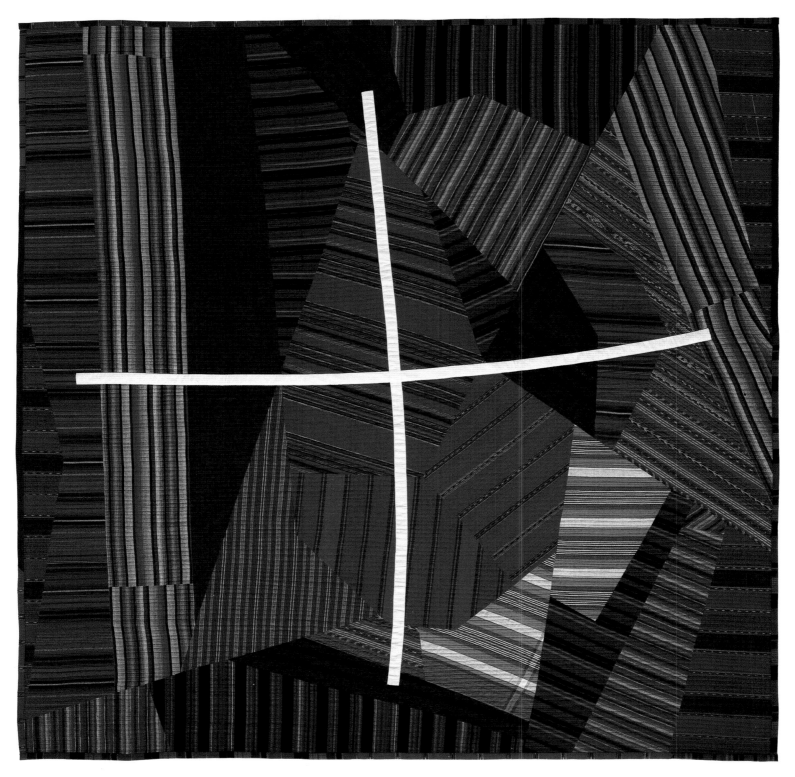

▲ **95: 5 RED**

Jonathan Shannon. 1995. Sonoma, California. Cotton fabrics. Machine pieced and quilted. 77 x 77 in. Collection of the artist.
In recent abstractions like this one, Shannon attempts to let his materials provide both the composition's integrity and interest.

improvisational approach of some African-American quiltmaking. Jonathan Shannon, who has recently moved from pictorial quilts to complete abstraction, explains that his new work is born of "a search for a way to describe the essential mystery of textile without resorting to narrative. I attempt, through the deliberate simplification of technique, to reveal the spirit of each piece of cloth, to discover how each relates to each and joins together to form a chorale of intense power. I find these surfaces beautiful because textiles are at their most seductive when arranged into patterns where beauty seems not to be the point."

PAMELA STUDSTILL

Pamela Studstill likens the effect of her pieced quilts to "the background buzz on a TV screen, without form or meaning. To me," she adds, "that shimmering quality is the mark of a successful quilt." The constant sense of change and movement in her quilts comes from many small bits of cloth that are full of tiny variations of color and pattern. Studstill, who trained as a painter and still works in that medium as well as in paper, adds, "I like to play with color gradations, sometimes working within the limitations of commercially dyed fabrics, sometimes dyeing the fabric myself."

Each of Studstill's quilts begins with a carefully planned drawing. She uses her master drawing as a planning document, choosing her palette of fabric colors and making templates for the different piece shapes. She marks fabric with the templates and then, before cutting the hundreds of pieces, she adds tiny squiggles, dots, and dashes of color with a paintbrush. The addition of surface paint not only creates a random pattern of its own but also helps ease the transition from one fabric color to another, thereby drawing disparate pieces of cloth closer together. More accents are carefully added with the brush after the quilt is assembled and stitched until she is satisfied. Her work done, she hands the quilt over to her mother, Bettie, who painstakingly hand quilts her daughter's works, adding yet another layer of meticulously detailed surface pattern and texture.

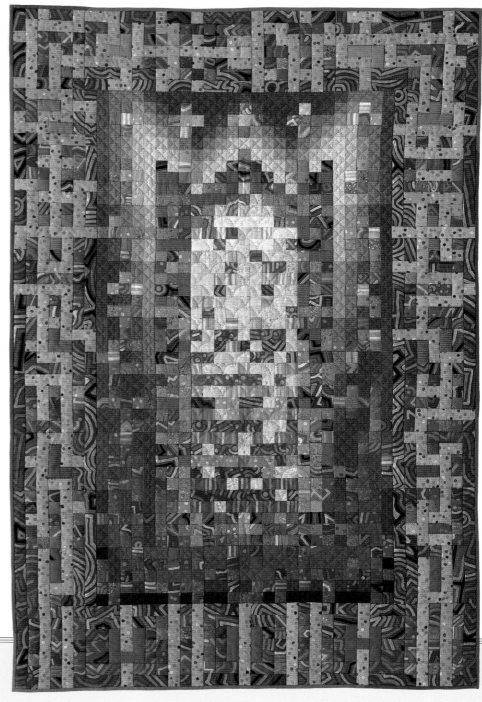

QUILT #118 ▶

*Pamela Studstill. 1995.
Pipe Creek, Texas. Hand-
painted cottons. Machine
pieced, hand quilted by Bettie
Studstill. Collection of the
artist.*
This jigsaw puzzle–like of
a quilt offers a seemingly
endless variety of subtle
shifts of pattern and color.
As in many of Studstill's
compositions, the colors in
the central portion of the
quilt darken from top to
bottom, as if the shapes
were tumbling into an ever
denser and somehow more
orderly pile.

◀ QUILT #127

*Pamela Studstill. 1996. Pipe
Creek, Texas. Hand-painted
cottons. Machine pieced,
hand quilted by Bettie
Studstill. 58 x 39 in.
Collection of the artist.*
Studstill's remarkable
abstract designs bring the
traditional pieced quilt into
the twenty-first century.
In this example a central,
architectural-type form is
framed by a wide outer
border, while Studstill's
hand-painted fabric dances
with flecks of light and
color.

▲ **HEAD GASKET MAZE**

Ellen Oppenheimer. 1994. Oakland, California. Hand-dyed and silk-screened cotton. Machine sewn, hand quilted. 60 x 60 in.
Collection of the artist.

Oppenheimer's maze quilts employ a single fantastically complicated line to create a pattern. Although its colors and pattern are unmistakably contemporary, the quilt also suggests a traditional Log Cabin block form set on point.

BLOWN AWAY ▶

Ann M. Adams. 1990. San Antonio, Texas. Cotton, silk, polyester, cotton backing, cotton batting and thread. Hand and machine sewn, appliquéd with heat-fusable interface, machine quilted. 49 x 44 in. Collection of the artist.

This quilt is one of a series exploring the tornado as metaphor. Here, hierarchical ideas about the relative merits of silk, cotton, and polyester are "blown away" by the central twister, which indiscriminately mixes bits of different fabric together.

RECONSTRUCTION ▶

Chris Wolf Edmonds. 1989. Lawrence, Kansas. Hand-painted and dyed cotton and silk. Machine sewn. 48 x 58 in. Collection of Piper Jaffray, Inc.

Edmonds has been quilting since 1965 and gained national recognition in the 1970s for her pictorial quilts. In recent years, she has often worked with paint and a variety of abstract approaches to design.

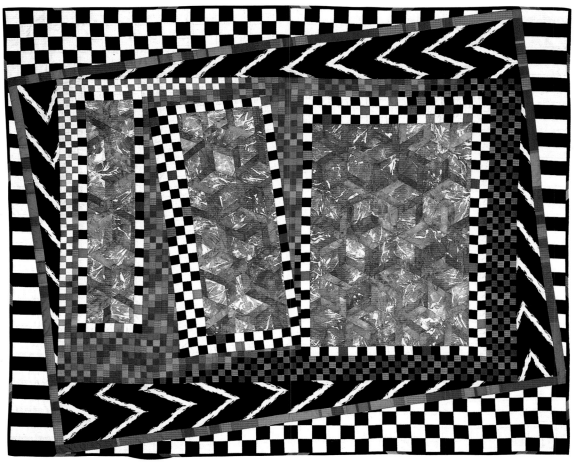

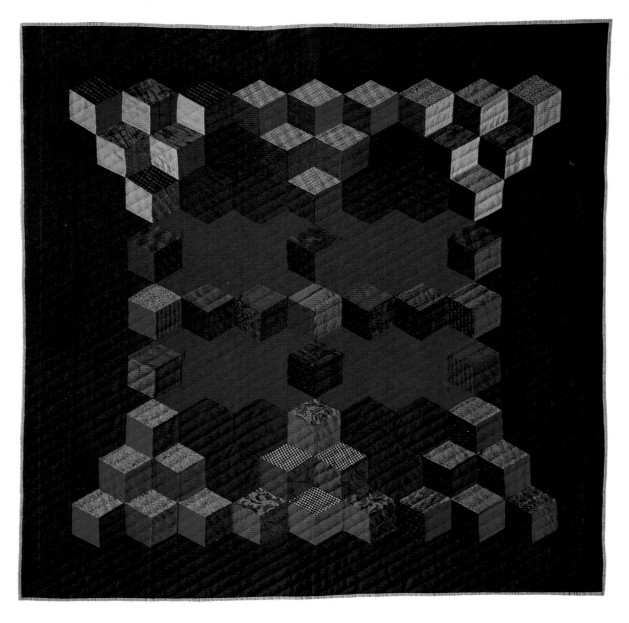

LAND, SEA, AND SKY ▶

Linda Perry. 1995. Lexington, Massachusetts. Cotton, silk, rayon, metallic lea, various small metal objects. Machine pieced, hand appliquéd, machine quilted. 60 x 48 in. Collection of Elizabeth Berg.
Author Elizabeth Berg, who commissioned this quilt, requested that the piece feature a starry sky with the constellation Orion and that it also include some reference to water. She gave Perry three personal charms—a Chinese coin, a turtle, and a fish—to incorporate into the work.

▲ NIGHT LIGHT

Rebecca Shore. 1991. Chicago, Illinois. Primarily wool with some cotton and blends, cotton batting and back. Machine pieced, hand quilted. 65 x 63 in. Collection of John Walsh III.
In this modern variation on the traditional Baby Blocks concept, the blocks seem to float in mid-air, balanced only by their symmetrical groupings and color rhythms.

THE DANCE ▶

Rebecca Rohrkaste. 1996. Berkeley, California. Commercial and purchased and dyed cotton fabrics, cotton batting. Machine pieced and quilted. 72 x 72 in. Collection of Ms. Gay White.
This is one of a series of recent quilts in which Rohrkaste uses a corner-to-corner quarter-circle block, a "simple, elegant shape" that she finds holds fascinating design and color possibilities. She notes: "I make more or less traditionally based quilts, for beds and for the wall. I don't make a particular distinction between the art quilts and the others until I'm confronted with show criteria."

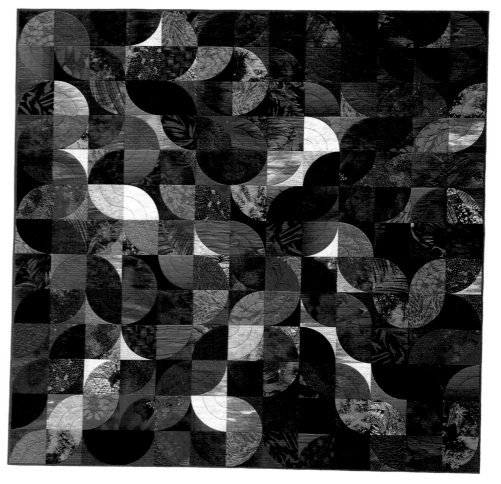

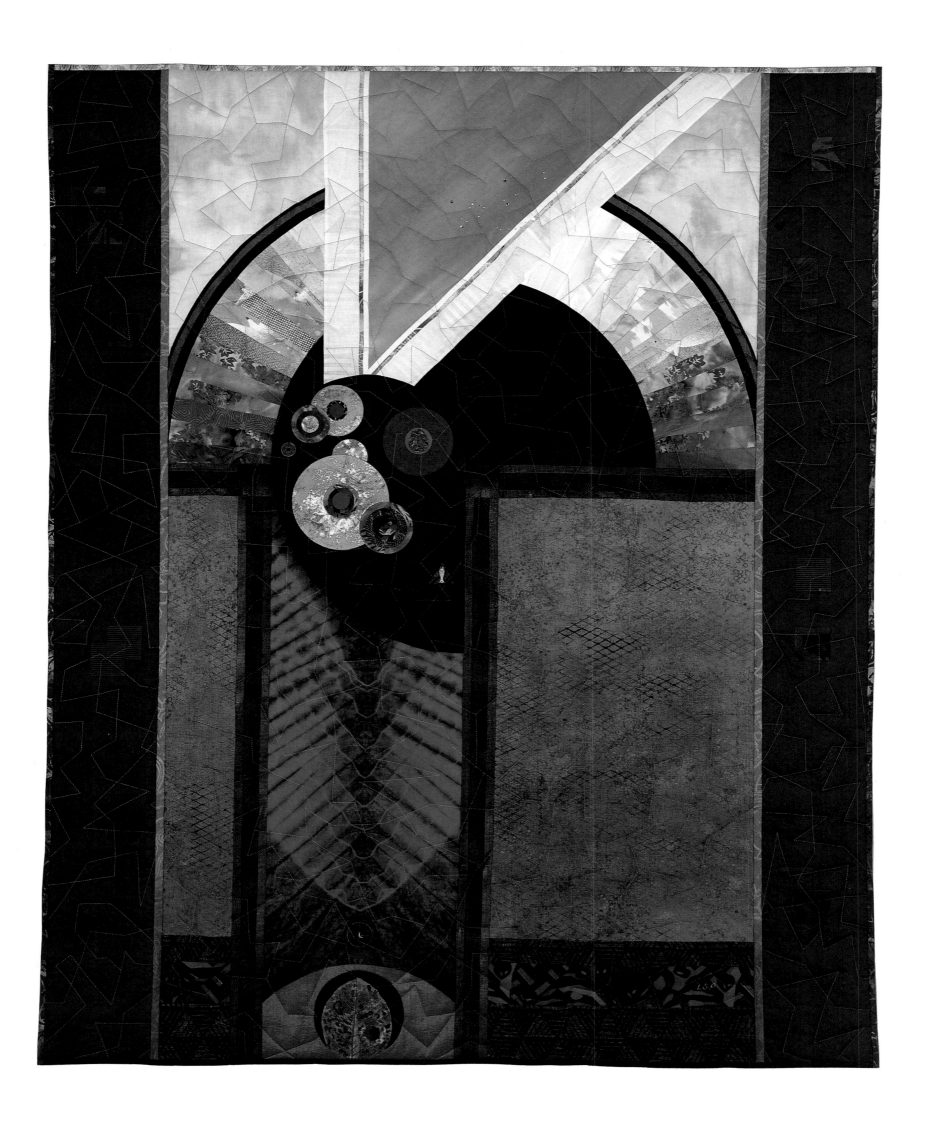

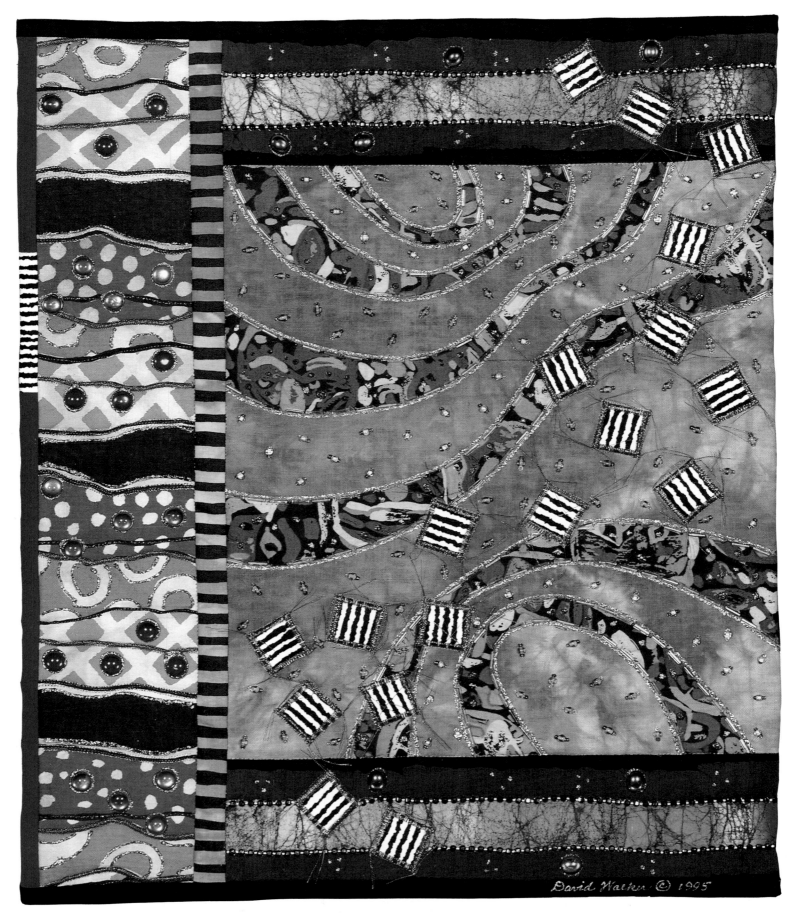

▲ PATTY'S DREAM

David Walker. 1995. Cincinnati, Ohio. Commercial and overdyed cottons, beads, metallic threads, fabric paints. Machine appliquéd and quilted. 19 1/4 x 16 in. Collection of Patty and Wes Hawkins.

Walker, who describes his quilts as "personal narrative abstractions," calls himself an artist and quiltmaker. "What I am is an artist, and what I do is make quilts. One title gives credit to the artist who I am, and the other gives credit to the craftsperson who does it." This little quilt, made for fellow quilt artist Patty Hawkins, is one of many smaller pieces he has created in the past few years.

◄ COLORS DANCE

Susan Webb Lee. 1985.
Weddington, North Carolina.
Cotton fabrics, poly/cotton batting.
Machine pieced and quilted. 52 x
53 in. Collection of the artist.
Lee's geometric pieced quilts present complex compositions full of small asymmetrical alignments that make the eye *and* the colors dance.

PARALLELOGRAM DIPTYCH ►

Ellen Zahorec. 1990. Cincinnati,
Ohio. Primed canvas, acrylic and
enamel paint, corduroy backing.
Machine pieced. 84 x 96 in.
Collection of the artist.
Zahorec says her Slavonic upbringing is perhaps the strongest influence on her richly patterned work. "In my childhood I was exposed to decorative needlework, and I was also raised in a Byzantine Catholic church. It was just natural for me to feel comfortable with design and decoration." In addition to stitched canvas constructions like this, she also creates collages from her own handmade paper. However modern her medium, the surfaces she creates are full of vivid color and texture that recall the ethnic arts of her ancestors.

◄ ZOETIC

Suzan Friedland. 1995. San Francisco, California. Home-dyed linen and hemp. Hand painted, machine pieced and quilted. 88 x 66 in. Collection of the artist. Many of Friedland's abstract quilts are inspired by observations of the colors and textures of geological formations, flora, and fauna. They often employ unevenly textured natural fibers like linen and hemp.

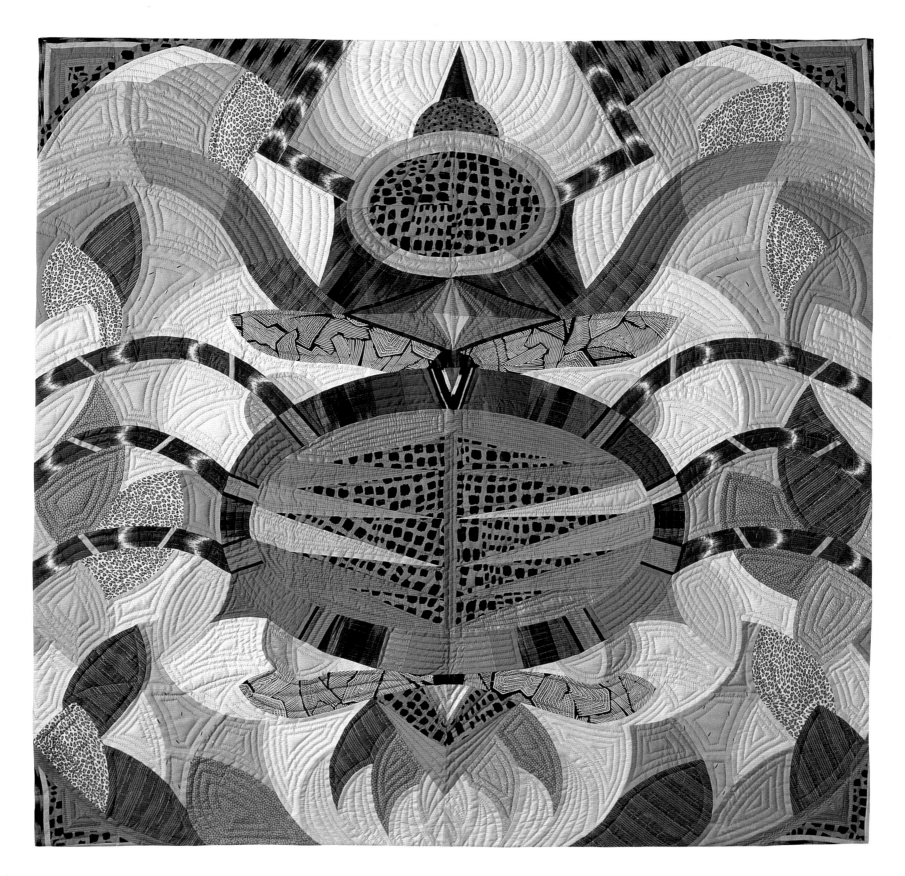

▲ PETITE MISUMENA

Francoise Barnes. 1989. Albuquerque, New Mexico. Cotton, cotton blends. Machine pieced, hand quilted by Sue Herschberger.
60 x 60 in. Collection of the artist.

This quilt presents a bold, mirrored geometric abstraction that can also be read as an imaginary spider. Barnes notes, "Insects provide flamboyance, geometry, and symmetry in one neat package." Barnes was a co-founder of *Quilt National* and is currently painting full time.

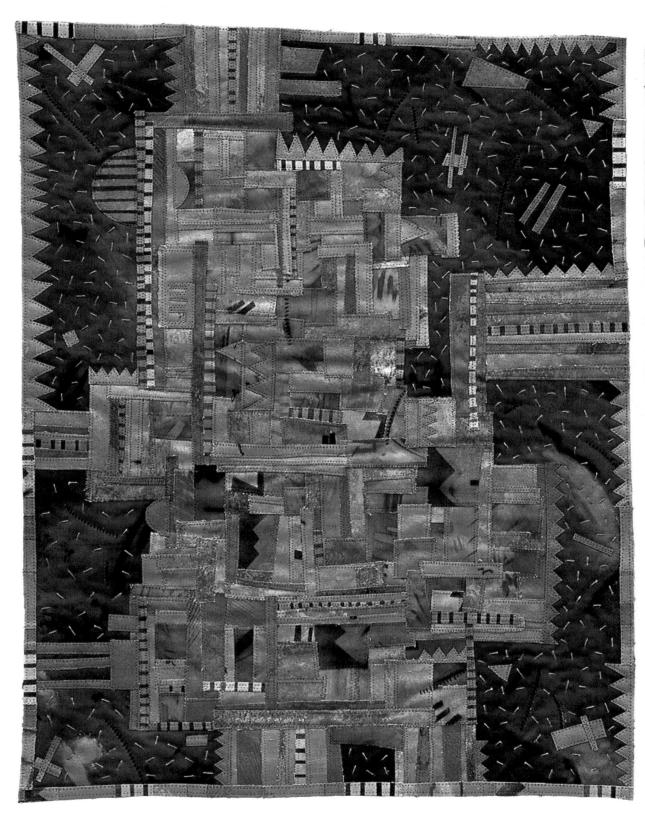

▲ **PAIR OF SHIELDS**

Melissa Holzinger. 1994. Arlington, Washington. Canvas painted with acrylics and pastels, waxed linen. Machine-enhanced stitching, stenciled. 36 x 57 in. Collection of the artist.
The painted canvas patchwork centers of this small pair of quilts are bordered by sections of mostly black canvas dotted with large machine stitches and occasional small bits of appliqué.

THE TIGER'S SPOTS, THE LEOPARD'S STRIPES ▶

Bridget Ingram-Bartholomäus. 1995. Berlin, Germany. Cotton, silk, mixed fabrics, synthetic fabrics. Hand and machine sewn and quilted. 83 x 83 in. Collection of the artist.
Ingram-Bartholomäus writes, "I'm a colourholic and really enjoy seeing colours bounce off each other. As is usual with the way I work, *The Tiger's Spots, The Leopard's Stripes* developed over two years, starting with some sketches and plans. Tibetan tiger rugs were a source of inspiration for the choice of fabrics. I wanted to make reference to the majestic and mystical qualities of these animals and their high status."

▼ BARRIER/GATE

Mary Jo Dalrymple. 1989. Omaha, Nebraska. Found and hand-dyed cottons. Machine pieced, hand quilted. 68 x 94 in. Collection of the artist.
Among the "found" fabrics included in this geometric abstraction are Japanese Ikat-dyed cloth and silk-screened cotton from Kenya.

▲ **DECO PINWHEEL VIII**

Patsy Allen. 1991. Greensboro, North Carolina. Cottons, poly/cotton batting. Machine sewn. 64 x 64 in. Collection of Resnick, Amsterdam & Leshner, Ambler, Pennsylvania.
Allen's masterful geometric quilts meld the simple forms of traditional piecework with modern graphic design, successfully building bridges between old and new. Slight irregularities in the repeating geometry of this quilt keep the eye guessing as the whole composition, like a pinwheel, revolves around the four-patch block at the quilt's center.

▲ MOONGEM OF PARADISE

Sharon Heidingsfelder. 1993. Little Rock, Arkansas. Cottons, some hand dyed by the artist. Machine pieced and quilted.
80 x 80 1/2 in. Collection of Dave Bromund.
Heidingsfelder makes traditional block-style pieced quilts, but updates the concept by using her own superb pattern designs and hand-dyed fabrics.

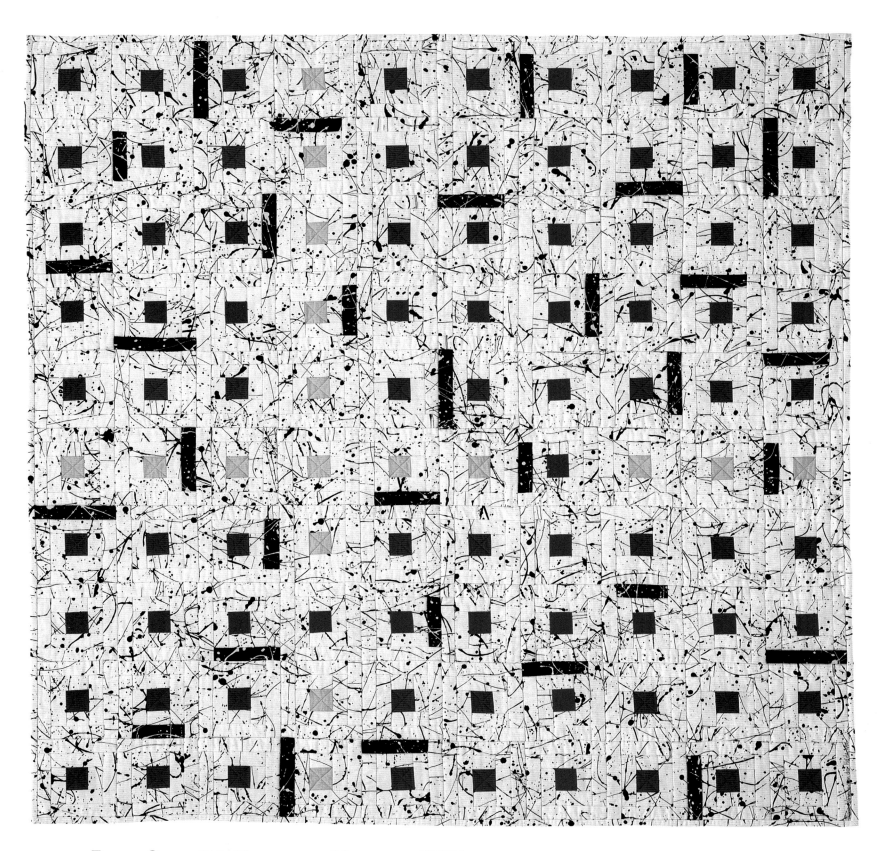

▲ **EARTH QUILT #58: HOMAGE TO MONDRIAN XXIV**

Meiny Vermass-van der Heide. 1995. Tempe, Arizona. Cotton fabrics, Mountain Mist Cotton Choice batting. Machine pieced and quilted. 47 x 47 in. Collection of the artist.
Vermass-van der Heide identifies strongly with Mondrian's mystical Utopian vision of harmony extending from the artist to his work and from there outward to the surrounding environment.

▲ FIELD NOTES

Dorothy Caldwell. 1995. Hastings, Ontario. Batiked and stitched cotton. Hand quilted by Evelyn Martin. 66 x 91 in. Collection of the artist.
Caldwell has been strongly influenced by trips to Japan, where she met other contemporary textile artists who share her belief in the integration of historical work in modern contexts.

BALANCING ACT I ▶

Ann Johnston. 1995. Lake Oswego, Oregon. Silks, hand painted with Procion dye. Hand appliquéd and quilted. 24 x 16 in. Collection of the artist.
This aptly titled little quilt balances its delicately painted, geometrically skewed pastel forms against an absorbing dark background. The patterns of the quilting subtly echo those of the much larger appliquéd chair-like forms.

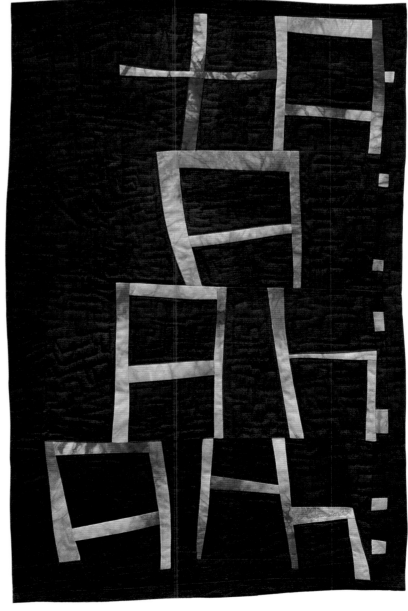

CHECKER CAB: NEW YORK CITY, 2:00 A.M. ▶

Mary Masopust. 1996. Berkeley, California. Twenty-one stripes, star and checkerboard prints silk screened by Katie Pasquini Masopust, assorted prints. Machine pieced, machine quilted. 64 x 64 in. Collection of the artist.

Mashuta has been exploring striped fabric for a number of years. Her challenge here was to use twenty-one stripes in a single quilt. She also wanted to evoke the feeling of a place without using realistic images.

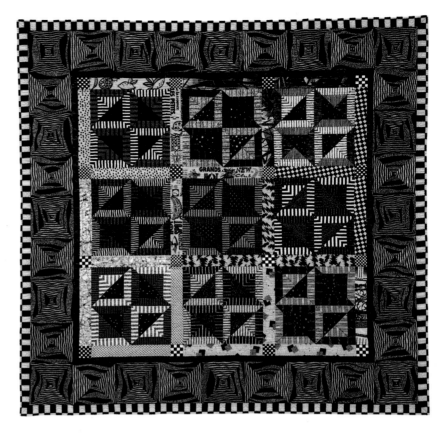

◀ TRANSITIONS X: NATIONAL STEEL GUITAR

Jenifer Eveleth Fisher. 1993. Pittsboro, North Carolina. Cottons. Machine pieced and appliquéd, hand quilted by Sarah Porecca. Collection of the artist.

The abstract forms that make up this quilt were inspired by a National brand steel guitar. National was one of the most innovative guitar makers of the 1930s, and among the first companies to produce acoustic and electric guitars made for Hawaiian-style slide playing. Many of the company's distinctive instrument designs were strongly influenced by Art Deco.

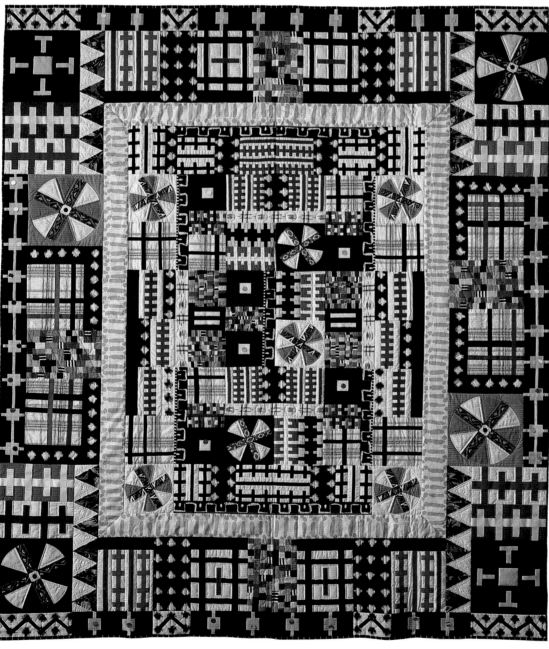

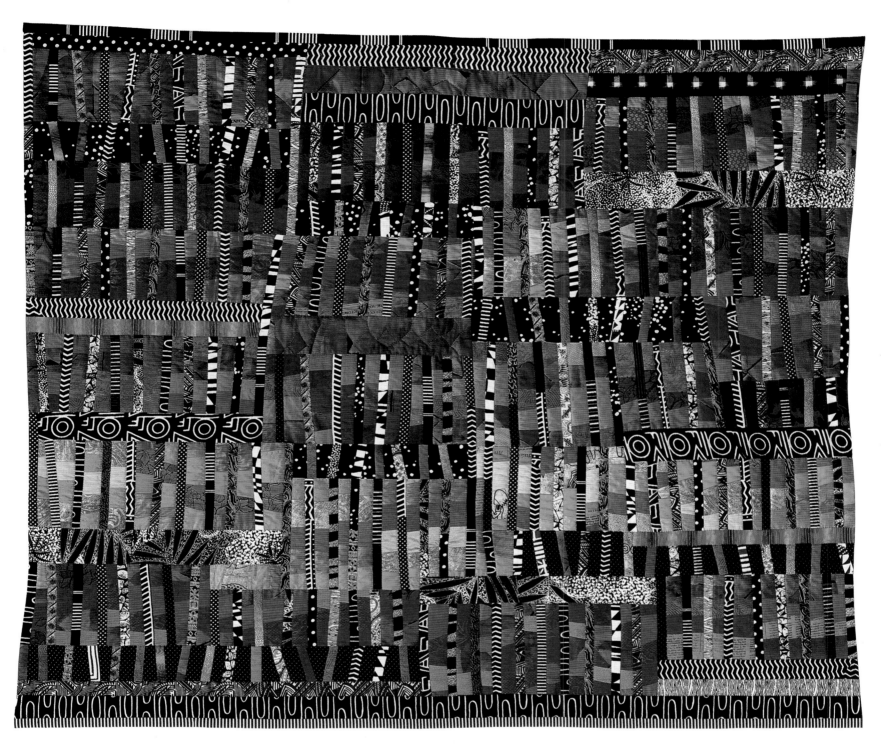

▲ PICCOLO II

Anne Woringer. 1993. Paris, France. Commercial cotton fabrics. Machine pieced, hand quilted. 51 x 60 in. Collection of the artist.
Woringer has been a leader in bringing art quilts to France since the mid-1980s. She studied and taught fine arts in Paris before marriage took her to Argentina, and is an expert in Italian fabrics of the Middle Ages. This is one of a series of five quilts the artist describes as having "a sort of musical rhythm." The title refers to the flute's small orchestral cousin.

NANCY CROW

Nancy Crow expects no more of her many students than she does of herself, saying, "I expect people to work out of their own experiences, not by rote. I believe quiltmaking is a process of discovery, and each person is responsible for his or her own journey."

Crow's own maverick journey has moved through many stages over the past eighteen years, from rigidly composed geometrics using a vast array of commercial fabrics to freely cut abstractions made from hand-dyed cloth. She drinks in visual stimulation, working in an isolated country studio surrounded by objects that excite her, including ethnic baskets, Peruvian weavings, African cloth, primitive masks, nomad rugs, and photos of stone walls, tilework, and other constructions. She works in series, creating from a handful to dozens of thematically related quilts as she attempts to discover all the pattern and color possibilities within a particular design approach.

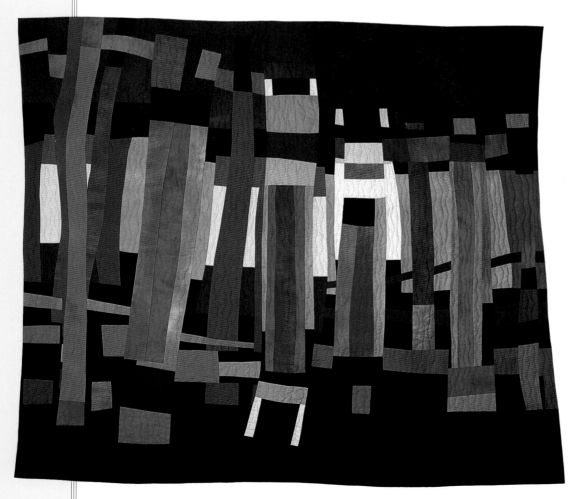

Until recently, Crow's quilts were meticulously planned, proceeding from elaborate design structures and built slowly using dozens of templates. She ultimately felt restricted by the tedious, mechanical parts of this process, and in the early 1990s left her templates behind and began improvising. The immediacy of this new approach has brought her full circle to the spontaneous cut-paper assemblages she loved to make as a child. And, by giving up the use of templates and dyeing her own fabrics, she is, paradoxically, now in more complete control of her materials and process than ever before.

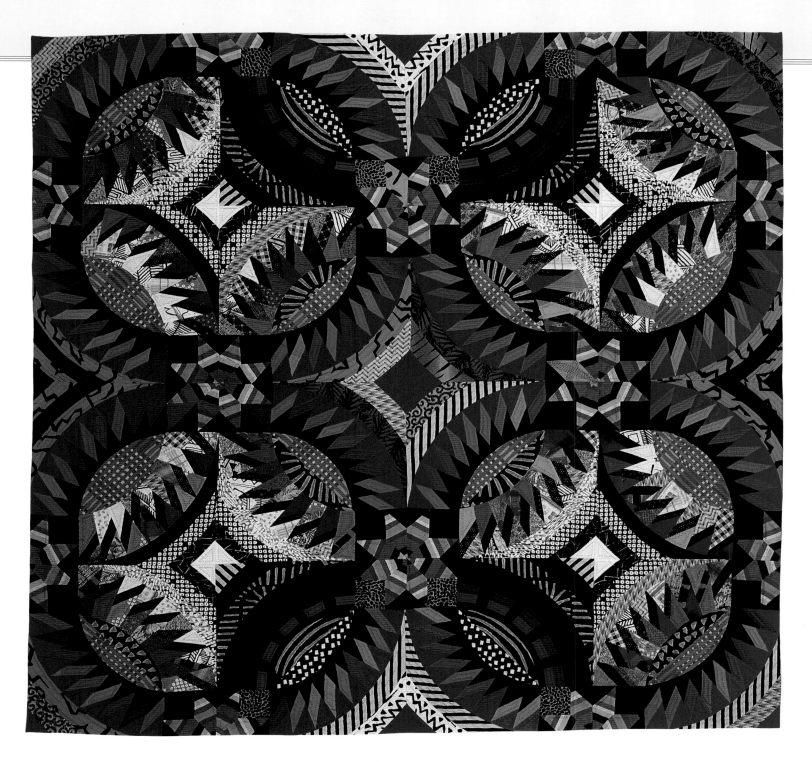

▲ DOUBLE MEXICAN WEDDING RINGS #4

Nancy Crow. 1989–90. Baltimore, Ohio. Commercial cottons. Machine pieced by Nancy Crow, hand quilted by Marie Moore. 72 x 72 in. Collection of John Walsh III.

This fabulously complex abstraction represents the acme of Crow's work with commercial patterned fabric. Like many of her quilts, it finds part of its inspiration in a traditional pieced pattern, the familiar Double Wedding Ring. The quilt is organized in a four-by-four set of eighteen-inch-square blocks. The blocks are arranged to form nine larger four-block units; eight of these are mirror repeats, but the central four blocks form a unique design. Slight variations in the fabrics that make up the blocks create a host of shifting, kaleidoscopic rhythms that leave the eye no place to rest.

◄ COLOR BLOCKS #70

Nancy Crow. 1995. Baltimore, Ohio. Pima cottons, hand dyed by the artist. Hand cut and machine pieced; hand quilted by Marla Hattabaugh. 55 x 64 in. Collection of the artist.

This recent addition to Crow's long-running *Color Blocks* series is an example of her work with richly colored hand-dyed fabrics and intuitive, freely cut forms.

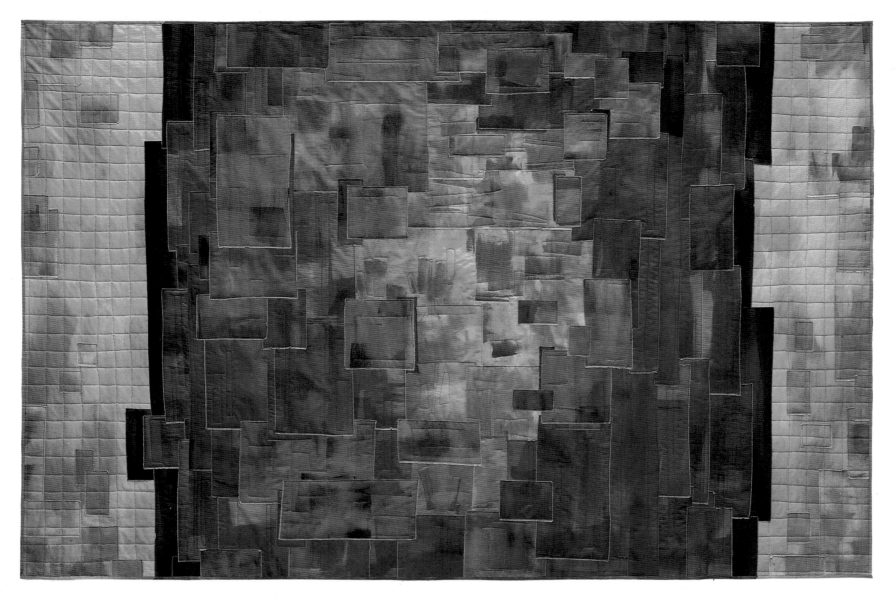

▲ INTERIORS

Erika Carter. 1996. Bellevue, Washington. Hand-painted cottons. Machine appliquéd, machine quilted. 46 x 67 1/2 in. Collection of the artist.

In recent years, Carter has moved from an impressionistic style based on landscapes and natural forms (especially trees) to complete abstraction. Of this quilt she notes, "Colors appear layered and stacked, suggesting order, but there is ambiguity as to what is really on top and what is behind."

NIGHT CLOCK ▶

Emily Richardson. 1994. Philadelphia, Pennsylvania. Textile paint on silk and cotton, nylon netting. Hand appliquéd, embroidered, and quilted. 82 x 60 in. Private collection.

Richardson notes, "Currently I am looking to what is appealing in traditional quilting (structure, patterns, repeated motifs, etc.) and using that to support an overall abstract image."

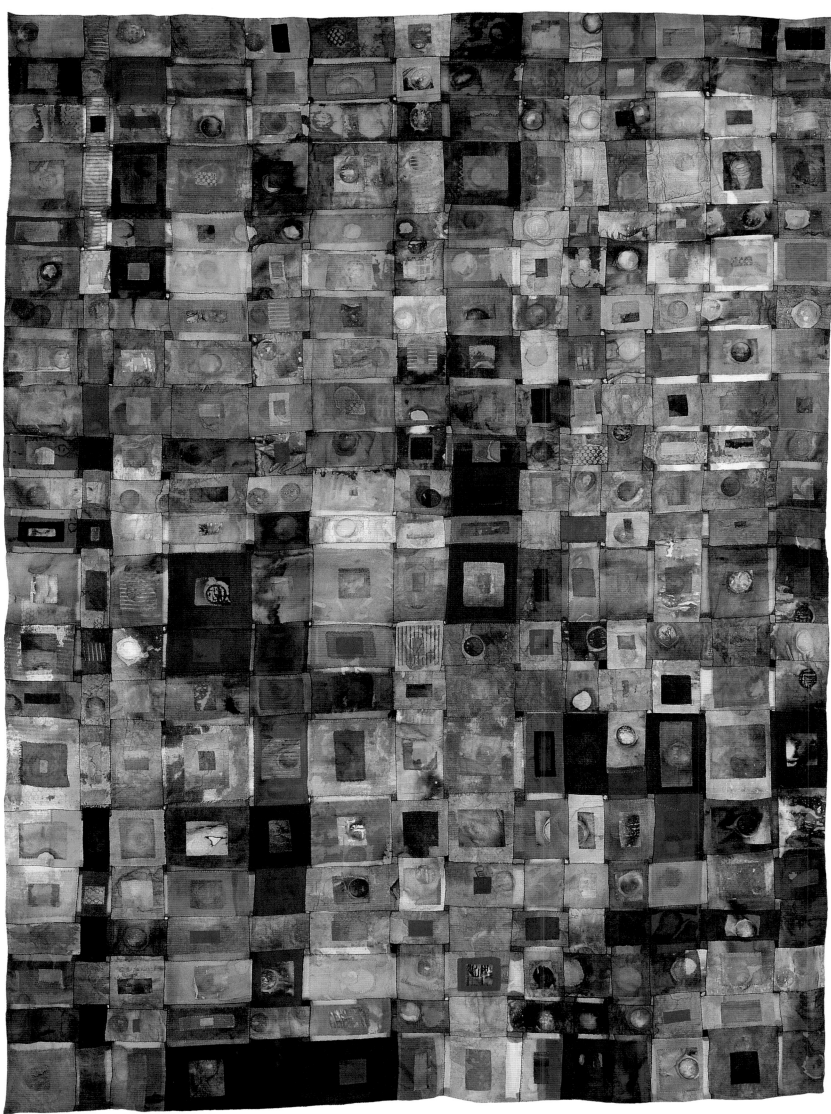

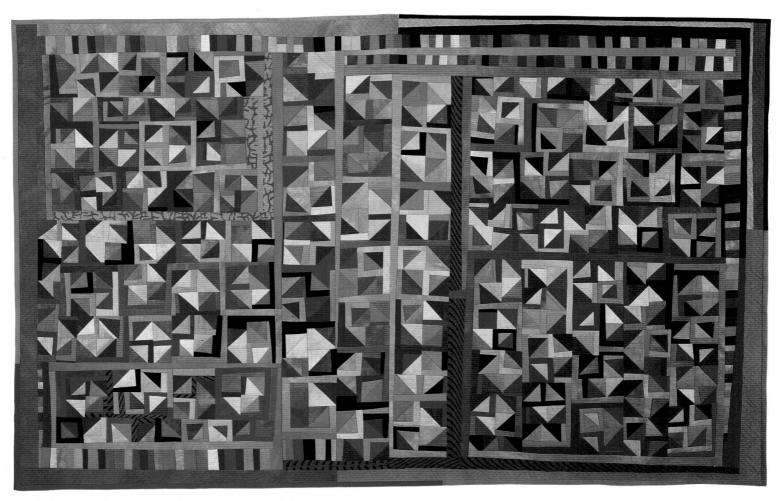

▲ **MUMBO JUMBO 3: RENAISSANCE THINKING**

Liz Axford. 1995. Houston, Texas. Hand-dyed and commercial cottons, cotton thread, cotton batting. Machine pieced and quilted. 49 x 77 in. Collection of the artist.

Axford explains, "This is a totally improvisational piece, begun with absolutely no idea where it was headed. I began by sewing triangular scraps together, combining them with linear scraps to create units of varying size and composition and organizing those units into columns and rows. I spent many hours in the next year and a half, on and off between other quilts, contemplating how to define and reinforce the basic organization, and when to stop. The title refers to the additive approach of Renaissance architecture, whereby buildings were designed by assembling units of varying function into a whole."

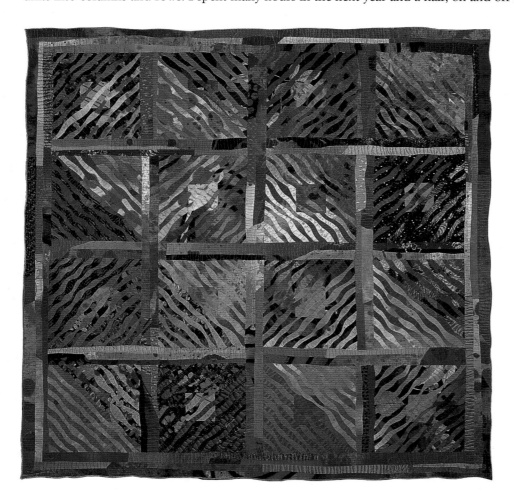

◄ **WATCHFUL EYE VI: OGALU WITH SQUARES (DETAIL ►)**

Sue Benner. 1995. Dallas, Texas. Dye on silk, commercial silks. Fused and machine constructed. 43 x 43 in. Collection of AMRESCO, Dallas, Texas.

Benner finds inspiration in ethnographic textiles and folk art and has been struck that similar patterns and designs often show up in diverse cultures. She says she thinks of these common patterns as a sort of universal language. This quilt was informed by similarities between variations on the traditional Roman Stripe quilt pattern, the "Eye of God" pattern from Mexico, and concentric diamond designs painted on walls by the Igbo women of Nigeria. These last are derived from tribal body scarification patterns called *Ogalu*.

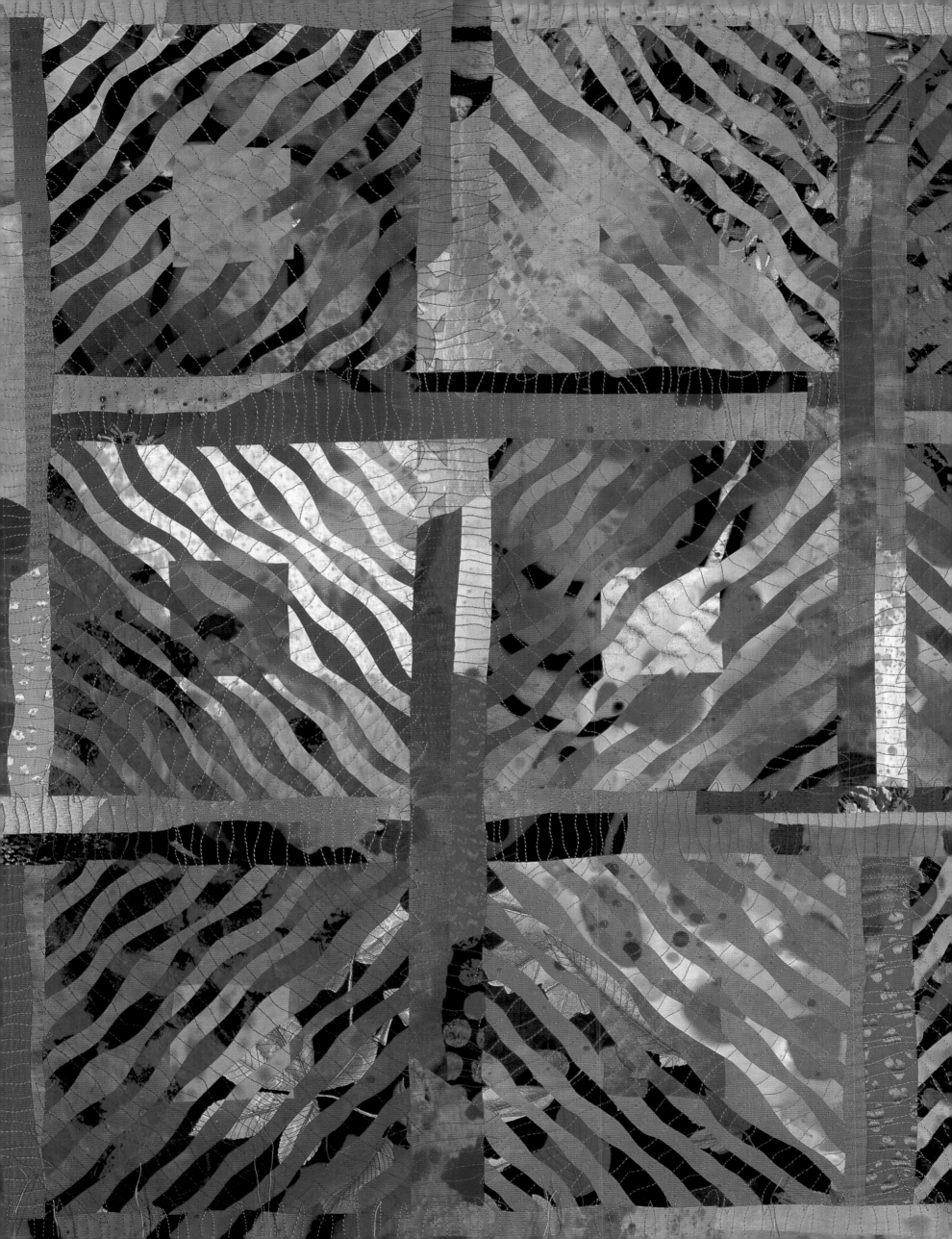

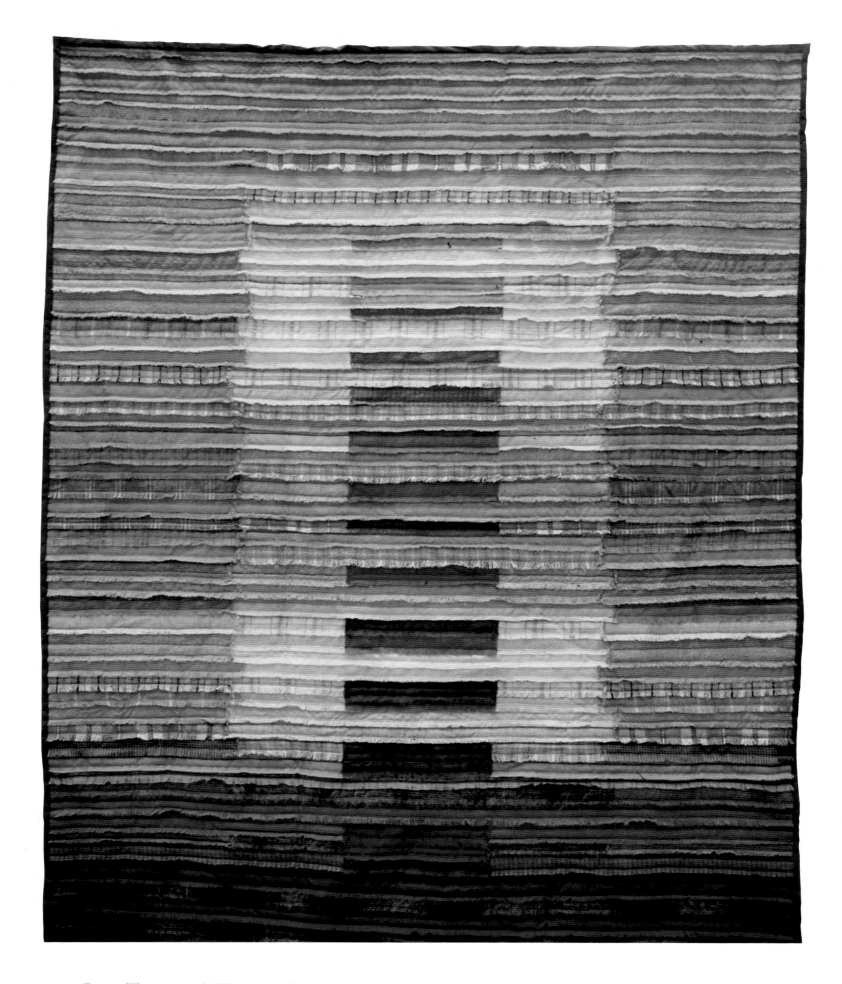

▲ BLUE TOWER—A WOOLEN SCRAP QUILT

Mary Fogg. 1990. Surrey, England. Mixed scraps of woolen materials, wool couching thread. Machine appliquéd, machine quilted. 87 x 70 in. Collection of the artist.

Mary Fogg's quilts often explore the textures and colors of different types of fabric. Here, she mixed scraps of tweeds and other woven wools, and appliquéd and quilted over couching thread. The overlapping edges of the pieces were then fringed to reveal the structure of the cloth and to add another layer of texture to the quilt's surface.

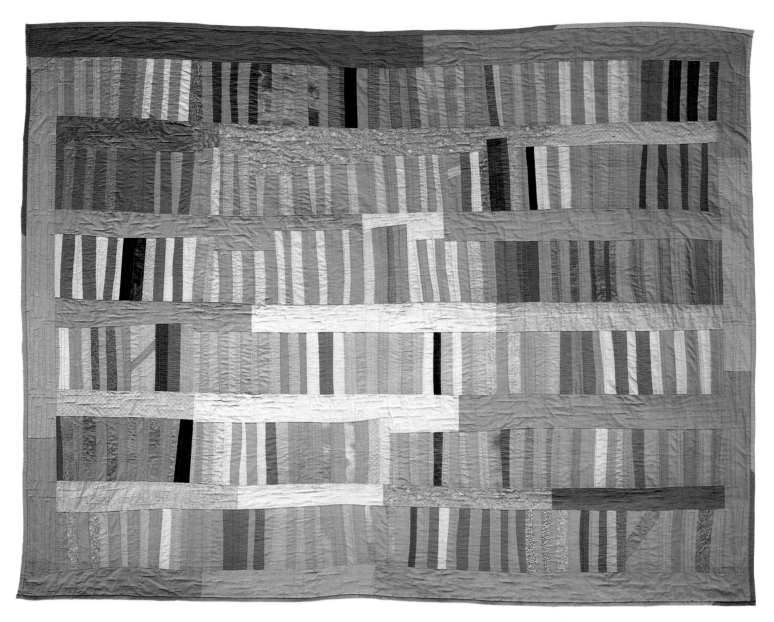

▲ LUMEN I IMPROVISATION 493

Carol M. Moe. 1993. Denver, Colorado. Commercial and hand-dyed cottons, cotton batting. Machine sewn and quilted. 60 x 73 1/2 in. Collection of John Walsh III.

Moe says she woke from a dream with this image in her mind's eye. The colored strips, horizontal bands, and borders were all cut freehand.

CIRCLE ON SQUARE I ▶

Lucy Wallis. 1984. Somerset, England. Machine-pieced taffeta overlaid with wool stitching, cotton backed and tied, bound with velvet. 108 x 108 in. Collection of Ardis and Robert James.

Wallis is an English jeweler and sculptor who has also made a handful of remarkable quilts. This massive quilt was pieced from hundreds of small strips of taffeta to create an effect that collector Ardis James has likened to a tantalizingly over-stuffed bookcase.

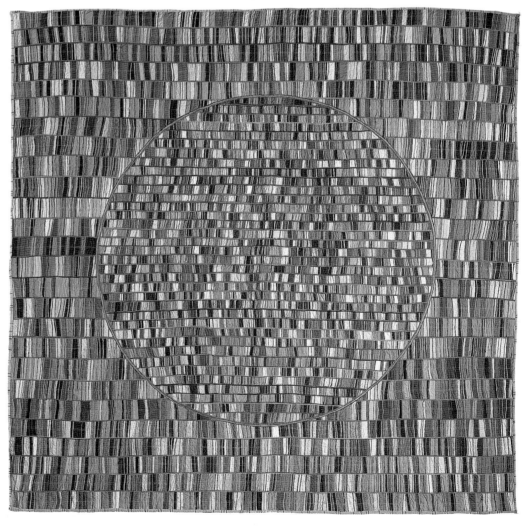

EINSTEIN AND TOMATOES ▶

Yvonne Forman. 1995. Hastings-on-Hudson, New York. Cotton. Photo-transfer, machine pieced, hand quilted by Grace Miller. 41 x 41 in. Collection of the artist.

Foreman explains: "*Einstein and Tomatoes* reflects my continued fascination with the transformation that occurs when an ordinary object is placed in an unexpected context. In this piece, I juxtapose the high-tech laser-printed photo-transfers with the traditional nine-patch blocks, dissolving boundaries and reordering fragments in pursuit of what can happen when two unlikely elements meet."

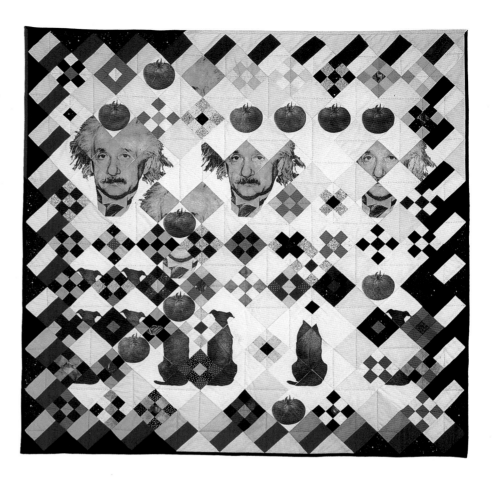

◀ CHIMERA I

Dominie Nash. 1995. Bethesda, Maryland. Cotton, silk organza, dyes, textile pigments. Machine pieced and appliquéd, machine and hand quilted. 49 1/2 x 42 1/2 in. Collection of the artist.

Nash dyes and prints all her own fabrics for her collage-like and often improvisational quilts. A former weaver who began making quilts in 1985, she finds design and color inspiration in her garden as well as in the paintings of Pierre Bonnard and Richard Diebenkorn.

▲ THIS IS A QUILT, NOT ART

Joe Cunningham. 1996. San Francisco, California. Cotton fabrics, cotton/poly batting. Machine pieced, hand quilted.
80 x 68 in. Collection of the artist.

Cunningham has been a professional quiltmaker and teacher since 1979 and is the author of eight books on traditional quiltmaking. This recent quilt is based on early glazed wool quilt design, with three wide borders enclosing a field of pieced blocks. In this case the blocks are made of Hawaiian shirt scraps, and the borders are sewn from various scraps "pretty much in the way I tossed them on the floor to see how they would look together."

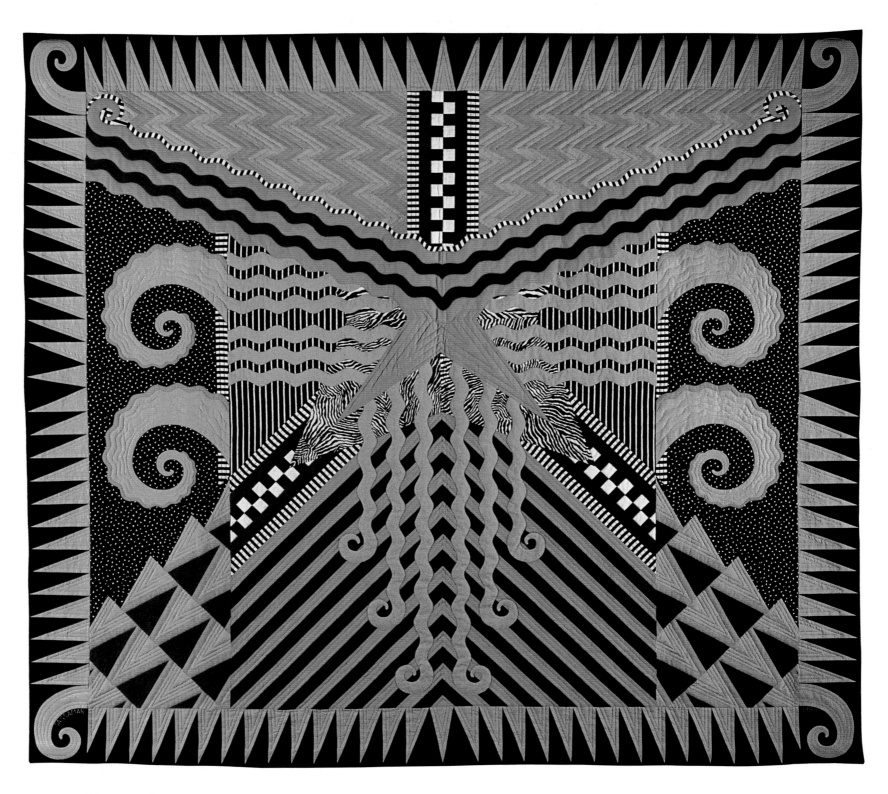

▲ **DIVINE RADIATION**

Jane A. Sassaman. 1989. Chicago, Illinois. Cotton and cotton blends. Machine pieced and quilted. 73 x 69 in. Collection of the artist.

Sassaman's strongly graphic quilts often feature radiating central forms that find their inspiration in nature.

AFRICANISHE LÄHMUNG (AFRICAN PARALYSIS) ▶

Ursula Rauch. 1996. Weingarten, Germany. Cotton and other fabrics. Wax painting, patchwork, mola, machine sewn. 78 3/4 x 57 in. Collection of the artist.

Rauch is a painter, sculptor, and collage artist who often works with textiles. Her works in all media revolve around a private vocabulary of hand-drawn, stick-like "letters," anthropomorphic forms, and cryptic symbols.

▲ CIRCUS COLLAGE: BLACK SEA LION (◄ DETAIL)

Bethan Ash. 1994. Cardiff, Wales. Cotton fabrics. Machine stitched. 30 x 24 in. Collection of the artist.
This charming little quilt is one of a group of four based on circus themes. The suite complement each other and can be hung together or separately.

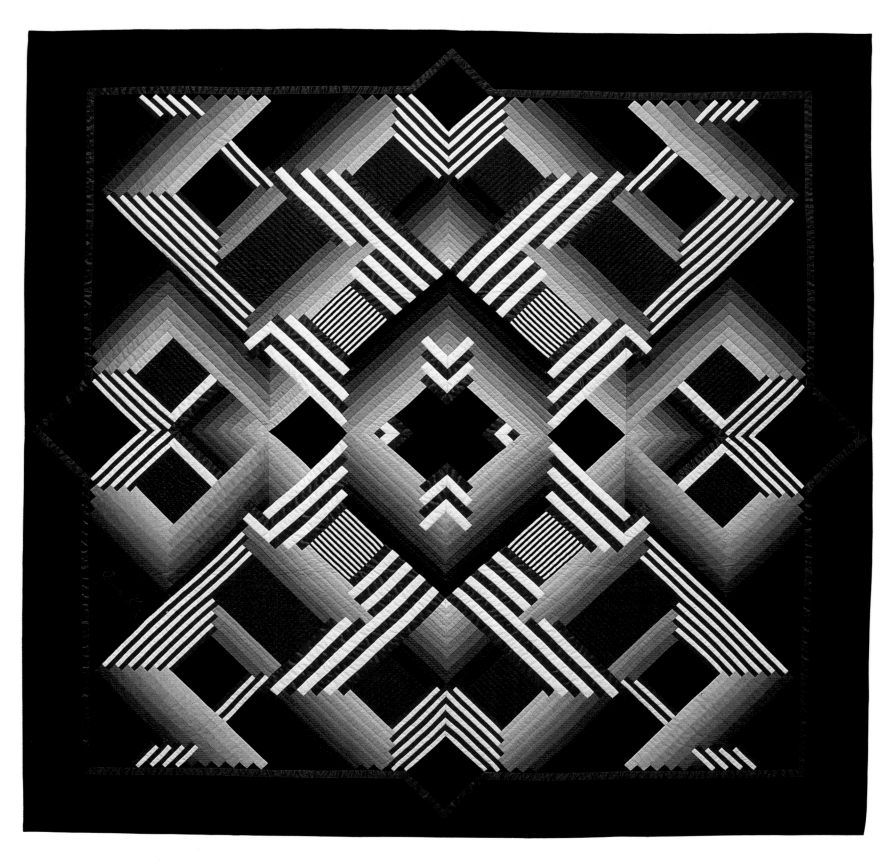

▲ **LCC 3:9 (STRUCTURAL PORTENTS)**

Glenda L. King. 1990. San Francisco, California. Cotton, some hand dyed, satin, cotton blends, cotton/polyester batting. Machine pieced, strip-pieced, hand quilted. 64 x 64 in. Private collection.

King says she built this thoroughly modern Log Cabin quilt "like a skyscraper, drawing on traditional forms, techniques, and materials, but in the end reflecting the character of a technological age."

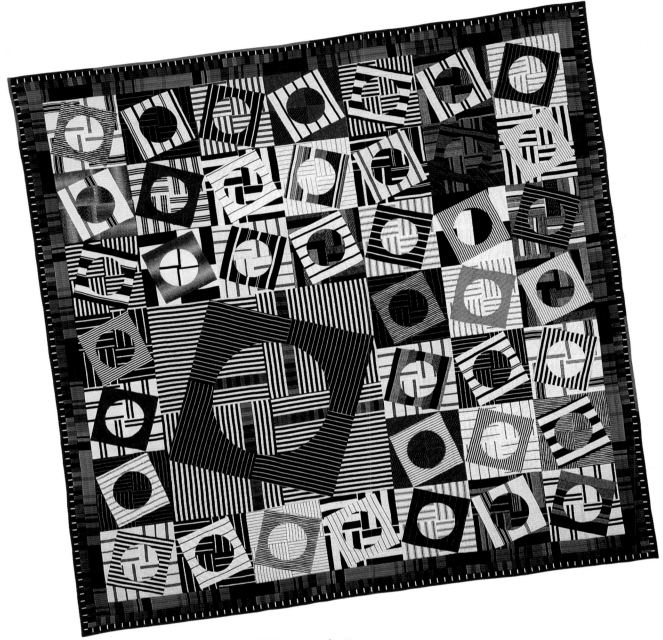

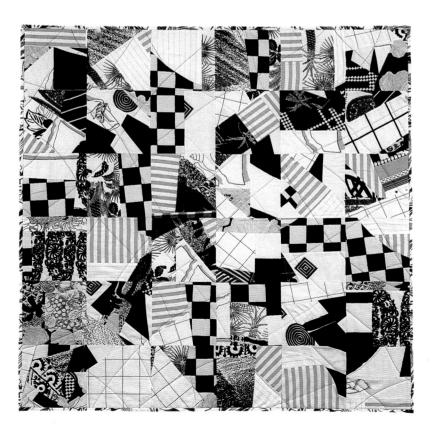

▲ NEWTON'S LAW

Marilyn Henrion. 1995. New York, New York. Cotton fabrics. Machine pieced, hand appliquéd, hand quilted. 61 x 61 in. Collection of the artist.

This quilt's title refers to Newton's third law of motion, which states that for every action there is an equal and opposite reaction. The idea behind the piece is expressed by words from the Greek philosopher Heraclitus: "The opposite is beneficial; from things that differ comes the fairest attunement; all things are born through strife." The quilt is intended to hang at an angle, suggesting the motion of a pendulum.

◄ PIERROT

Sylvia Einstein. 1996. Belmont, Massachusetts. Cotton and cotton blends. Machine sewn and quilted. 48 x 48 in. Collection of the artist.

Einstein has been making art quilts since the mid-1970s. Although she is much better known in Europe than in the United States, her unique and painterly approach to fabric combinations has quietly influenced a number of her colleagues in Massachusetts.

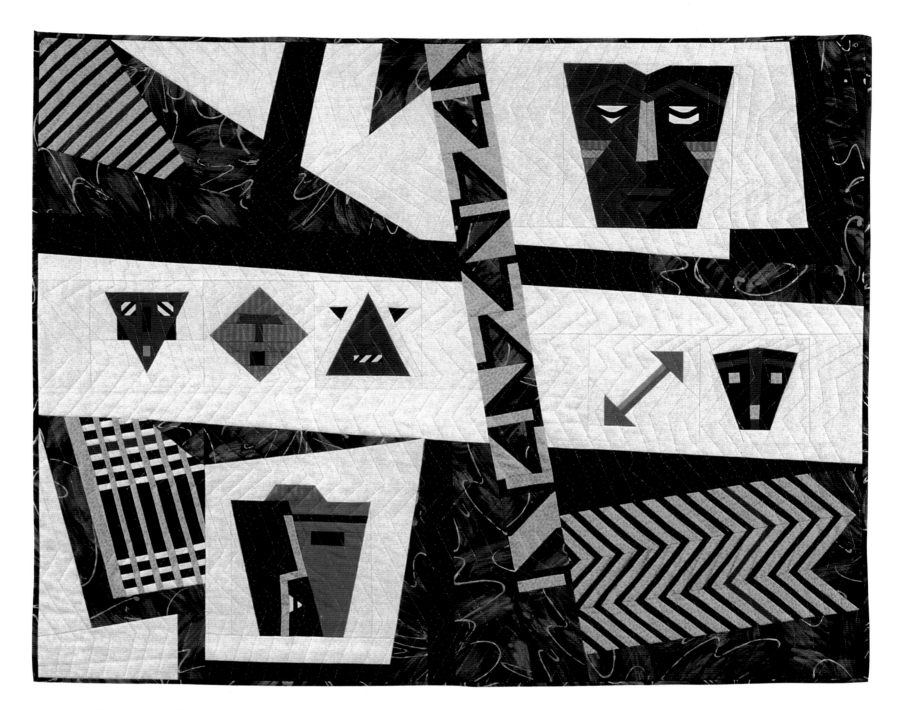

▲ IDENTITY CRISIS

Judy Becker. 1995. Newton, Massachusetts. Taffeta, batik, drapery fabric, cotton, cotton batting. Machine pieced and quilted. 48 x 60 in. Collection of Randolph Associates, Inc.
In this quilt, Becker combines ambiguous mask-like faces and off-kilter geometry to suggest the onset of an "identity crisis."

RITES OF SPRING (SERENDIPITY) ▶

Radka Donnell. 1991. Zurich, Switzerland. Cottons. Hand pieced, machine quilted by Claire Mielke. 80 x 54 in. Collection of Nancy Halpern.
Although she insists that art must speak for itself, Donnell says she hopes this quilt reflects her buoyant mood when she made it.

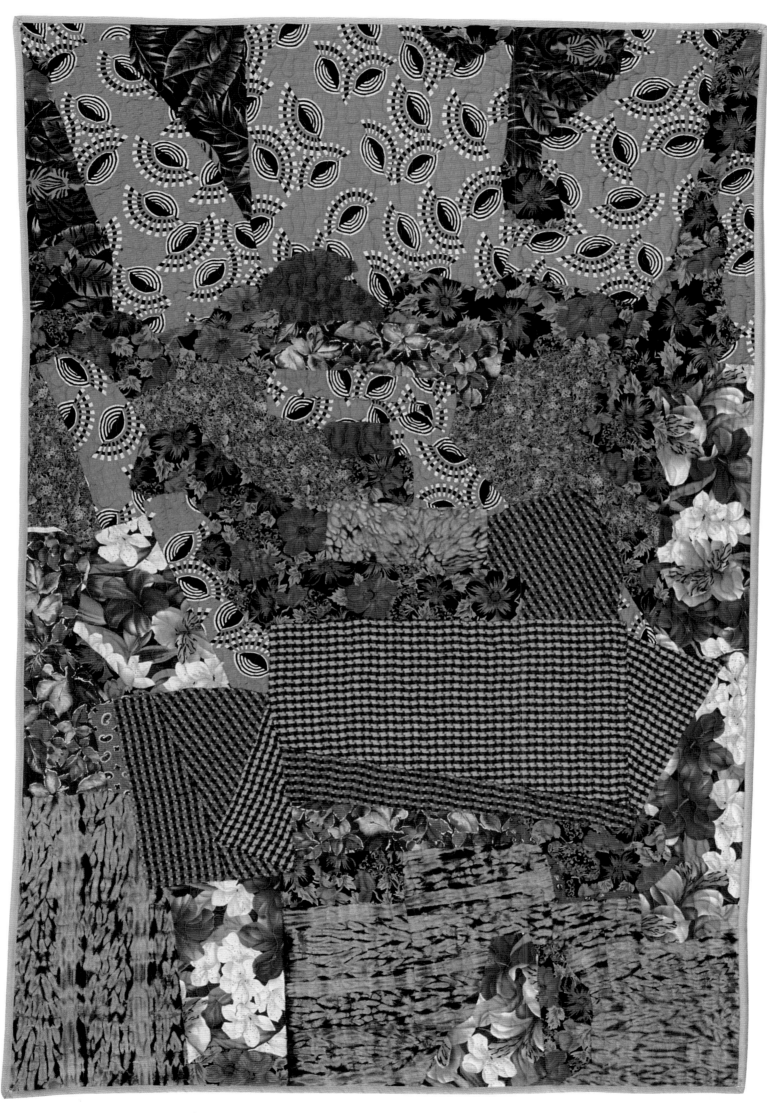

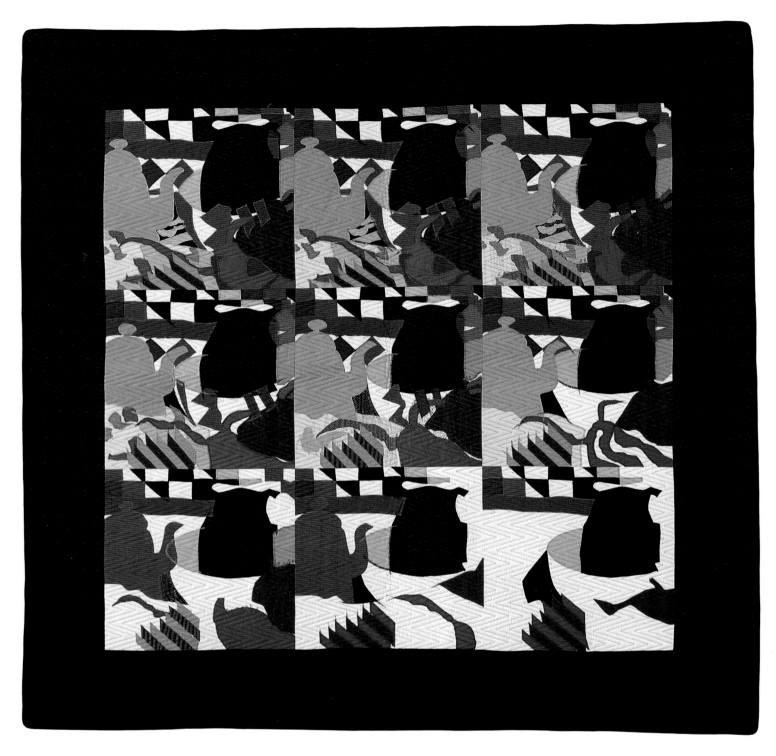

▲ THE PINK TEAPOT

Pauline Burbidge. 1987. Berwickshire, Scotland. Cotton fabrics, some hand dyed. Machine appliquéd, pieced, and quilted. 55 x 55 in. Collection of Ardis and Robert James.

Burbidge's innovative work has astonished quilters on both sides of the Atlantic since the early 1980s. When she made this block-style quilt, she was using paper collage studies as a starting point and would pick an area from the collages to produce as her fabric block. With *The Pink Teapot* she realized that she did not want all its blocks to be identical. Burbidge explains: "So I began with the top left block and worked my way along with the intention of simplifying the pattern and shapes and allowing them to form a well-balanced overall image. It was an exciting step for me."

STAR SHOWER ▶

Judy Dales. 1990. Kingwood, Texas. Cotton, poly/cotton, polyester batting. Machine pieced, hand quilted. 43 x 60 in. Collection of the artist.

Dales began quilting in 1970 while living in England, and says her isolation from other quilters provided her with the freedom to develop her own style. This star quilt is typical of her ability to honor quilting's traditions in the context of an original contemporary design.

FISH PARTS ▶

Helen Giddens. 1989. Rainbow, Texas. Cottons. Machine pieced and quilted. 70 x 100 in. Collection of Carmen O'Brien.

Giddens used to work as a telephone operator and often doodled between calls. Almost all of her quilt designs have their origins in such free hand sketches. The idea for this quilt came to her from fish she had been cutting up for a meal. She adds, "It's pretty much the way they looked on the plate."

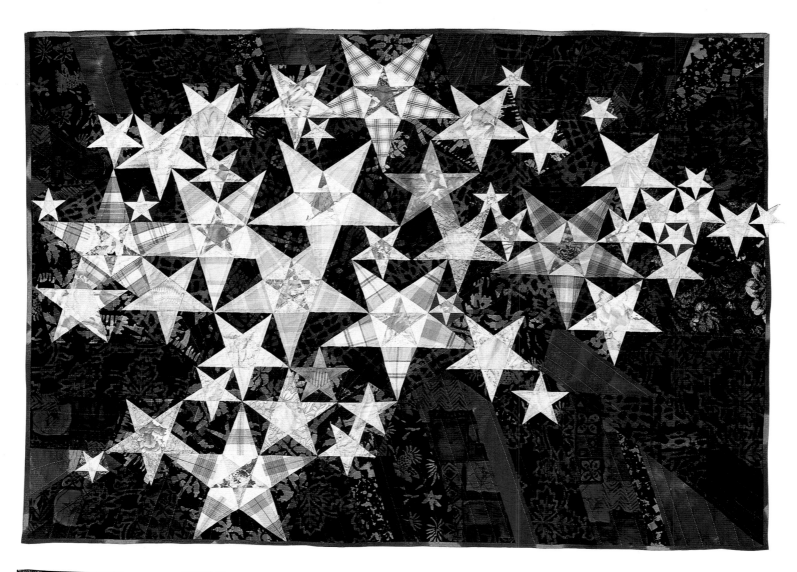

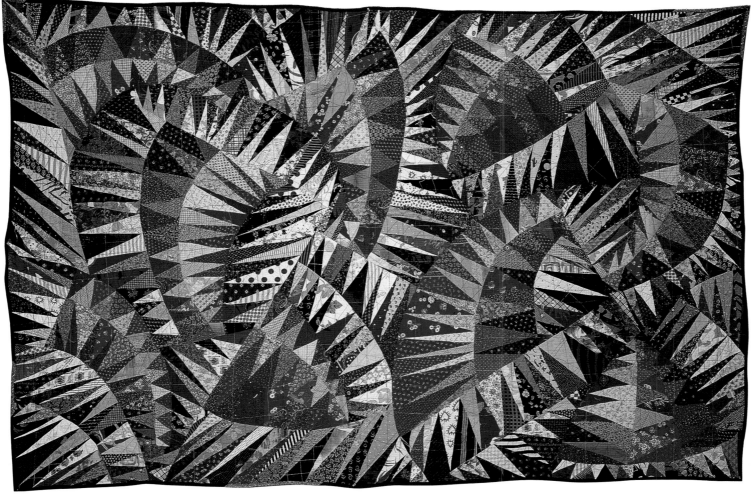

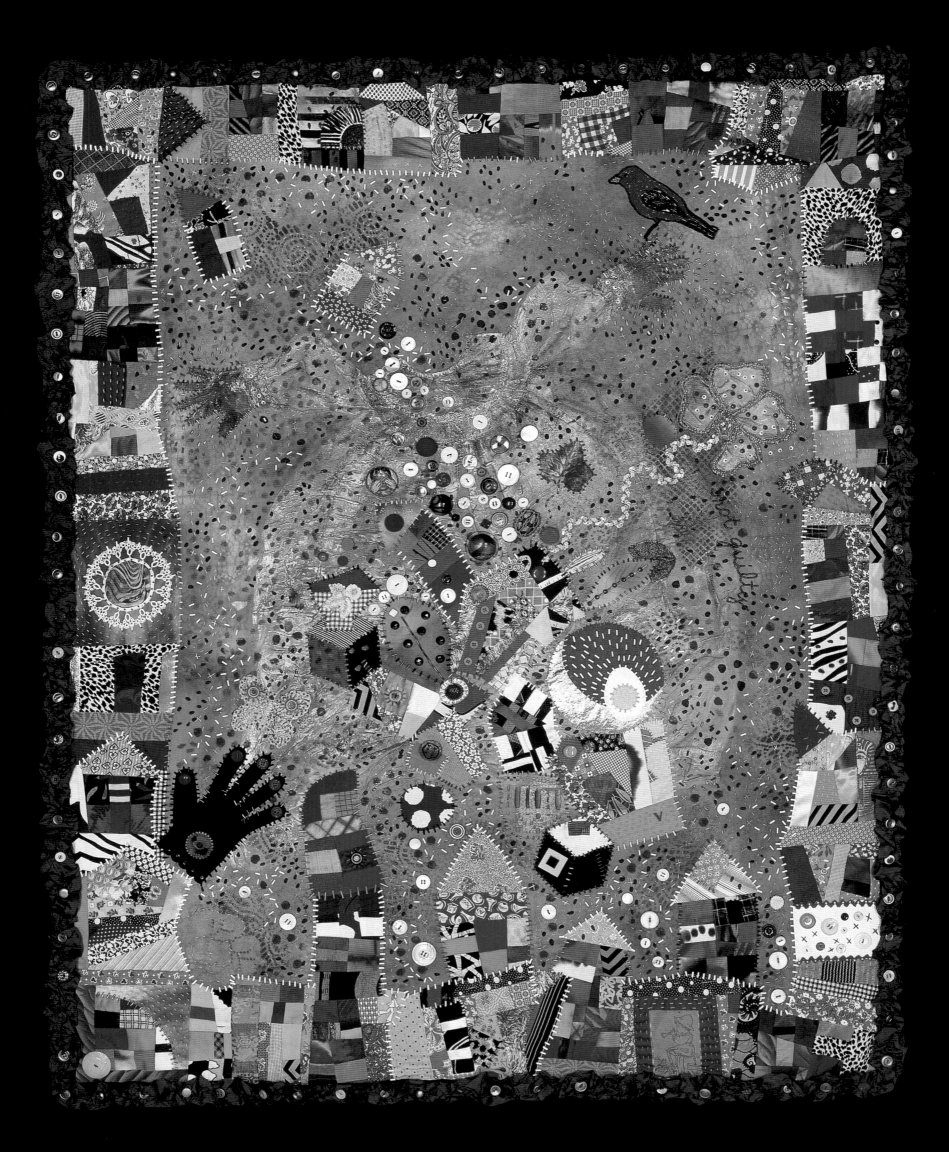

The Quiltmaker as Artist

Narrative and Figural Quilts

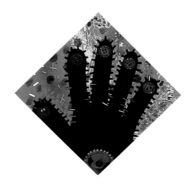

While abstraction is the quilt's most familiar and traditional milieu, a number of art quiltmakers specialize in quilts that deal with intellectual concepts or which seek to explore human relationships and behavior. Such conceptual works usually present narratives or portraits, rendering recognizable images in or on fabric. Their subject can be deadly serious, like Arturo Alonzo Sandoval's *Lady Liberty/Babylon II*, or it can be light and playful, like Ruth McDowell's *Coffee and Conversation*. At either end of the spectrum, the quilts are driven by their content, and their visual approach is dictated by their subject matter.

Some contemporary quilt artists view themselves as storytellers or portraitists, while others render quilts full of personal or political symbolism. Like painters and other artists working with representational concepts, the themes, concerns, and approaches of these quilt artists are widely varied. Contemporary pictorial quilts may be intended to convey a specific message, or comment on issues such as the environment (*Proposed Deep Pit Mine Site* by Terese Agnew), spousal abuse (*The Domestic Violence Quilt* by

◄ **American Childhood**

Jane Burch Cochran. 1995. Rabbit Hash, Kentucky. Fabric, beads, buttons, paint, baby dress, gloves. Machine pieced, hand appliquéd using beads, hand embellished. 53 x 42 in. Collection of Pam Monfort.
This quilt offers a host of images related to childhood as touchstones of memory, connection, and meditation. "I want the viewer to make his own narrative," says Cochran.

Justine Nauman-Greif), or societal images of women (*The Happy Homemaker* by Wendy Huhn). Like Barbara Pietila's *Signifyin'*, they may present carefully observed portraits of people or vignettes of everyday life, or, like the mixed-media extravaganzas of Susan Shie and James Acord, they may serve as intimate diaries of the artists' own activities and concerns. The story that the quilt-maker chooses to present can be as clear as Laura Wasilowski's *Gus Cleans His Room: A Mother's Fantasy* or as dreamlike and open to interpretation as Risë Nagin's *Drop Cloth* or Therese May's *Pregnant Winter Tree*. Similarly, figures can be as realistically rendered as Carole Lyles's *Ms. Vincent* and Deidre Scherer's *King of Spades* or as vaguely defined as Jean Hewes's amorphous, shape-shifting *Leopards*.

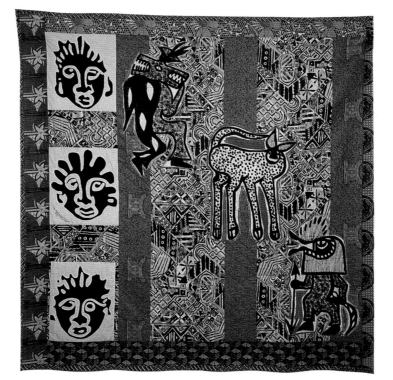

Many narrative quiltmakers work from a personal body of images and technical approaches they have developed over the years. Gretchen Echols has collected paper dolls since she was a child and now incorporates images of dolls from her collection into her quilts. The somewhat stiff, artificial, and impersonal quality of the dolls allows her to delve into psychological realms that would overwhelm more realistic figures. Her *Innocentia Descending*, for example, depicts a barefoot, flower-bedecked, haloed, and star-spangled young woman climbing down a wavy stairway into waters full of skeletal fish and tiny human skeletons.

Arturo Alonzo Sandoval is a professor of fine art at the University of Kentucky in Lexington, where he has taught since 1974. Sandoval became involved in fiber arts in the mid-1960s while studying at the Cranbrook School of Art. Originally trained as a weaver, he now works with such unusual and often fragile man-made materials as Mylar, microfilm, acetate, metallic threads, netting, and movie film, combining them into seductively beautiful quilts and mixed media textile works with powerful and sometimes disturbing meanings. A veteran of the Vietnam war, Sandoval often focuses on political, environmental, or military themes in his work. He has created a number of quilts that play on the meanings of the American flag; his *Flag for the Americas*, for example, was made to commemorate the 500th anniversary of Columbus' landing. It comments on the politically divided status of the American continents by incorporating colors and symbols of many North and South American nations and cultures into the design of the U.S. flag. Another series depicts targets for nuclear strikes seen from the air; the colorful circular *Ground Zero* targets are as lovely to behold as their message is upsetting to contemplate.

▲ OUR ANCESTORS SPEAK TO US

Carolyn Mazloomi. 1996. Cincinnati, Ohio. Cottons. Machine sewn. 60 x 60 in. Collection of the artist
Mazloomi is a former aerospace engineer who founded the Women of Color Quilters Network in 1985 and has been instrumental in promoting the work of African-American quiltmakers past and present. Most of her own work is based on African-American life and history.

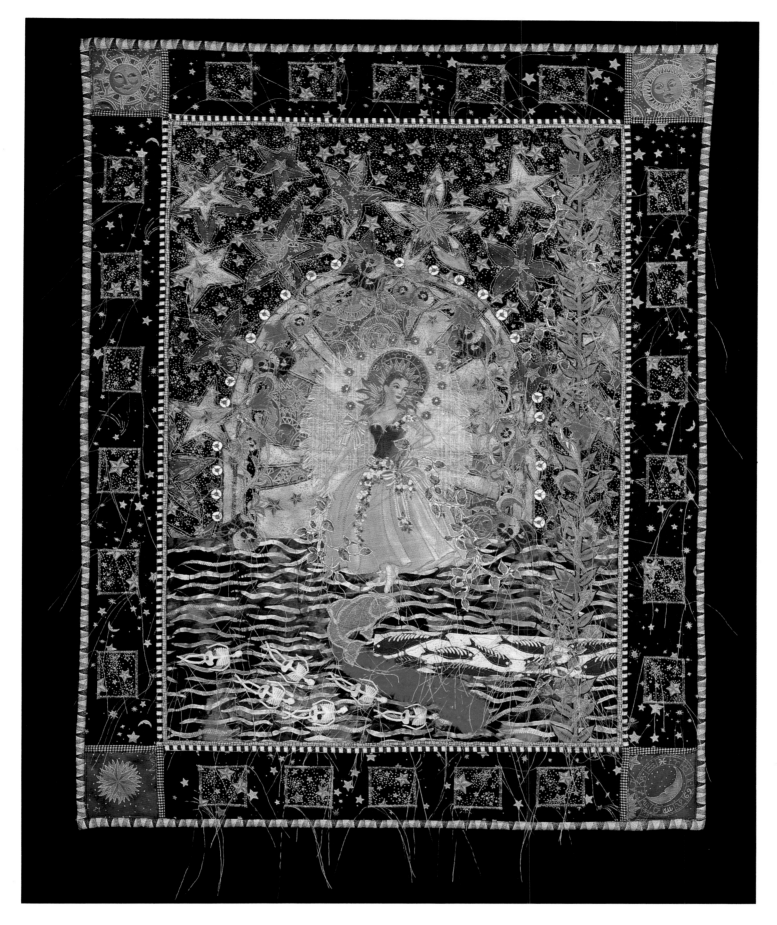

▲ INNOCENTIA DESCENDING

Gretchen Echols. 1994. Seattle, Washington. Cotton, heat transfers of color images, ribbon, buttons, found objects, DMC perle cotton, Cotton Classic batting. Hand appliquéd and reverse appliquéd, machine quilted. 30 x 23 in. Collection of Doug duMas and Cherry Haisten.

Echols comments: "This work simultaneously tells the story of Persephone and the story of the descent into womanhood that all girls must traverse. The salmon, the Celtic symbol of wisdom, arises from the deep to initiate the beautiful maiden into the mysteries of blood and bones. Out of the flow of blood, new life is formed."

◀ **BY THE LIGHT OF THE VOLCANO: HAND SHADOWS #3**

Nancy Erickson. 1995. Missoula, Montana. Velvet, satins, cottons, polyester batting, acrylic and pearlescent paints. Hand painted, machine quilted and appliquéd. 70 1/2 x 62 1/2 in. Collection of the artist.
This quilt is part of a series exploring studio life. Here Erickson muses on how an unusual group of models might kill time while they wait for the artist.

Jane Burch Cochran considers herself a storyteller, but her approach is not didactic. Her quilts are full of evocative images, which viewers are free to connect in a variety of ways to create their own narrative storylines. Cochran is interested in presenting a group of images that resonate for her in each of her quilts, but she is not inclined to attempt to label their meanings. The titles of her quilts—*When All Is As It Should Be, Southern Devotion, Surprise Party, American Childhood, Life Line, Pot Luck, The Last Dance, Life Starts Out So Simple, For All Our Grandmothers*—are broad and inclusive, offering a suggestive grouping of allusions through which the viewer can search to find personal meaning. Cochran works intuitively, often allowing recycled materials to suggest a starting point or direction for a piece. Many of her quilts include gloves, which are used to symbolize hands "reaching and searching for both questions and answers about race, the environment, and the human psyche." *American Childhood*, for example, began with an old, worn baby dress someone had given to her and a small pair of kid gloves that had belonged to her uncle as a child. These became the quilt's central image and were juxtaposed with quilted childlike images of houses, blocks, a ball, butterflies, and a beaded red bird, all surrounded by a frame of charmingly naive patchwork. The other images suggested themselves to Cochran as she thought about childhood while she worked on the quilt, but she made no effort to push them in any particular direction. The quilt offers an associative meditation on childhood in America onto which the

viewer can project his own thoughts, feelings, and experiences.

Nancy Erickson, a painter who also holds degrees in zoology and nutrition, creates narrative scenes involving encounters between animals, man-made objects such as TVs and bare light bulbs, and a lone, naked woman. Her ongoing body of work often depicts an empty, environmentally ravaged, post-millennial landscape in which polar bears, rabbits, female lions, and other animals encounter a nude female who attempts to establish relations with the curious beasts. Despite its potentially portentous and oppressive intellectual premise, Erickson's work is invariably charming, amusing, unpretentious, and hopeful. Her observations of animals are direct and knowing, and they are as admiring of their subjects as her sly self-portraits are humble and self-deprecating. The nudity of the ambiguous woman (artist? model?) in the quilted paintings deflates her dominant stature, putting both the real (Erickson) and painted women on even footing with the animals who are at once their subjects and companions. The nudes also play tongue-in-cheek fun with the historic position of woman as artist's model. A hilarious and touching recent series depicting polar bears in the artist's studio goes straight to the heart of this complex relationship; titles in the series include *Considering Domesticity; The Ice Bear, Curious, Inspects His Image in the Mirror;* and *By the Light of the Volcano: Hand Shadows.*

Terrie Hancock Mangat's narrative quilts are more obviously personal and specific than those of either Erickson or Cochran. She usually works directly from personal experience or portrays a single imagined event, and often draws on religious imagery. Her iconic quilts often represent acts of memory or act as memorials themselves. Her *Memory Jars*, for example, recalls in fabric a ceramic memory jar her grandmother kept

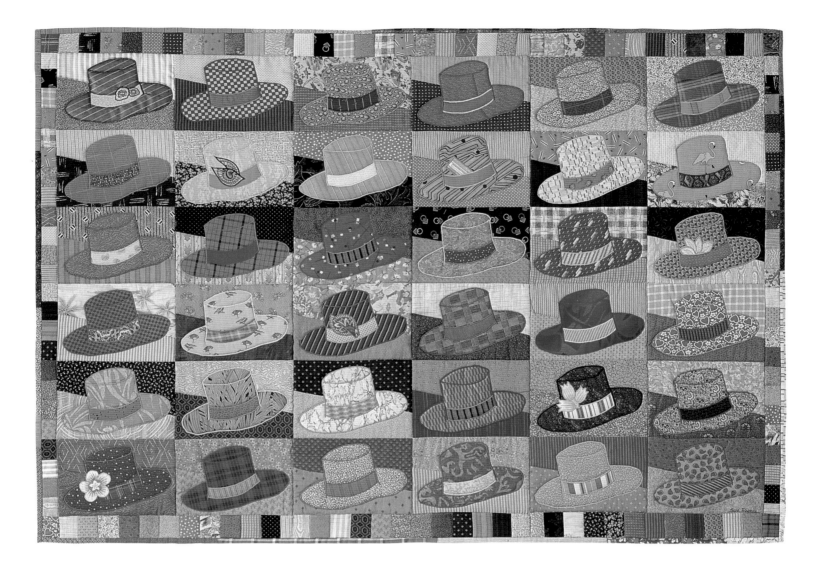

which she and her cousins played with as children. Memory jars are a type of Southern folk pottery, made of stoneware. After the jar is formed on the wheel, a host of small personal keepsakes is pushed into the wet clay. Mangat's *Memory Jars* quilt translates the custom to another medium; it depicts three enormous jars, larger than any that could ever be practically thrown on a wheel, which are covered with a variety of Hancock's personal memorabilia, including buttons, pins, jewelry, charms, beads, shells, and even her rosary beads.

Some quilt artists reference traditional quilt-making in their work, making use of its historic meanings and playing with viewers' expectations. Joyce Marquess Carey's *Red Squares*, Rachel Brumer's *Let Her*, and Sue Pierce's *Hat Trick* all use repeated images in a manner reminiscent of a traditional block-style quilt, but the images—of Russian dictator Joseph Stalin, an unselfconscious daughter's mismatched clothing, and a broad-

brimmed woman's hat, respectively—are decidedly contemporary. In each of the three quilts, the repetition of images is used playfully to generate the quilt's story and meaning. Brumer's *Let Her* and Pierce's *Hat Trick* offer the same pattern worked in a variety of different fabric combinations, while Carey's punning *Red Squares* combines printed pictures of Stalin with squares of plain red fabric. The sly and slightly disquieting quilt is made from commemorative fabrics that were printed in China.

African-American quilt artists such as Yvonne Wells, Carolyn Mazloomi, Faith Ringgold, Michael Cummings, and Barbara Pietila have continued and expanded the Black tradition of pictorial story quilts in recent years. Their quilts present portraits and stories of African and African-American men and women, commenting on their history and the dignity of their daily lives. Most of the figures in these works have a

◀ **HAT TRICK**

Sue Pierce. 1989. Rockville, Maryland. Cottons and cotton blends. Machine appliquéd and quilted. 42 x 60 in. Collection of Tom Wolfe.
Pierce has here flattened the standard square of the traditional block-style quilt into a rectangle to fit the shape of her hat and offers the viewer a choice of thirty-six appliquéd variations on a theme.

RED SQUARES ▶

Joyce Marquess Carey. 1989. Madison, Wisconsin. Assorted fabrics, including satin and Chinese jacquard-woven political posters of Stalin, found sheriff's badge. Machine pieced and quilted. 43 x 45 in. Collection of the artist.
Carey describes this punning piece as a political cartoon. The woven pictures of Stalin, the embodiment of the U.S.S.R.'s "Evil Empire," were all made before the fall of communism in Eastern Europe.

purposely unsophisticated "folk" quality in keeping with well-known historic story quilts such as the Bible quilts of Harriet Powers. Wells is a former schoolteacher who has no formal artistic training. Her quilts' subjects range from amusing representations of cartoon characters like Mickey and Minnie Mouse to fanciful explorations of biblical and political themes. Her *Me Masked* is more personal than most of her work, but still reflects her self-deprecating sense of humor. Cummings, who is also self-taught, creates series of stylized, mythic African-American portraits in cloth. His *Haitian Mermaid #1* offers an ambiguous encounter between a woman and a huge fish, while his *African Jazz* series takes three New York musicians out of their normal smoky nightclub milieu and back to Africa, where their origins and, by extension, those of their music, lie.

Even more than the feminist artist Miriam Schapiro, the African-American painter and storyteller Faith Ringgold has made the quilt an integral part of her highly respected art. Ringgold's paintings are in the contemporary art collections of such prestigious institutions as the Museum of Modern Art and the Solomon R. Guggenheim Museum in New York, the Museum of Fine Arts Boston, the Newark Museum, and the St. Louis Museum of Art. Ringgold grew up in Harlem, and her quilt-framed paintings, like *Subway Graffiti #3*, present proud community portraits and upbeat slices of Black life. Since the late 1970s, she has framed her narrative paintings with quilted patchwork, sometimes made of printed or tie-dyed African textiles. While fine art curators admire Ringgold's powerful painted representations of everyday African-Americans and their experiences, her use of the quilt as a framing device deliberately and symbolically ties her work directly to the domestic context it portrays.

THERESE MAY

Therese May's quilts tell stories, but the logic of her tales is ultimately as elusive as a dream. Titles like *Thy Will Be Done*, *For All the World to See*, *Cup-O-Wurms*, and *God Bless Us One and All* are not intended to clarify her imagery, but rather to add yet another layer of associative complexity to the visuals.

May's quilt art has evolved gradually over the years, one layer of process and meaning building on another. "All during the 1970s," she recalls, "I was keeping journals, writings, and drawings [of] dreams and fantasies, humor, playfulness, and childhood. I wanted to begin to express the feelings of intuition and freedom that were flooding through me." These new, childlike images—strange little animals, plants, braided rugs, and other forms—first emerged in her paintings, and then, in 1981, began to appear in her quilts.

◄ **CUP-O-WURMS**

Therese May. 1995. San José, California. Fabric, paint, buttons, beads. Machine appliquéd, beaded, painted. 65 x 60 in. Collection of the artist. May comments, "Every idea is a new 'cup-o-wurms.' Each one contains infinite possibilities. Choice is of utmost importance in the matter. Decision is what counts. The butterflies are below, waiting to be born. The braids provide a protection."

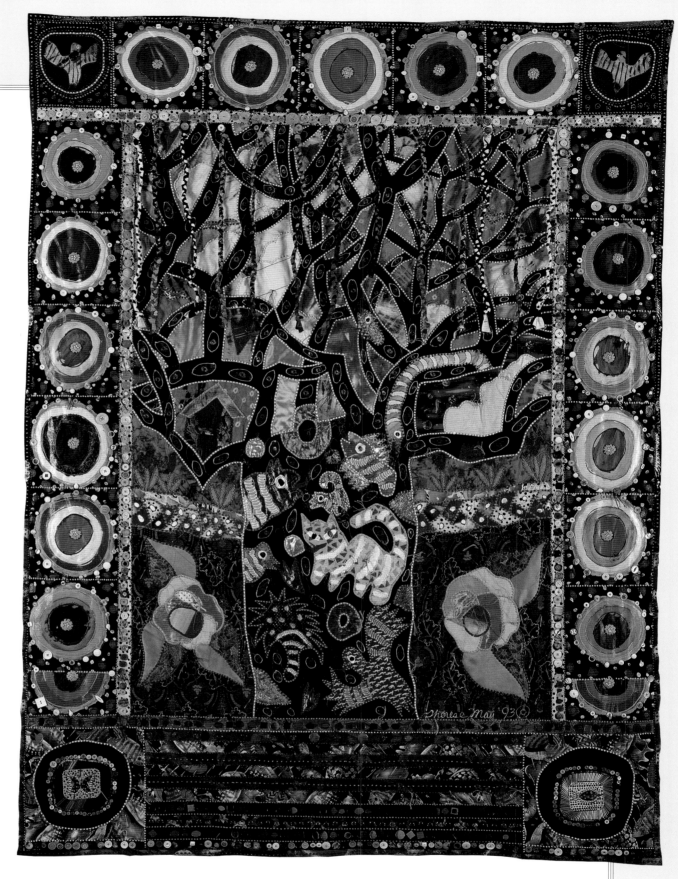

PREGNANT WINTER TREE ▶

Therese May. 1993. San José, California. Fabric, paint, buttons, beads. Machine appliquéd, beaded, painted. 90 x 69 in. Collection of John Walsh III.
May notes, "Much of the time there is so much more to the world than is apparent. In the creative process sometimes we think nothing is happening, but actually lots is happening. When things don't seem to be growing, they really are." May's talismanic menagerie of little creatures appears in quilt after quilt, shifting forms and relations but always representing the bright and hopeful energy of the inner child's imagination.

At the same time, May started to expand and develop her use of color and surface decoration. First, thread color became an important part of her palette. "I left threads hanging loose instead of cutting them off to allow a network of texture and color to build up." Still not completely satisfied, she began to paint directly onto finished quilts with acrylics, "to add an element of risk to the creative process," and, most recently, to embellish her surfaces heavily with a combination of paint, buttons, and beads. May, who collects buttons, salt and pepper shakers, and dolls, adds, "An embellished quilt has the feeling of a collection."

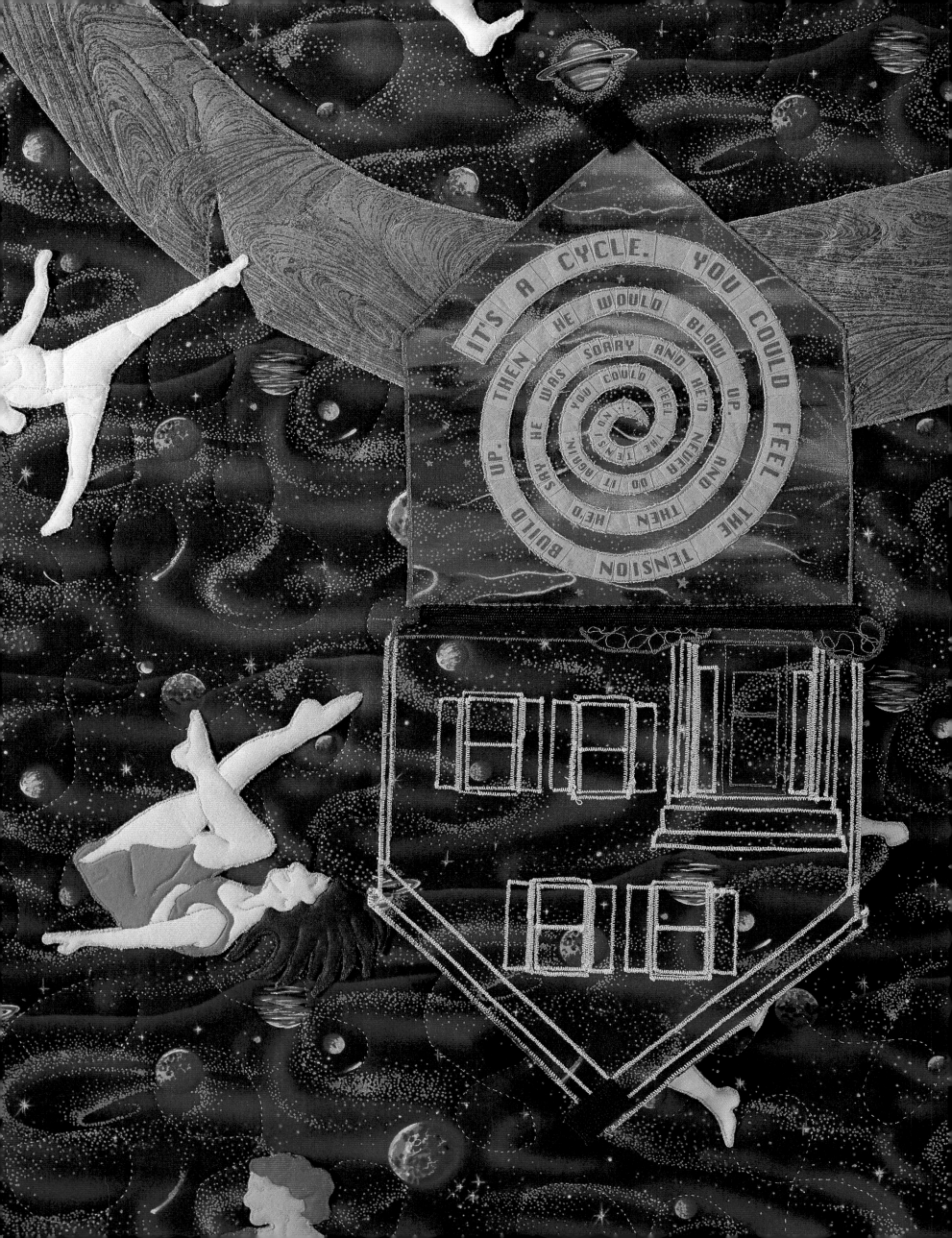

IT'S A CYCLE. YOU COULD FEEL THE TENSION BUILD UP. THEN HE WOULD BLOW UP. AND HE'D SAY HE WAS SORRY AND HE'D NEVER DO IT AGAIN. THEN YOU COULD FEEL THE TENSION

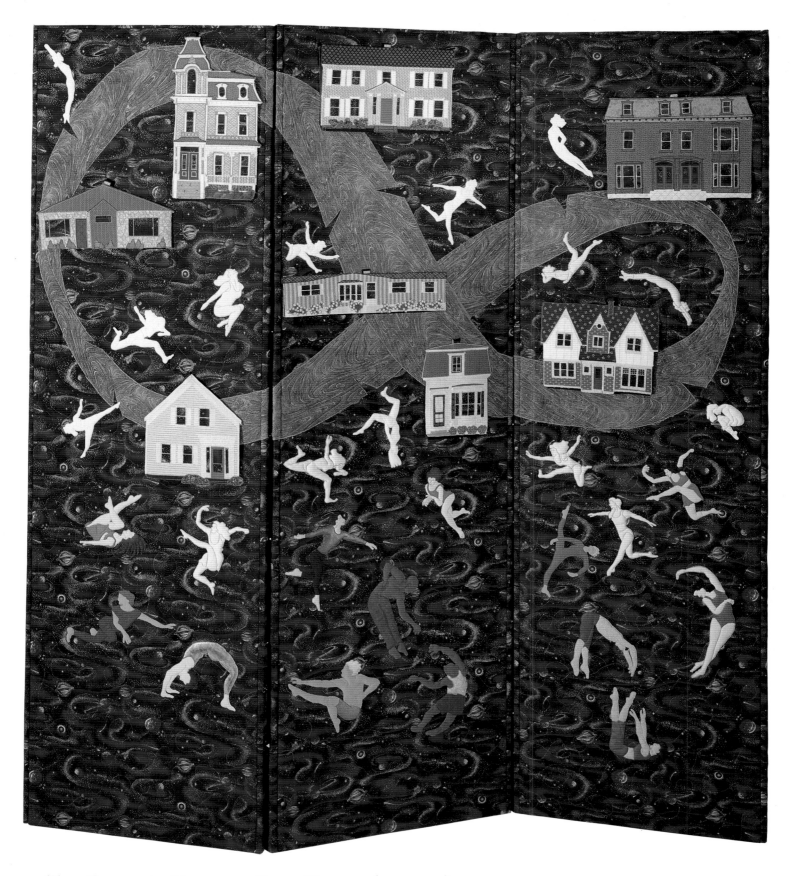

▲ THE DOMESTIC VIOLENCE QUILT/SCREEN (◄ DETAIL)

Justine Nauman-Greif. 1995. Kennebunk, Maine. Cottons, Velcro, fabric paint, mounted with glue on folding wooden ladder frame with fabric hinges. Hand and machine appliquéd, hand and machine quilted, some figures hand painted, computer printed. 72 x 66 in. (Each panel 20 in. wide). Collection of the artist.

Nauman-Greif made this complex, multilayered work of sadness, awareness, and hope while writing a college thesis on the quilt as a metaphor and domestic violence. A quilted fabric Mobius strip at the center of the quilt stands as a metaphor for the social "fabric" of domestic violence. Dancing women, representing those who have escaped the continuous Mobius cycle of violence, dance in the black and blue universe outside the strip. Eight seemingly neat house facades touching the strip hide the violence that takes place inside; their windows are black and their doors are closed. However, each house opens on a Velcro hinge to reveal words and pictorial scenarios told to Nauman-Greif by abused women she interviewed. These include: "I was stalked from town to town"; "They just thought it was our business, and they didn't want to get involved"; "I got all packed to leave and I realized I had nowhere to go"; and "He kicked the bathroom door . . . the mirror shards were everywhere . . . my hand was bleeding." Three narrative interviews are printed on fabric windows on the back of the quilt, and ghostly images of women that are quilted over the printing on the window panes represent all that is left of their sense of themselves. A statement by The National Coalition Against Domestic Violence is also hidden in one of the houses.

BLUE EYES ▶

Lynn Last Rothstein. 1988. Athens, Ohio. Cottons, ribbons. Machine appliquéd and quilted. 67 x 63 in. Collection of the artist.
Lynne Last Rothstein has made a number of "face" quilts which use appliquéd strands of ribbon to define features against an abstract, multicolored background.

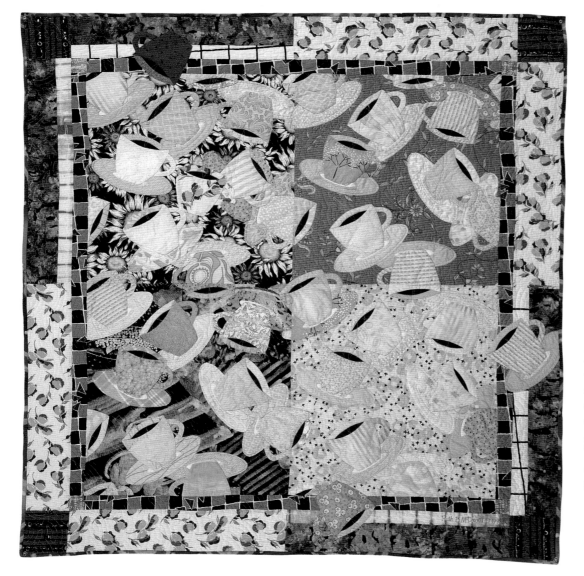

◀ COFFEE AND CONVERSATION

Ruth McDowell. 1995. Winchester, Massachusetts. Cotton fabrics, thread, and batting. Machine pieced, hand appliquéd, machine quilted. 55 x 52 in. Collection of the artist.
This lighthearted recent work is a departure from McDowell's usual nature imagery.

▲ FINDING THE GOLDEN EDGES

Joan Schulze. 1994. Sunnyvale, California. Silk, cotton, paper. Machine sewn and quilted. 56 x 57 1/2 in. Collection of the artist.
Schulze is a published poet, and her complex quilts reflect a poet's finely tuned sensitivity to life's contradictions and nuances. This quilt questions ideals of female beauty, ironically juxtaposing the classical statue of a goddess with modern commercial images from Madison Avenue and Hollywood.

▲ LADY LIBERTY/BABYLON II

Arturo Alonzo Sandoval. 1990. Lexington, Kentucky. Cibachromes, webbing, acetate transparencies, netting, colored and monofilament threads, fabric, fabric backing, Velcro. Machine stitched, embroidered, and pieced. 86 x 60 in. Collection of the artist.
Using modern industrial materials rather than traditional fabrics, Arturo Sandoval creates beautiful, seductive surfaces that draw the viewer into contemplation of his serious and often unsettling subjects. Another version of this politically charged work won the Most Innovative Use of the Medium Award at *Quilt National '93.*

▲ **FEATHER BED**

Rachel Brumer. 1994. Seattle, Washington. Hand-dyed cottons by Fabric to Dye For (Liz Axford and Constance Scheele) and the artist, commercial cottons. Silk screened, painted, hand appliquéd, machine pieced, hand quilted. 60 x 48 in. Collection of the artist. Appropriately enough, this quilt's subject is sleep. Brumer comments: "Even my dreams are about sleep, as my life never allows for enough uninterrupted hours."

◄ WINDOWS XI: JAZZ CITY II

Elizabeth Barton. 1994. Athens, Georgia.
Hand-dyed, hand-painted, and commercially
printed cottons. Machine sewn with some hand
stitching. 72 x 46 in. Collection of the artist.
Barton was born in York, England, and the
influence of that city's renowned cathedral and
other Gothic architecture remains strong. "[I
grew up] seeing ruined abbeys with open sky
windows," she recalls. "For me, a window is a
metaphor—not only the source of physical
light, but also psychological light— looking for-
ward, looking back, looking in, looking out."

DROP CLOTH ►

Risë Nagin. 1992. Pittsburgh, Pennsylvania.
Cotton (dyed by Jan Myers-Newbury and then
stained by the artist), polyester, textile paint,
acrylic paint, colored pencil, wonder-under.
Hand sewn. 84 x 78 in. Collection of the artist.
Nagin comments, "I am interested in produc-
ing enigmatic images that imply narrative. *Drop*
Cloth is ambiguous in its identity. It functions
as [a] painting and deals with aesthetic issues
within that tradition, but it is also a pieced,
appliquéd coverlet. The title refers to the large
canvas sheets that house painters drape over
objects of value, protecting them from splat-
tered paint. This drop cloth is splattered with
anger. It is not backed, as quilting seemed
irrelevant to the image. The poles supporting
dog and human heads actually pierce the fab-
ric, extending to the back. The image pierces
the cloth, reducing its protective ability."

MONKEY ON MY BACK ►

Sally Broadwell. 1994. St. Augustine, Florida.
Various fabrics, beads, and paint. Hand and
machine pieced, hand appliquéd. 37 x 34 in.
Collection of the artist.
Broadwell's fabric collages combine a wide
variety of materials with ambiguous symbols to
create complex visual puzzles full of "clues to
detect and messages to decipher."

▲ SAMPLER I: DREAM HOUSE

Gerry Chase. 1995. Seattle, Washington. Cotton fabric, photo-transfers, India ink, acrylic paint, and various embellishments. Hand appliquéd, machine pieced and quilted. 42 x 55 in. Collection of the artist.

This block-style piece is based on the traditional sampler quilt format in which each block is different but often complementary in theme or technique.

SPOTTED TEACUPS ▶

Esther Barrett. 1996. Cirencester, England. Cottons, interlined with vilene. Machine appliquéd and pieced, hand tied. 55 x 35 in. Collection of the artist.

This Warhol-esque block-style quilt was inspired by Barrett's collection of spotted china. Each of the cups and saucers was bondawebbed onto a background and then machine stitched down. Ties in the corners of the blocks hold the layers of the quilt together.

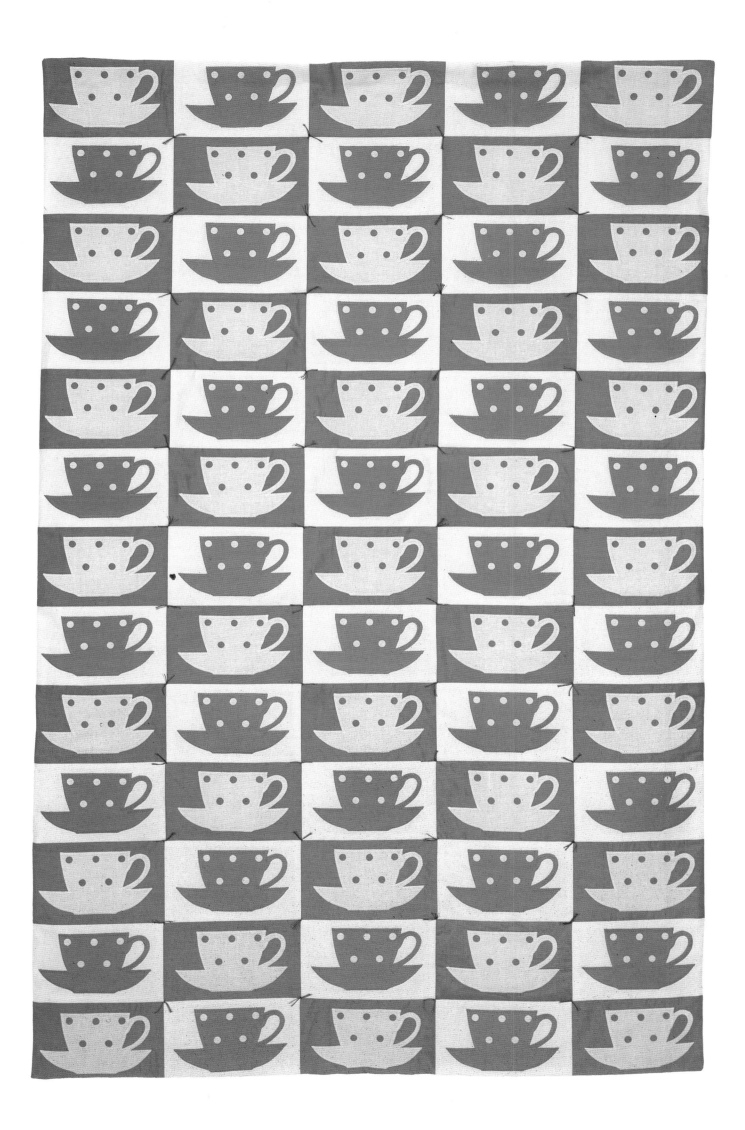

WHEN YOU ARE VERY STILL ▶

Sally Sellers. 1996. Vancouver, Washington. Cotton, metallics and synthetics on painted canvas. Machine appliquéd. 48 x 79 in. Collection of the artist. Sellers has made several quilts based on charmingly lopsided house forms that recall children's drawings while at the same time referencing the repeating block form of the traditional School- house pattern.

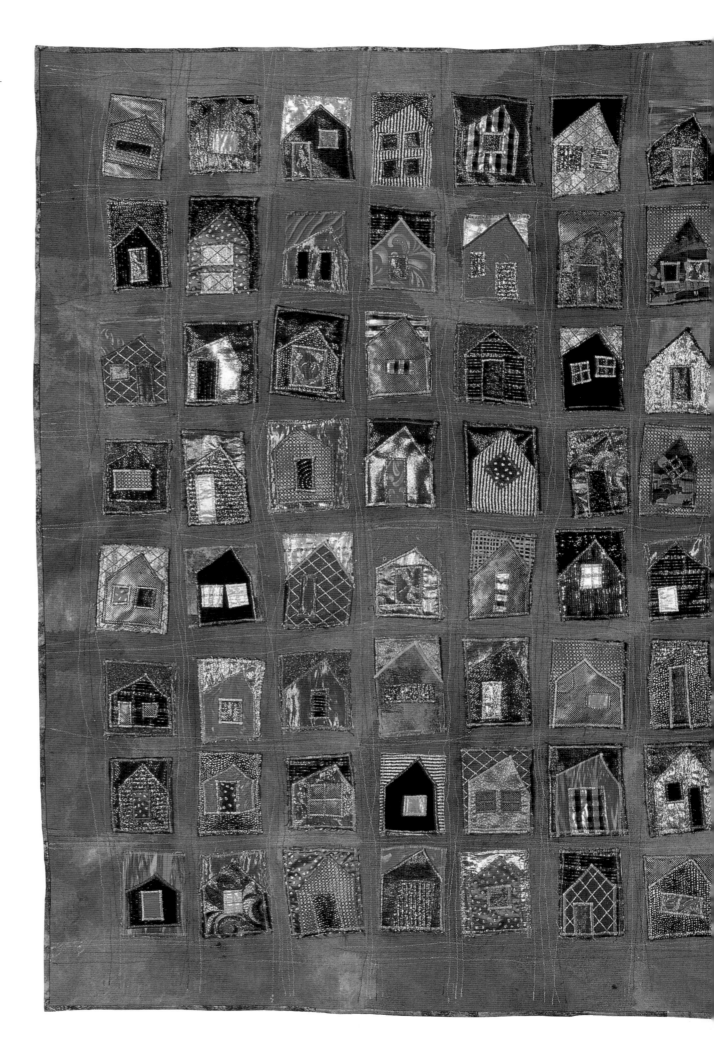

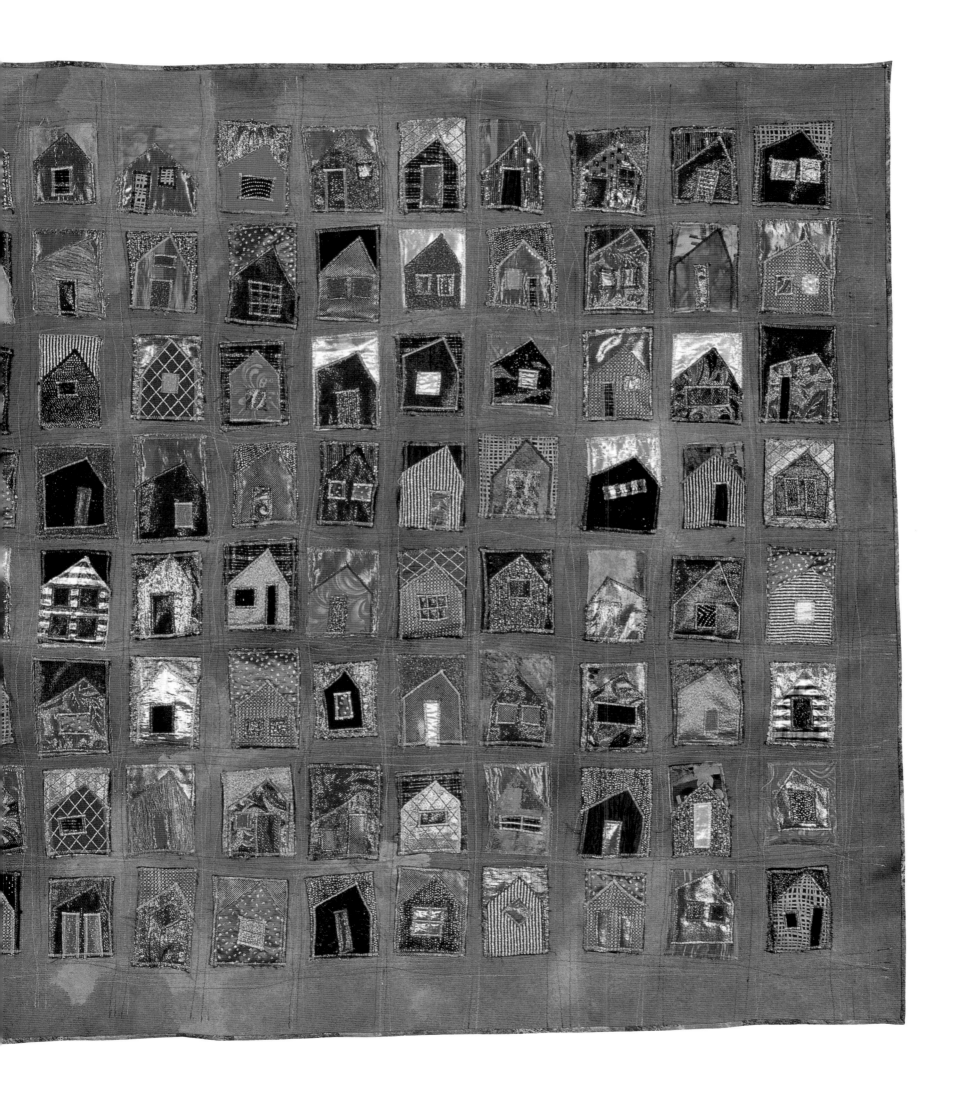

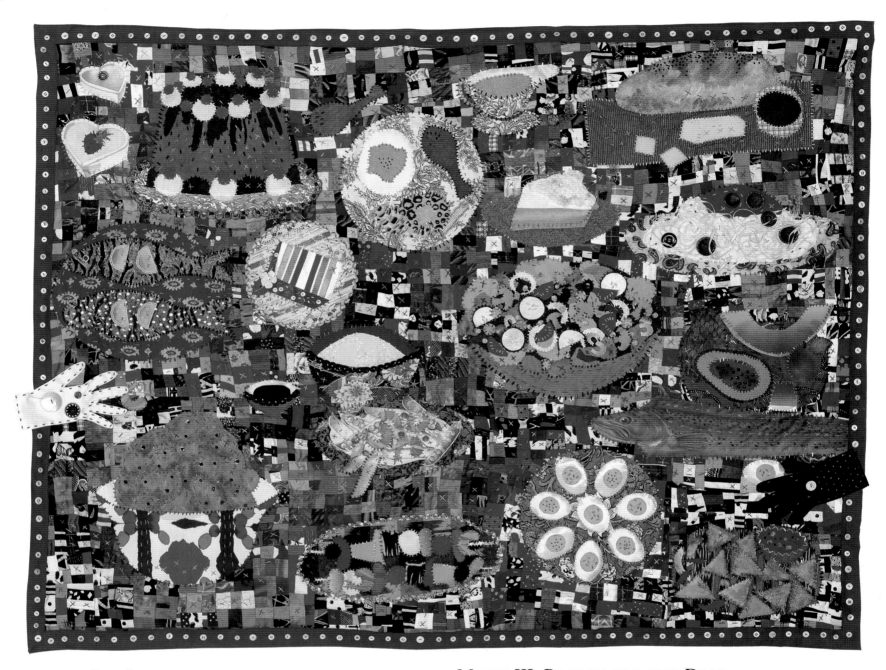

▲ POT LUCK

Jane Burch Cochran. 1993. Rabbit Hash, Kentucky. Fabric, beads, buttons, paint, gloves. Machine pieced, hand appliquéd using bugle beads, hand quilted using embroidery thread. 45 x 59 in. Collection of Fidelity Investments, Covington, Kentucky. Cochran explains, "*Pot Luck* was inspired by the tradition of taking food to a gathering to share with the other guests. My hope is that we can learn to accept and respect other races and nationalities as easily as we accept and enjoy their traditional foods."

MASKS III: PRAYERS FOR THE DEAD ▶

Gayle A. Pritchard. 1993. Bay Village, Ohio. Commercial cottons and cotton blends, hand-dyed and hand-painted fabrics, antique dress fabric, organza, acrylic and fabric paints, fabric pens, photo-transfers, thread, floss, yarn, beads, buttons, violin string, stones, crystals, found objects, text. Collaged, machine and hand quilted, embroidered, embellished, mendign tape transfer method. 29 x 41 in. Collection of the artist. According to Pritchard, her *Masks* series is informed by Native American and African tribal art as well as by religious triptychs. She explains, "Like a prayer rug, these pieces are meant to be a place for the expression of grief, hope, and healing." *Prayers for the Dead* memorializes the sudden death of the artist's father.

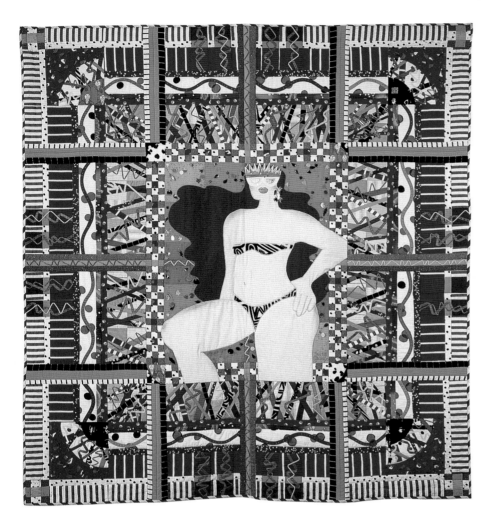

◄ **BEACH GAMES**

Sue Alvarez. 1990. North Carolina. Hand-dyed cottons, ribbons, beads, sequins. Machine pieced, appliquéd, and quilted. 70 x 64 in. Collection of the artist.

This exuberant quilt, which Alvarez says was inspired by a pair of sunglasses given to her by her husband, offers a portrait of a swimmer who proudly defies the viewer to find her unglamorous. The bather is framed with vibrantly colorful geometrics, squiggling ribbons, bright beads, and sparkling sequins. Bits of the bikini material can also be found in the blocks above and below the swimmer.

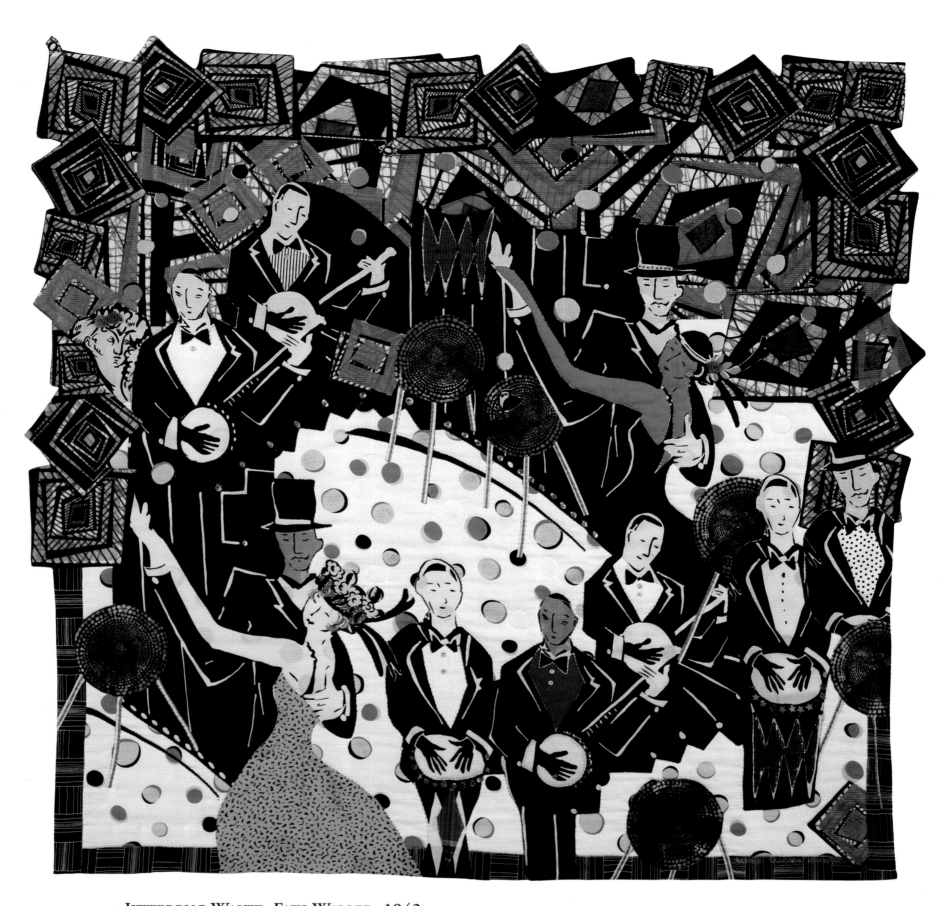

▲ JITTERBUG WALTZ, FATS WALLER, 1942

Sandra Townsend Donabed. 1996. Massachusetts. Rayon, imported African cotton, cotton, and various other fabrics, metallics. Hand appliquéd and quilted, embellished. 43 x 43 in. Collection of the artist.

Thomas "Fats" Waller, the inimitable and ebullient clown prince of pre-World War II jazz, was also a brilliant stride pianist and organist. The immortal "Jitterbug Waltz" is his best-known composition. Donabed's quilt imagines a club scene from the 1930s.

THE GIFT OF TONGUES ▶

Robin Schwalb. 1991. Brooklyn, New York. Photo silk-screened, stenciled, marblized, and commercially available cotton and silk fabrics. Machine pieced and hand appliquéd, hand quilted by Grace Miller, Mt. Joy, Pennsylvania. 98 x 54 in. Collection of the artist. Schwalb describes this piece as a meditation on the biblical story of the Tower of Babel, noting that the "image informing this quilt is a fragile yet fertile egg: the city cracking open to reveal its diverse human heart." The randomly pieced, silk-screened text ("Language— the gift of tongues . . . has a rebellious and wayward vitality compared to which the foundations of the Pyramid are as dust") is from Bruce Chatwin's *The Songlines*.

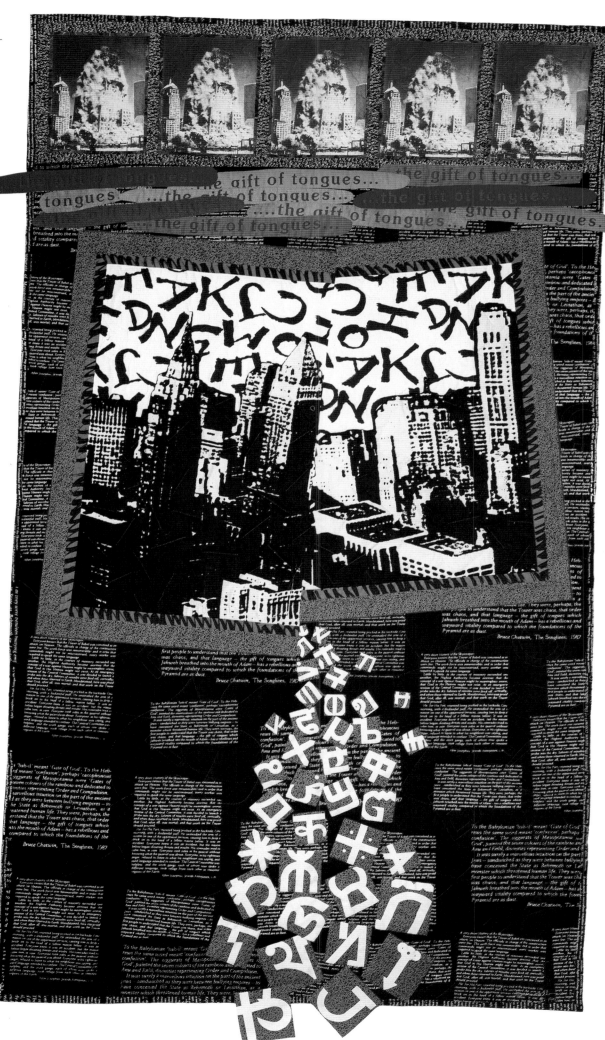

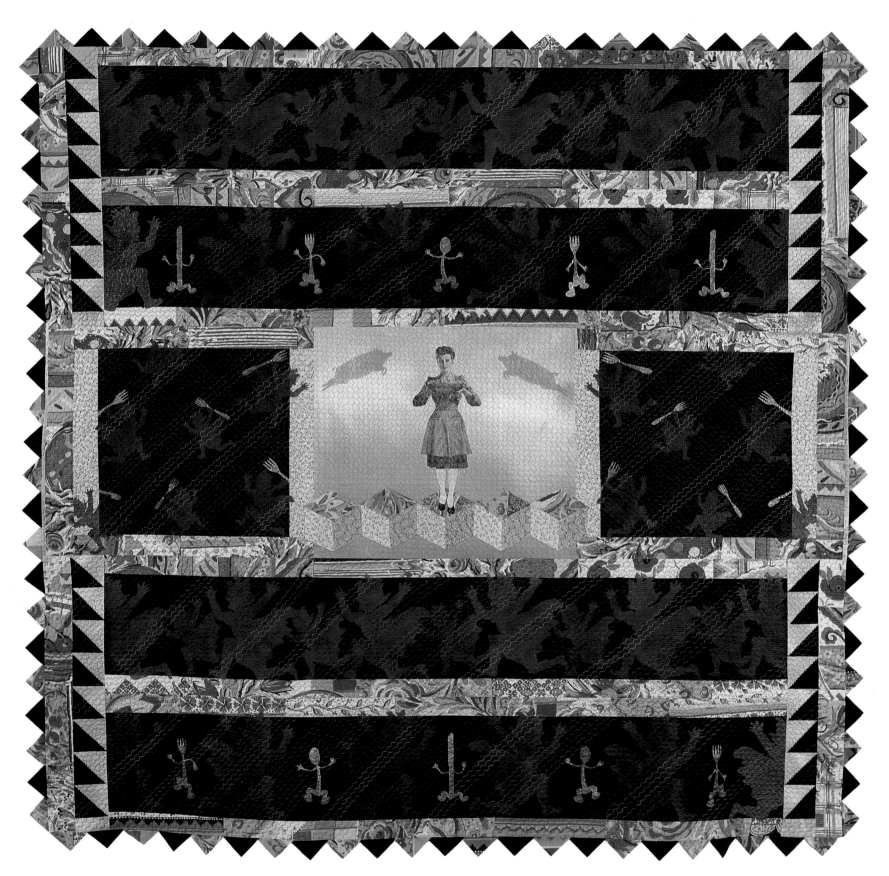

▲ THE HAPPY HOMEMAKER

Wendy Huhn. 1993. Dexter, Oregon. Cotton fabrics, stencils, polymer transfers, beads, paint. Machine pieced and quilted, appliquéd. 72 x 72 x 1/2 in. Collection of Ardis and Robert James.

According to Huhn, "This is a story about a woman who has spent her life striving for perfection. Standing on the pedestal of tumbling blocks, she is empowered, radiant, and secure. She appears to be happy, peaceful, and solid as a rock. But looks are deceiving. The running girls symbolize the frenzy, anxiety, and constant motion she always seems to be in. The dancing knives, forks, and spoons remind us not to take life so seriously."

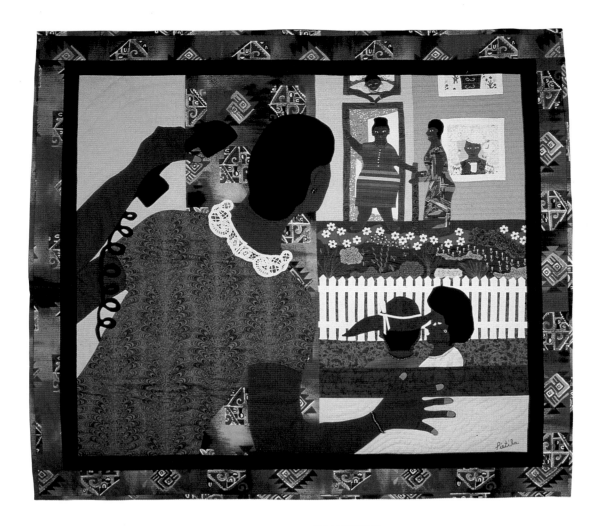

▼ LEOPARDS

Jean Hewes. 1993. Fort Worth, Texas. Silks, cotton, rayon, synthetics. Machine sewn. 88 x 92 in. Collection of the artist.

Hewes began making quilts in 1974 and soon developed her own unique approach. Her impeccably crafted quilts typically feature amorphous, semi-abstract human or animal figures.

▲ SIGNIFYIN'

Barbara G. Pietila. 1994. Baltimore, Maryland. Hand-appliquéd and hand-quilted fiber with some machine embellishments. 36 x 40 in. Collection of the artist.

Pietila explains the story behind this slice of Black American life: "In the African-American community we do not gossip, we signify. This quilt shows how multilayered signifyin' can be. The two women on the back porch are the center of attention. The other figures—the young girl in the upper window, the man drinking coffee in the kitchen, the two women coming home from church, and me looking out of the window in the foreground—are all curious about the conversation taking place on that back porch. I saw these two women on a Sunday morning driving through the neighborhood in which I grew up. It reminded me of my mother and Sunday mornings when she talked over the back fence to our next-door neighbor while the wonderful smells of bread baking, meat roasting, and spicy sweets floated on the morning air."

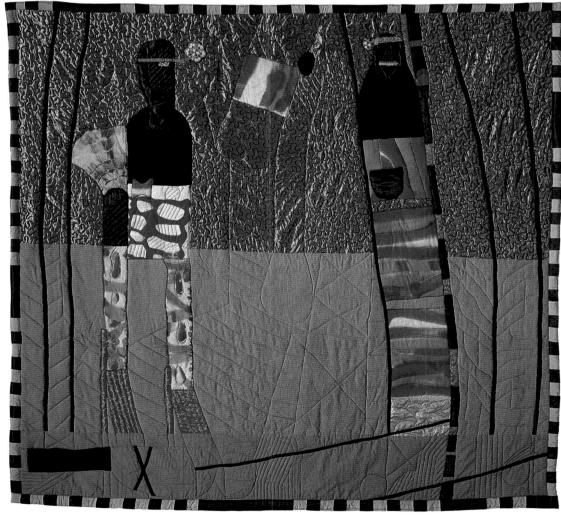

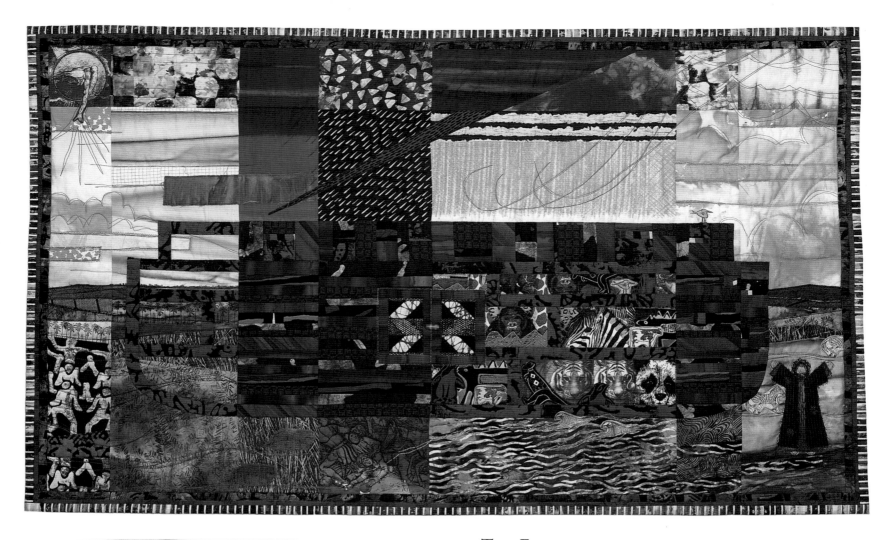

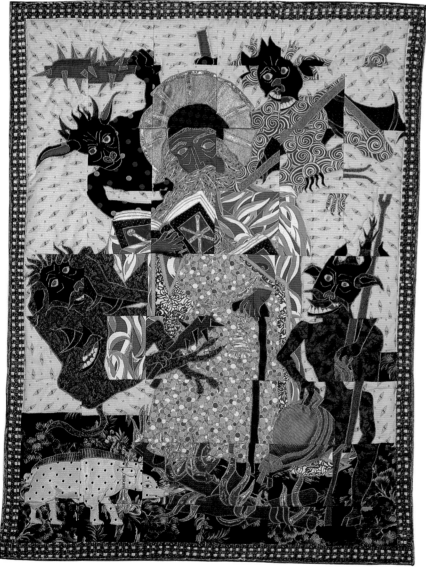

▲ THE FLOOD

Marguerite Ann Malwitz. 1994. Brookfield, Connecticut. Cotton, linen and organza fibers, some dyed and painted, collaged on canvas foundation, metallic threads, colored pencil, photo-transfers, buttons. Hand and machine stitched, stamped, printed, hand colored. 31 x 52 in. Collection of the artist.

This contemporary pictorial Bible quilt depicts the story of the flood in seven vertical sections: corrupt people, building the ark, foreboding skies, safety in the ark/rain beginning, flooded earth, water subsiding, and the rainbow of promise. Malwitz says her purpose in making the quilt was to show that God's justice is balanced with mercy, a theme she finds recurring throughout the Bible.

◄ SAINT ANTHONY'S TORMENT

Mary Catherine Lamb. 1993. Portland, Oregon. Secondhand household fabrics, contemporary commercial cottons and metallics, metallic thread. Machine appliquéd and hand quilted with metallic thread, machine pieced, machine-embroidered faces. 68 x 48 in. Collection of Christopher Rauchenberg.

Lamb comments: "I particularly enjoy the visual richness of medieval art and the way terrifying images were used as inducements for faith." Lamb fractured the rhythm of her blocks by turning a few on their sides and transposing others out of sequence to emphasize the theme of her original image, "an individual struggling to maintain his concentration in the face of diabolical distraction, clinging to faith and sanity while everything is spinning apart."

▲ BITCHES, VICTIMS, SAINTS, AND WHORES ONE: BOUNDARY VIOLATIONS

Nancy Condon. 1993. Stillwater, Minnesota. Cotton, linen, fabric paint, fabric markers, acrylic paint, rayon thread embellishments. Hand painted and stamped, machine pieced, appliquéd, and quilted. 60 x 42 in. Collection of the artist.

The life-sized figure's head is a photo-transfer from a seventeenth-century Russian icon. The title comes from Gloria Steinem, who used these words to describe the only roles available to women in American society. The other words written on the body are from an essay by Joanna Ross, which discusses the social paradox that women must be powerful for others but are powerless to meet their own needs.

TERRIE HANCOCK MANGAT

Terrie Mangat's quilts are, first and foremost, intensely personal documents. For Mangat, everything can be related to fabric, and she uses fabrics of all sorts and objects of all sizes to reference events and emotional states. Her quilts tell the story of her life—her childhood, her relationships with her mother and father, her struggle with her Catholic upbringing, her marriage and divorce, her growth as an artist, her parents' death in an automobile accident.

She recaptured the feeling of security she felt as a child while camping with her father and the joyful adventure of stretching sheets over chairs in the kitchen to make a "tent" in a makeshift, tent-like piece that invited gallery viewers to write down their own childhood remembrances. And when she retired her first table-model sewing machine, a gift from her mother, she turned it into a piece of art by encrusting it with bits of fabric and personal memorabilia gathered from her recently deceased mother's bureau drawers.

◄ **MEMORY JARS**
Terrie Hancock Mangat. 1984. Cincinnati, Ohio. Cotton blends and novelty fabrics, various embellishments. Tied, reverse appliquéd, embroidered. 33 x 50 in. Collection of Ardis and Robert James. Mangat told collector Ardis James that it took her two months to sew all the small objects (which include her rosary and Girl Scout pin) onto this quilt. In a letter to Mrs. James, she wrote, "[*Memory Jars*] is my smallest and most precious [quilt] because it contains so much joy."

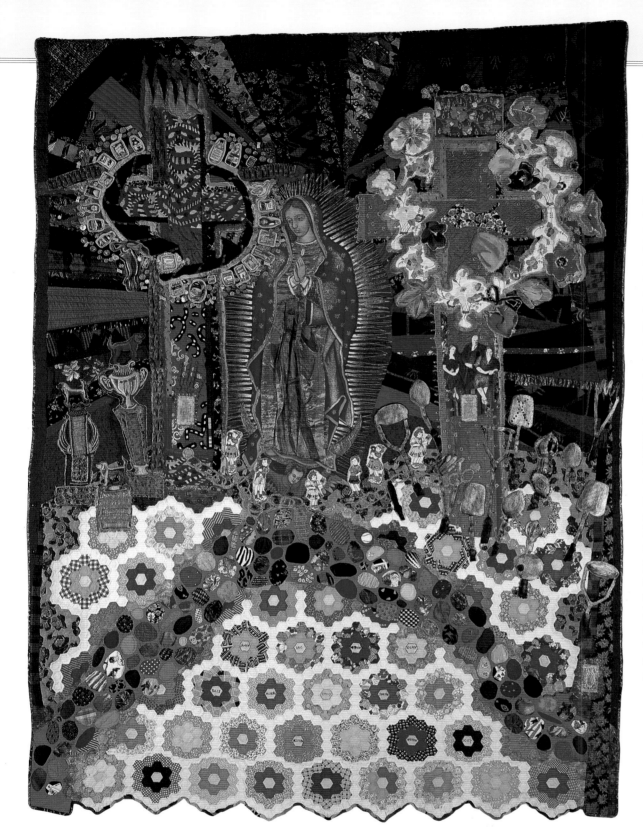

◄ **HANCOCK MEMORIAL QUILT**

Terrie Hancock Mangat. 1994. Cincinnati, Ohio. Cotton, novelty cloth, oil-painted canvas, acrylic-sealed paper images, embroidery thread, acrylic paint, photo silk-screened images, coins and other embellishments. Machine appliquéd, reverse appliquéd, embroidered, painted, strip-pieced, cut throughs, beaded, silk screened, hand quilted by Sue Rule. 114 x 83 in. Collection of the artist. This quilt was made as a memorial to the artist's parents, who were killed in a car crash in 1992. Hancock comments: "After the wreck, my sister and I wanted to put one of those New Mexico crosses on the roadside, but instead I put the crosses on the quilt." Portions of a traditional Grandmother's Flower Garden quilt are also incorporated along with a variety of images and embellishments associated with her parents.

Mangat's quilts combine piecework and appliqué with realistic painting, masterful hand embroidery, and detailed embellishment with beads, jewelry, toys, keepsakes, buttons, and other small objects (as well as intricate hand quilting added by her colleague Sue Rule) to create pictorial works with many different levels of meaning. Mangat's art is both narrative and intuitive. She uses pictures to tell a story, allowing her carefully chosen fabrics and embellishments to suggest the complex and often conflicting emotions that lie under its surface.

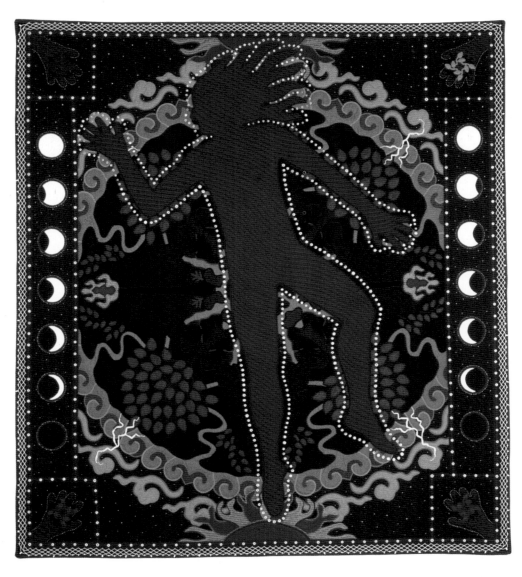

◀ REVELATION

Patrick Dorman. 1986. Seattle, Washington. Cotton fabric, cotton batting, mother-of-pearl buttons, glass buttons and beads. Hand appliquéd, hand quilted, spotstitch beading, beaded net. 92 x 83 in. Collection of Ardis and Robert James.

According to the artist, "*Revelation* is [a] celebration of the sacred mystery of life. The mandala of earth, air, fire, and water is surrounded by images which mark the passage of time, rising and setting sun, seasons of the year, and cycles of the moon. My shadow floats within this place and time. The buttons and net of beads [represent] the mystery and spirit which bind the cosmos. The tracks of over twenty different animals are quilted into the surface." *Revelation* received the *Quilt National '87* Award of Excellence.

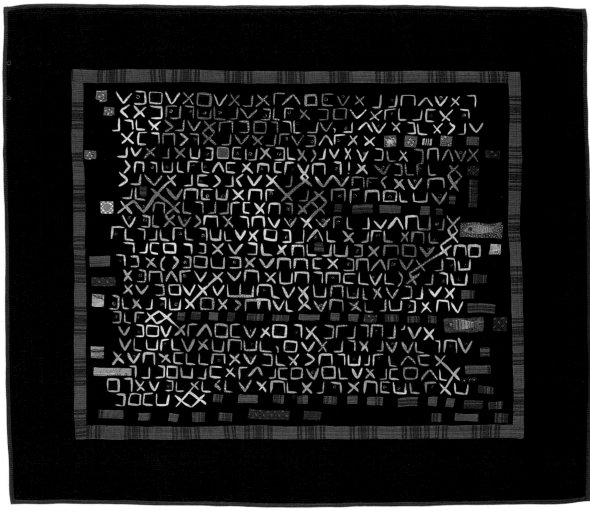

◀ A LETTER FROM ARTHUR

Liz Alpert Fay. 1985. Sandy Hook, Connecticut. Hand-dyed cottons, hand-painted raw silk, solid and patterned commercial fabrics, cotton batting. Hand stitched, appliquéd and reverse appliquéd, machine quilted. 44 1/2 x 51 in. Collection of Joan Alpert Rowen.

This quilt was inspired by a secret code in which Fay's grandfather wrote to her when she was a child. After his death, she discovered one of the letters and decided to write something about him in the code. She used reverse appliqué and random bright colors to recall children's drawings in which black crayon is scratched away to reveal other colors that lie underneath.

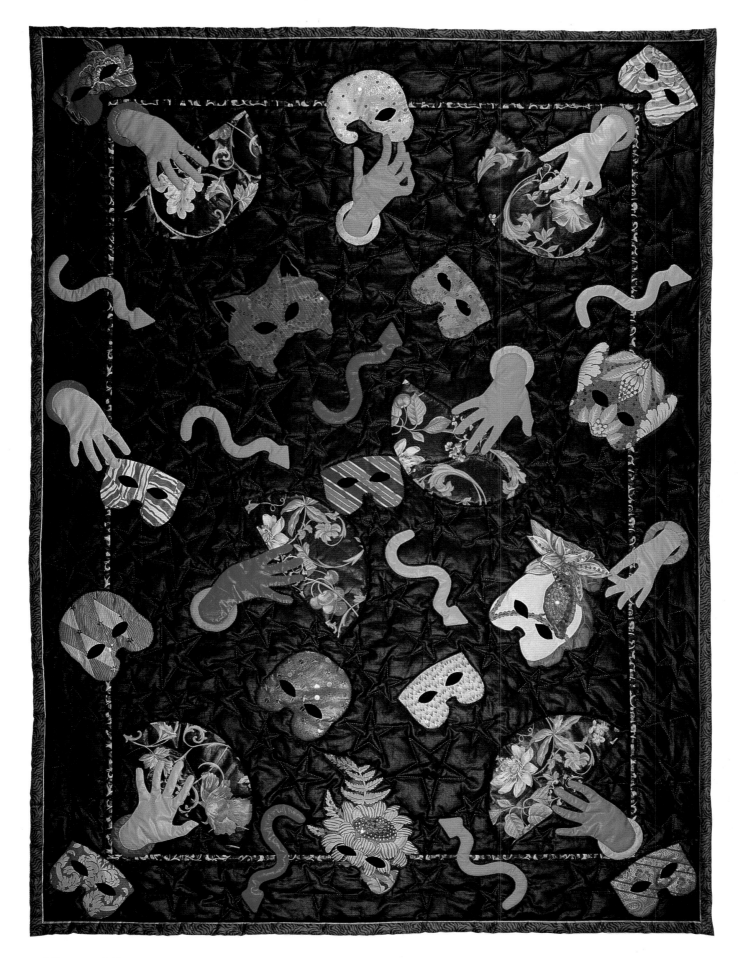

▲ NIGHT MASQUE

Marjorie Claybrook. 1990. Augusta, Georgia. Cotton chintz, sateen, airbrush-painted fabric, sequins, metallic threads. Machine pieced, hand appliquéd, hand quilted. 75 x 55 in. Collection of the artist.

In Elizabethan times, a masque was a stylized theatrical entertainment, often performed by amateur actors. The word can also refer to a masquerade. Claybrook offers these lines from John Milton's *L'Allegro* to accompany her elegantly playful piece: "And pomp, and feast, and revelry,/ With mask and antique pageantry,/ Such sights as youthful poets dream."

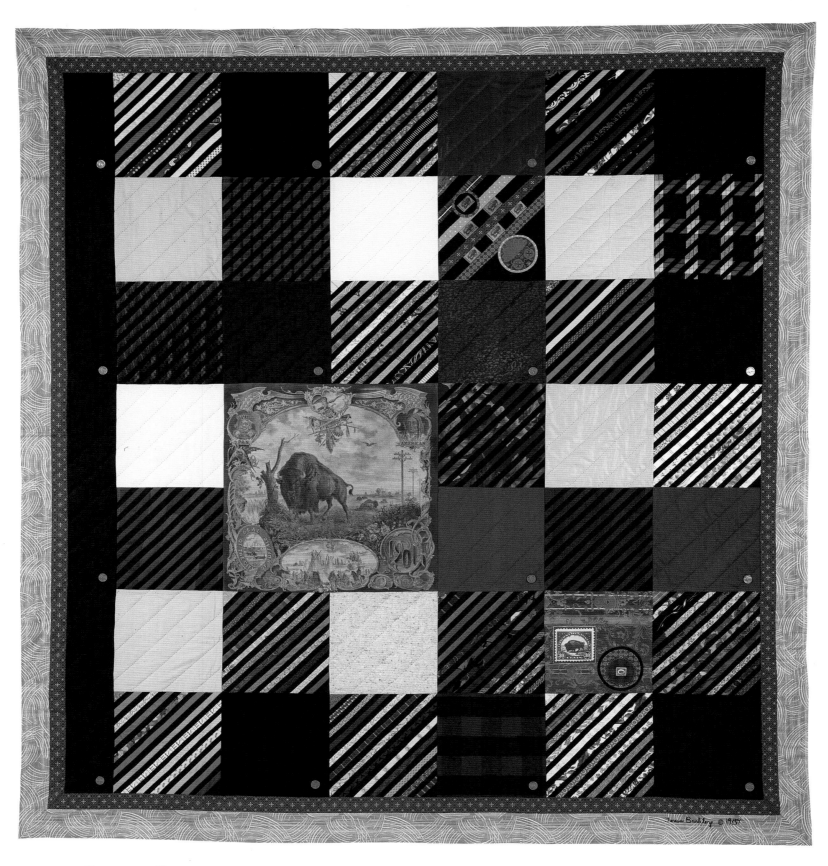

▲ BUFFALO PLAID

Teresa Barkley. 1989. Maplewood, New Jersey. Cotton, wool, rayon, "found" commemorative pillow top, "Buffalo" nickels, heat transfers of U.S. postage stamps. Machine pieced, hand appliquéd, hand quilted. 75 x 80 in. Collection of Porter Novelli, Inc., New York.

Barkley has made several quilts that play with the idea of stamps and stamp designs. This example combines a commemorative pillow top from the 1901 Pan-American Exposition in Buffalo, New York, quilt blocks arranged to suggest "Buffalo plaid" patterned fabric, fifteen "Buffalo" nickels, and heat transfers of two historic postage stamps that featured buffalos into a richly allusive and amusing composition.

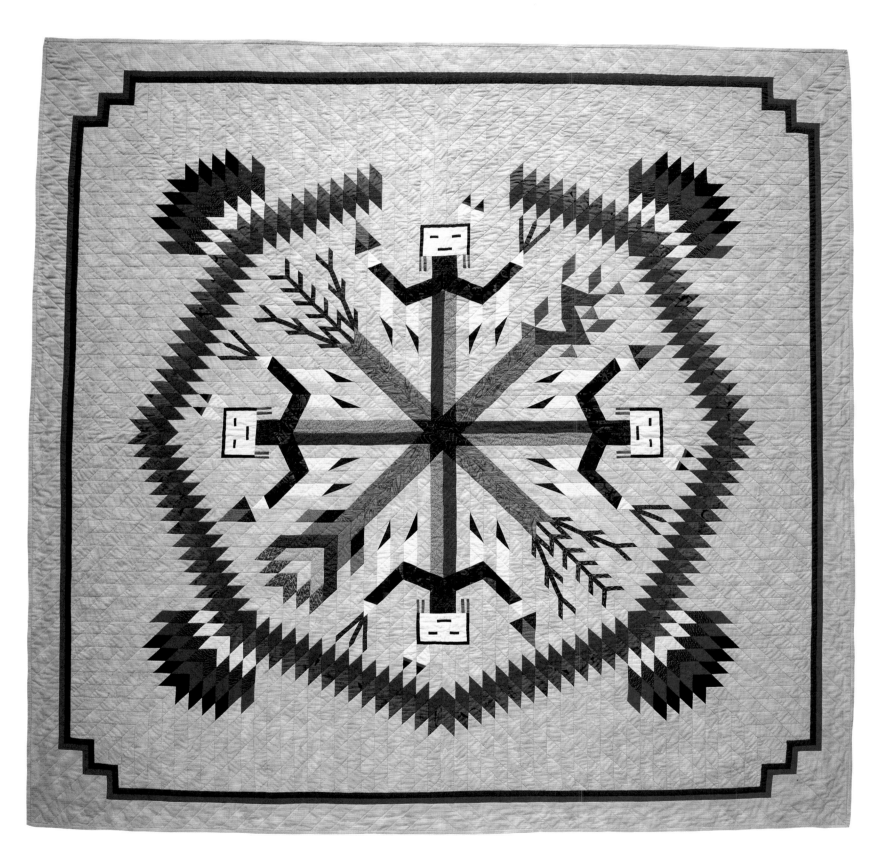

▲ SANDPAINTING

Dri Brown. 1992. Pasadena, California. Cottons, cotton batting. Machine pieced with some hand-piecing and small amounts of hand and machine appliqué, machine quilted. 84 x 84 in. Collection of the artist.

Brown is a pediatrician who has been making quilts for twenty-five years. This quilt is a depiction of a Navajo sandpainting, using the sunburst pattern as a grid. It includes over 2600 pieces and took a year and a half to complete. Brown notes, "Soon after starting [*Sandpainting*], I was diagnosed with multiple sclerosis. I dragged it around with me everywhere, did the hand work in waiting rooms and on exam tables. Completing it was my longest term goal. With all my quilts, including *Sandpainting*, I sew things like sand or feathers inside the corners and write something personal on a piece of fabric tucked into the batting."

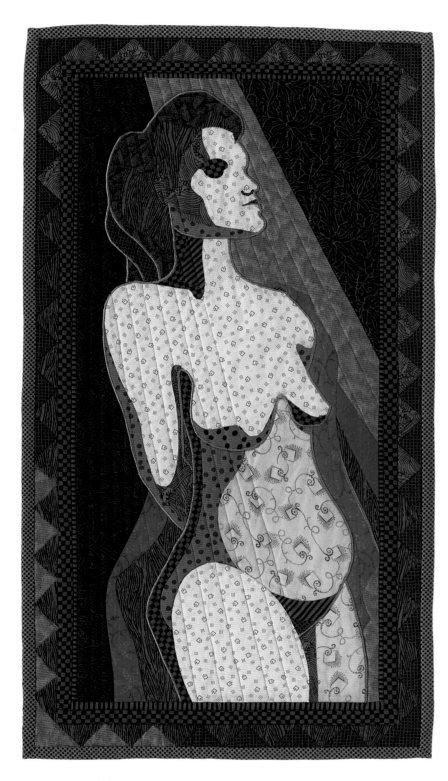

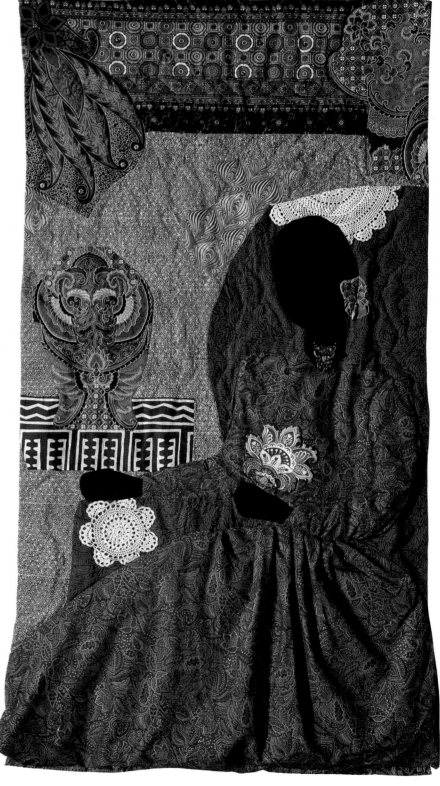

▲ THE MOST BEAUTIFUL DISTANCE . . . IS A CURVE

Norah McMeeking. 1994. Palo Alto, California. Cottons. Machine appliquéd and quilted, hand embroidered. 30 x 161/4 in. Collection of the artist.

This painterly nude uses a carefully chosen palette of fabric to suggest the modulation of light over different parts of the model's body, and demonstrates that beautiful line can be created with scissors as well as with a brush or pen.

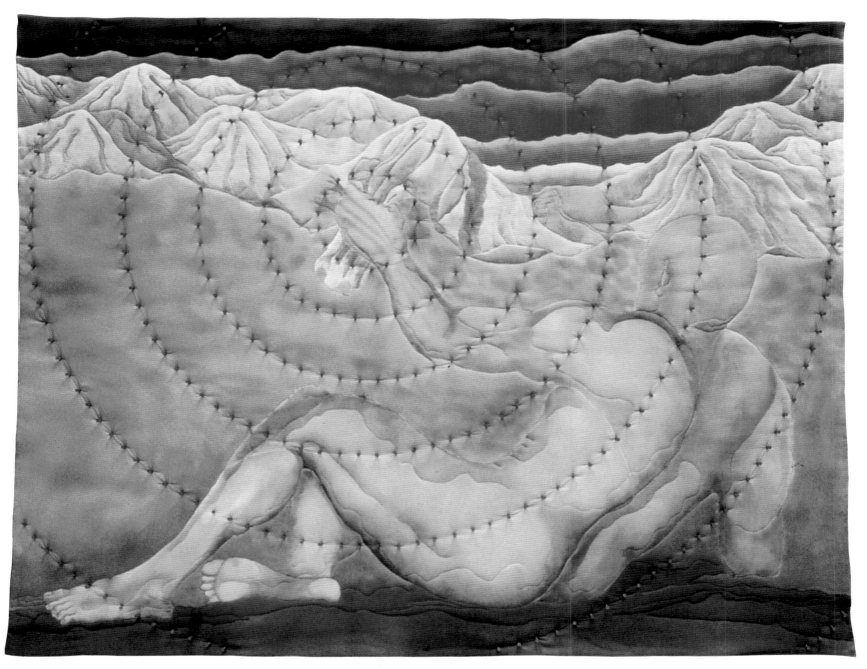

◄ SISTERS: MS. VINCENT AT HOME

Carole Y. Lyles. 1995. Columbia, Maryland. Cotton, cotton blends, African cotton prints and embellishments. Hand pieced, appliquéd, and quilted. 63 x 30 in. Collection of the artist.

This gentle portrait study in cloth employs a number of African print fabrics.

▲ GREEN COVERLET

Cherry Partee. 1990. Seattle, Washington. Wood pulp rayon, Procion MX dye, polyester fiberfill batting, silicone-coated cotton thread, rusted steel concrete nails, muslin backing, 1/2-inch plywood. Batiked, hand quilted, nailed. 54 x 68 x 2 1/2 in. Destroyed.

This quilt depicting Nature as male was intended to raise questions about gender roles and how they affect perceptions. Partee queries, "What happens when only one gender is seen as part of nature? What meaning is evoked if one violates a traditionally female medium with what is a traditional male artifact? And what does it mean for a female quiltmaker to commit such an act?" To further complicate matters, the rusted nails were intended to eventually destroy the entire piece.

▲ NIGHT SWIMMING

Debra Kam. 1995. Hampton Falls, New Hampshire. Cottons, some hand dyed, netting. Machine pieced, appliquéd, and quilted. 72 x 32 in. Collection of the artist.

Kam creates what she calls "soft paintings," which are based on specific emotional moments. This quilt is part of a series called *Memory of Water*, made in part in response to the drowning of a family friend off the coast of Nantucket. Kam adds, "With *Night Swimming* I wanted to capture the play of moonlight on moving water and the sense of joy but also danger of being in the ocean at night."

THE TWINS ▶

Kathleen Sharp. 1996. Monte Sereno, California. Cotton cotton/rayon. Hand and machine stitched. 40 x 74 in. Collection of the artist.

Sharp's quilts often present dreamlike, illusory architectural spaces. She uses faux marble, stone, and granite fabrics to add realism to her "rooms" and shrinks the assembled works to create puckered textures. She adds quilting last to outline tiles, windows, and other elements.

▼ ICARUS

Pat Autenrieth. 1995. Hyattsville, Maryland. Cottons, photo-copy transfers, fabric crayon. Machine embroidered, hand appliquéd, hand and machine quilted. 72 x 62 1/4 in. Collection of the artist.

This quilt adds some modern twists to the ancient Greek myth of Icarus, the boy whose wax and feather wings melted when he flew too close to the sun. In Autenrieth's expansion of the classic story of human daring and high-flown failure, a stitched silhouette of Icarus tumbles through drifting downy feathers toward a panel of photo-transferred landscapes. The blazing sun also looks down on an embroidered treatise on the molting of bird wing primaries, the winged horse Pegasus, the constellation Canis Major, and an ascending airplane.

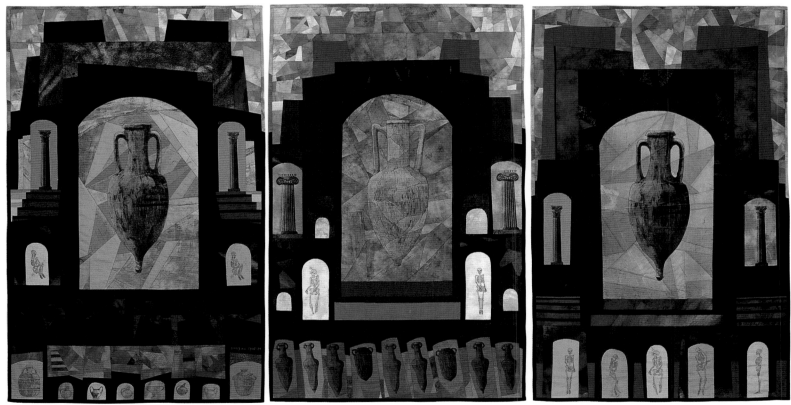

▲ #129, TWILIGHT SERENADE/MUSIC IN THE TOMBS

Julia Pfaff. 1995. Richmond, Virginia. Cottons, cotton batting. Hand dyed, dye painted and printed with zinc plate etchings by the artist. Hand appliquéd, machine construction and quilting. Three panels, each 47 x 29 in. Collection of the artist.

Pfaff is a printmaker and quilter who for many years has made part of her living doing archeological drawings during summer digs in Egypt and Greece. Many of her quilts, including this triptych, are based on these experiences. While working in underground tombs one evening, her party's electricity suddenly went out, leaving Pfaff and her co-workers in the dark. Only the haunting sound of a battery-operated Walkman playing an early Leonard Cohen recording connected them. This quilt attempts to capture the unearthly feeling of that moment.

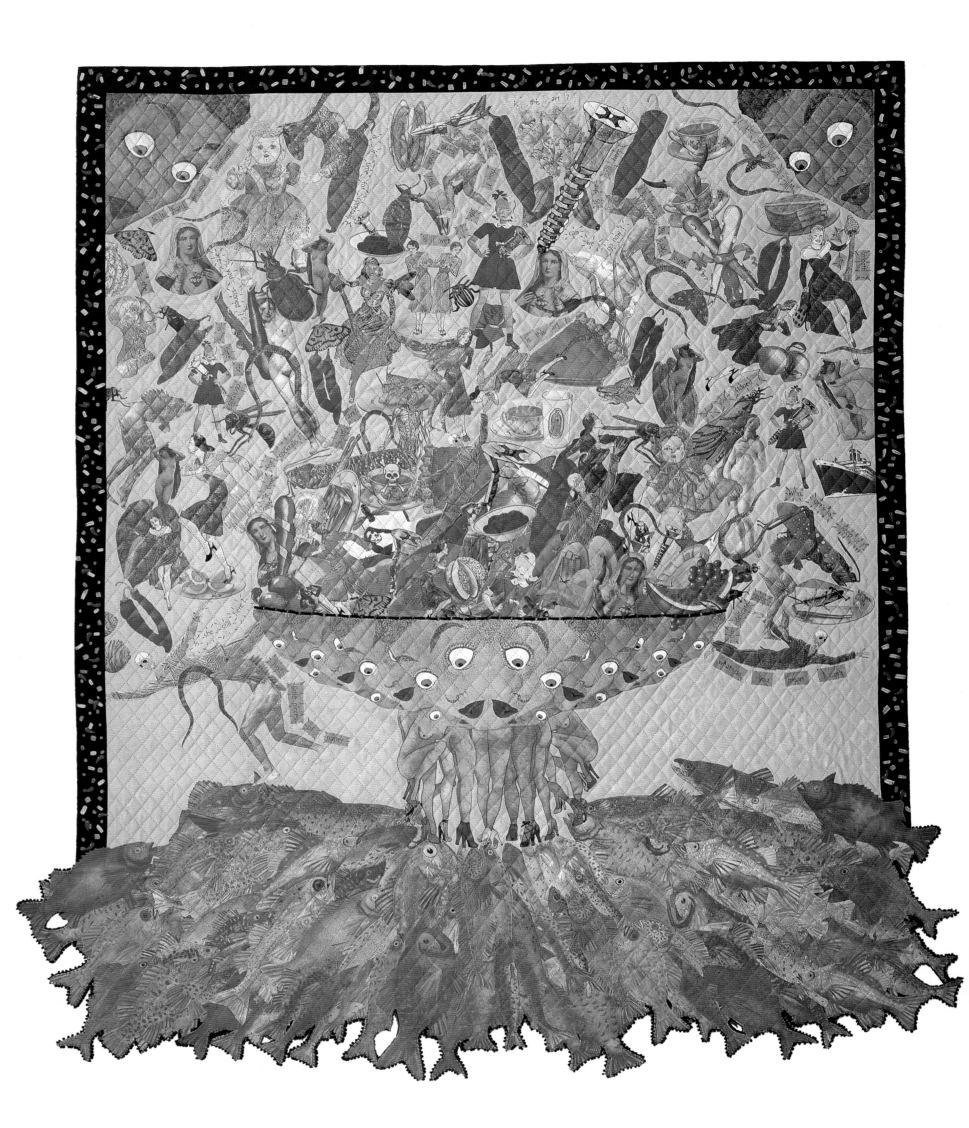

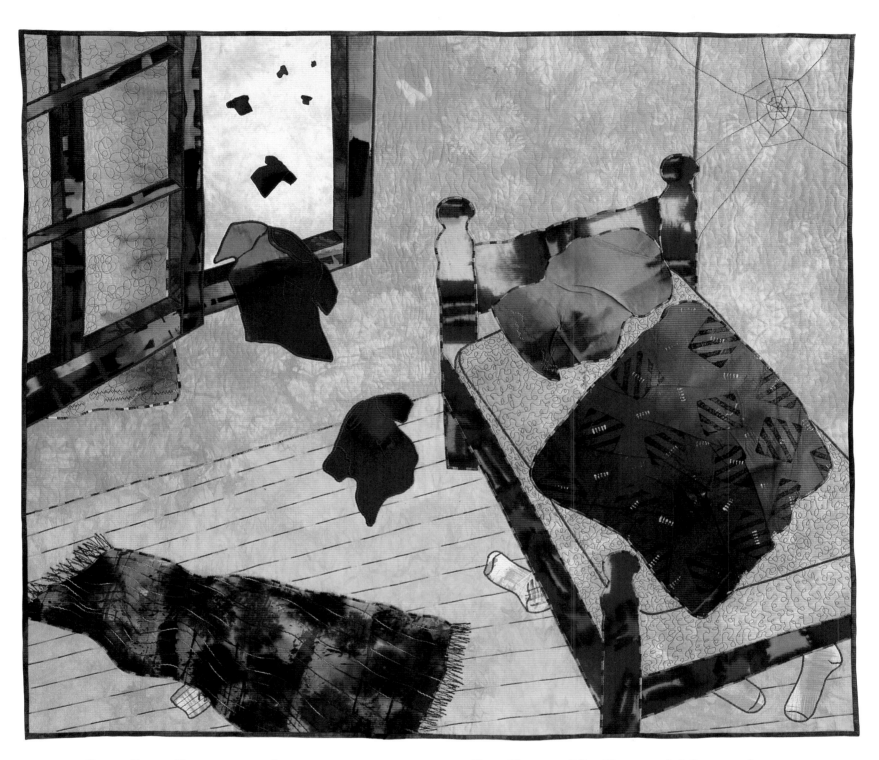

◄ STILL LIFE: BALANCING ACT

Melissa Holzinger and Wendy Huhn. 1996. Arlington, Washington, and Dexter, Oregon. T-shirt color transfers, photo-copy fabrics, painted and airbrushed canvas, paint, pastels, waxed linen, beads. Industrial machine quilted, hand stitched. 60 x 47 x 1/2 in. Collection of the artists.

This phantasmagoria of iconic female imagery is Huhn and Holzinger's second collaborative work. "We're pretty excited about working together," says Huhn. She speaks to this quilt's manic energy by noting that her interest in art is centered on "fun, humor, and attempting to turn the ordinary into the extraordinary. It is my wish that each piece touch both the imagination and memory in a playful way."

▲ GUS CLEANS HIS ROOM: A MOTHER'S FANTASY

Laura Wasilowski. 1995. Elgin, Illinois. Cotton fabric and thread, fiber-reactive dyes, rayon thread. Machine quilted in satin stitch and free-motion embroidery. 50 x 57 in. Collection of the artist.

Wasilowski has stamped, silk screened, painted, and dyed her own collection of fabrics since 1985. Her whimsical narrative quilts offer stories of her family and friends. The composition of this typically cartoon-like work also winks at Van Gogh's well-known 1888 painting of his bedroom at Arles.

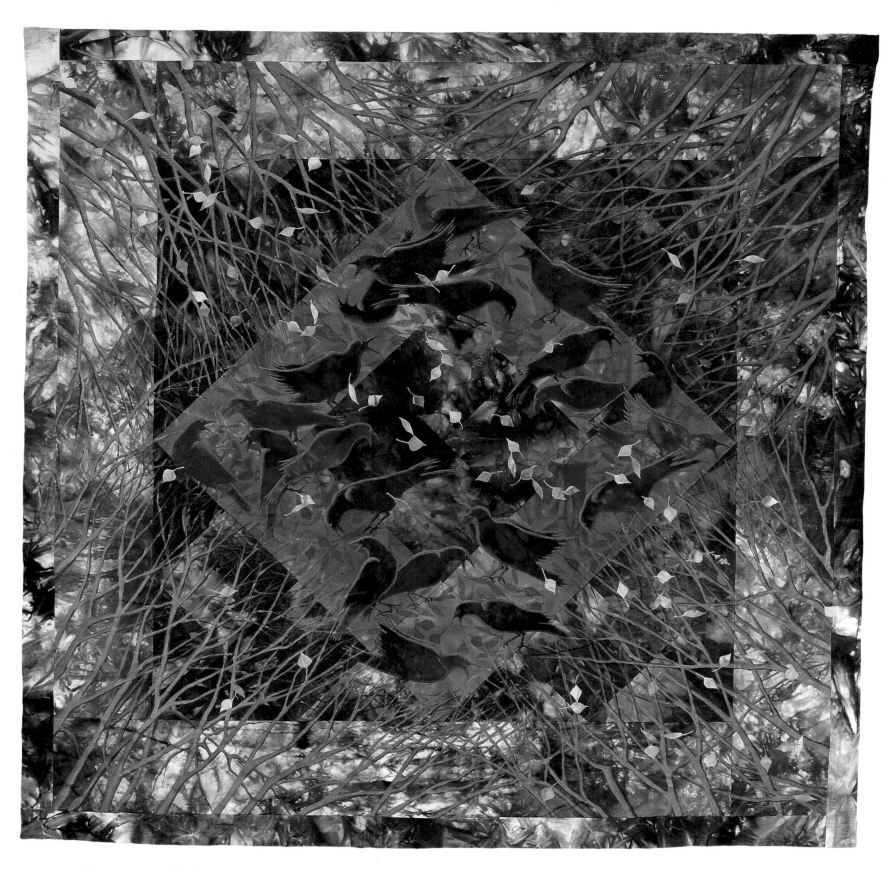

▲ **SEPARATION'S SORCERY**

Roxana Bartlett. 1995. Boulder, Colorado. Cottons, sateen, duck, velveteen, Procion dye, acrylic paint. Machine pieced, hand tied with pearl cotton. 59 x 59 in. Collection of the artist.

Bartlett's dark, brooding quilts often combine traditional pieced patterns with stark moonlit paintings of wild birds and animals to evoke emotions of loss and change. Bartlett comments on this piece: "Life is a series of good-byes. Separations are the common denominator of all beings, not just people. Animals don't worry about it the way we do. It's a lesson we can learn from them."

▲ NIGHT SKY

Barbara Todd. 1994. Montreal, Quebec. Woolen fabric with wool batting and cotton back. Hand appliquéd and quilted.
102 x 94 in. Collection of the artist.

Between 1986 and 1993, Todd made a series of *Security Blankets*, which presented unsettling juxtapositions of association, meaning, and imagery between the mortal body, domesticity, and warfare. Like many of Todd's recent quilts, *Night Sky* extends her use of the quilt's natural associations to explore the resonances and paradoxes of darkness, night, sleep, dreams, and death. The appliquéd images are based on children's drawings.

◄ THRESHOLD

Jeannette DeNicolis Meyer. 1995. Portland, Oregon. Hand-dyed cotton, painted canvas, cotton batting. Machine pieced, hand and-machine quilted. 44 x 49 in. Collection of the artist. The artist explains, "I sat holding my mother's hand in the last hour of her life, and by then the cancer had taken her somewhere else. Although still physically alive, I knew she was poised on the threshold between here and there, wherever *there* is. She couldn't speak, so I couldn't ask what she saw behind her closed eyes. Later that summer, when I removed this [central] piece of fabric from the dye bath, I was instantly back at my mother's bedside. I knew this is what she had been looking at from the threshold, as she hoarded her last amount of strength to step through, and beyond."

◂ SQUARES AND BARS

Carol Hemphill Gersen. 1989. Boonsboro, Maryland. Commercial cottons, hand-dyed cottons, cotton/polyester batting. Machine pieced, hand and machine quilted. Signed and dated in quilting on the quilt top. 52 x 77 in. Collection of Adrian Rothschild.
From folk artists to Jasper Johns, the Stars and Stripes has been a recurring theme in American painting as well as quilts. *Squares and Bars* won the Domini McCarthy Award for Exceptional Craftsmanship at *Quilt National '91.*

▴ FEELING BLUE

Charlotte Yde. 1996. Copenhagen, Denmark. Mostly hand-dyed and painted cotton and cotton sateen, some commercial cottons. Machine pieced and appliquéd, machine quilted. 45 1/2 x 43 1/2 in. Collection of the artist.
Yde, who has been making quilts since the late 1970s, is Denmark's leading art quilter. She usually works intuitively, with only a rough idea of the finished piece in her head, and allows the fabrics to lead her. Yde says this quilt "appeared" on her working wall while she was sewing another quilt and at a time when she was feeling "really depressed."

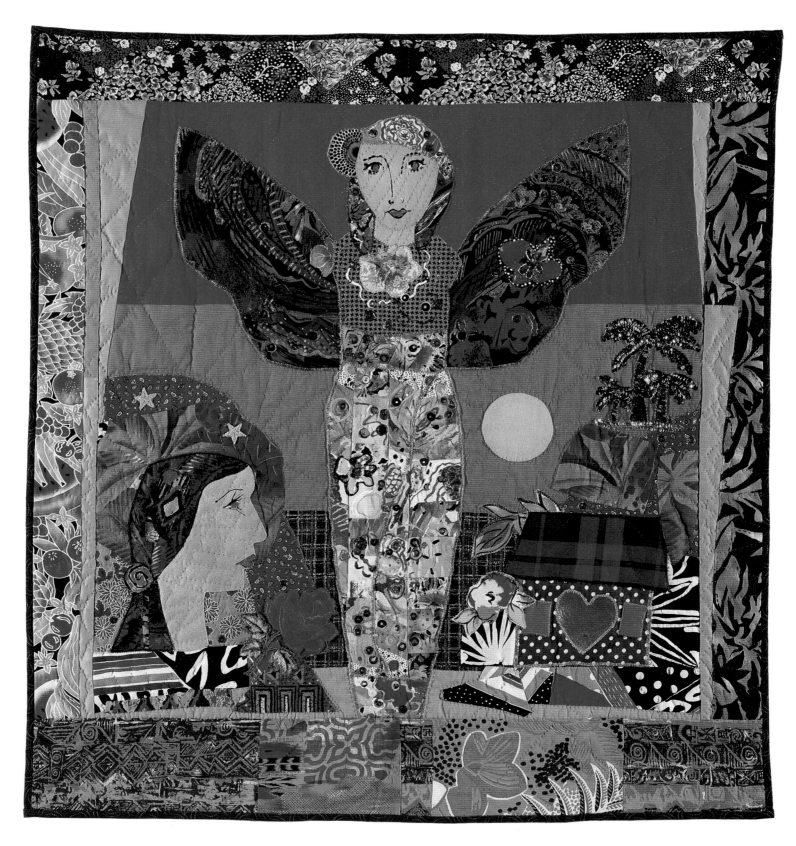

▲ SANCTUM

Carol Drummond. 1993. Sarasota, Florida. Assorted fabrics, painted canvas, paint, sequins, appliqués, metal thread. Hand and machine pieced, hand and machine appliquéd. 35 x 32 in. Collection of Ms. Jean Mellano.

Drummond worked as a collagist and painter for many years before turning to the quilt as her medium. Her small, stylized quilts, which are peopled with purposefully naive female figures and usually explore spiritual themes, combine all three artistic approaches.

ALL GOOD DOGS GO TO HEAVEN ▶

Kay Burlingham. 1990. Evanston, Illinois. Vintage cottons, chintz, seersucker, lamé, lace, damask, buttons, beads, rhinestones, plastics, and dog hair. Hand sewn and quilted. 65 x 48 in. Collection of the artist.

This memorial quilt was made after the death of Burlingham's beloved companion, Gladys. Burlingham, a self-confessed "dog fool," adds, "My quilts are shrines to everyday routine, attempts to preserve and raise up the mundane. Months after Gladys died I found a 'fur ball' of hers in one of our camping tents. I quickly stitched it inside a plastic heart and attached it to the center of the quilt."

◄ SATCHEL PAIGE: WORLD'S GREATEST PITCHER

Designed by Edward Larson, made by Yvonne Porcella Studios. 1989. Libertyville, Illinois, and Modesto, California. Cottons, textile paint. Machine pieced and appliquéd, hand quilted. 65 x 52 in. Collection of Yvonne Porcella.

Ed Larson is a sculptor who has designed many delightful cartoon-like quilts which have been fabricated by other artists. This example portrays Leroy "Satchel" Paige, the greatest star of the so-called Negro Leagues. Although his color kept him out of the white "major" leagues until well past his prime, more than a few experts believe he was indeed what he claimed to be: "The world's greatest pitcher."

ME MASKED ►

Yvonne Wells. 1993. Tuscaloosa, Alabama. Cottons and cotton blends, satin, velour, yarn, shoelace. Hand appliquéd and quilted. 60 x 58 1/2 in. Collection of the artist.

This unusual self-portrait has the logic of a dream, masking one layer of reality while revealing another. The image manages to be both self-deprecating and serious, funny and unsettling, funky and sophisticated, cartoonish and complex.

◄ HAITIAN MERMAID #1

Michael Cummings. 1996. New York, New York. Cotton, sequins, linen, hand-dyed cotton, velvet. Machine appliquéd. 60 x 42 in. Collection of the artist.

Cummings complements his appliquéd fabric paintings with discreet embellishments, and sometimes adds simple hand quilting. This recent piece is not quilted.

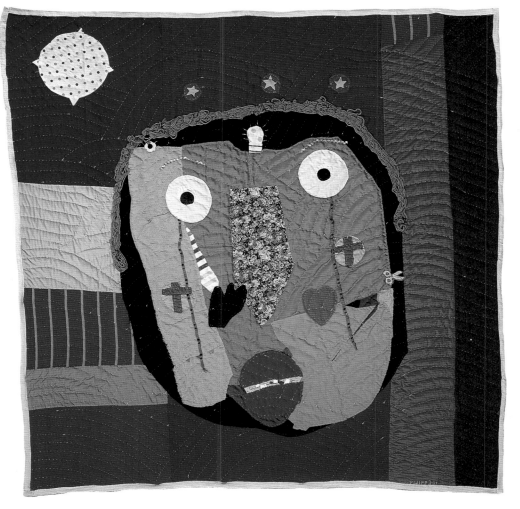

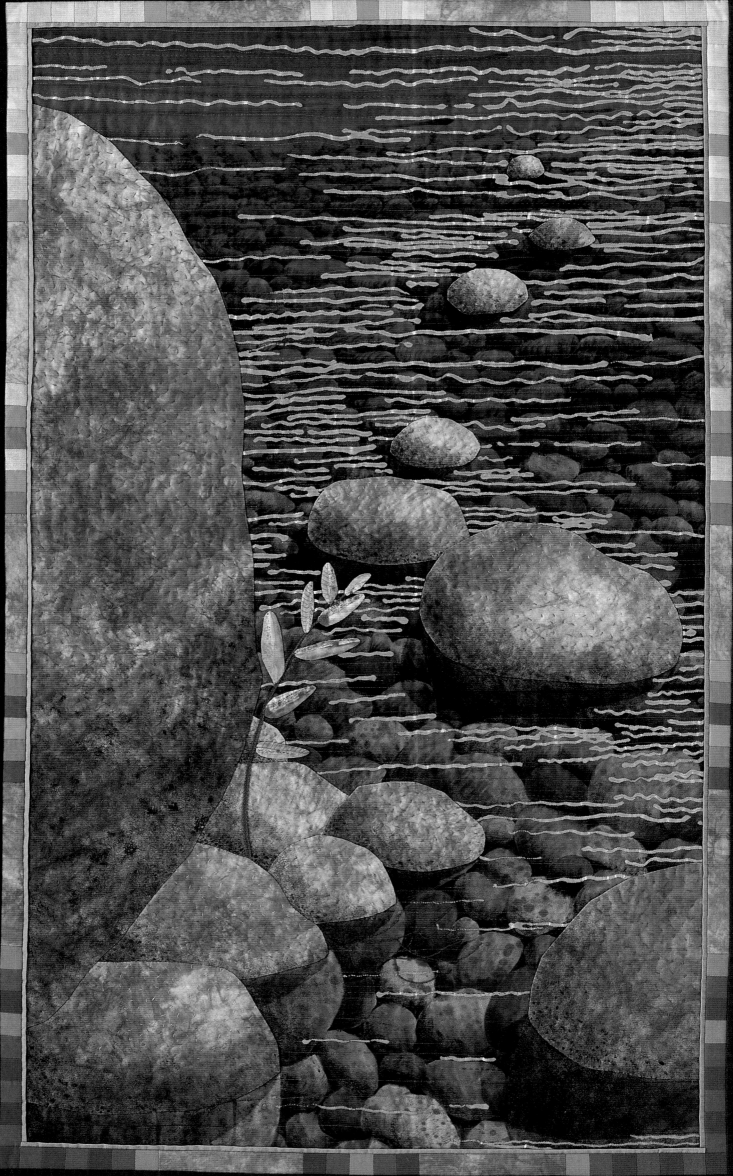

THE QUILTMAKER AS ARTIST

NATURE AND LANDSCAPE QUILTS

Like other artists throughout history, art quiltmakers often find beauty and creative inspiration in the world of nature. The natural world has always inspired quiltmakers and provided them with many visual and expressive concepts. Traditional quiltmakers often derived imagery for pieced and appliqué patterns from the flora and fauna that surrounded them. Flowers and gardens, fruits and vegetables, grasses and meadows, trees and leaves, domestic and wild animals all found their way into quilts as did images of hills and mountains, ocean waves, rocks, clouds, the sun and moon, and the stars of the night sky.

Some art quiltmakers concentrate almost exclusively on depictions of natural forms and landscapes, while others examine the place of human beings in the natural world and our unique power to alter the environment which supports us and other living things. Ruth McDowell, for example, has created many impressionistic quilts that use commercial fabrics to depict wild and cultivated plants from the New England wildflower bloodroot to a common garden cabbage. Velda Newman takes a more realistic approach, laboriously dyeing her own cloth and composing intricate and enormously oversized representations of fruits, flowers, and, most recently, butterflies. Gayle Fraas

◄ SLENDER PURCHASE

Karen Perrine. 1995. Takoma, Washington. Cotton sateen and nylon tulle treated with Procion MX dye, fabric pigments, and felt marker, cotton and metallic threads. Hand dyed, painted and airbrushed, hand and machine quilted. 53 x 32 in. Collection of the artist.
Perrine's work has been influenced by Japanese art and textiles as well as such nature photographers as Art Wolfe and Shinzo Maeda. Of her dyed and painted whole cloth quilts, she says, "Technically, I'm intrigued by the challenge of portraying wet, slippery water in a soft, fuzzy medium. Ditto hard, rough rocks. I also like the intellectual challenge of playing with the rules of physics and rearranging Mother Nature."

and Duncan Slade dye-paint realistic landscapes as they seek to explore place and how man's presence can inform a landscape with meaning. Fraas and Slade explain, "For a long time we've been painting places, sometimes real and others suggested by the real. We don't go anywhere without what we're seeing becoming fodder for our ongoing dialogue. Places are stories told through the remnants of history and the experience of the occupants, through the luxury of wealth, the strugle for existence, and the endurance of nature."

Others take a more abstract approach to their source material. Elizabeth Busch cuts up her own abstract landscape paintings to form the compositional and contextual fabric of her quilts. The fragmented landscape paintings are juxtaposed with pieces of commercial fabric in compositions that metaphorically explore the uneasy relations of the natural and human world. Joy Saville, who uses nature as a touchstone for her abstract, pointillistic explorations of color and light, explains her concerns this way: "I am intrigued with the optical mixing of color, what the eye perceives at a distance as well as up close. To work with color is to be involved with light, both visually and emotionally... I am in awe of the color at sunset, the subtleties of greens in the forest, the unex-pected color of mushrooms, a spectacular array of wildflowers, and the vividness of light striking the sea. Color serves as a vehicle to integrate what I see with what I know and feel. To express what exists is my task. It is also a celebration."

In addition to their own experiences and observations of the natural world, art quiltmakers also look to previous artistic approaches to the study and use of nature. Pre-Christian, Native American, and non-Western arts have a special appeal because their understanding of nature and man's place within it is markedly different from that of the Christian cultures of Europe and America. Joan Lintault has a fascination for the wall paintings in Imperial Roman garden rooms of the late first century B.C. and the early first century A.D., which, she says, "has led me to begin a series of quilts that I call *Evidence of Paradise*. In these rooms, rich with symbolism, people could refresh their minds while contemplating nature. The same contemplation was used as the basis for Japanese screens. The images on the screens were meant to inspire a feeling for the beauty of nature. I want to reveal the Japanese idea of *mono-no-aware*, the 'pathos of things' and the poignancy inherent in a garden. It is the idea that a garden is the achievement of perfection before the beginning of decline and decay."

Far Eastern art, which took a deeply spiritual approach to the natural world as early as the tenth century, has profoundly affected some quilt artists. Informed by Buddhist teachings, Chinese, Japanese, and Korean artists and craftspeople saw art as an act of meditation that aimed to create objects which could also serve as subjects for meditation. They created highly stylized but carefully observed landscapes and plant and animal studies centuries before Western artists, whose Christian religion did not find spirituality in nature. And because such art was honored as a sort of visual poetry, artists and craftspeople have always held a special place in Far Eastern society. Japan's ancient textile

◄ **UNTITLED IV**

Danaë Kouretas. 1990. Newton, Massachusetts. Mixed fibers printed with cyanotype photographs. Pieced, appliquéd, quilted. 96 x 106 in. Collection of the artist.

Kouretas says she purposely avoids explaining her quilts, adding, "I am happy if [they] evoke some personal feeling or thought, in the viewer." In this example of her diaphanous work, she explores the play of light on water, using a variety of materials and techniques to suggest movement, depth, and constant change.

▲ **NA PUA E LIKO ANIANI (BUDS AND FLOWERS MIRRORED)**

Stan Yates. 1993. Eleʻele, Island of Kauaʻi, Hawaii. Cottons, polyester batting, cotton-covered polyester threads. Hand appliquéd and quilted. 44 x 44 in. Collection of Mr. and Mrs. C.F. Story.

This quilt's "double design" was influenced by the art of M.C. Escher; as in Escher's work, the same design element is present in both the foreground and background. Yates notes that the Hawaiian title might also be translated as "The Flowers and Buds Mirrored to Each Other."

▲ HAPUʻU (TREE FERN)

Designed by Rachel P. Keehne, made by Malia Range Keehne. 1989–91. Keaau, Island of Hawaii. Cottons. Hand appliquéd and quilted by Malia Range Keehne. 107 x 102 in. Collection of Malia Range Keehne.

Hapuʻu are tree ferns that are native to the Hawaiian Islands. Although traditional designs inspired by hapuʻu exist, Rachel Keehne did not find them entirely convincing. Her new design, which was executed by her mother Malia, juxtaposes the strong central forms of crossed hapuʻu trunks against a background of lacy foliage.

traditions are particularly revered by her citizens, and textile artists have long enjoyed an esteem that Western quiltmakers envy and emulate. Although Japanese society is deeply patriarchal, there has never been a stigma attached to working with fabric like there is in Western countries, and men have always been involved with textiles.

Judi Warren's trips to Japan have inspired all of her work since 1986. She has created several atmospheric quilts based on moods and images described by Japanese haiku as well as pieces inspired by Japanese flowers and gardens and the lantern light on Tokyo Bay. Other quilt artists, including Marjorie Claybrook and Judith Content, have employed the philosophical content of the kimono form to create serene, contemplative images based on such natural forms as marsh grass and koi goldfish.

Just as Japanese textiles are born out of that country's traditions and historic approach to nature, Hawaiian quilts have always been closely tied to the lush and exotic natural world of the Hawaiian Islands. Hawaiian women developed a unique approach to quiltmaking in the nineteenth century, combining designs used on their own traditional Polynesian barkcloth bedcovers with appliqué techniques drawn from quilts brought to the islands by Christian missionaries from the United States. They folded large pieces of solid-colored cloth and cut it into enormous symmetrical abstractions. A single appliqué pattern formed the entire top of the quilt, which was then sewn with lines of contoured, wave-like quilting which echoes the forms of the design. Most Hawaiian appliqué designs found their inspiration in the natural forms of the islands and acted as symbols of the mystical relationship between the native islanders and their land, a relationship similar to that held by mainland Native Americans. Like much Native American art, traditional Hawaiian quilts are not really observations of nature, but

rather expressions of their creators' feelings of affinity and unity with the natural world.

While most Hawaiian quiltmakers continue to copy and adapt traditional patterns handed down for generations, a few are creating their own unique designs, looking ahead to bring the Hawaiian quilt into the twenty-first century. Many of these artists, including English-born Helen Friend and mainland American Stan Yates, are immigrants who have combined off-island sensibilities and influences with more traditional concepts in their work. Yates, for example, is a devotee of the Dutch artist M.C. Escher and has brought Escher's fiendishly clever geometric art to bear on the unique problems of Hawaiian appliqué design. Friend has experimented with such atypical techniques as reverse appliqué and the use of transparent cloth. Some native Hawaiian artists, such as Rachel Keehne, are creating original designs that bring traditional concepts up to date. The design for her *Hapu'u (Tree Fern)* is based on a genre of tree ferns native to Hawaii. It advances traditional design by combining a thoroughly modern color sensibility (placing chocolate brown and light green appliqué forms against a peach background) with contemporary ecological concerns. She writes, "We hope [the] quilt will portray this forest fern long after man has bulldozed our forest for farms or homes. Better still, we hope Hawaii will always have deep forests filled with hapu'u where birds sing and build their nests and the sound of rain keeps [the] fronds glistening like so many prisms that become thousands of rainbows!"

The approaches of Western painters to nature and landscape have also, of course, influenced many quilt artists. Influenced by the works of such Impressionist and Post-Impressionist masters as Monet and Seurat, quilt artists such as Pauline Burbidge and Holley Junker create quilts that explore the effects of natural light in cloth rather

than oils. The use of fabric allows them to create layered textures that would be impossible to realize with a brush. Fabric also absorbs and reflects light differently from a dried liquid medium, so the surfaces of quilts by these artists are often more inviting than those of a painting. Unlike a canvas, which must ultimately yield its illusion of softness and texture, the inherent tactile qualities of the quilt's fabric medium draw the viewer into intimate contact with its shimmering, multifaceted surface.

Burbidge is particularly fascinated by the movement of water and the ever-changing play of light upon its surface, while Saville and Junker prefer to study the play of light on or within a landscape. Burbidge's *Nottingham Reflections* and *Tweed Reflections II*, which are both based on observations of reflected images in rivers near her home, are arguably the most refined and successful

of her many quilts exploring mirrored images. Both quilts capture the fragmented, constantly shifting appearance of solid objects reflected in moving, sunlit water. Junker's *Salt Meadow* moves into the landscape, employing the fuzzy edges of tiny bits of pinked cloth like the dots of a pointillist painter to depict a softly lit seaside hayfield. While Junker is interested in capturing a sense of place, Saville's concern is the intersection of light and time. Her quilts carry titles such as *November Eve* and *Summer's End* and are abstract impressions of landscape, frozen glimpses of light and color that allow the viewer to contemplate a momentary sensation.

Similarly, Susan Wilchins's quilts allow unlimited access to normally fleeting or unobservable aspects of nature. Wilchins, who holds a M.F.A. in textile design and fiber arts from the University of Kansas, has created works based on images derived from aerial photography, maps, microscopic photographs of animal and plant tissue, and the carpet of debris on forest floors. Her series of quilts called *Sea Mantles* is, she says, "based on my past and present experiences with the ocean. In this series I am using color and composition to evoke the feeling of the ocean and the rhythms of the waves. [My] intent is to convey the intersection of tranquility with constant change."

◀ **GROUNDWORK**

Rhoda Cohen. 1993. Weston, Massachusetts. Cottons and blends. Hand pieced and quilted. 108 x 83 in. Collection of the artist.
Although she does all her piecing and sewing by hand, Cohen typically chooses to work on a large, enveloping scale. This abstract aerial landscape suggests both man-made and natural land formations.

▲ THE MOUNTAIN AND THE MAGIC: NIGHT LIGHTS

Judi Warren. 1995. Maumee, Ohio. Cotton, rayon, lamé, silk, beads. Machine pieced, hand appliquéd, hand quilted. 65 x 65 in. Collection of the artist.

Warren observed the scene that inspired this quilt on a trip to Japan. "Under a canopy of darkness boats lined with lanterns floated on water as black as the sky. Far in the distance, Tokyo's lights flickered, but near us—all around us— were the reflections of the lanterns making paths of light and color that moved with the water."

▼ **SEA MANTLE: ACMAEIDAE** (DETAIL ▶)

Susan Wilchins. 1992. Raleigh, North Carolina. Dyed, screen-printed, overdyed, pieced, appliquéd and machine-stitched cotton fabrics, synthetic metallic fabrics. 45 x 54 in. Collection of the Lucy Daniels Foundation, Cary, North Carolina.
Wilchins originally worked as a weaver but found herself frustrated by the flatness and grid structure enforced by the loom. This piece, like most of her quilted work, employs a variety of layered textures in an attempt to capture the visual feel of her observations of nature.

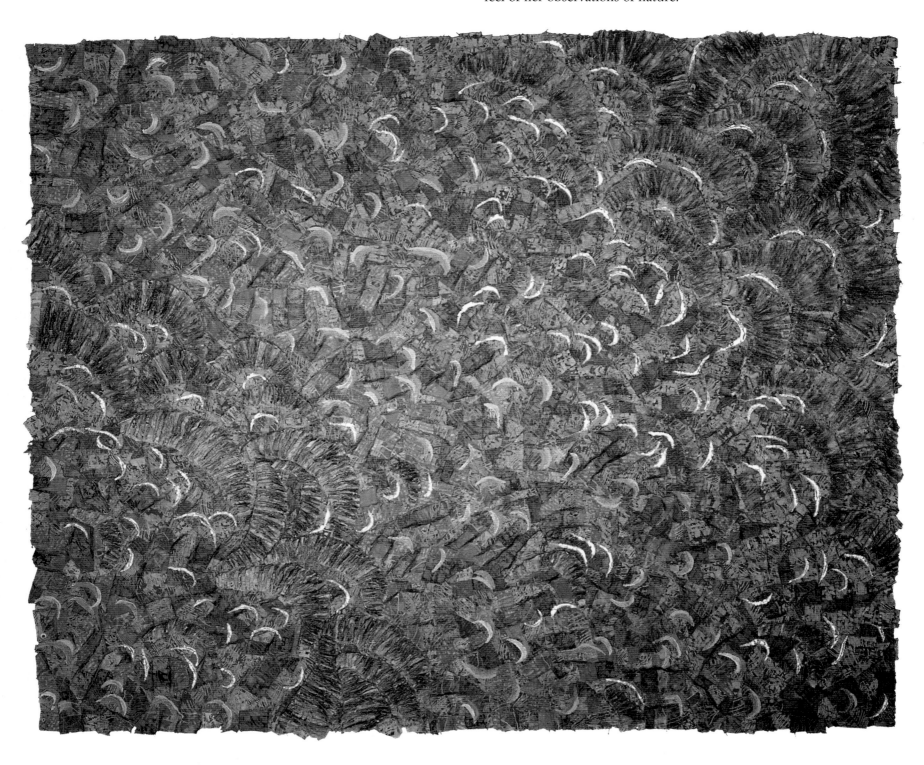

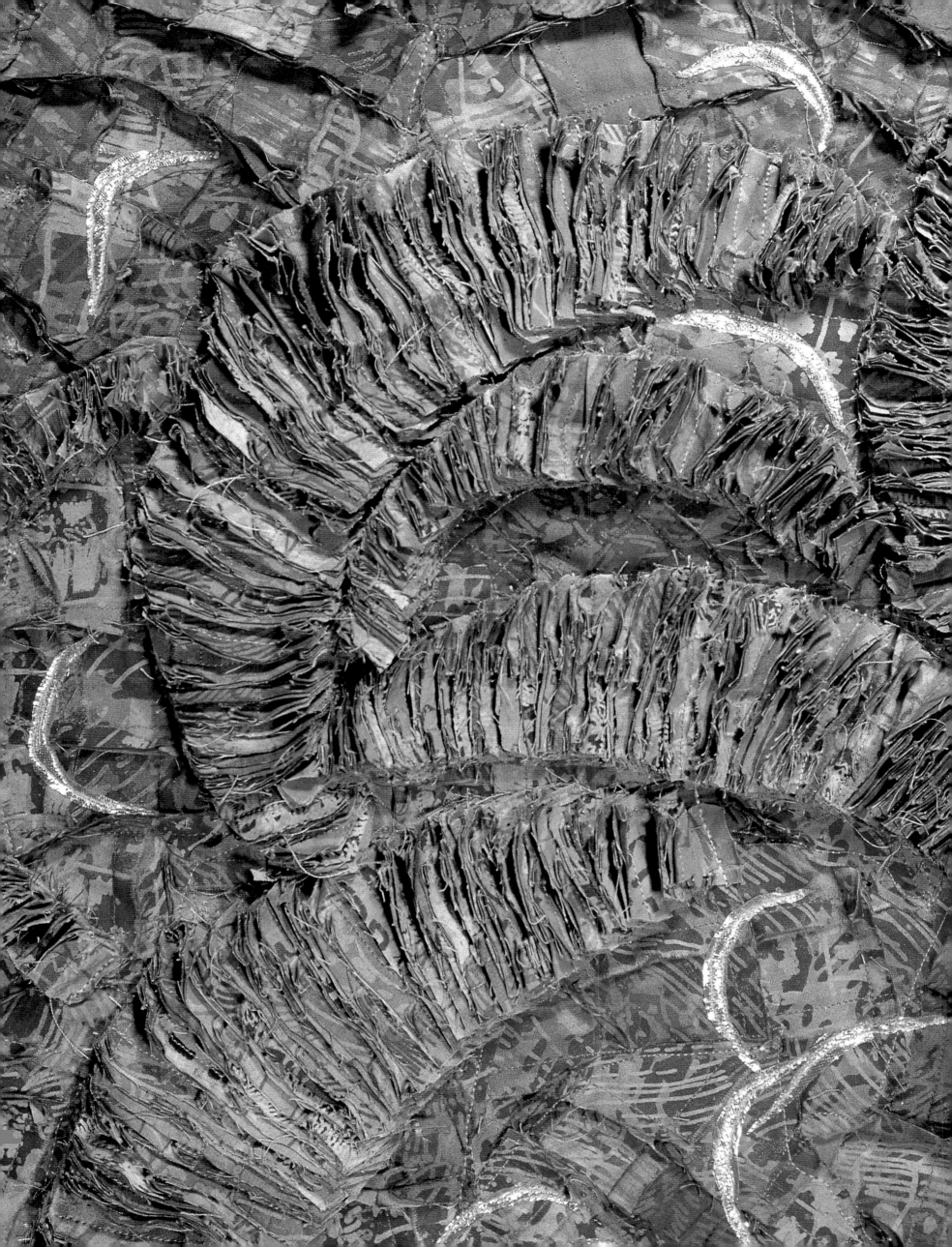

▲ **BALLYCONRY**

Holley Junker. 1992. Sacramento, California. Cotton fabric. Machine sewn and quilted, hand embroidered. 58 x 56 in. Collection of the Alza Corporation, Palo Alto, California.

Ballyconry is a small town on Galway Bay in the west of Ireland that Junker has visited a number of times. Seeds from as far away as Africa are blown into the area, and many exotic plants thrive in the climate, which is tempered by the proximity of the Gulf Stream. The weather changes constantly, often shifting several times within the course of a day.

▲ **BRIDAL VEIL MEADOW**

Norah McMeeking. 1995. Santa Barbara, California. Cottons. Hand dyed, appliquéd, and quilted. 38 x 34 in. Collection of the artist.
The shifting planes of hand-dyed color in this small landscape quilt are complemented by strong contoured quilting that adds textural depth to the land and water forms. *Bridal Veil Meadow* won first place in the 1995 Great British Quilt Festival.

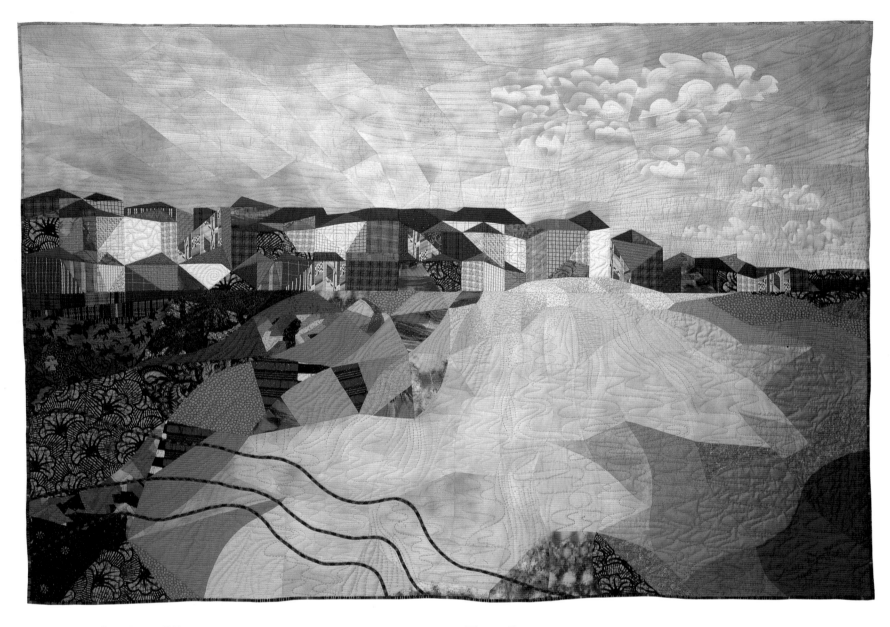

▲ ST. IVES HARBOUR 2

Susan Denton. 1995. Saltash, Cornwall, England. Cotton, silk, polyester batting. Machine pieced, hand appliquéd, hand quilted. 66 x 92 in. Private collection.

St. Ives is a fishing town in Cornwall, on the southwest tip of England. Denton writes: "It is a place of remarkable light and colour, constantly changing and always arresting. I have come to know the town, coastal footpaths, and nearby inland moors well over the past few years, and [this] quilt celebrates my joy in the place."

THE CANYON ▶

Katie Pasquini Masopust. 1996. Sante Fe, New Mexico. Cottons, blends, velveteen, satins, lamé. Machine appliquéd and quilted. 60 x 96 in. Private collection.

Masopust is a former painter who has been making original quilts since the mid-1970s. Over the years she has developed a number of different design approaches that are documented in her five books on quiltmaking. This recent commissioned landscape was based primarily on a photograph taken on a trip to Canyon De Chelly in Arizona. Her clients did not want any blue in the sky so its colors were taken from a photo they had of a Missouri sunset. Masopust notes, "The yellows serve as a great backdrop for the bright orange of the canyon."

DEATH OF A SEQUOIA ▶

Erma Martin Yost. 1993. Jersey City, New Jersey. Cotton and synthetic fabrics, opalescent thermo plastic, sequoia cone pods. Machine sewn, machine and hand embroidered. 52 x 44 in. The American Craft Museum, New York.

The giant sequoia, which can live more than 3000 years and may reach a height of over three hundred feet, stands alone as the earth's largest living thing. In 1979 Yost visited Sequoia National Park in California. She recalls, "I was overwhelmed by the sheer size and stunning beauty of these forest giants. But a visit to an area called the Stump Basin left me with haunting images. These giant trees that could resist fire and disease were not safe from human destruction. Some were cut down merely for exhibition." The Mark Twain Tree pictured in this quilt was 1,341 years old when it was cut down in 1891. Its basal section has been on exhibit at the Museum of Natural History in New York ever since.

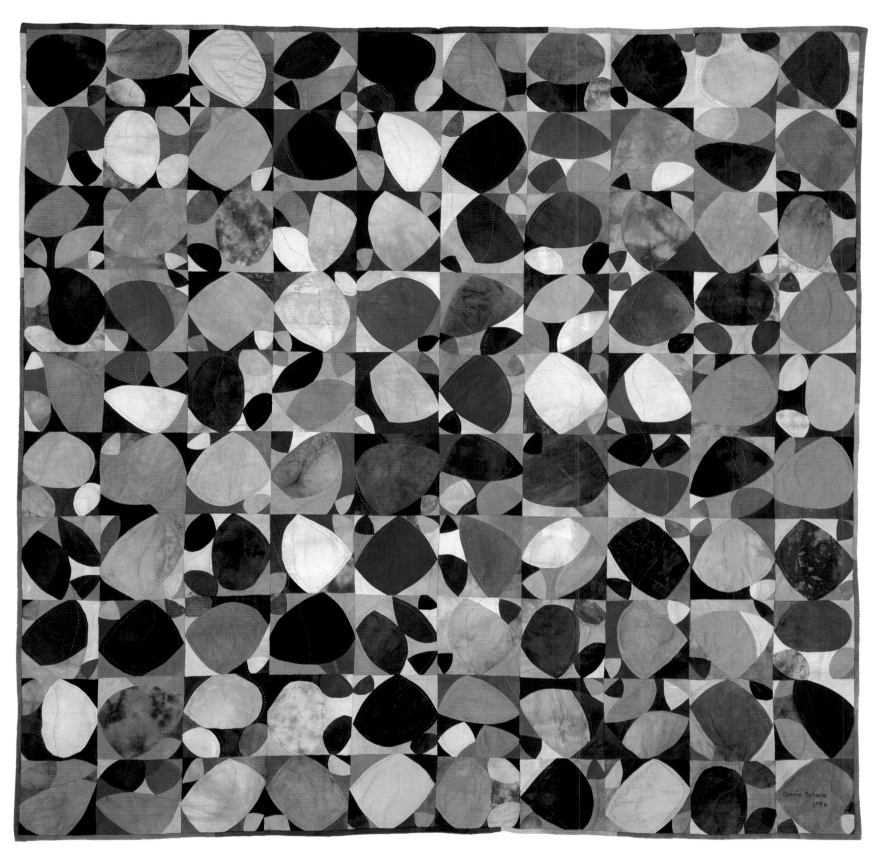

◄ VILLAGE STREET

Beatriz M. Grayson. 1996. Winchester, Massachusetts. Commercial cottons, machine pieced, hand appliquéd. 53 x 43 in. Collection of the artist.

Grayson often uses architectural themes, which she develops from memories of places she has visited or imagined. She explains, "[Sometimes] fantasy takes over and I fly over a scene in a balloon to design roofs that are architecturally incorrect yet seem more alive for being so."

▲ 611 RIVER ROCKS

Connie Scheele. 1996. Houston, Texas. Cottons, hand dyed by the artist, silk and cotton thread. Machine pieced, machine quilted by the artist, hand quilted by Hallye Bone. 60 x 60 in. Collection of the artist.

This is one of a series inspired by rocks in the Brule River in Wisconsin, where Scheele has often canoed in the summer. 611 was Scheele's street number at the time she made the quilt.

▲ SUMMER'S END

Joy Saville. 1995. Princeton, New Jersey. Cotton, linen, silk. Machine sewn. 48 x 67 in. Collection of the artist.

Saville notes, "I am intrigued with the optical mixing of color, what the eye perceives at a distance as well as up close." Her abstract landscape quilts employ thousands of tiny pieces of colored fabric to render the impression.

◄ SOLEIL ORIENT (ORIENT SUN)

Annie Viche. 1996. La Celle St. Cloud, France. Silks, taffetas, satin ribbons, cottons, transfers. Machine pieced, hand quilted. 39 3/8 x 39 3/8 in. Collection of the artist.

Viche has worked for the past three years on quilts that study the changing light in the sky from dawn to dusk. She describes this strip-pieced quilt as "a glimpse to the Oriental world, on the Bosphore gateway."

▲ **FLORA 2**

Janet Twinn. 1995. Tadworth, Surrey, England. Cottons. Hand pieced. 60 x 58 in. Collection of the artist.
Although this quilt projects an overall image of undulating, plant-like forms, it is actually composed in the traditional block style.

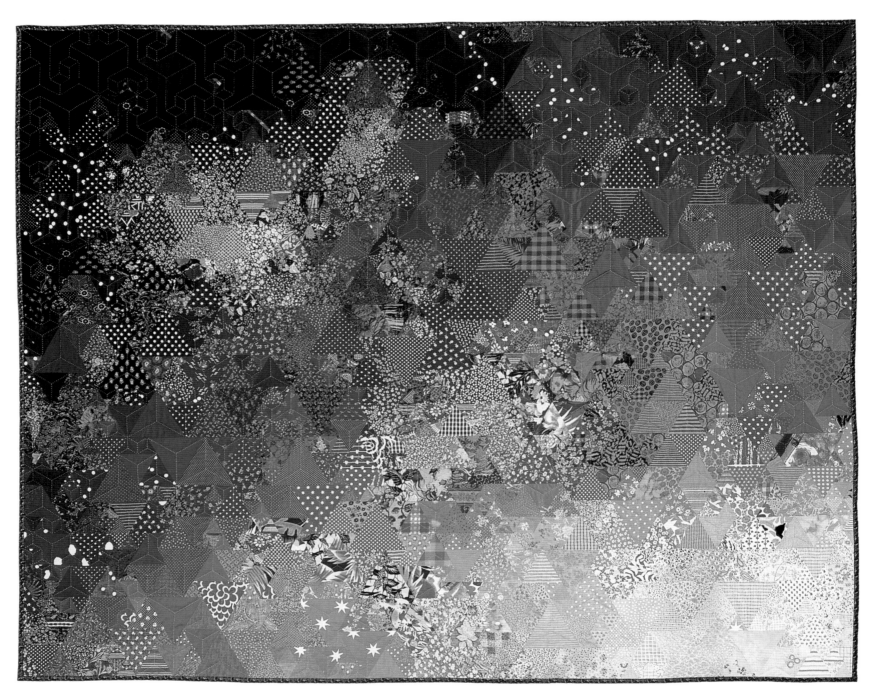

▲ NIGHT-TIME BLUES

Deirdre Amsden. 1987. London, England. Cottons and cotton blends. Machine pieced and hand quilted. 68 1/2 x 85 in. Collection of Martin Hildyard.

This quilt was inspired by a sky full of stars seen during a walk along a country road on a crisp, clear winter night. Amsden explains, "I wanted to convey the great tranquil dome of the night sky as seen from the earth, yet hint at the fury of the universe we see in photographs of space."

FLOW ▶

Joan Schulze. 1995. Sunnyvale, California. Silk, cotton, paper. Machine sewn and quilted. 101 1/2 x 100 in. Collection of John Walsh III.

John Walsh III has collected a number of quilts based on water themes. Knowing that Schulze often creates water quilts, he asked her to produce one for him and to make it as large as she wanted. Over the course of a year, Schulze and Walsh shared ideas, thoughts about the subject of water, and partial views of the work in progress. Midway through the process, Walsh sent Schulze some photographs he had taken of a favorite series of waterfalls, and some of these studies of flowing water became raw material for the artist's abstractions. Schulze is a poet who also works with paper and makes books by hand, so when the quilt was delivered to Walsh, she gave him a handmade book full of poems and other writings about the project.

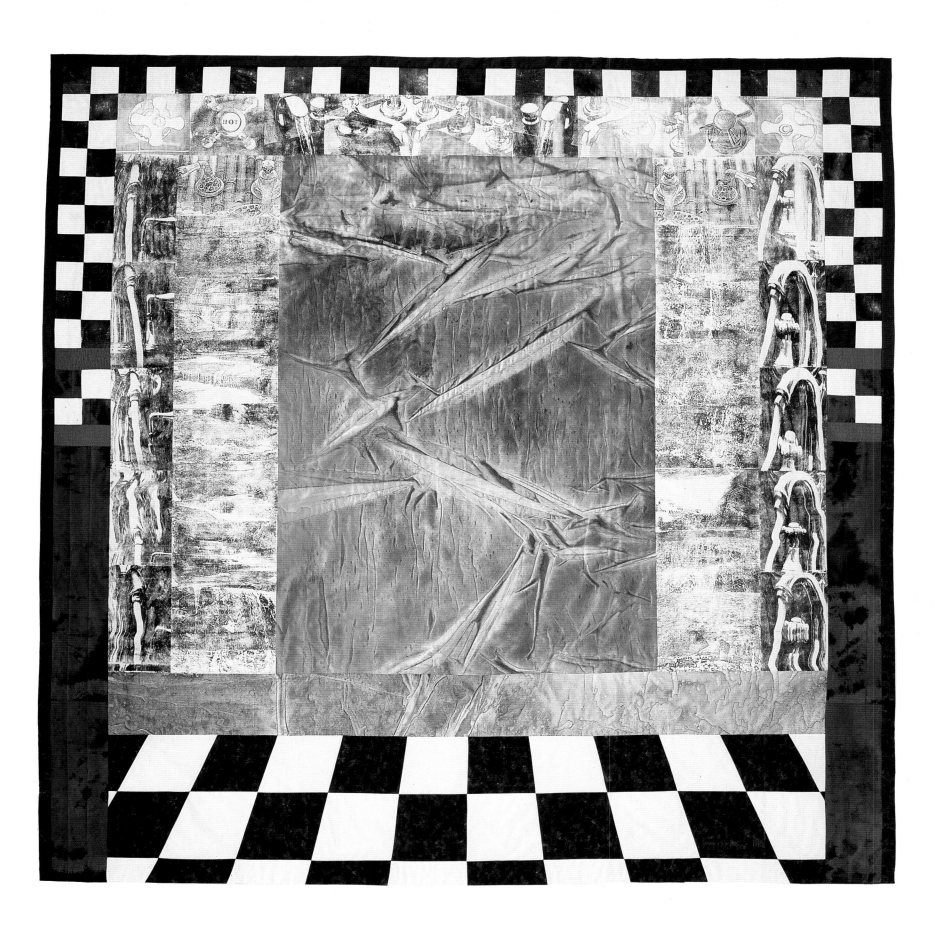

MOOSE RIVER GOTHIC ▶

Gayle Fraas and Duncan Slade. 1990. Edgecomb, Maine. Quilt: fiber-reactive dyes on whole cloth pima cotton, cotton batting. Hand painted, hand and machine quilted. Moose columns and trout: 1/8 in. wood laminate, acrylic paint. (All wood pieces are mounted 1/4 in. from the textile surface.) 57 x 87 x 3 in. (overall); quilt: 49 x 76 in. Collection Forest Hills Consolidated School, Jackman, Maine, Maine Percentage for Art Commission.

Like most of Fraas and Slade's work, this commissioned piece references the "regional vernacular" of its site, those human and natural elements which together define a place. Jackman, Maine, is the gateway to "The Great North Woods," and the Moose River, seen in the landscape painting, runs through the center of town. Moose, trout, "Carpenter gothic" architecture, and the buffalo plaid shirts of lumberjacks are also important parts of the region's history and unique character. The painted plywood lawn ornaments that are created by the area's many French-Canadian residents inspired the work's three-dimensional elements.

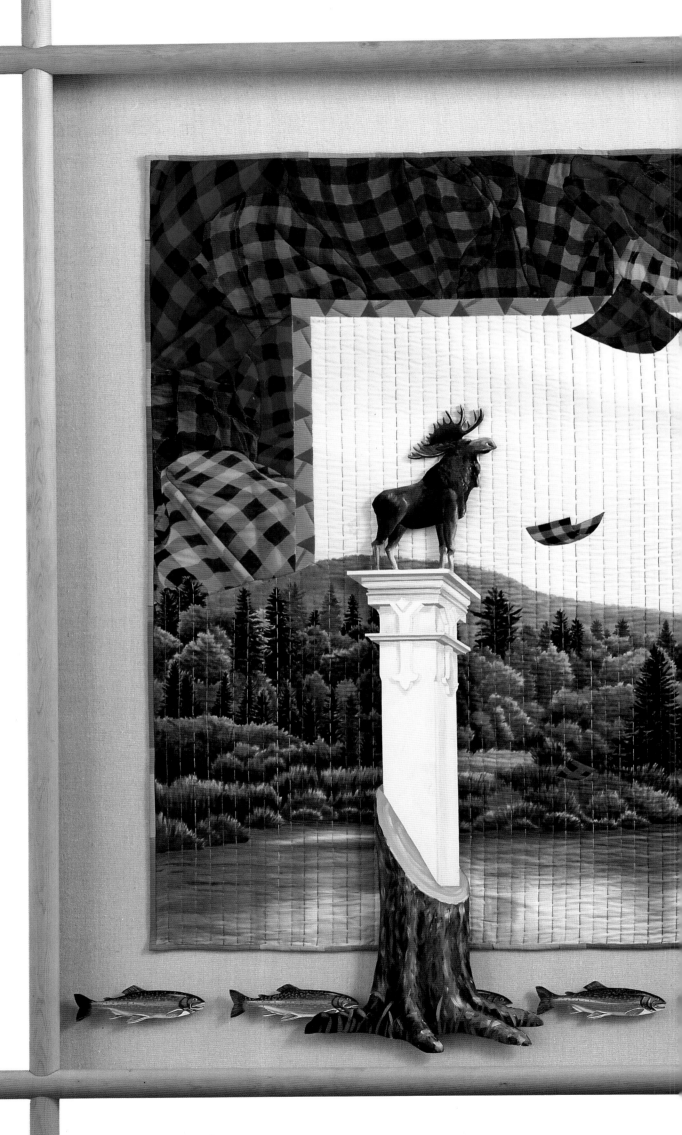

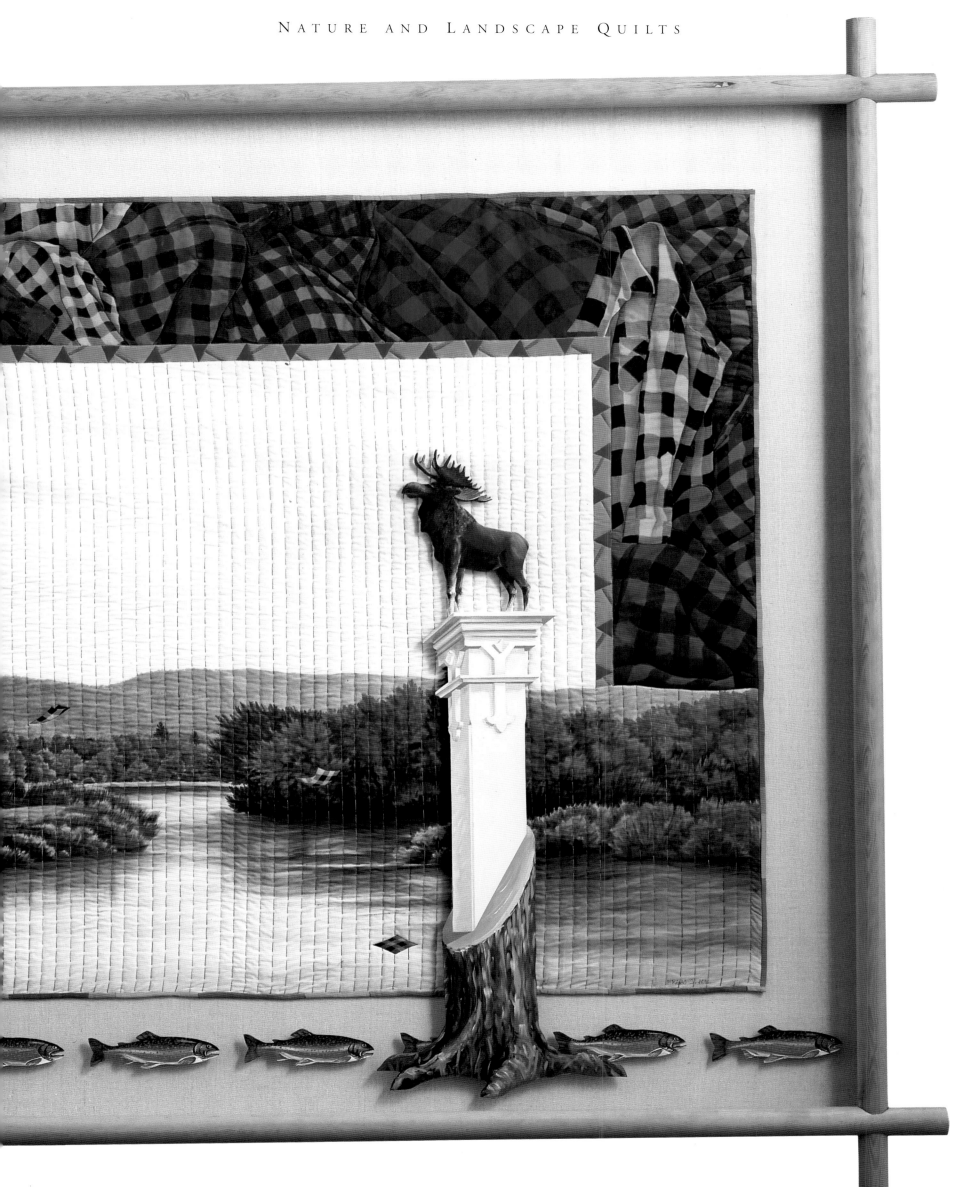

▲ DESERTED TROPICS (◄ DETAIL)

Deborah Felix. 1989. Oakland, California. Commercial fabrics, vinyl, pastels. Hand painted, reverse appliquéd. 87 x 120 in. Collection of the artist.

In addition to pieces like this that combine traditional quilting techniques with pictorial painting, Felix has also made several enormous (as large as 6 by 19 feet) pastel paintings on unstretched commercial fabric.

▲ FOREST FLOOR

Jan Myers-Newbury. 1997. Pittsburgh, Pennsylvania. 100%
cotton muslin. Procion dyed and bleached, machine pieced and
quilted. 62 x 75 in. Collection of the artist.

Newbury comments, "[I dye] various [pole-wrapped] pieces
of fabric two and three times in sequence, and in some, color
is removed. This layering of color creates a visual depth
within each individual length of cloth. My methods are pretty
'quick and dirty' compared to [the] precise patterning that
can and has been achieved by the Japanese. I am more
interested in exactly the random linear quality that comes
from the rather cavalier way I wrap and shove [fabric] onto
the pole."

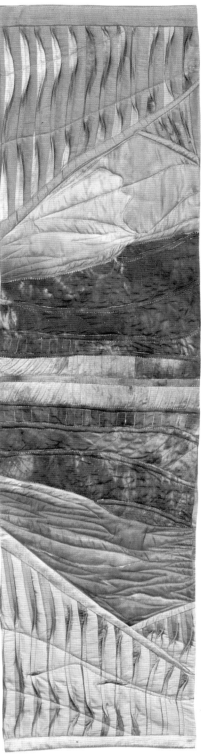
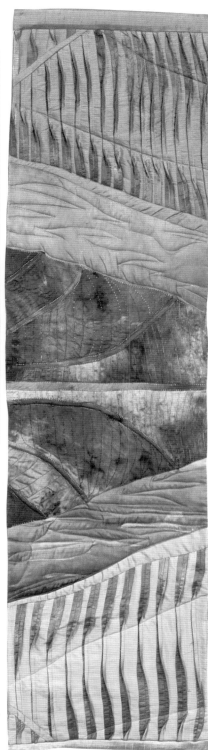
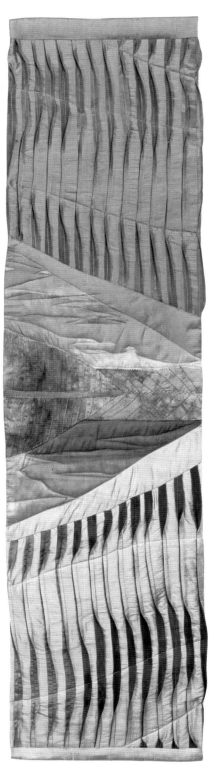

▲ MULLAGHMORE-REFLECTIONS

Ann Fahy. 1996. Galway, Ireland. Dupion, Habotai, and Antung silks, cotton batting. Pleated, dyed, and painted, machine sewn and embroidered. Four panels, each 46 x 12 in. Collection of the artist.

This stylized landscape portrays an area in the west of Ireland where wild natural beauty is threatened by the proposed building of a tourist center. Fahy comments, "This is my vote of support for the status quo!" The quilt's richly textured surface was created by tucking, pleating, and embroidering the fabric before piecing it together.

NANCY HALPERN

Nancy Halpern is a connoisseur of fabric, keenly aware of how different colors, materials, textures, and patterns will work together to translate a visual effect observed in nature. She finds many of today's fabrics "too beautiful," and believes their use often results in quilts that "lack guts." She looks for special qualities in her materials that will create illusions of form and depth, either juxtaposing contrasting colors and patterns to suggest the broken quality of light at play, or carefully mixing her own subtly valued hand-dyed fabrics to achieve a more serene balance.

Halpern's landscape quilts, which typically combine geometric forms with intricate textured hand quilting, reflect her study of architecture, both in their choice of subject and their piecework construction. Her quilts are inspired by places she has visited, and many present views of structures and natural forms softened by sunlight, shadows, clouds, fog, or rain. Her hand quilting provides another layer of contrast, adding watery or windy swirls of line and texture.

Halpern is a passionate believer in the importance of staying connected to the functional bases and human scale of the traditional bed quilt, and thinks art quilters should make a traditional quilt now and again to ground themselves. She works very slowly and deliberately, and her quilts, which she does not sell but either keeps or gives away, are always large enough to enwrap and comfort herself or a friend.

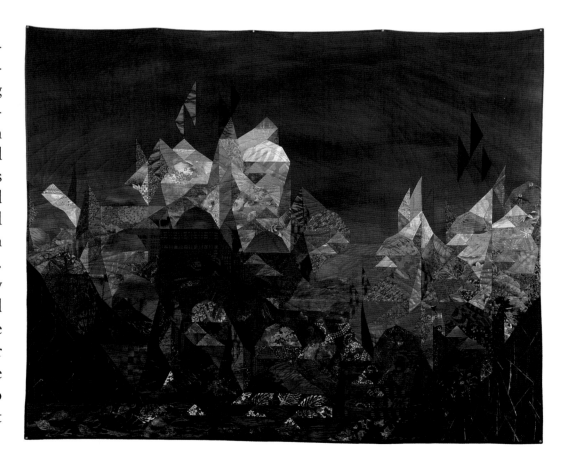

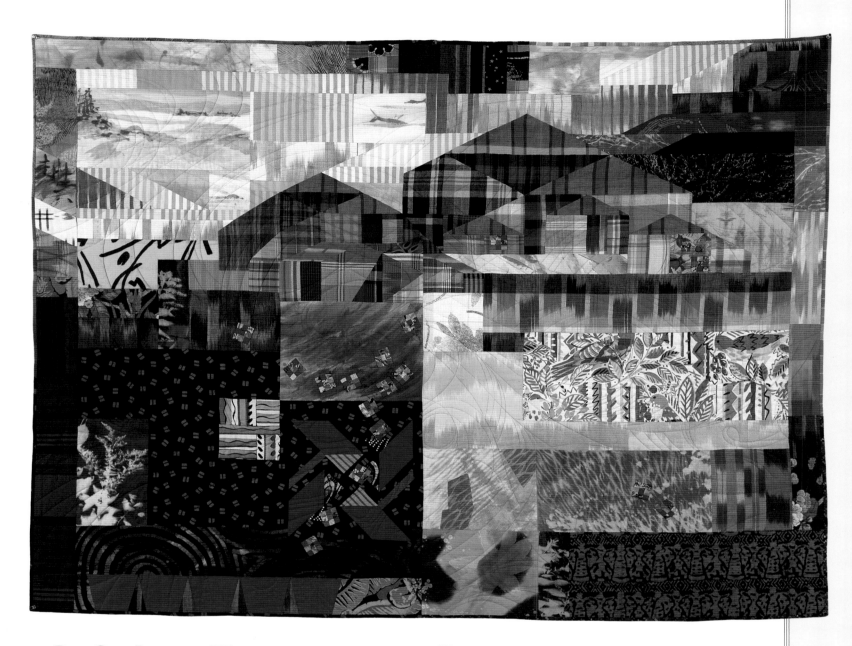

◄ RED CITY LOOKING WEST

Nancy Halpern. 1994. Natick, Massachusetts. Hand-dyed and commercial cottons and cotton blends. Machine pieced and hand quilted. 85 x 70 in. Collection of the artist.
This quilt depicts the domes and spires of Prague rising against "an astonishing sunset" that Halpern witnessed on a visit to the Czechoslovakian capital after the collapse of the Soviet Union. She was prodded to make the quilt by a persistent friend who became very sick and died before it was finished. Halpern notes, "I completed the quilt as much for Ellen as for me. The title seemed [doubly] appropriate: the view of Prague washed by the red of the sunset and the idea of the formerly communist city turning toward Europe and the U.S.A. Then I realized there was a third meaning: 'west' [also] signifies 'the land of the spirits,' the place where Ellen is now, the place where I am not."

▲ HOPPER

Nancy Halpern. 1992. Natick, Massachusetts. Hand-dyed and commercial cottons and cotton blends. Machine pieced and hand quilted. 57 x 76 in. Collection of the artist.
Like Halpern's *Falls Island/Reversing Falls, Hopper* was inspired by the landscape of coastal Maine. On a trip to Damariscotta to buy blueberries, Halpern observed the scene depicted in the quilt. She recalls: "In front of a shed covered with purple/blue/green shingles stood a bright blue winnower, at its base were flats of blueberries and purple boxes, and everything was flanked by fields of goldenrod. The title refers to the winnower's hopper, the bouncing berries, and to [American painter] Edward Hopper's swathes of yellow grass."

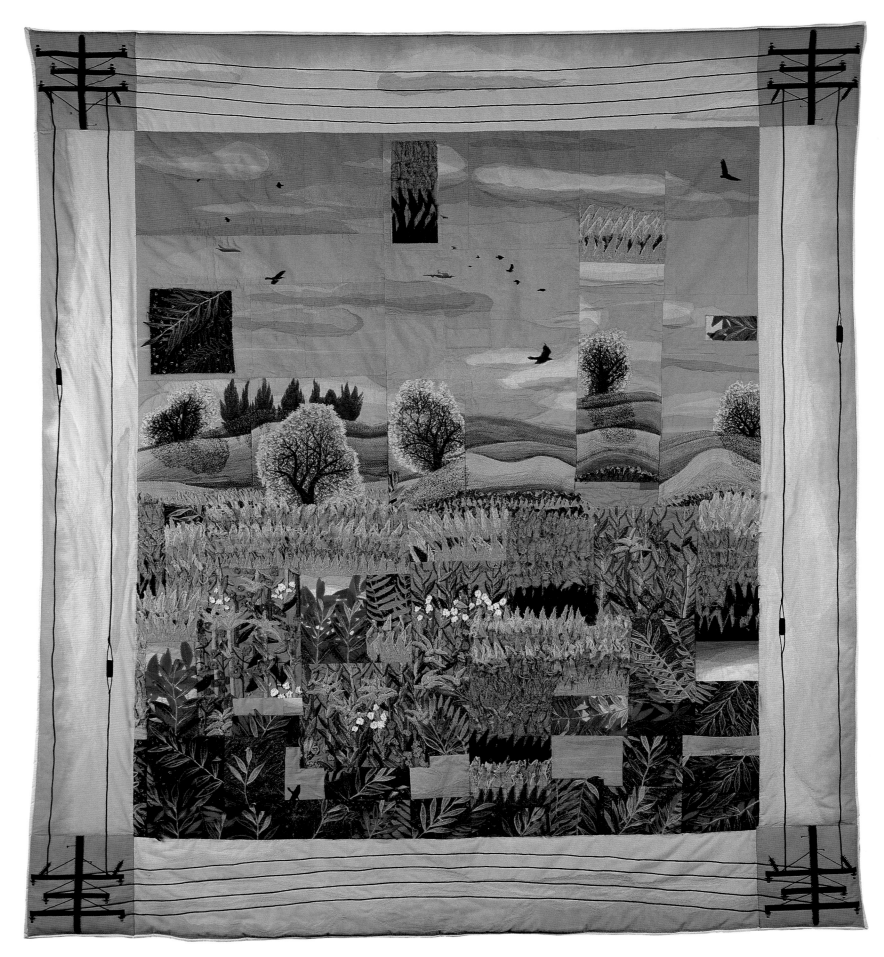

▲ FLIGHT PATTERN OVER ELECTRIC COMPANY EASEMENT PROPERTY

Terese Agnew. 1993. Milwaukee, Wisconsin. Various cottons, some hand dyed, silk organza, bridal tulle. Image created with machine embroidery and construction, hand quilted. 91 x 82 in. Collection of John Walsh III.

This quilt captures an oasis amid city neighborhoods and the Milwaukee airport where Agnew has walked her dog for many years. She describes it as a place where one can "be watching cedar waxwings and then look up to see the five o'clock flight coming in."

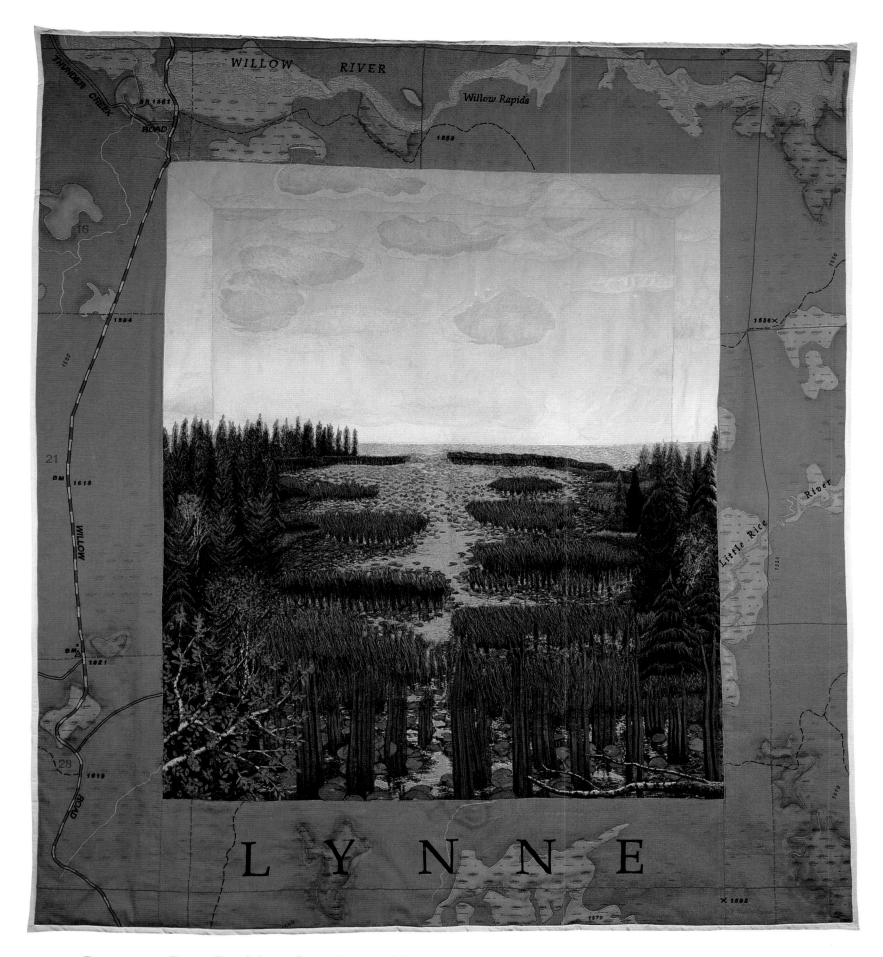

▲ PROPOSED DEEP PIT MINE SITE, LYNNE TOWNSHIP, WISCONSIN

Terese Agnew. 1994. Milwaukee, Wisconsin. Hand-dyed cotton and various manufactured cottons, hand-dyed silk, silk organza, bridal tulle, invisible thread. Machine appliquéd, machine embroidered, hand quilted. 80 x 73 in. Collection of John Walsh III. This quietly powerful and elegaic quilt allows the landscape to present its own eloquent case against the threat of man's exploitation. The title invites viewers to project their own image of a deep pit mine onto what Agnew describes as one of the most beautiful pieces of land she has ever seen.

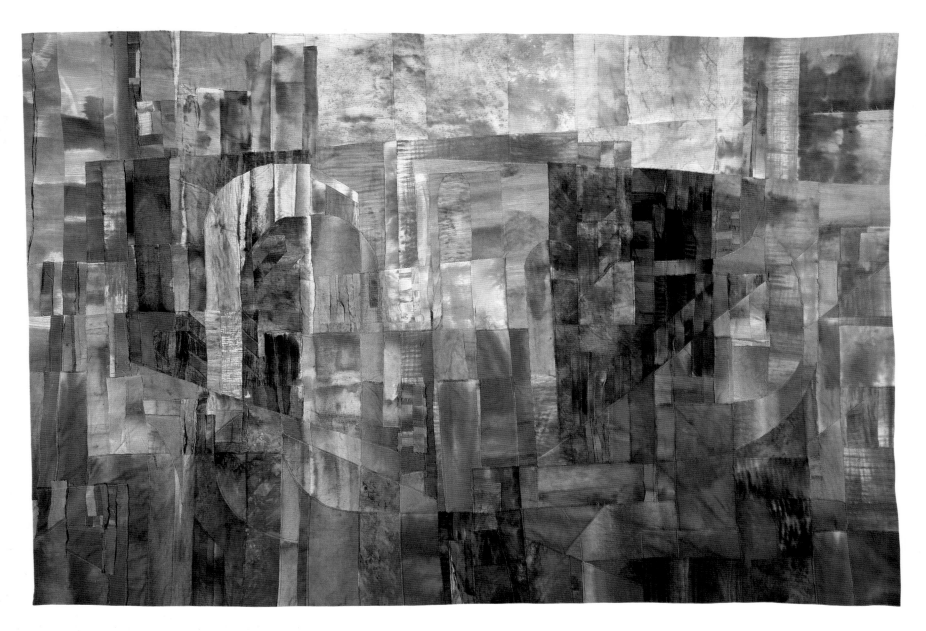

▲ PAESE DEI SOGNI (LAND OF DREAMS)

Linda Levin. 1994. Wayland, Massachusetts. Cottons, Procion-dyed by the artist. Hand and machine sewn. 50 x 77 in. Collection of the artist.

This piece was inspired by a balloon flight over the cathedral in Siena, Italy, and abstracts its architectural features. Levin recalls: "It [was] a time of day when the light casts a golden glow over everything, and the shadows are deep, dark, and mysterious. Seen from the air, they seem to create a whole other city in the midst of the solid, tangible buildings."

MARSH LIGHT ▶

Judith Content. 1996. Palo Alto, California. 100% silk satin and Thai silk, dyed and discharged using an adaptation of the Japanese thread resist process called Arashi Shibori. Pieced, machine quilted and appliquéd. 46 x 69 in. Collection of the artist.

Content here alternates strips of shibori-dyed silks to suggest the play of dappled light in a marsh landscape.

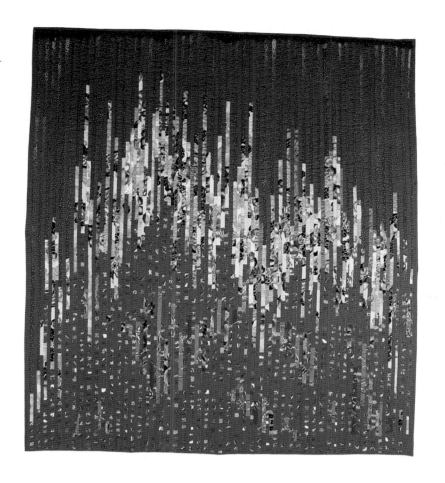

NORTHERN LIGHTS V ▶

Ann Bird. 1994. Ottawa, Canada. Cotton. Machine pieced, machine quilted. 58 x 52 in. Collection of the artist.

Bird comments, "The [Aurora Borealis's] green curtains of light, twisting and turning in patterned bands and sometimes erupting into dazzling shafts of purples, reds, and yellows, are familiar sights in Canada's sky. For me they are mystical and enchanting."

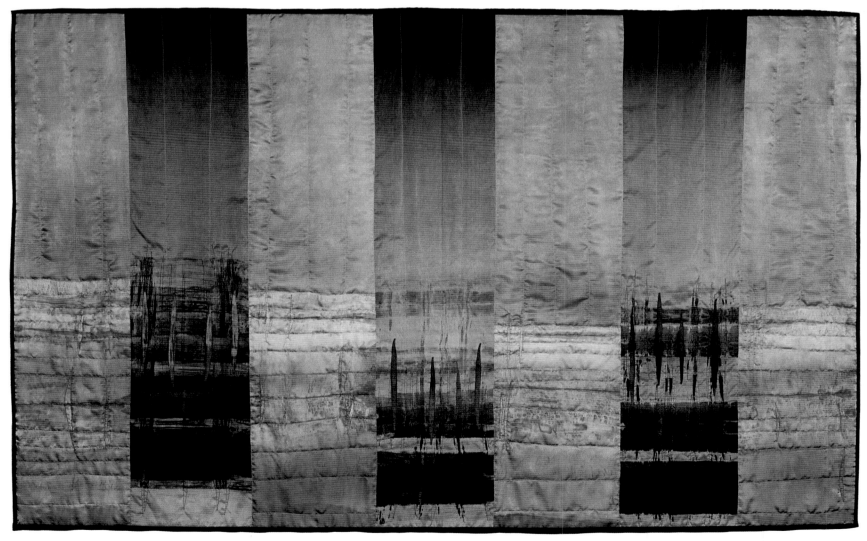

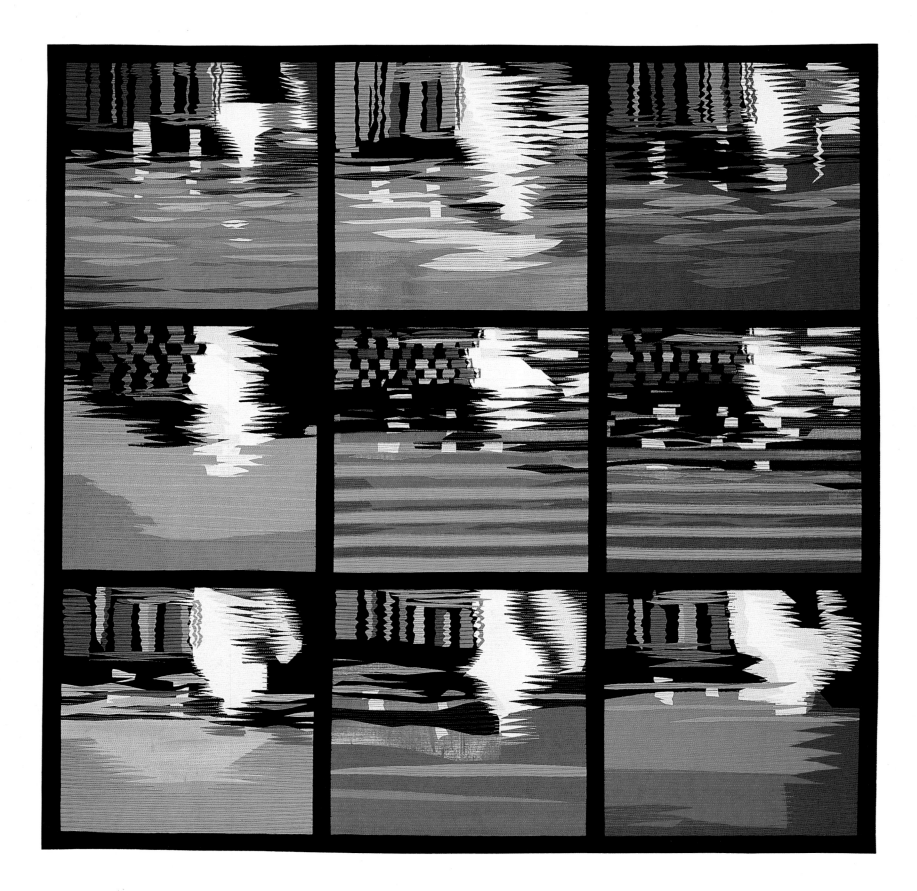

▲ TWEED REFLECTIONS II (DETAIL ►)

Pauline Burbidge. 1995. Berwickshire, Scotland. Cotton fabrics, some hand dyed. Machine appliquéd and quilted. 47 x 47 in. Collection of John Walsh III.

Water reflections are a continuing theme in Burbidge's work. This fabric collage began with photos she took of the river Tweed, near an old chain bridge about five miles from her home. Burbidge explains, "I think I realize these days that the image I am working from has to have a quality which reminds me of fabric in some way." In this case the shapes of the reflected image reminded her of fabric pieces, so she was "all set."

▲ Leaves I: Springer Street (◄ Detail)

M. Joan Lintault. 1981. Carbondale, Illinois. Printed, drawing on canvas. Hand quilted. 51 x 134 in. Collection of the artist.
Lintault lives on Springer Street and based this quilt on photographs taken around her neighborhood.. The flat leaves were printed, then cut out and appliquéd to the quilt. They are only sewn at the top, so they overlap like shingles (or real leaves).

Desert Village ►

Dorle Stern-Straeter. 1985. Munich, Germany. Cottons. Machine sewn and hand quilted. 67 x 84 in. Collection of Mrs. Bridgette Thun. Stern-Straeter lived in the United States for several years and began making quilts in the mid-1970s. During the 1980s, she was one of the first to bring non-traditional quilting to Europe. In this piece, she used a crazy quilt technique developed while living in Saudi Arabia to create a fractured, impressionistic desert landscape. She recalls, "I had minimal access to fabric and wanted to use small scraps."

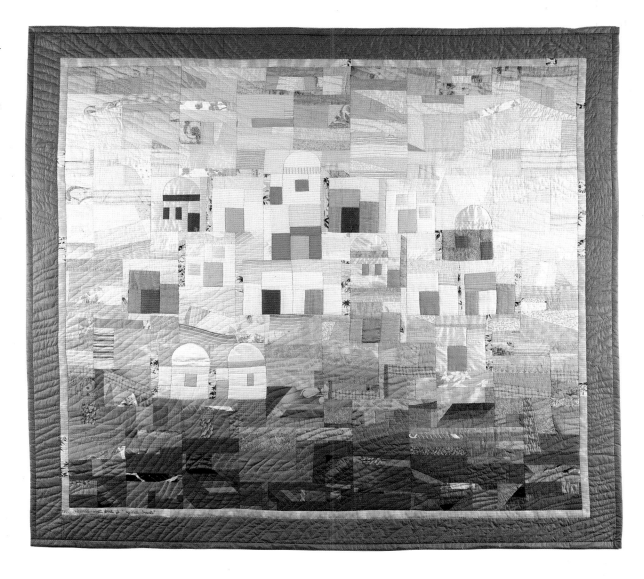

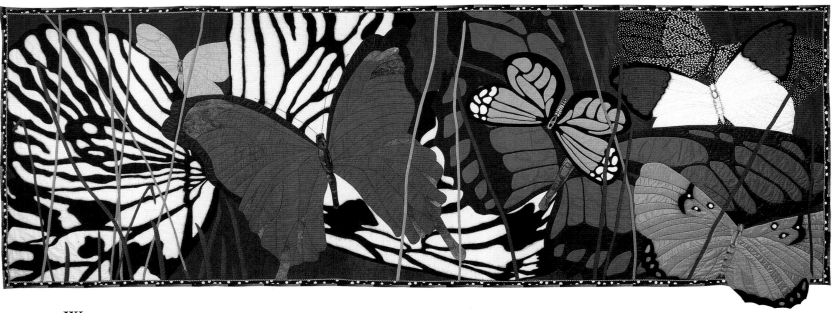

▲ WINGS

Velda E. Newman. 1994. Nevada City, California. Hand-dyed cottons and silks. Hand and machine stitched. 62 x 180 in. Collection of the artist.

This huge, greatly magnified study of butterflies epitomizes Newman's attention to the subtlest details of her small and easily overlooked subjects. She paradoxically succeeds in combining monumentality with great delicacy, and strong graphic appeal with meticulously detailed craftsmanship.

◄ ALERT!

Elizabeth A. Busch. 1991. Glenburn, Maine. Acrylic paint on 7 oz. duck, dye on muslin, textile ink, purchased fabric, polyester batting. Hand painted, photo silk-screened, machine pieced, hand quilted and embroidered. 52 x 37 1/2 in. Collection of the artist.

Alert! is part of a series of quilts by Busch that deal with a tragic 1988 Maine hunting accident in which a woman was shot and killed in her own suburban backyard. The accident happened about ten miles from Busch's home. She notes, "Rogerson [the hunter] had a 'bucks only' permit. Wood [the victim] wore white mittens, but no antlers. Rogerson was acquitted of manslaughter in 1990.

SPIRIT OF THE MOON ►

Natasha Kempers-Cullen. 1992. Topsham, Maine. Cotton, fiber-reactive dyes, commercial striped fabric, glass and clay beads, coral. Hand painted, machine and hand quilted, embroidered. 63 x 42 in. Collection of the artist.

Kempers-Cullen explains that this quilted painting "honors the gentle strength and wisdom of moon energy. A shrine is built in her honor." Many of Kempers-Cullen's quilts deal with the relationship between humans and the natural world.

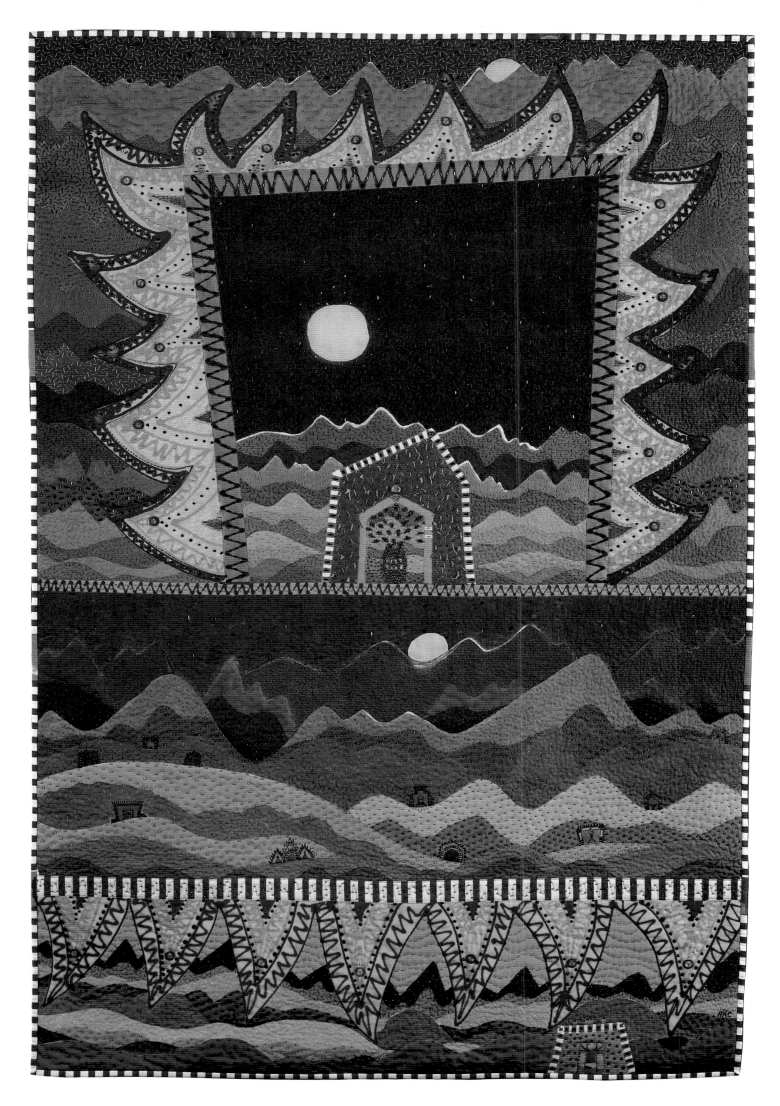

ACKNOWLEDGMENTS

This book would not have been possible without the support of hundreds of generous people, some of them old friends, many newly met in the course of my research.

First of all, my profound thanks to everyone who sent me photos of their work to consider for the book. Although I looked at well over six thousand quilts, most of which inevitably could not be included, each slide and bit of background information helped me to better understand the scope of the art quilt, and I am grateful for the opportunity to see them all.

Thanks also to all the artists with whom I talked or corresponded. Many deserve special thanks. The indefatigable Yvonne Porcella answered endless questions, graciously xeroxed material from the archives of Studio Art Quilt Associates, loaned me obscure catalogues, and put me in touch with many artists. Nancy Halpern loaned books as well; she also spent several delightful hours with me recalling the early days of the movement, helped open some important doors, and provided many helpful leads and suggestions. Michael James loaned his catalogue of the DeCordova Museum show, shared two wonderful early quilts from his personal collection, and offered a number of insightful suggestions. Nancy Erickson sent me half of her library as soon as she heard about the project, and Nancy Whittington, Meiny Vermass-van der Heide, Judy Dales, Susan Shie, Teresa Barkley, and Duncan Slade and Gayle Fraas also loaned rare books and catalogues. I hope I have returned them all. Duncan and Gayle also explained the history and techniques of dye painting to me and alerted me to a group presentation by art quilters in Lowell, Massachusetts. Lynn Lewis Young helped spread the word about the project to quilt artists around the world. Jude Larzelere shared some of her lecture notes and helped me think about the book's structure. Nancy Crow sent me photos of her studio and encouraged me to visit her and others at work. Radka Donnell called and sent wonderful letters and photos from Switzerland; her long-distance embrace of the project was wonderful. Susan Hoffman helped me to better understand both her own work and that of Molly Upton. Quilt historians Bets Ramsey and Joyce Gross helped fill gaps in my knowledge about early quilt artists; Bets also loaned several photos and put me in touch with John LaRowe, who graciously allowed his Charles Counts quilt to be included. Beth Gutcheon also helped me sort through the early years of the art quilt. Jean Ray Laury dug through her old slides and papers, even though she told me she dislikes nothing more, and both she and Joan Lintault shared photos of many of their ground breaking early works. Dorothy Caldwell directed me to several other remarkable artists, both in the United States and Canada, and Susan Hagley and Deirdre Amsden introduced me to other members of the European group Quilt Art. Marilyn Henrion acted as liaison with Russian artist Ludmila Uspenskaya and made several helpful suggestions. Carolyn Mazloomi sent me slides of work by members of the Women of Color Quilter's Network. Terrie Mangat suggested several artists she admired, and Sandra Sider sent me updates from quilters' Web sites on the Internet.

Penny McMorris, curator of the seminal exhibition *The Art Quilt*, gave enthusiastic support to the project, xeroxed reams of useful material from her files, and directed me to the work of several obscure but important artists. Hilary Fletcher, director of *Quilt National*, loaned catalogues of past shows, arranged new photography, and helped contact many artists. Thayes Hower, director of Quilt San Diego, graciously loaned photographs from past shows. Kei Kobayashi offered sage advice on the work of Japanese quilters, and put me in touch with several artists.

I am deeply grateful to John Walsh III and Ardis and Robert James, who enriched the book with quilts from their extraordinary private collections. Jack also introduced me to the work of several artists and sent a number of quilts to Shelburne to be perfectly captured by photographer Ken Burris, whose eyes I trust as my own. Sharon Risedorph in San Francisco also shot many previously unphotographed quilts especially for the book.

At Levin Associates, I am again indebted to Hugh Levin, who suggested the book and supported it from start to finish, and to my invaluable colleague Ellin Silberblatt, who managed the project with her usual aplomb. Particular thanks are also due to Jenny Sabo, who kept track of all the pictures and attendant pieces of paper as they came in, to my trusted editor Debby Zindell, who improved the manuscript in myriad ways, and to designer Kathy Herlihy-Paoli, who gave the book its elegant appearance.

Finally, loving thanks to my girls, my daughters Emma and Georgia, who told me which quilts they thought were really cool, and my wife Nancy, who balanced us all with constant love and grace.

ROBERT SHAW
Shelburne, Vermont

PHOTO CREDITS

Photo by Ole Akhoj: p. 11.

Photo by Jim Anthony: p. 143.

Photo by Thomas Askew III: p. 49.

Photo by James Austin: pp. 86, 156 (top).

Photo by Bill Bacchuber: pp. 65, 228–9, 252 (top).

Photo by Jeff Baird: p. 131.

Photo by Stuart Bakal, New York City: pp. 57, 242.

Photo by Tom Bamberger: pp. 286, 287.

Photo by Susan Beard: p. 83.

Photo by David Belda: p. 104 (bottom).

Photo by Clinton Bell: p. 207 (bottom).

Photo by Karen Bell: pp. 8, 110, 160, 196, 203 (top), 233.

Photo by Jan Bindas Studios: pp. 112, 113.

Photo by Roger Bird: p. 289 (top).

Photo by Stan Bitters: pp. 46, 63.

Photo by Brian Blauser: pp. 191, 220 (top), 272; courtesy of Quilt National: p. 273.

Photo by John Bonath, Maddog Studio, Denver, CO: p. 195 (top).

Photo by Erik Borg: p. 106.

Photo by Pamela Braun, Bronze Photography, Cincinnati, OH: p. 176.

Photo by Tafi Brown: p. 64.

Photo by David Browne: pp. 21, 236 (bottom).

Photo by Steve Budman: pp. 177 (top), 182.

Photo by Bill Burlingham: p. 255.

Photo by Ken Burris: pp. 13, 28, 72 (top), 80, 89, 116, 146, 149 (bottom), 174 (top), 186 (bottom), 218, 219, 224, 235 (bottom), 237, 246 (left).

Photo by David Caras: pp. 61 (top), 68, 78, 94, 95, 102, 103, 156 (bottom), 162, 203 (bottom), 204, 205, 220 (bottom), 232, 260, 264, 284, 285.

Photo by Robert Cargo: p. 257 (bottom).

Photo by Thomas Carroll: p. 240 (top).

Photo by J. R. Claybrook: p. 241.

Photo by John Coles: p. 276.

Photo courtesy of the Connell Gallery, Atlanta, GA: p. 71.

Photo by Mark Corliss: p. 111 (bottom).

Photo by Taylor Dabney: p. 247 (bottom).

Photo by Bennett Davis: pp. 150, 151.

Photo by D. James Dee: pp. 108 (left), 168 (bottom).

Photo by Michael Dixon, Sierra Photo: p. 9.

Photo by eeva-inkeri: p. 44.

Photo by George Erml: pp. 32–3.

Photo by Michael Everson, Dickinson Studios, Sarasota, FL: p. 254.

Photo by Michael Faeder: p. 76 (top).

Photo by Neal Farris: pp. 192 (bottom), 193.

Photo by J. Kevin Fitzsimons: pp. 109 (bottom), 188.

Photo by Nicole Fortin, Berlin: p. 181 (top).

Photo by Mark Frey: pp. 13, 223.

Photo by Gregory Gantner: p. 198.

Photo by John Gibbons: pp. 227, 270.

Photo by Thomas Goldschmidt: p. 199.

Photo by Dennis Griggs: pp. 123, 294 (bottom); Tannery Hill Studios, Topsham, ME: pp. 121, 278–9.

Photo by Mark Gulezian: p. 196 (bottom).

Photo by Bob Hanson: pp. 56, 57 (left), 58 (right), 59, 60.

Photo by Hawthorne Studio: p. 271 (bottom).

Photo by Gerhard Heidersberger: p. 130.

Photo by Greg Heins: p. 73 (top).

Photo by Hester and Hardaway: pp. 109 (top), 192 (top).

Photo by Richard Hockway: p. 108 (right).

Photo by Peter Hogan: pp. 98, 99.

Photo by Roland Hueber: pp. 18, 19, 158, 159.

Photo by Alex Hughes: p. 177 (bottom).

Photo by Bruno Jarret: p. 187.

Photo by Richard Johns, Superior Color: p. 247 (top).

Photo by Eric Johnson: p. 6.

Photo by Huw Jones: pp. 200, 201.

Photo by Isaac Jones: p. 244 (right).

Photo by Susan Kahn, Taunton Press: p. 252 (bottom).

Photo by Clay Kappelman: p. 173 (bottom).

Photo by Robert Keziere, Vancouver: pp. 147, 251.

Photo by Paul Kodama: p. 90.

Photo by Erik Landsberg: pp. 126, 127.

Photo by John Lanning, Dallas, TX: pp. 192 (bottom), 193.

Photo by Schecter Lee: p. 72 (bottom).

Photo by David Leveall Photography, Eugene, OR: pp. 139, 234.

Photo by Eric Long: pp. 50, 292, 293.

Photo by Melissa Karlin Mahoney, courtesy of *Quilter's Newsletter Magazine*: p. 249.

Photo by Donnelly Marks, courtesy of The American Craft Museum: p. 27.

Photo by Chas. E. Martin: p. 210.

Photo by Jack Mathieson: p. 243.

Photo by Bill McLemore Photography: p. 104.

Photo by Myron Miller: pp. 16, 24, 62, 69, 195 (bottom), 238.

Photo by Josseline Minet: p. 247 (bottom).

Photo by Pam Monfort, Bronze Photography, Cincinnati, OH: pp. 134, 208, 230.

Photo by Thomas Moore: pp. 118, 185 (top).

Photo courtesy of the Museum of American Quilter's Society: p. 73 (bottom).

Photo by Sam Newbury: pp. 144 (bottom), 225 (top), 282.

Photo by Jeffrey Nintzel: p. 128.

Photo courtesy of Noho Gallery, New York: p. 271 (bottom).

Photo by Bill O'Flynn, Crawford School of Art: p. 101.

Photo by Joe Ofria: pp. 10, 175.

Photo by Dan Overturf: pp. 114, 115.

Photo by Joseph Painter: p. 107.

Photo by Bill Parsons, Little Rock, AR: p. 183.

Photo by Grover Partee: p. 245.

Photo by Photo House, Inc.: p. 207 (top).

Photo by Photographic Reflections, Stephen Buckley: p. 105.

Photo courtesy The Quilt Complex: pp. 30, 39.

Photo courtesy Quilt San Diego: pp. 141 (top), 179.

Photo courtesy Bets Ramsey: p. 177 (bottom).

Photo by Mary S. Rezny: pp. 20, 222.

Photo by Sharon Risedorph: pp. 53, 67, 124, 125, 152, 153 (bottom), 155, 156–7, 169, 174 (bottom), 178, 181 (bottom), 184, 186 (top), 216, 221, 225 (bottom), 240 (bottom), 244 (left), 257 (top), 261, 267, 268, 269, 277; courtesy of the Connell Gallery, Atlanta, GA: frontispiece, pp. 170, 171.

Photo by River City Silver, San Antonio, TX: p. 173 (top).

Photo by John Ryan: p. 168 (top).

Photo by Kou Saito: p. 166.

Photo by Ken Sanville, Boulder, CO: p. 250.

Photo by Bill Saunders: p. 100.

Photo by Roger Schreiber: p. 211.

Photo by John Schulman: p. 69 (top).

Photo by Paul Seheult: p. 111 (top).

Photo courtesy Sheffield Hallam University: p. 92.

INDEX